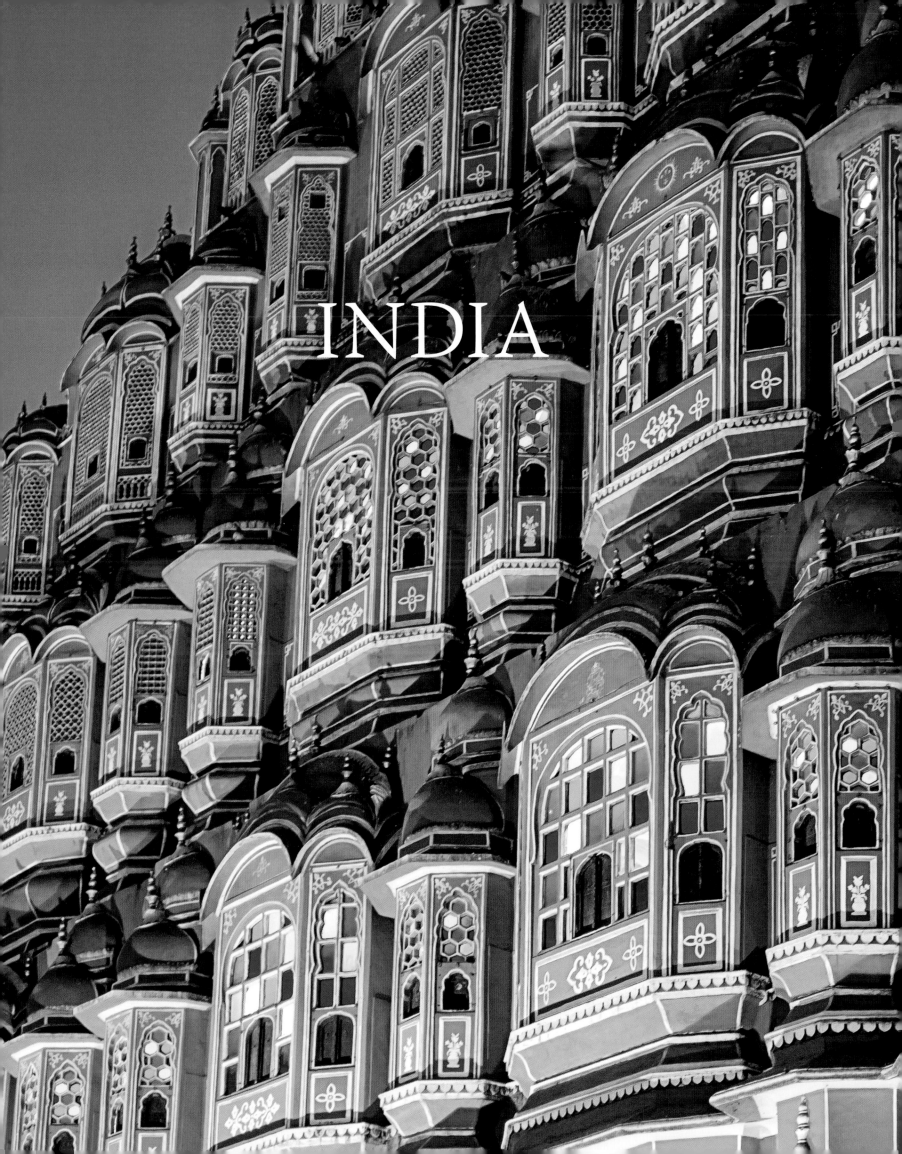

INDIA

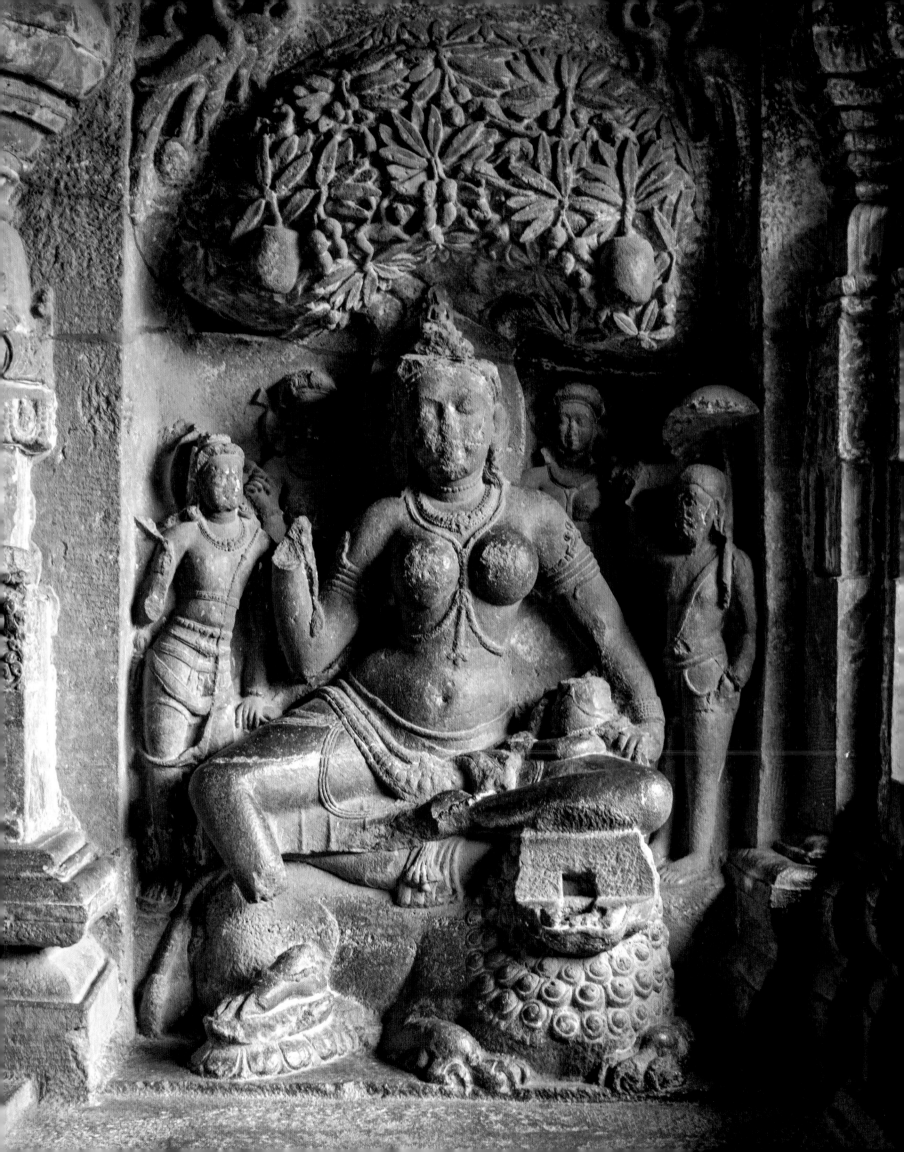

INDIA
UNESCO WORLD HERITAGE SITES

Edited by **Shikha Jain** and
Vinay Sheel Oberoi

Photo Editor **Rohit Chawla**

Preface by **Eric Falt**

United Nations
Educational, Scientific and
Cultural Organization

HIRMER

Publishers are grateful to the following for their
unstinting support towards the publication of this book:

Manasi Kirloskar-Tata

France Marquet and the
Madanjeet Singh Foundation-South Asia Foundation

This is a co-publication between
Mapin Publishing Pvt. Ltd
706 Kaivanna, Panchvati, Ellisbridge Ahmedabad 380006, India
and
United Nations Educational, Scientific and Cultural Organization (UNESCO)
7, Place de Fontenoy, 75007 Paris, France UNESCO Office New Delhi
1, San Martin Marg, Chanakyapuri, New Delhi Delhi 110021, India
and
Hirmer Publishers
Bayerstr. 57–59, 80335 Munich, Germany

ISBN: 978-92-3-100440-7 (UNESCO)
ISBN: 978-3-7774- 3571-8 (Hirmer)
www.hirmerpublishers.com

Title of the Indian edition published by Mapin Publishing:
Incredible Treasures: UNESCO World Heritage Sites of India

Bibliographic information published by the Deutsche Nationalbibliothek
The Deutsche Nationalbibliothek lists this publication in the Deutsche
Nationalbibliografie; detailed bibliographic data is available on the Internet at
hiip://www.dnb.de.

Text © Authors
Photographs © as listed on page 239

Copyediting: Mithila Rangarajan / Mapin Editorial
Proofreading: Ateendriya Gupta and Neha Manke / Mapin Editorial
Design: Gopal Limbad / Mapin Design Studio
Production: Mapin Design Studio
Printed in Italy

Front cover image: © Shutterstock
The dome of the Taj Mahal seen from the archway of the mosque. (See, p. 137)

Back cover © iStock
One of the *sursundari*s in a sculptural panel showing three of the ten *avatar*s
(manifestations) of Lord Vishnu at Rani-ki-Vav, Patan, Gujarat (*detail*). (See, p. 102)

For captions to the images on pages 1–20, please turn to p. 240.

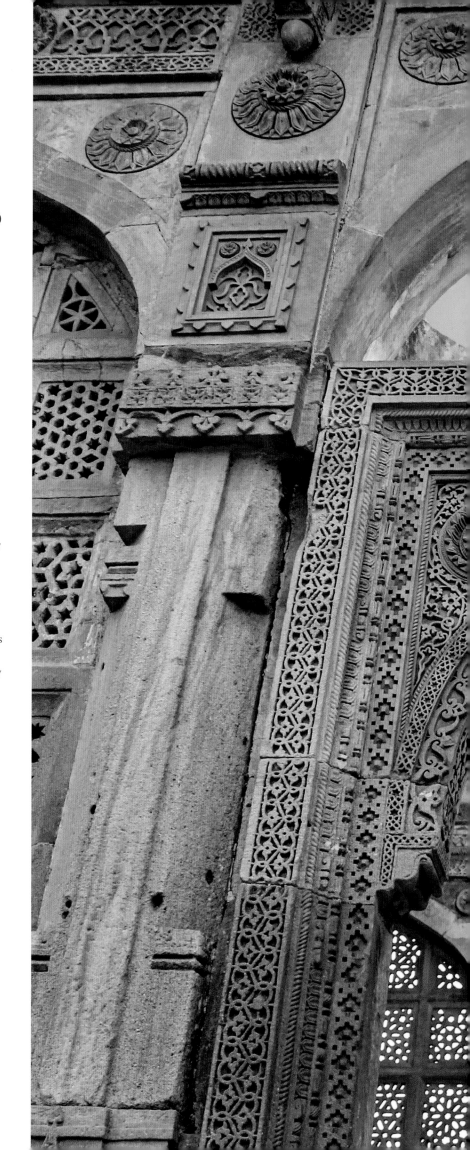

CONTENTS

Natural Sites

Mixed Site

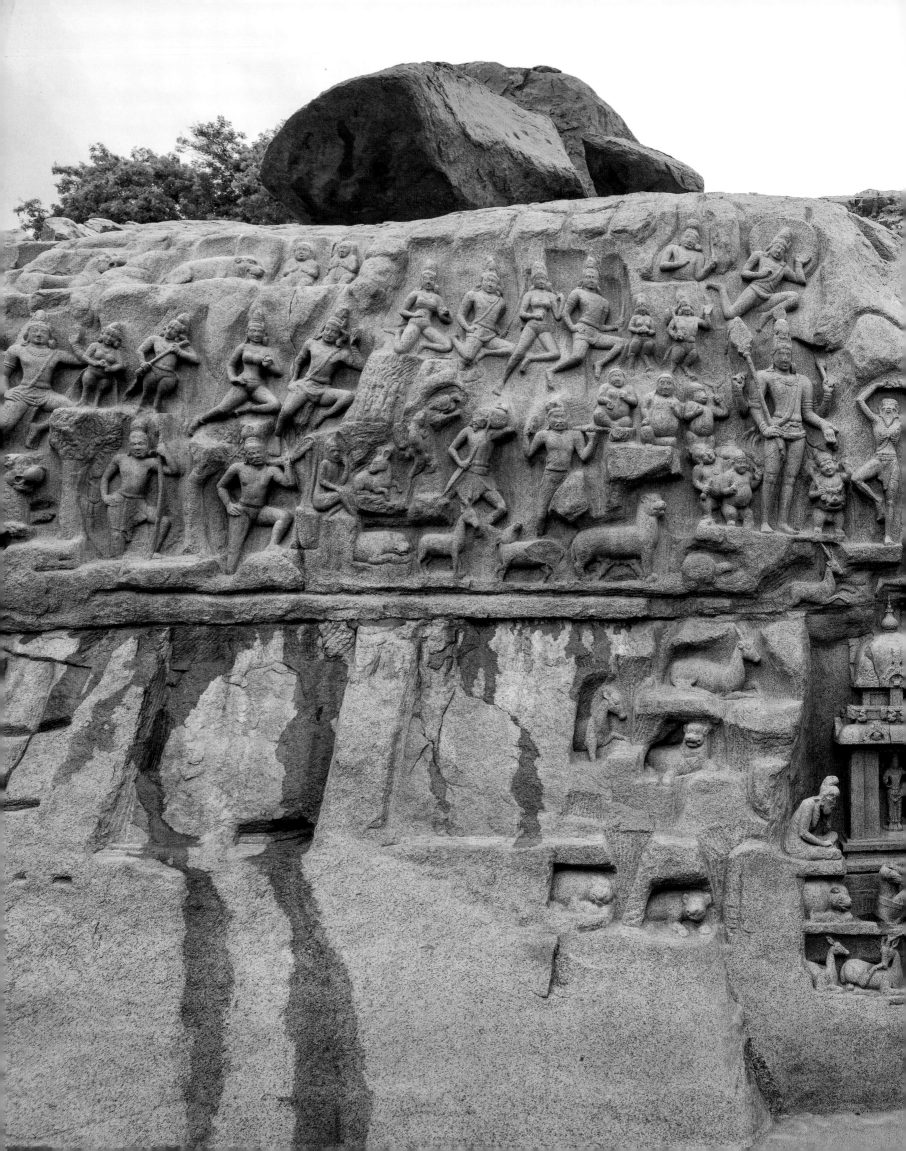

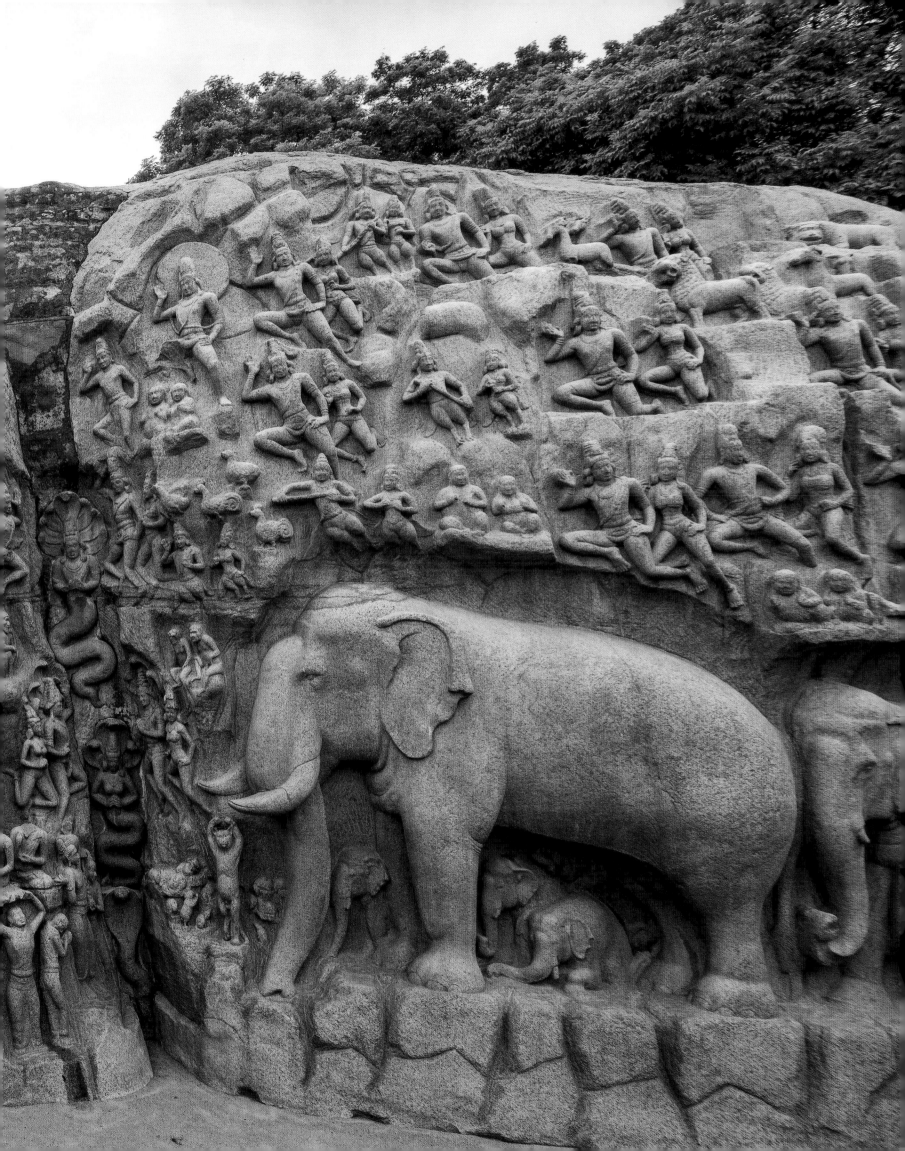

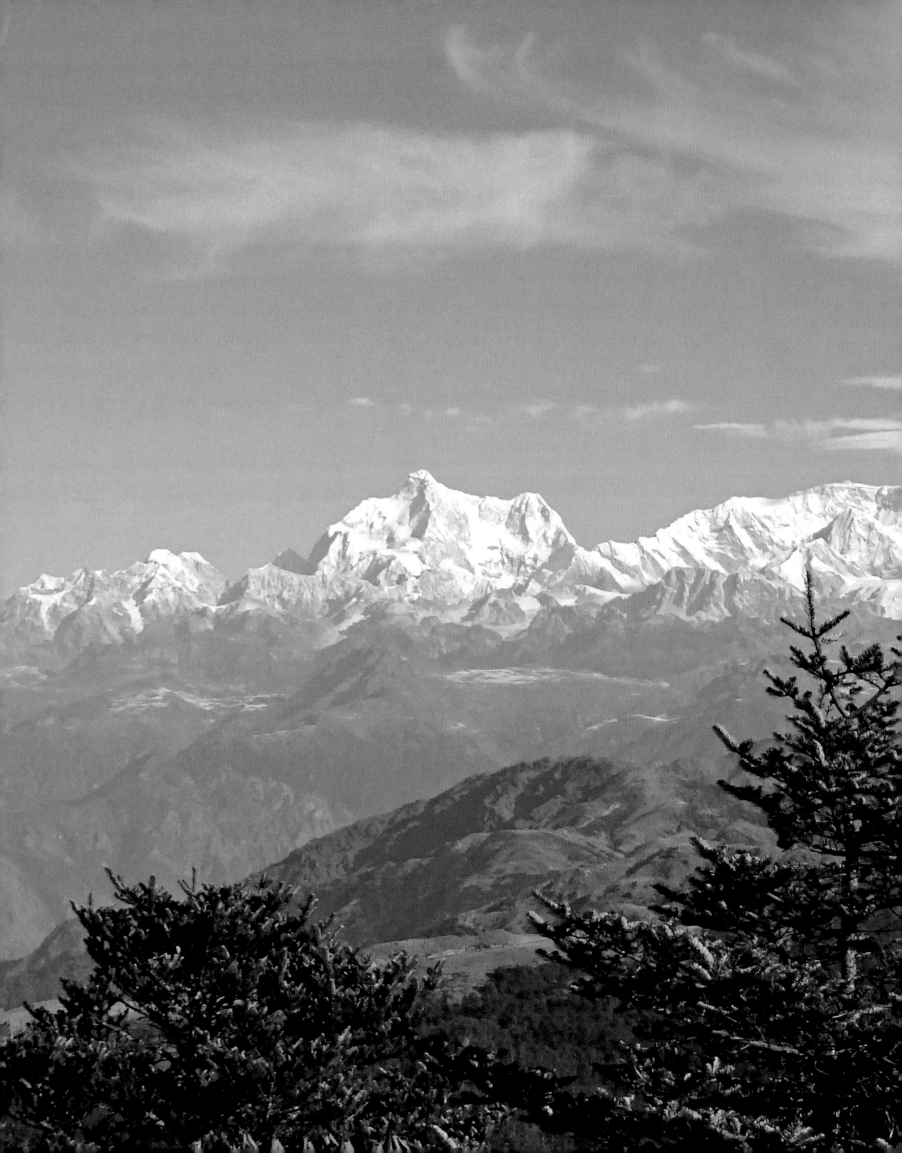

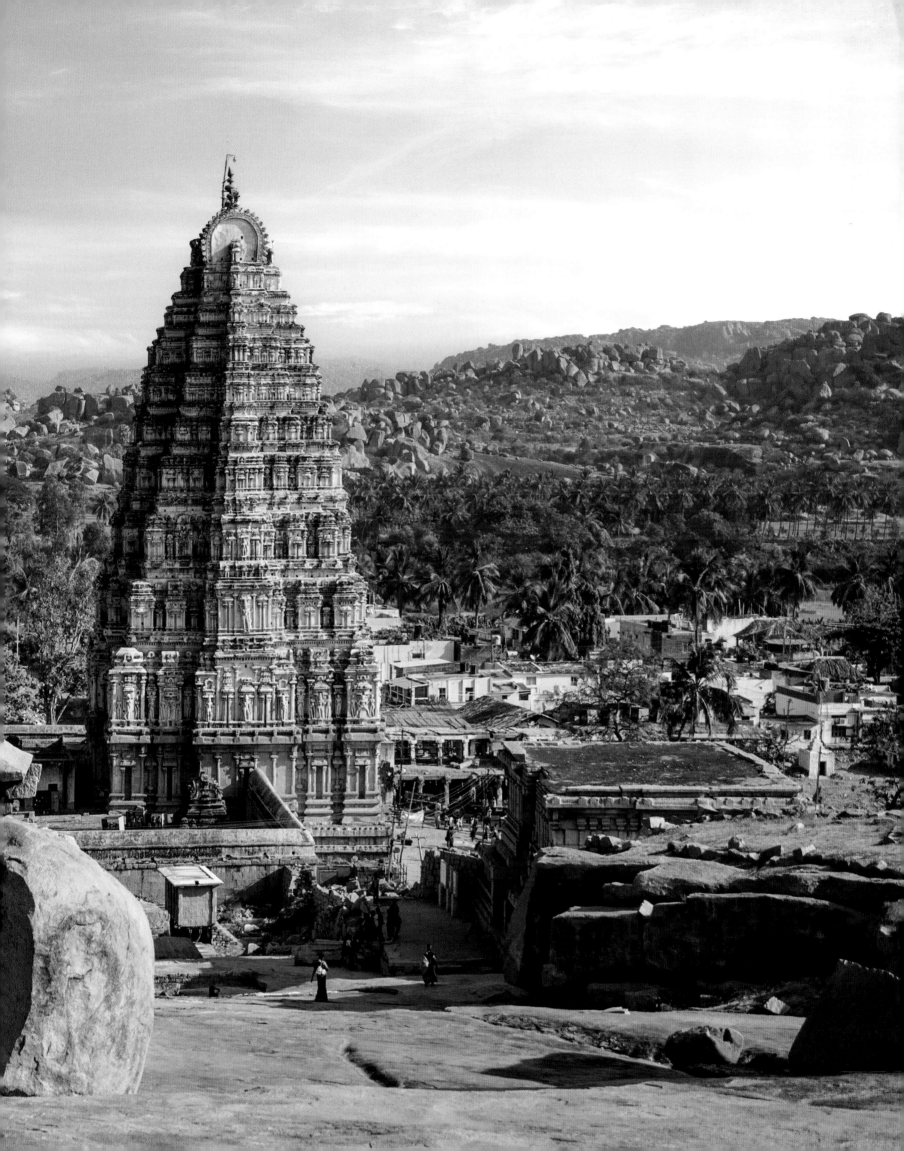

PREFACE

In the 167 countries where they are currently listed, UNESCO's World Heritage Sites are landmarks of outstanding historical, cultural and natural significance. Enlisted under the international Convention Concerning the Protection of World Natural and Cultural Heritage (1972), they are beacons of universal value and assets for the whole of humanity.

Today, India has thirty-eight magnificent World Heritage Sites—a number that we are certain will grow in the years ahead. The city of Jaipur in Rajasthan, inscribed in July 2019, was the most recent addition. Each of India's World Heritage Sites is a priceless marker of India's history and identity. Not only do they contribute to national pride, but their global recognition has also resulted in numerous other benefits. Every year, they receive millions of visitors, resulting in substantial economic gains for the communities where they are located. Typically, the presence of cultural and natural World Heritage Sites and related ancillary services tends to catalyse tourism, attract investment and sustain livelihoods.

The importance of World Heritage Sites to India's social and economic landscape and their impact on the public consciousness, therefore, cannot be underestimated.

Mahatma Gandhi has written eloquently of the "synthesis of the different cultures that have come to stay in India, that have influenced Indian life, and that in their turn have themselves been influenced by the spirit of the soil". These thirty-eight World Heritage Sites are physical manifestations of the cultural diversity and synthesis that is India. Indeed, along with the traditional practices and art forms that constitute the country's rich intangible cultural heritage, we believe that its tangible World Heritage Sites reflect the very soul of India. Published by UNESCO and Mapin Publishing, *Incredible Treasures: UNESCO World Heritage Sites of India* is the first attempt ever to present the country's thirty cultural heritage sites, including the cultural landscape of the Rock Shelters of Bhimbetka, seven natural sites and one mixed site, the Khangchendzonga National Park, between the covers of an illustrated book. We have no doubt that this meticulously researched publication, enhanced with lavish photographs, will become a collector's item almost instantly.

The cultural World Heritage Sites presented here span both the history and geography of India—from the earliest periods of rock art, Buddhist caves and Hindu temples; Sultanate and Mughal forts, palaces, tombs and memorials; medieval Islamic and Hindu cities, stepwells and observatories; and heritage sites from the twentieth century. The natural and mixed sites are landscapes of exquisite beauty that also represent age-old instances of harmonious dialogue between people and their environment.

We believe that this book will help build greater awareness about India's World Heritage Sites among specialists and other readers alike. We hope it encourages them to support "efforts to protect and safeguard the world's cultural and natural heritage". as Target 11.4 of the Sustainable Development Goals urges us to do.

Incredible Treasures has benefited immensely from the research and contributions of a high-powered group of experts in the fields of architecture, cultural conservation, sustainable

heritage development, wildlife and ecology. It has been superbly edited by Shikha Jain and Vinay Sheel Oberoi, both of whom shared long and close associations with UNESCO.

Vinay sadly passed away in the final stages of editing this publication. He was a remarkable and passionate Ambassador of India to UNESCO in Paris for several years and remained active in promoting internationally the cultural heritage of his country when he returned home. Vinay touched many people with his personality and his sense of humour. I feel privileged to have known him and to dedicate *Incredible Treasures* to him.

The remarkable photography and photographic research of Rohit Chawla, one of India's leading photographers today, brings the country's World Heritage Sites to life. These curated images combine a keen sensitivity for his subject with an artist's quest for meaning, and transform this publication into a thoroughly immersive experience.

We owe a debt of gratitude to Manasi Kirloskar-Tata, France Marquet and the Madanjeet Singh Foundation-South Asia Foundation for their unstinting support.

Finally, a very warm word of thanks to Bipin Shah of Mapin Publishing, our co-publisher for this work. His passion for bringing marvels of Indian history and culture before a wider reading public is infectious. The present book marks UNESCO's second collaboration with Mapin, the first being our Roshni Series on Indian World Heritage Sites for younger readers. We remain grateful to Bipin for his immediate enthusiasm for this project.

Incredible Treasures is the definitive book on the subject. We hope you enjoy reading it and poring over its lush photographs as much as we enjoyed putting it together.

Much like you (I am sure), I have yet to discover all thirty-eight sites in India myself. During my visits so far, I was particularly struck by the Group of Monuments at Mahabalipuram in Tamil Nadu, where I stood in awe of the "Descent of the Ganges", a giant rock relief carved on two boulders of pink granite; and was fascinated by Krishna's Butterball, which reposes at a gravity-defying angle a stone's throw away.

As you continue exploring the UNESCO World Heritage Sites beyond this publication, we invite you to: (a) Use the dedicated hashtags **#ShareOurHeritage** and **#unescowhsitesinindia** and tag us at **@unesconewdelhi** when posting your photographs of Indian World Heritage Sites on Instagram; or (b) Use our Instagram handle @unesconewdelhi to tag us in your public posts about Indian World Heritage Sites, thus allowing us to repost your photographs on our Instagram page.

Now, let us give free rein to our wanderlust and begin our journey of discovery together.

Eric Falt

Director and Representative

UNESCO New Delhi (covering India and also Bangladesh, Bhutan, the Maldives, Nepal and Sri Lanka)

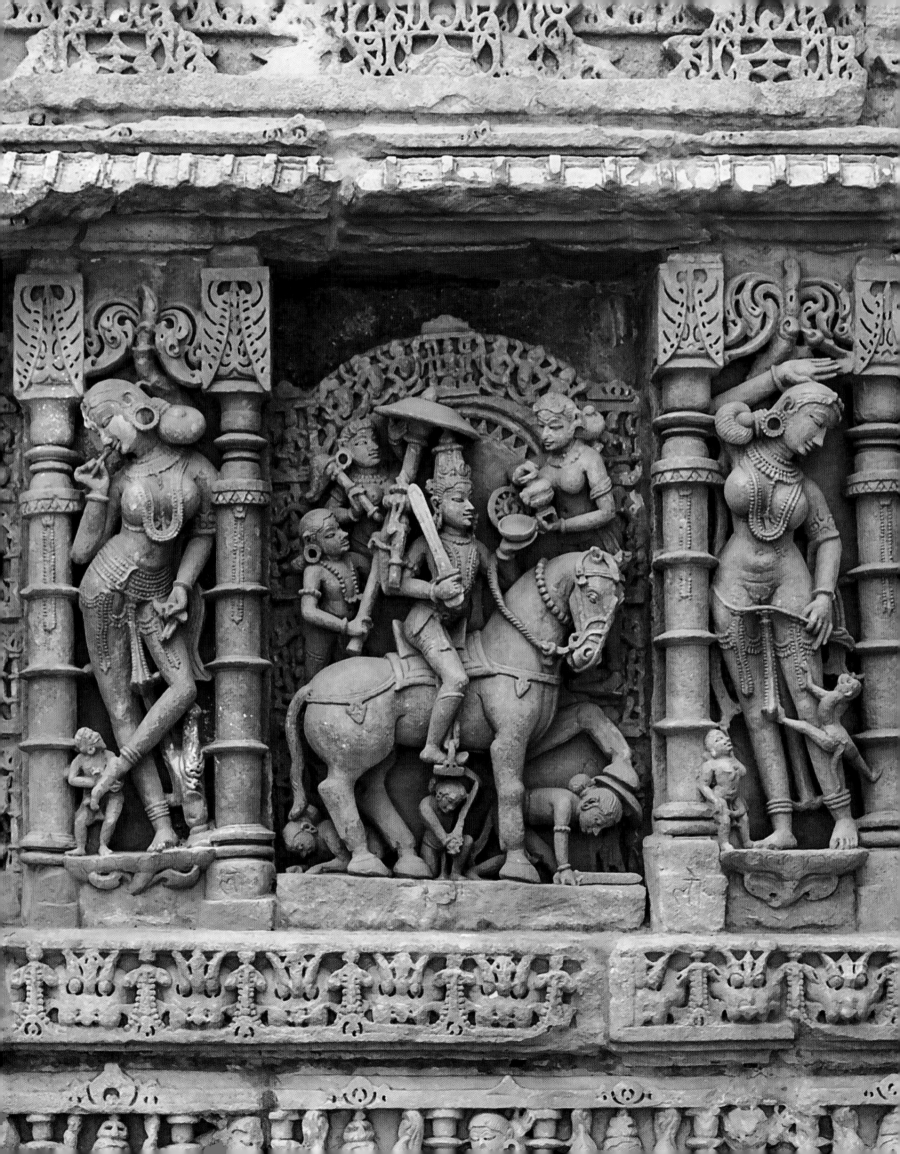

I am pleased to endorse this panoramic publication on India's thirty-eight World Heritage Sites. These thirty-eight jewels reflect the extraordinary vision, planning and characteristics of various cultures and our ancient Indian civilisations. Recognised for their Outstanding Universal Value, each World Heritage Site is a unique icon.

NITI Aayog has initiated a nationwide effort to understand the current challenges for heritage management in India and to provide a future roadmap along with an appropriate branding of India's invaluable archaeological and built heritage. We are also ensuring guidance to the concerned heritage custodians of these World Heritage Sites, including the nodal agency, the Archaeological Survey of India (ASI), to further enhance, conserve and promote these locations for local communities as well as visitors.

India has played a key role as a member of the World Heritage Committee for three terms, since its ratification in 1977. We are concerned with the significant role of safeguarding these World Heritage Sites for posterity and deeply encourage intercultural exchanges with other countries for this purpose. We recognise the need for capacity-building and the use of technology in this sphere of World Heritage. The UNESCO Category 2 Centre for Natural Heritage at the Wildlife Institute of India, Dehradun, is already functioning to provide guidance and training for the entire Asia-Pacific Region. A parallel initiative for establishing a cultural Category 2 Centre of UNESCO at Asia-Pacific level is in progress with the ASI.

With the diversity of thirty cultural, seven natural and one mixed site from India on the World Heritage List, we understand the wide range of typologies, terrains and cultures that need to be addressed. While India's heritage custodians are striving hard to protect, conserve, enhance and interpret the existing World Heritage Sites, we are also working towards a larger representation on the List to aim at a more Balanced, Credible and Representative Listing in harmony with our neighbouring countries and the World Heritage Convention.

There is a serious need for communicating the values of India's UNESCO World Heritage Sites to the larger public and this publication is an excellent step in this direction. This visually rich publication is a unique attempt to reach out to the people and make them aware of these invaluable treasures of India.

Amitabh Kant
CEO, NITI Aayog,
Government of India

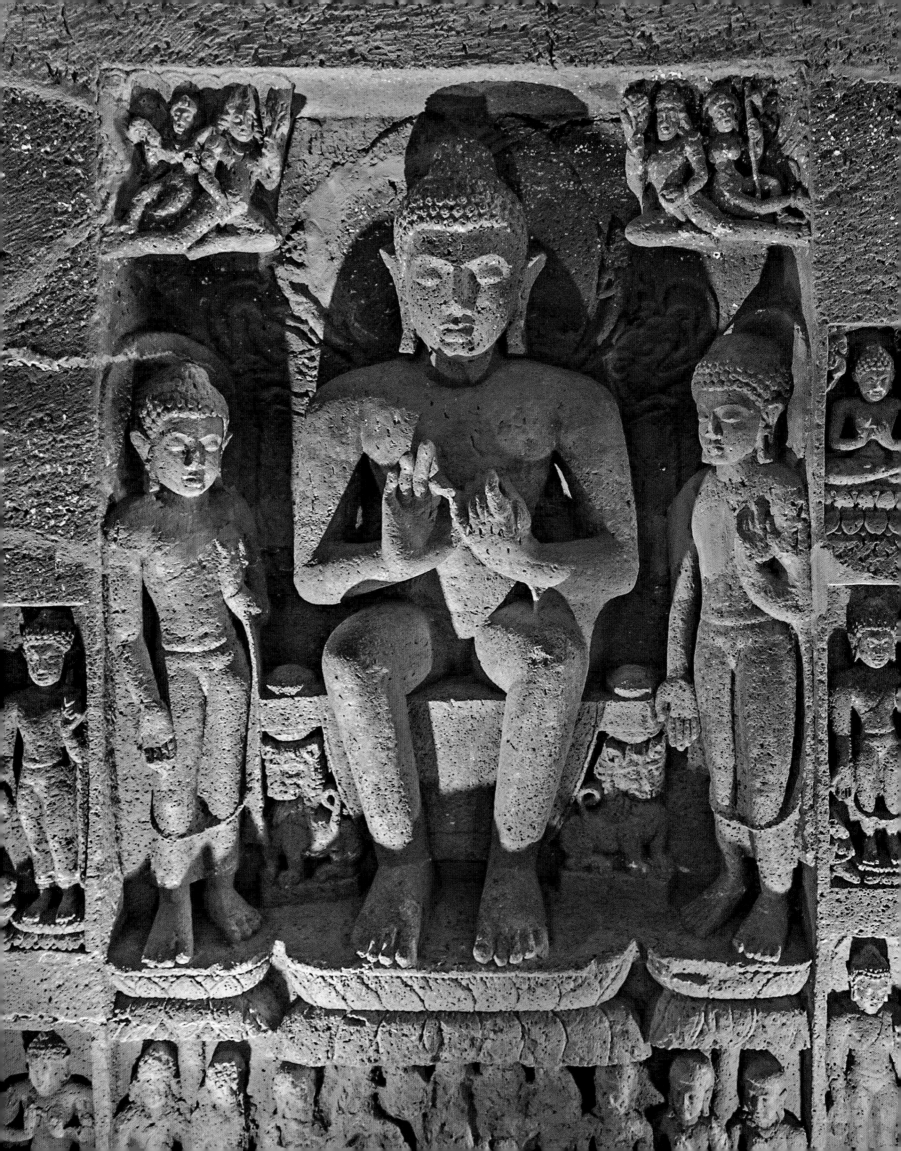

"Whatever sphere of the human mind you may select for your special study, whether it be language, or religion, or mythology, or philosophy, whether it be laws or customs, primitive art or primitive science, everywhere, you have to go to India, whether you like it or not, because some of the most valuable and most instructive materials in the history of man are treasured up in India, and in India only."

—F. Max Müller

India: The World Heritage Narrative

Max Müller's statement on India's culture truly encapsulates the ethos of its rich cultural and natural heritage and its World Heritage Sites, which are a testimony to its invaluable treasures. The Indian subcontinent is one of the largest geopolitical expanses in the world, with a huge diversity of heritage. It is well established that, historically, India was a melting pot of several civilisations and cultural exchanges and gave space to multiple faiths, including Hinduism, Jainism, Buddhism, Islam, Sikhism, Christianity and others, at various stages in its history. This "culture of assimilation" of ideas and beliefs is reflected in the current range of its World Heritage Sites that establish India as a repository of archetypal diversity and artistic excellence. A unique feature of many of India's World Heritage Sites is their continuity over centuries; age-old traditions that embody its living heritage continue to be in practice even today, be it at the Buddhist Mahabodhi Temple at Bodh Gaya, the Great Living Chola Temples in Tamil Nadu, or the mosque at the iconic site of the Taj Mahal in Agra.

Though the thirty-eight World Heritage Sites across India were inscribed individually, they do collectively contribute to a cohesive historical narrative of India's diverse archaeological, architectural and geographical spectrums within the framework of its millennia-old socio-political history. The sites are spread across the expanse of the country, framed between the picturesque natural setting of the Great Himalayas in the north, the rugged Western Ghats along the Arabian Sea to the west and the coastal expanse of the Indian Ocean to the south and the east. As an entire corpus, these World Heritage Sites chronicle centuries-old history, the ancient grandeur of various empires and the diverse physiography of the Indian subcontinent. This Introduction is an attempt to understand the individual context of these sites and their setting within the Indian cultural landscape that has evolved through the centuries, producing natural and cultural classics in each evolutionary phase.

The natural heritage site of the Western Ghats, spread across four states of India, recounts a 150-million-year-old history, dating to when the Indian subcontinent was yet to take its full shape and the Himalayas had not yet emerged as the highest mountains of the world. The Western Ghats demonstrate the processes of the break-up of the ancient land mass of Gondwanaland, the formation of the Indian subcontinent and the tectonic shift of the Indian land mass with Eurasia. Responsible for the pattern of the Indian monsoon that has determined the tropical climate of the southern Indian peninsula for aeons, the Western Ghats are home to 325 globally threatened plant, bird, amphibian, reptile and fish species of the world today. Besides the outstanding natural features for which the Western Ghats

are inscribed on the list, their geological structure in coastal Maharashtra determined the form, location and dimensions of the earliest Buddhist, Hindu and Jain rock-cut cave architecture in India from 200 BCE to 1000 CE, as seen in the three cultural World Heritage Sites of Ajanta, Elephanta and Ellora Caves.

The World Heritage Site of the Rock Shelters of Bhimbetka, with the earliest caves of the hunter-gatherers and their rock paintings, however, lies in the Vindhyan mountain range in the state of Madhya Pradesh in central India. The Vindhyan Range is a sedimentary sandstone escarpment running from east to west that roughly divides northern India from the southern peninsular area. The natural clusters of rock shelters, integrated with the

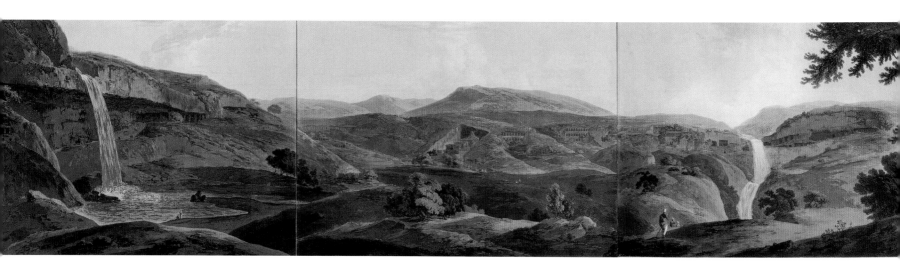

Painting of the mountain of Ellora (detail) by Thomas Daniell from the drawings of his deceased friend James Wales, 1803.

Vindhyan landscape, are spread over the upper parts of the hills and exhibit the history and evolution of humankind from 10,000 years ago to the early medieval period. This part of central India also houses two other cultural sites—the Buddhist sanctuary at Sanchi, dating from the first and second century CE, and the temples of Khajuraho, representing the architectural grandeur of the Chandela dynasty between 950–1050 CE. These three sites stand as symphonies in sandstone; one as a prehistoric outcrop, the second from the early Buddhist period and the third from the medieval Hindu period.

Moving further east one observes the development of the Indo-Gangetic plain in the state of Bihar. The early Buddhist-period cultural sites of the Mahabodhi Temple complex at Bodh Gaya and the Nalanda Mahavihara, the world's most renowned ancient Buddhist institution, are demonstrations par excellence of the brick architecture from the region. Nalanda, dating from the third century BCE to the thirteenth century CE, is one of the longest-serving monastic and scholastic establishments in the Indian subcontinent, and also displays artwork in stone and metal.

Further east is the Ganga deltaic zone on the coast of West Bengal. Recognised as part of the world's largest delta, formed from sediments deposited by three great rivers—the Ganges, the Brahmaputra and the Meghna—the land has been moulded by tidal action, resulting in a distinctive physiology. This marks the natural World Heritage Site of the Sunderbans, one of the largest remaining areas of mangroves in the world, also home to the Bengal tiger. This natural formation dates back to 7000 BCE.

Down south, the eastern coastline of peninsular India is witness to the three earliest freestanding temple complexes in the country, dating from 600 CE to 1250 CE. The story of the great southern empires of India is told via the Group of Monuments at Mahabalipuram, founded by the Pallavas; Great Living Chola Temples; and the Sun Temple at Konârak, which serves as a testimony to the Eastern Ganga Empire. Each of these three sites is recognised as a masterpiece in art and architecture of the particular period; the first two are carved in locally available granite, while the Sun Temple is built in khondalite. These three temple sites are not only examples of architectural excellence but also narrate stories of the coastal cultural exchanges of their empires along the Indian Ocean trade routes. The World Heritage Site of the Churches and Convents of Goa tells similar tales of the western coast, showing the architectural influences from trading and cultural exchanges with the Portuguese in the sixteenth century.

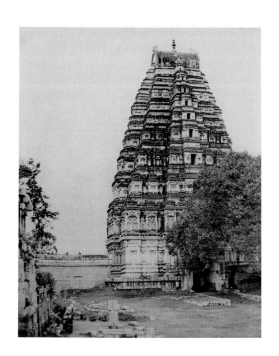

Virupaksha Temple, East *Gopura*, Alexander Greenlaw, Modern Positive (2007) from Waxed-paper Negative, 1856.

The legacy of the temples of southern India is further evident in the World Heritage Sites at Pattadakal and Hampi, both located in the Deccan Plateau region, in the heart of peninsular India. These demonstrate developments in temple architecture during the Chalukyan period in the eighth century, and the Hindu empire of Vijayanagar at Hampi, which lasted from the fourteenth to sixteenth century.

The Champaner-Pavagadh Archaeological Park in the northwestern state of Gujarat records the remains of another Hindu-period capital on the Pavagadh hill, with its extraordinary water systems and a living temple dating from the eighth century. It also includes remains of the Gujarat Sultanate capital of Champaner, designed by Mehmud Begada in the sixteenth century. The northwestern state of Gujarat houses two more cultural heritage sites: the Queen's Stepwell, or Rani-ki-Vav, at Patan, a supreme example of subterranean architecture dating from the eleventh century, and the capital city of Ahmedabad, or Ahmadabad, designed by Sultan Ahmad Shah, on the eastern bank of the Sabarmati River, dating from the fifteenth century.

The clan capitals of the Rajputs and their fortress designs—adapted to various hilly terrains—as well as their eclectic architectural styles are exhibited in the six Hill Forts of Rajasthan, as are their several layers of history dating from the seventh to the nineteenth century. Four of these are spectacularly spread across the Aravalli Range, one of the oldest mountain ranges of the world, which cuts diagonally across the state of Rajasthan, while the fifth fort crowns a desert outcrop and the sixth one is a water fort on the Vindhyan outcrop. The exceptional eighteenth-century observatory of the Jantar Mantar and the planned city of Jaipur are two other cultural heritage sites of the Rajput dynasties, who served as commanders to Mughal emperors and yet created an architectural legacy of their own. Interestingly, even the Keoladeo National Park in Rajasthan started as a duck-hunting reserve of one of the Rajput rulers before evolving into a major wintering area for large numbers of aquatic birds from Afghanistan, Turkmenistan, China and Siberia. It is the only artificially created natural World Heritage Site listed in India.

The monuments from the Delhi Sultanate, such as the thirteenth-century Qutb Minar, and the magnificent memorials, forts and palaces of Mughal rule, dating from the mid-

sixteenth to the eighteenth century, including Humayun's Tomb, the Red Fort, the Agra Fort, Fatehpur Sikri and the Taj Mahal, are located in the imperial capitals of Delhi and Agra, in the plains at the heart of northern India. Their monumental splendour speaks of the Indo-Islamic exchanges and finesse achieved in art and architecture over a period of three centuries. Their construction materials of marble and sandstone came from the stone quarries of Rajasthan.

The post-Mughal era saw the arrival of the British in India and the beginnings of industrialisation, which is evident in the nineteenth-century development of the three Mountain Railways of India, one of the most ambitious colonial projects of the time. Mumbai's Victorian Gothic and Art Deco urban architecture of the nineteenth and early twentieth century is a testimony to the trade and cultural exchanges of the colonial and pre-Independence period.

The northernmost part of India is home to the Himalayas, a mountain range that formed 40–50 million years ago and is considered to be the highest in the world today. These mountains continue to rise by one centimetre every year, with the shifting of the tectonic plate. This amazing phenomenon has given rise to the rich repository of four natural World Heritage Sites in the region—the Great Himalayan National Park Conservation Area, the Nanda Devi National Park and the Valley of Flowers National Park in the mountain ranges of Himachal Pradesh, along with the biodiversity hotspots of the Kaziranga National Park and the Manas Wildlife Sanctuary in Assam. India's crowning glory is its only mixed World Heritage Site—the Khangchendzonga National Park in Sikkim, containing the third-highest peak of the Himalayas, which is venerated by several communities.

The spirit of independent India is seen in the World Heritage Site of the Capitol Complex at Chandigarh, which is part of the transnational site of the Architectural Work of Le Corbusier. The Capitol Complex is strategically located at the foothills of the Shivaliks, the lowest Himalayan mountain range.

These thirty-eight World Heritage treasures of India can be viewed as a strong, cohesive narrative, bringing together India's origin as a land mass; the earliest humans who lived on this subcontinent; the various kingdoms and empires that left their mark as architectural testimonies of different time periods, technologies and styles; and, finally, the emergence of modern India with its own architectural idiom. India's rich heritage, its centuries-old history and diverse geography leave the field open for more World Heritage Sites in the future, which can enhance this narrative.

Given the diverse spread of these sites across India, they are owned, protected and managed by various organisations, including the ASI; the Ministry of Railways; the Ministry of Environment, Forest and Climate Change; various State Government departments of Forest, Archaeology and Culture; local municipal bodies; and even some private temple trusts. The ASI is the nodal agency that acts on behalf of the Ministry of Culture, Government of India, for World Heritage matters, and is also the custodian of twenty-two out of the thirty cultural sites.

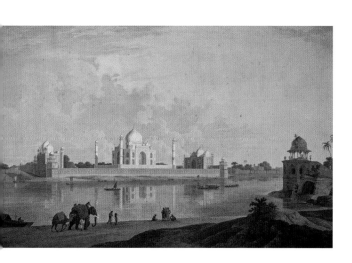

"The Taje Mahel, Agra" (detail), aquatint, drawn and engraved by Thomas and William Daniell. Published by Thomas Daniell, London, 1801.

The Story of World Heritage: Concept and Convention

What is World Heritage and how did this idea come into being? In the postwar period, cultural heritage and nature conservation professionals across the world began to be concerned about the long-term protection and conservation of important archaeological sites and natural environments. The concept of a "World Heritage Trust" was first proposed during a conference at the White House in 1965, which was being celebrated as International Cooperation Year, and also marked the twentieth anniversary of the founding of the United Nations (UN). The two parallel movements focusing on the protection of cultural sites and the conservation of natural heritage eventually came together in the framing and adoption of the "Convention Concerning the Protection of World Cultural and Natural

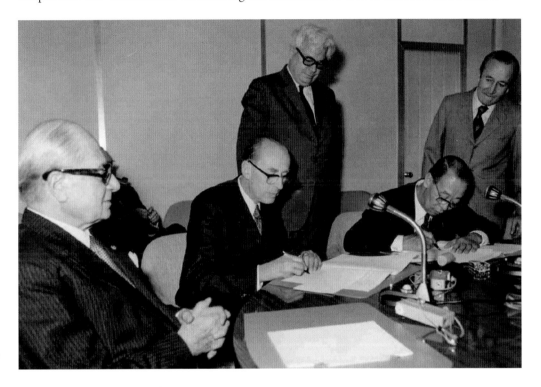

Signature of the World Heritage Convention by René Maheu (centre), UNESCO Director-General, 23 November 1972.

Heritage 1972" by UNESCO on 16 November 1972. Between 1965 and 1972, the idea took various forms, with several international bodies, nations and professionals involved. The path to framing this Convention as well as its ratification by various countries and the initiation of the list between 1965 and 1972 was a long and arduous one, recorded by UNESCO in its various publications, including its History Papers on "Invention of World Heritage".

The Convention is popularly termed "the World Heritage Convention" today, and defines the kind of exceptional cultural and natural properties that can qualify to be inscribed on the World Heritage List.

It is interesting to note India's involvement in this initial stage between 1965 and 1972. It was at the 1969 International Union for Conservation of Nature (IUCN) Congress at New Delhi that a decision was taken to present the issue of World Heritage at the UN Stockholm Conference in 1972. As the matter became more complex a number of international bodies became involved. A UN Conference on the Human Environment in Stockholm, Sweden, in 1972, between member nations and UNESCO led to two or three drafts of the "World Heritage Trust", and it was decided at the Stockholm conference that the final version of

UNESCO WORLD HERITAGE SITES OF INDIA

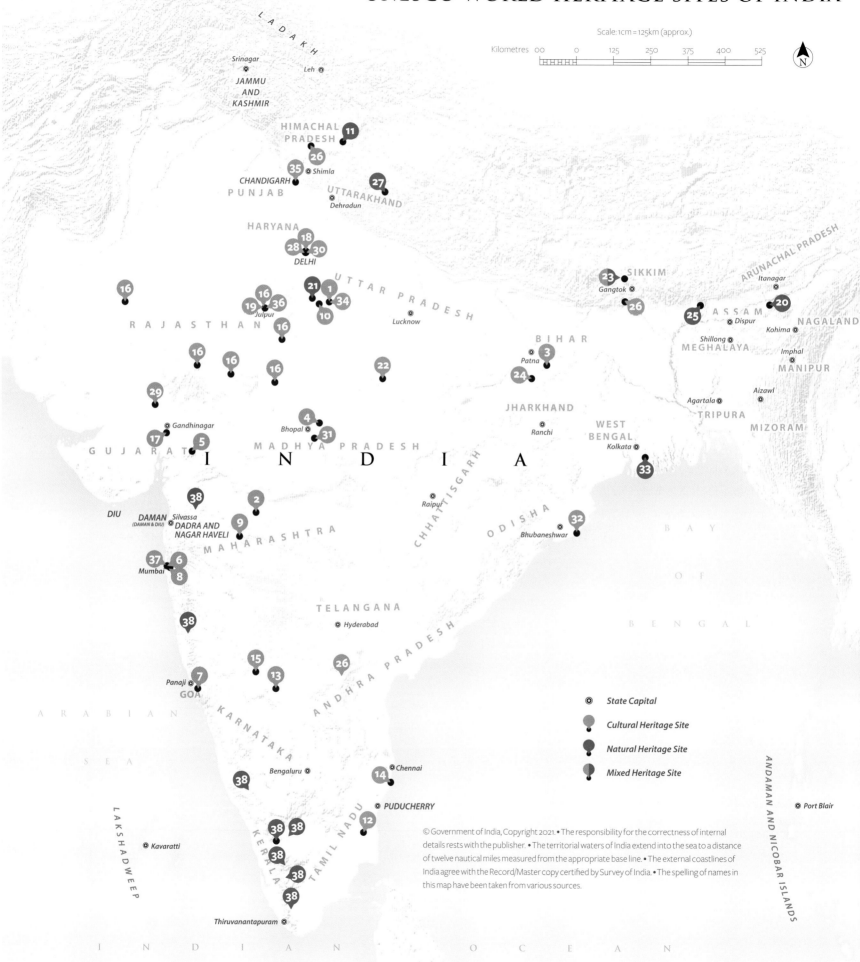

Scale: 1cm = 125km (approx.)

Kilometres 00 0 125 250 375 400 525

N

State Capital

Cultural Heritage Site

Natural Heritage Site

Mixed Heritage Site

1. Agra Fort, Uttar Pradesh

2. Ajanta Caves, Maharashtra

3. Archaeological Site of
 Nalanda Mahavihara at Nalanda, Bihar

4. Buddhist Monuments at Sanchi, Madhya Pradesh

5. Champaner-Pavagadh Archaeological Park, Gujarat

6. Chhatrapati Shivaji Terminus
 (formerly Victoria Terminus), Maharashtra

7. Churches and Convents of Goa

8. Elephanta Caves, Maharashtra

9. Ellora Caves, Maharashtra

10. Fatehpur Sikri, Uttar Pradesh

11. Great Himalayan National Park Conservation Area,
 Himachal Pradesh

12. Great Living Chola Temples, Tamil Nadu

13. Group of Monuments at Hampi, Karnataka

14. Group of Monuments at Mahabalipuram, Tamil Nadu

15. Group of Monuments at Pattadakal, Karnataka

16. Hill Forts of Rajasthan

17. Historic City of Ahmadabad, Gujarat

18. Humayun's Tomb, Delhi

19. Jaipur City, Rajasthan

20. Kaziranga National Park, Assam

21. Keoladeo National Park, Rajasthan

22. Khajuraho Group of Monuments, Madhya Pradesh

23. Khangchendzonga National Park, Sikkim

24. Mahabodhi Temple Complex at Bodh Gaya, Bihar

25. Manas Wildlife Sanctuary, Assam

26. Mountain Railways of Himachal Pradesh,
 Tamil Nadu and West Bengal

27. Nanda Devi and Valley of Flowers National Parks,
 Uttarakhand

28. Qutb Minar and its Monuments, Delhi

29. Rani-ki-Vav (the Queen's Stepwell) at Patan, Gujarat

30. Red Fort Complex, Delhi

31. Rock Shelters of Bhimbetka, Madhya Pradesh

32. Sun Temple, Konârak, Odisha

33. Sundarbans National Park, West Bengal

34. Taj Mahal, Uttar Pradesh

35. The Architectural Work of Le Corbusier,
 an Outstanding Contribution to the Modern
 Movement, Chandigarh

36. The Jantar Mantar, Jaipur

37. Victorian Gothic and Art Deco Ensembles of Mumbai

38. Western Ghats in Kerala, Tamil Nadu, Karnataka,
 Goa and Maharashtra

the Convention Concerning the Protection of World Cultural and Natural Heritage would be proposed at the General Assembly of UNESCO in 1972. India was an active member in this process, participating in the April 1972 UNESCO meeting (to draft the Convention and offer recommendations), the UN Conference in Stockholm in June 1972 and the UNESCO General Conference in the same year, where the Convention was adopted. The adoption of the Convention was followed by its ratification by 1974 by various countries such as Algeria and the United States of America. India ratified the World Heritage Convention in 1977. Since then, it has been an active elected World Heritage Committee member for three terms—1985–1991, 2001–2007 and 2011–2015—and has played a key role in contributing to the amendments in various World Heritage–related guidelines and documents and seen the listing of its thirty-eight World Heritage Sites.

The World Heritage Convention is the only existing UN Convention that brings forth the significance of culture and nature in conjunction with each other. This was exemplified by René Maheu, UNESCO Director-General (1961–1974), in his statement at the Stockholm conference:

"For long the subject of separate—even of rival—forms of study and devotion, nature and culture now appear to be simultaneously threatened with death if they remain separated, and along with them man himself, who can exist only when the two are combined."

Thus began the journey of selecting sites of exceptional cultural and natural heritage value, which would be placed on the World Heritage List. Initially, the list aimed to identify only a hundred sites; the number has since risen to over a thousand, due to the increasing worldwide recognition of the list, as well as the aspirations of the signatory countries. As per the Convention, World Heritage Sites were initially classified either as natural or cultural. Later, the category of mixed sites was added to cover sites with outstanding cultural as well as natural values. As of May 2020, there are 1,121 properties on the World Heritage List from 167 of the world's 193 countries. Of these, 869 are listed as cultural sites, 239 as natural sites and 39 as mixed sites. The increasing number and variation of sites on the list, including living historic cities and cultural landscapes, has posed substantial management challenges that were not envisaged at the time of framing the Convention. The UN sustainable development goals, which identify the important role of conservation of natural and cultural heritage for sustainable development, are thus a welcome initiative to support the Convention's objectives.

Connecting Tales from the World

After the adoption of the Convention in 1972, it remained to define the criteria and process of inscribing a site onto the World Heritage List. The two advisory bodies of UNESCO mentioned in the Convention, International Council on Monuments and Sites (ICOMOS) and IUCN, were tasked with outlining the selection criteria for sites of cultural and natural heritage of Outstanding Universal Value. Over time, these criteria for cultural and natural heritage and the subcategories of cultural sites became more elaborate, with the Operational Guidelines for implementing this Convention having been revised almost thirty times.

The inscription of sites on the World Heritage List could only be initiated in the 2nd World Heritage Committee Session in 1978, at which time around twenty countries had ratified the Convention. In the spirit of balancing the claims of culture and nature, the first two sites to be inscribed were the Galapagos Island in Ecuador, as a natural heritage site, and the city of Quito, also in Ecuador, as a cultural heritage site. Twelve sites were inscribed in total. As per the Convention, nominations for cultural heritage were allowed under three heads: as monuments, as groups of buildings and as sites.

India began contributing to the World Heritage List from 1983 onwards, with its first four cultural World Heritage Sites, namely, the Ajanta and Ellora Caves, representing the Buddhist period, and the Agra Fort and the Taj Mahal, as iconic Mughal monuments. Comparable South Asian sites had already appeared on the list, with Nepal's Kathmandu Valley and Sagarmatha National Park inscribed in 1979; Pakistan's Archaeological Ruins at Moenjodaro (also spelt Mohenjo-daro), Buddhist Ruins of Takht-i-Bahi and Neighbouring City Remains at Sahr-i-Bahlol, the Fort and Shalamar Gardens of Lahore, and the Historical Monuments at Makli, Thatta and Taxila, all inscribed between 1979 and 1981; and Sri Lanka's three Buddhist-period cities of Anuradhapura, Polonnaruwa and Sigriya inscribed in 1982. In 2020, India nominated Dholavira, a site of the Indus Valley Civilisation contemporary to Mohenjo-daro, for inscription.

Natural heritage properties can be nominated under three categories: those that include exceptional natural features; those that present geological and physiographical formations that constitute the habitat of threatened species of animals and plants of Outstanding Universal Value; or those that exist as outstanding natural sites. In 1985, India's first three natural World Heritage Sites made their way onto the list: these were the Kaziranga National Park, the Keoladeo National Park and the Manas Wildlife Sanctuary. At this stage, other natural heritage sites from South Asia included the Sagarmatha National Park and the Chitwan National Park, both in Nepal.

The Convention also aimed to identify sites of humankind's shared heritage, whose long-term protection and preservation were the responsibility of the entire international community, as well as to recognise cultural and natural heritage equally and understand their interdependency so as to better protect both.

A global study carried out by ICOMOS from 1987 to 1993 revealed that European properties, historic towns and religious monuments, Christianity, historical periods (in relation to prehistory and the twentieth century) and "elitist" architecture (as opposed to "vernacular") were all overrepresented on the World Heritage List, while all living cultures, especially traditional cultures, were underrepresented. This was followed by a gap analysis of the World Heritage List by ICOMOS and IUCN in 2004. The category of cultural sites was expanded over time to include more diverse properties such as cultural landscapes, recognising the links between man and nature, historic towns and town centres, heritage routes and heritage canals.

Though mixed sites (which fulfilled both cultural and natural heritage criteria) were inscribed as early as 1979, the cultural landscape category came into being in 1994. This

is an important category for India and the Asian region, which are rich in sacred and associative (linked with spiritual beliefs) cultural landscapes. While India inscribed its first cultural landscape site, the Rock Shelters of Bhimbetka, in 2003, under the subcategory of a "relict cultural landscape", its first mixed site was the Khangchendzonga National Park, inscribed in 2016. India has a great diversity of such living cultures.

Other classifications of World Heritage Sites include serial nominations and trans-boundary or transnational nominations. These are interesting developments that take into account a more holistic and collaborative approach for cultural, natural or mixed sites that may belong to the same historical, cultural or natural group, though spread across nations. The serial nomination of a site includes a number of components, rather than a single area, where each component adds to the historical, cultural or natural narrative, contributing to a collective Outstanding Universal Value. A good example of a serial site in India are the Mountain Railways of India. Initially inscribed in 1999 as the single site of Darjeeling Heritage Railways, it became a serial site when the Nilgiri Mountain Railway and the Kalka-Shimla Railway were added as extensions in 2005 and 2008. India later nominated thirty-nine components of the Western Ghats in four different states as a natural serial property, and the six Hill Forts of Rajasthan as a cultural serial property; these were inscribed on the World Heritage List in 2012 and 2013 respectively.

It is often observed that some World Heritage Sites, whether a single property or a serial site, may spread beyond the boundaries of a single country. For example, some of India's World Heritage Sites, such as the Sunderbans and the Manas Wildlife Sanctuary, have the potential to be trans-boundary sites, as large portions of these properties fall in Bangladesh and Bhutan, respectively. Trans-boundary listing is often a complex process, so countries prefer to retain their individual mandate for inscribing and protecting the site. Such an inscription is truly in the spirit of the World Heritage Convention, which encourages the collaboration of member states in protecting and conserving these heritage sites, which belong to all humanity. The Capitol Complex in Chandigarh, inscribed in 2016, is part of the transnational site of The Architectural Work of Le Corbusier, which was initiated by France and includes examples of Le Corbusier's architectural legacy in seven different countries.

Typologically, India's list of World Heritage Sites was dominated by archaeological sites, monuments and religious properties until 2010, in keeping with international trends. In the last decade, India has successfully filled the gap by adding sites from industrial, technological and modern heritage along with associative cultural landscapes and historic cities. In terms of chronological framework and dynastic periods, large quanta of the sites belong to the Mughal period, followed by sites from the sixth to the twelfth century, such as temples, tombs and forts, with a fair number of colonial and post-Independence sites. India has made a conscious effort to address UNESCO's Global Strategy for a Representative, Credible and Balanced World Heritage List by revising its Tentative List and nominating properties from these underrepresented categories in the last few years. Refer to page 228 for more information on India's Tentative List.

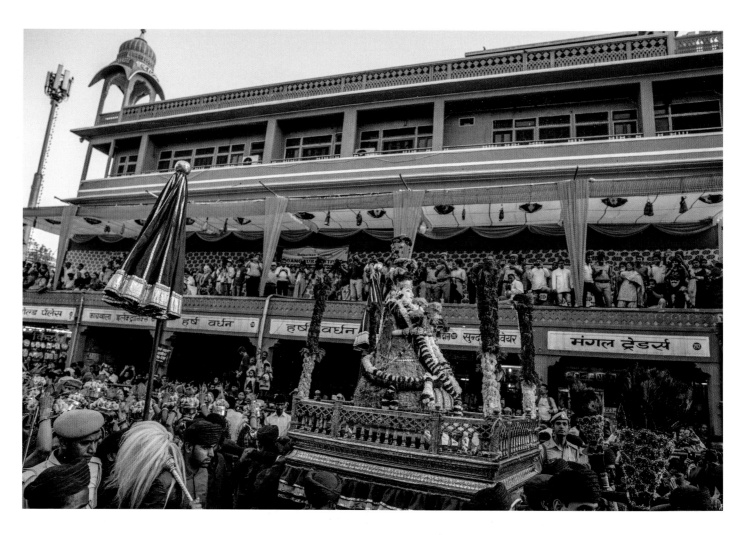

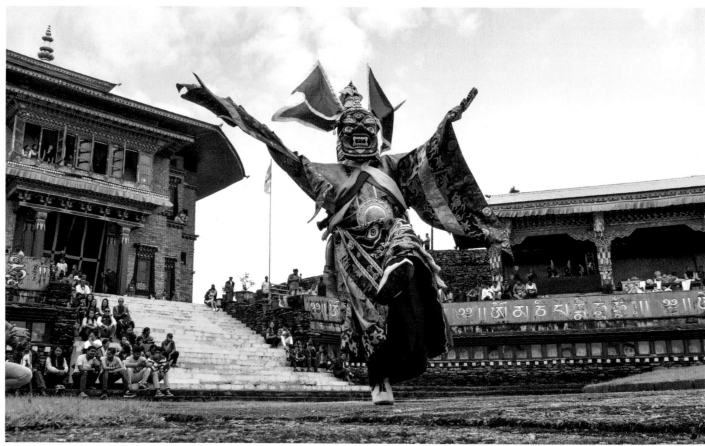

An Indian Army contingent rehearses for an Independence Day function at the Red Fort in New Delhi.

FACING PAGE
ABOVE: The goddess Parvati is honoured in a ritual procession during the annual Gangaur Festival celebration, in the *bazaar*s of Jaipur.

BELOW: The Pang Lhabsol festival is observed to honour Mount Khangchendzonga, the guardian deity of Sikkim, and to celebrate Sikkimese unity. This photograph shows a monk dressed as the deity during the Pangtoed Chaam at Pang Lhabsol, at Ralong Monastery in Ravangla.

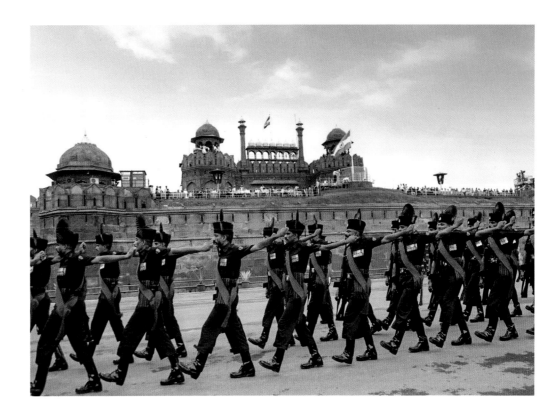

Of India's thirty cultural sites, twenty-three are protected by the ASI. The Mountain Railways are protected by the Central Ministry of Railways, while the remaining six cultural sites fall under various local and state government protection frameworks in Chandigarh, Gujarat, Maharashtra and Rajasthan. The mixed site and the seven natural sites are all protected by the Forest Departments.

India possesses one of the most diverse and complex ranges of World Heritage Sites. Lynn Meskell has rightly mentioned this in *A Future in Ruins: UNESCO, World Heritage, and the Dream of Peace*, where she states "if anywhere could teach us about the monumental challenges of World Heritage, it is India". The strength and uniqueness of India's World Heritage Sites is the living culture that inextricably binds the communities and their intangible values to the tangible-built attributes of the sites. Thus, as also emphasised by UNESCO in Article 5 of the 1972 World Heritage Convention, the role of communities in site management is essential in the case of most cultural and natural heritage sites in India.

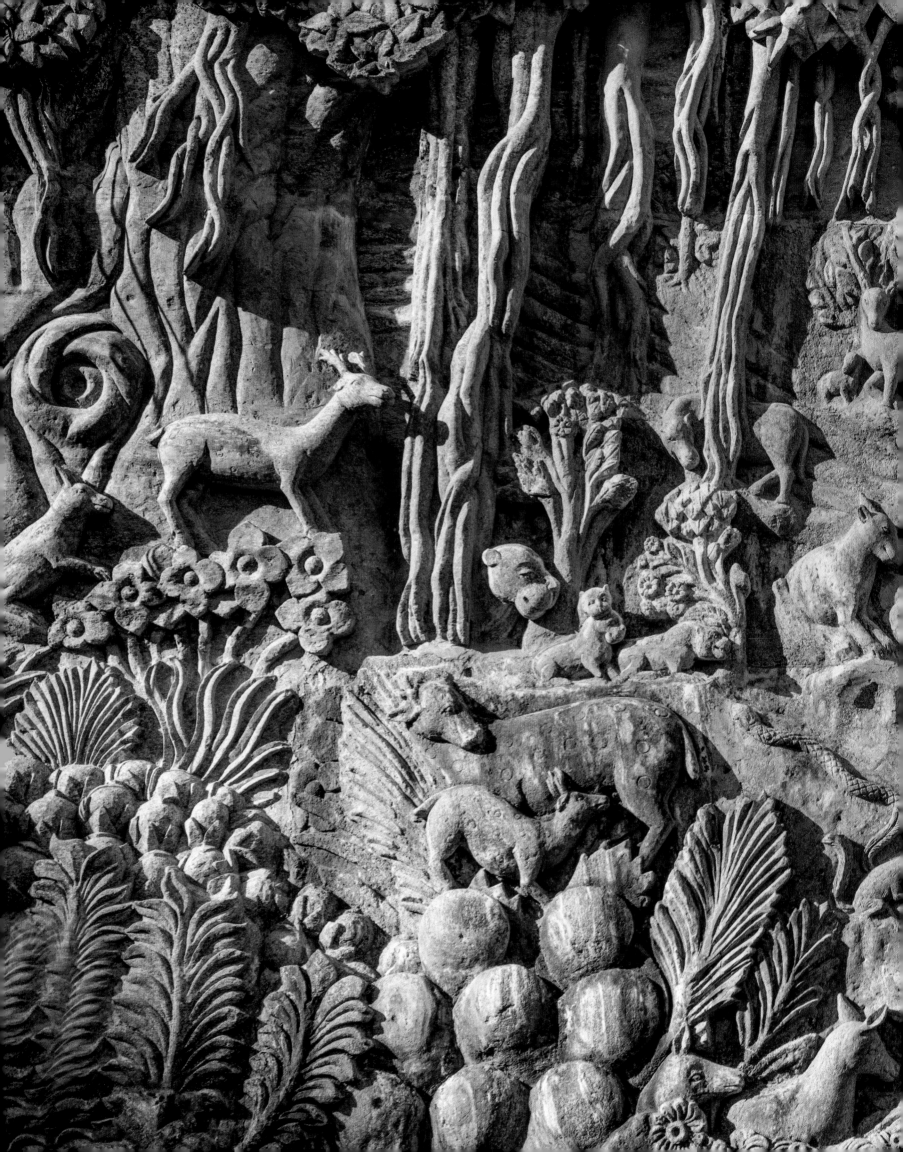

Vanguards of Enlightenment
From the Rock Shelters to the Stupa and the Temple

Professor Amareswar Galla

"Stupas... demonstrate the triumph of enlightenment's wisdom over suffering's ignorance. They are memorials... to the possibility of freedom from suffering for all beings. They signal the triumphal reality of a nature that enables beings to evolve to experience the ultimate fulfilment of perfect bliss, beyond death and unsatisfying life. Stupas stand as eloquent testimony to the higher purpose of life, beyond competing or struggling, getting or spending. Consciously or subliminally, they help turn people's minds away from their frustrating obsessions and towards their own higher potential."

—Professor Robert Thurman, from the Foreword to *Buddhist Stupas in Asia: The Shape of Perfection*, 2001

The longest archaeological evidence of human habitation in central India is from the geological formations of what was once the supercontinent of Gondwanaland. It comprised South America, Africa, Madagascar, subcontinental India, Australia and Antarctica in a single land mass before splitting millions of years ago. The name "Gondwanaland" was coined by the Austrian geologist Eduard Suess, with reference to Upper Palaeozoic and Mesozoic geological formations in the region of Gondwana in central India. Geomorphological evidence of the same age is also found on various continents in the southern hemisphere.

India's first cultural landscape to be inscribed on the World Heritage List is from this region of central India: the Rock Shelters of Bhimbetka. Along with their hinterland, they provide evidence for the longest continuously inhabited cultural landscapes in the world. Acheulian hand axes and remains of other Stone Age cultures have been found in nearby riverbeds. The earliest material culture yielded in excavations is from the Mesolithic period. The Rock Shelters of Bhimbetka constitute the largest gallery of prehistoric art in India, and the artists are possibly ancestors of the present-day Daroi Gond tribal community groups found in the surrounding villages.

India's early cultural landscapes are dotted with examples of rock art from the Palaeolithic and Mesolithic periods, along with the later Neolithic ash mounds and ruins and the world-famous Bronze Age Harappan sites. There are several highly significant sites yet to be nominated by India. While these Indian cultural landscapes illustrate continuities and changes from the Palaeolithic to more recent historical times, it is the sites from the later, "golden period" of the Gupta Empire that presently enhance the World Heritage List of India.

Around the third century BCE, about 250 years after the Great Departure of the Buddha, India witnessed an unprecedented spread of Buddhism. It was accompanied by the emergence of special architectural typologies: the *stupa* (Buddhist mound with relic) and rock-cut architecture. Emperor Asoka, the first ruler known to have adopted Buddhism, was largely responsible for this phenomenon. Ancient texts mention, though somewhat exaggeratedly, that he built 84,000 *stupas* across the country to redistribute Lord Buddha's relics from the four initial *stupa* sites at Lumbini (in Nepal), Bodh Gaya, Saranath and Kushinagara, which are associated, respectively, with the four important moments of the Buddha's life: Birth, Enlightenment, the Turning of the Wheel of Dharma (or the First Sermon), and Nirvana (or the Great Departure).

Asoka's role in the spread of Buddhism and the commissioning of *stupas* is well evidenced in the two

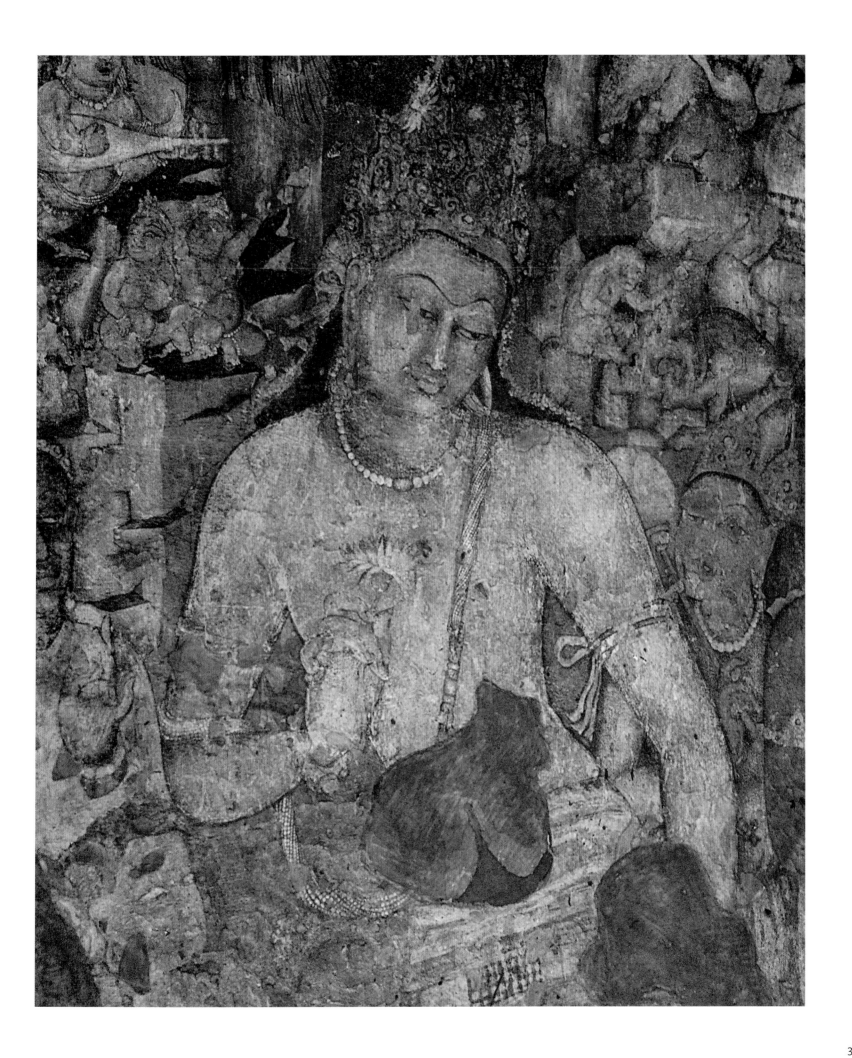

World Heritage Sites at Bodh Gaya and Sanchi. The Mahabodhi Temple at Bodh Gaya, the seat of the Buddha's Enlightenment, is one of the most revered sites for Buddhists. It also records Asoka's visit and the construction of a temple without a roof. A stone throne is extant at the site. There is also a monumental brick temple with *shikhara* (spire), constructed later, in the fifth century CE. Sanchi, though never visited by the Buddha, is significant for its monumental *stupa*s and gateways, with extensive stone carvings depicting the Buddha's life and teachings as well as Asoka's practice of the Buddhist faith.

The World Heritage Site of Nalanda Mahavihara is also contemporary with this spread of Buddhism as a faith, initiated in the third century BCE and reaching its peak between the fifth and thirteenth century CE. It is still under excavation and has revealed a range of *stupa*s, *vihara*s (cells for monks), temples and *chaitya*s (meditation halls) within its precinct.

Between the *stupa* and the later temple structures (with *shikhara*), there is an important phase, from the second century BCE to the tenth century CE, in the evolution of rock-cut temples in western India as a result of the spread of various religions that specifically patronised such dwellings. Buddhist and Jain monks adapted the caves into shrines since these could easily accommodate the prescription for monastic life. Geographically, the topographical features of the Western Ghats in Maharashtra were best suited for such adaptations, and hence the largest concentration of rock-cut caves in India is found in this region. There are other such caves sparsely located across the rest of the country, mostly along strategic, historic trade routes.

The inscription of three cave sites from Maharashtra on the World Heritage List is clearly a recognition of this extraordinary heritage. The caves provided a platform to appreciate the values embedded in the practice of Buddhism. They also enabled the simultaneous adaptation of cave architecture in Jainism and Brahmanism. The site of Elephanta presents a cluster of Brahmanical caves of the Shaivite sect with impressive iconography. Ajanta Caves display the evolution of Buddhist cave art and architecture over seven centuries, with the introduction of large-scale sculptures of the Buddha, besides a variation in *chaitya* halls and *vihara*s.

In this context, Ellora remains the most diverse and distinct. It is an extraordinary example of a site of complexity, with multiple faiths represented in thirty-four caves patronised by Brahmanical, Buddhist and Jain sects. While the donors belonged to diverse faith backgrounds, it is quite certain that the same guilds of master artisans, sculptors and others worked on these structures. This interfaith practice goes beyond the idea of people following a singular religion. The Kailasa Temple in Cave 16 at Ellora is a masterpiece of rock-hewn artisanship. It stands as a record of the architectural transformation from cave temples into structural ones with a *shikhara*. Although these cave temples had the patronage of various ruling dynasties, such as the Vakatakas, Kalachuris, Satvahanas, Rashtrakutas and Yadavas,

The Great *Stupa* at Sanchi. A profile of the stairwell leading from one circumambulatory path to the next, with the stone railing and one of the famous gateways to the left.

over the centuries, they were largely built through the donations of the pious, illustrating the religious concept of accumulating merit.

It is against this background of the spread of various faiths that the readers of this section are invited to imagine the hinterlands and community groups that provided the foundation for these sites on the World Heritage List. One could further visualise and discuss the complexity of skills and competencies of artisans who worked together to produce such outstanding art and architecture. What were the rural and urban structures and social landscapes where people from a diversity of castes and creeds lived together? Understanding the socio-economic context of the World Heritage Sites is critical for a better perspective of local values and for providing a location for the Outstanding Universal Value of the site. ◆

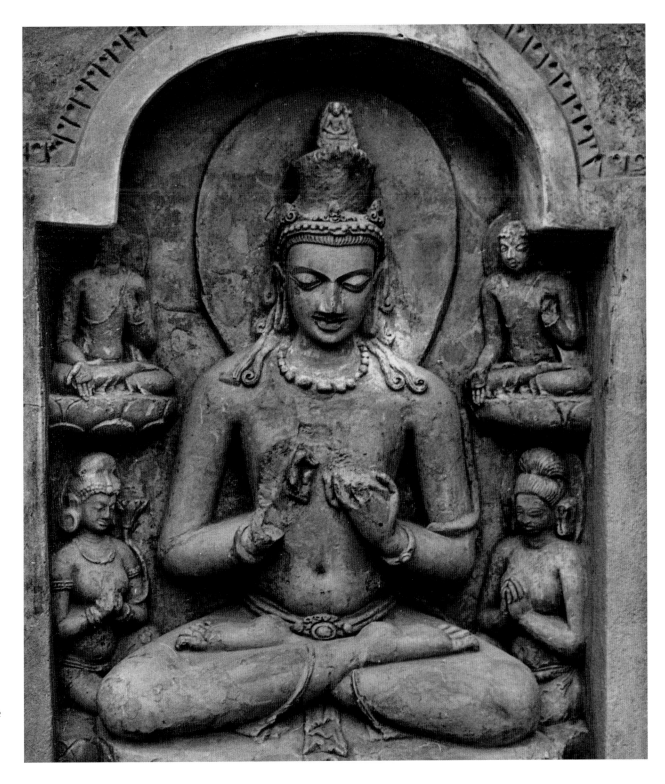

This archival photo of a sculpture at Nalanda depicts seated Buddha showing the *dharmachakrapravartan mudra* (gesture of teaching the Dharma). He is flanked by demigods in postures of worship, seated on lotuses.

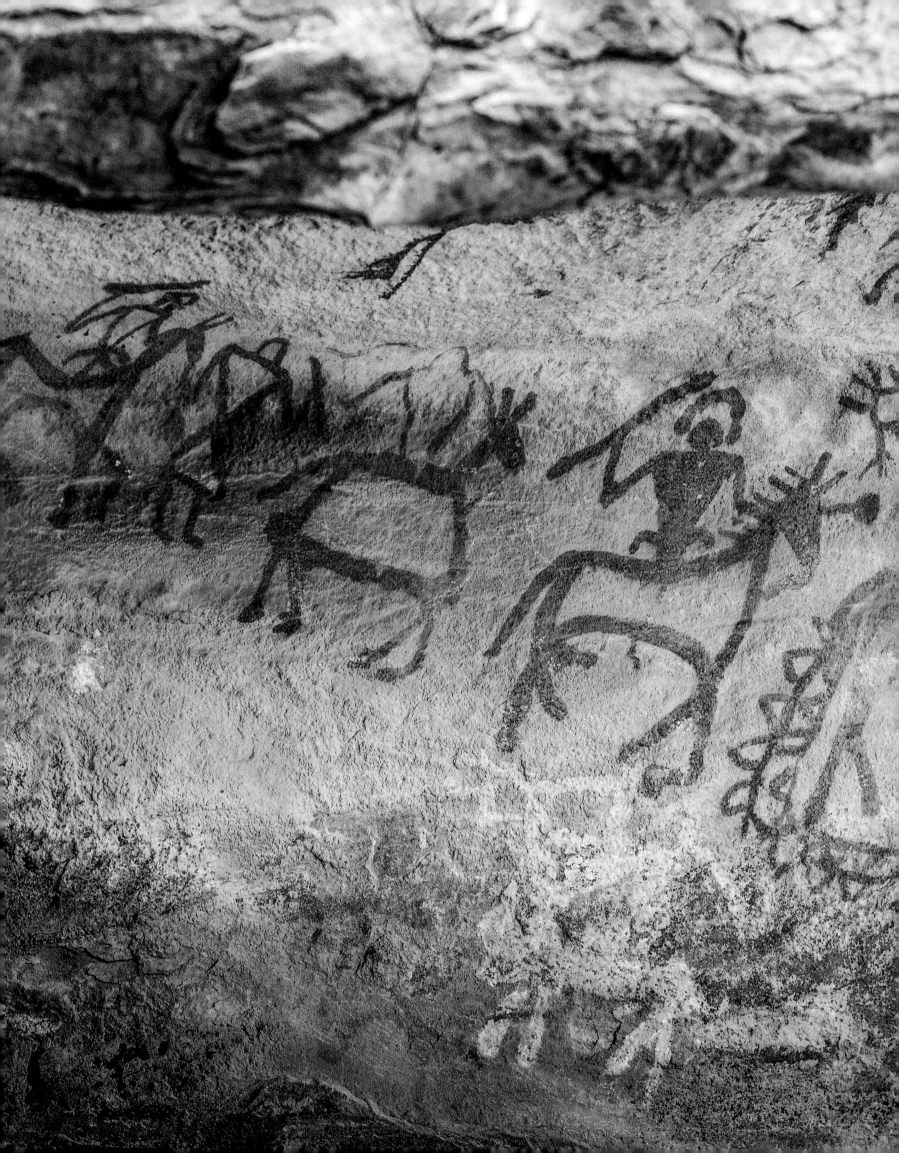

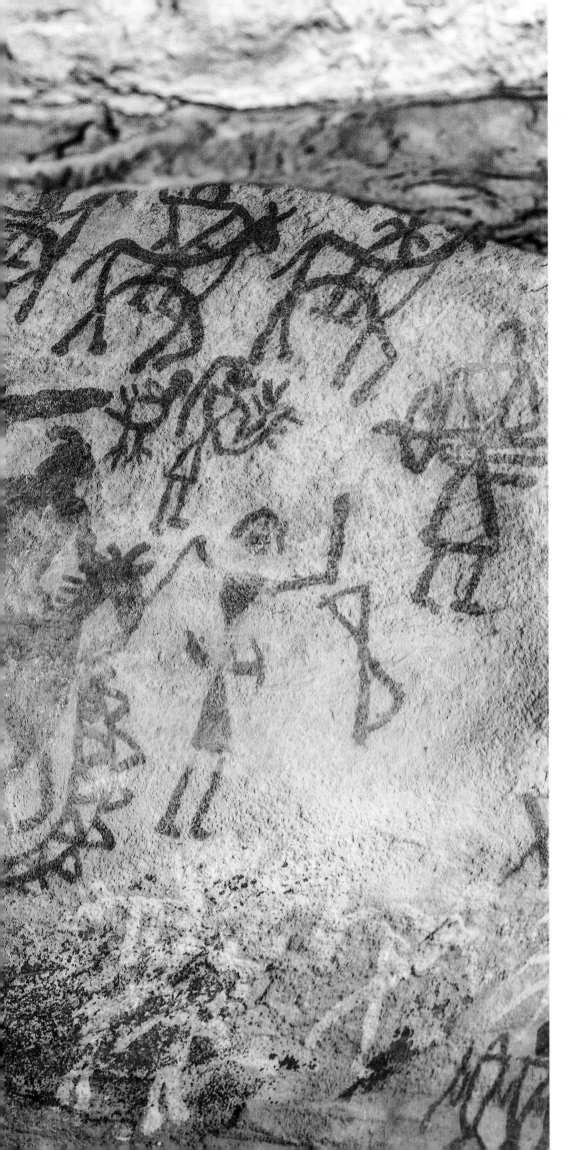

Rock Shelters of Bhimbetka

LOCATION: Madhya Pradesh, India

COORDINATES: N22 55 40 E77 34 60

DATE OF INSCRIPTION: 2003

CATEGORY: Cultural (Cultural Landscape)

OUTSTANDING UNIVERSAL VALUE

The Rock Shelters of Bhimbetka are in the foothills of the Vindhyan Range on the southern edge of the central Indian plateau. Within massive sandstone outcrops, above comparatively dense forest, are five clusters of natural rock shelters, displaying paintings that appear to date from the Mesolithic period right through to the Historical period. The cultural traditions of the inhabitants of the 21 villages adjacent to the site bear a strong resemblance to those represented in the rock paintings.

CRITERIA: (iii) (v)

(iii): Bhimbetka reflects a long interaction between people and the landscape, as demonstrated in the quantity and quality of its rock art.

(v): Bhimbetka is closely associated with a hunting and gathering economy, as demonstrated in the rock art and in the relicts of this tradition in the local Adivasi villages on the periphery of this site.

Part of a famous historic-period painting on top of a small shelter, this cave art depicts soldiers, dancers and various animals and birds, painted in red haematite pigment and white clay.

Bhimbetka records the extraordinary rock art of the earliest artists of India—the hunter-gatherers. The site of Bhimbetka includes five clusters of rock shelters that display a continuous tradition of rock painting from the advanced Mesolithic (the middle part of the Stone Age) to the historic periods.

This property of 18.9 square kilometres covers five hills of the Vindhyan Range in the Raisen District of the state of Madhya Pradesh, among which Bhimbetka is the most easily accessible. The buffer zone for this site includes twenty-one villages that, interestingly, display an indigenous culture among the local tribes that is well aligned with the culture of the original inhabitants of Bhimbetka as evident in the activities shown in the paintings.

The Palaeolithic evidence from excavations within these cave shelters, carved naturally in sandstone rocks, indicates the antiquity of human settlement, including walls and stone from the Stone Age and Iron Age. The paintings also reveal the use of hunting tools, such as hafted microlithic stone objects wielded on wooden spears and arrows.

The themes of the rock art are distinctly categorised by archaeologists and researchers into three main categories: human figures, such as men, women and children; animals and birds of different species; and scenes of hunting, battle, music and dance, rituals and family. Some archaeologists have also brought forth interesting aspects of the paintings, such as the contrast between the minimalistic rendering of basic human figures as against animal figures, which are presented in great detail, showing the innards of the animal being hunted, including the ribs

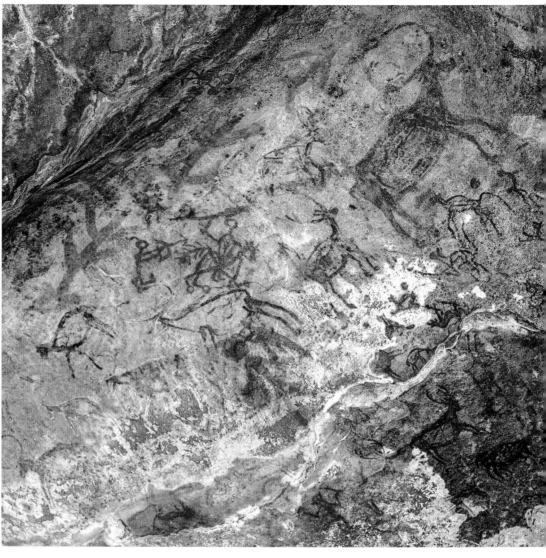

A Bhimbetka rock painting showing popular themes, with animals such as deer, stags and monkeys, along with hunting scenes and human stick figures.

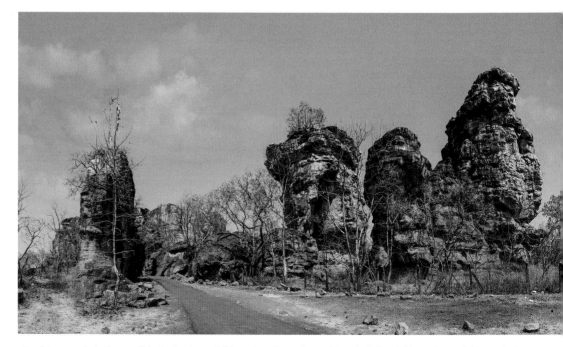

Sandstone rock shelters at Bhimbetka that exhibit rock art from the prehistoric, Palaeolithic and Mesolithic periods.

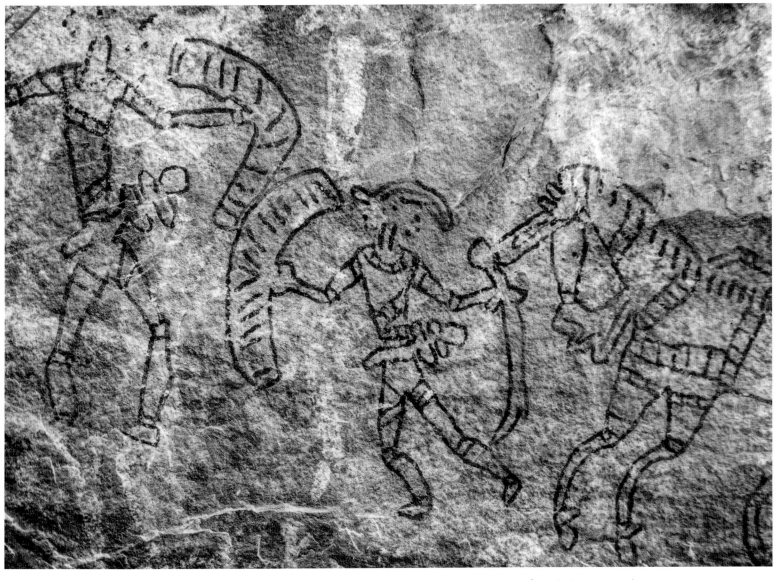

Horses and warriors feature in this painting in a rock shelter on the Bhonrawali Hill, dating from the historic period.

and other organs. The purpose of making such paintings is a matter of further research and musings. Stylistically, the paintings are said to be of three kinds—naturalistic, geometric and abstract—in their representations.

Often the representations of a mother goddess, ritual performers, bull riders and mythical animals were indicative of local beliefs. The most spectacular mythical animal painted in the caves combines the characteristics of a boar, ox and elephant. It is located at the top of a shelter and seems to be chasing a small masked man and a large crab. The animal is surrounded

by armed men much smaller in size as compared to its own. It is interesting to note that the Korkus, a local tribe, worship wild boar, while another local tribe of the area, the Gonds, sacrifice them during an annual ritual.

The paintings use varying stone-pigment colours—red, white, green and yellow—and are said to have been made with three different techniques: diluting the colour with water (transparent technique); mixing the pigment, possibly of several colours, with water (opaque technique); and applying the pigment directly on the wall as with a crayon (crayon technique).

Bhimbetka is one of the highest-density sites for rock art in the world, including about 400 painted rock shelters in its five clusters. Only twenty of these 400 shelters are open to the public on a daily basis, with limited access through narrow pathways as part of the protection strategy for these incredible rock paintings. Classified under the category of a relict cultural landscape, the site is protected and managed by the ASI. ●

Shikha Jain

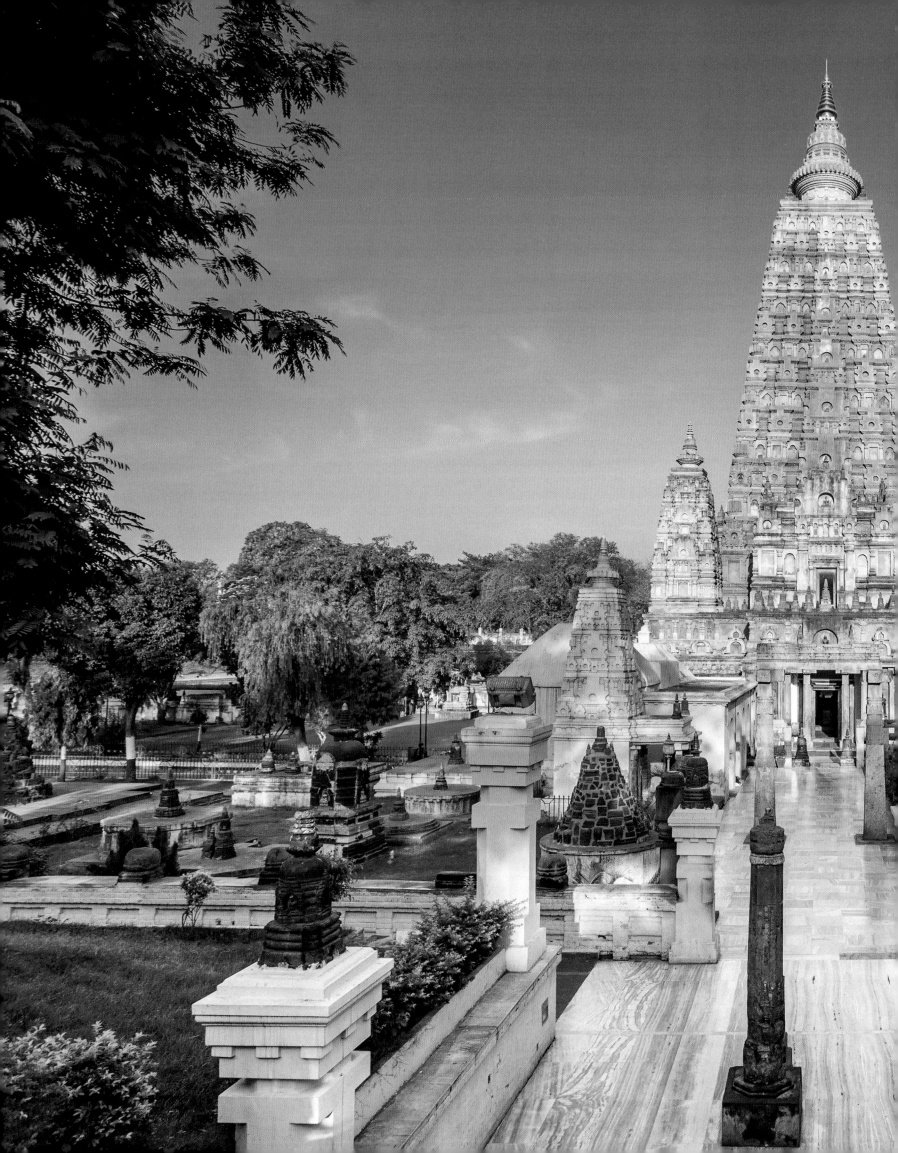

Mahabodhi Temple Complex at Bodh Gaya

LOCATION: Bihar, India

COORDINATES:
N24 41 43.008 E84 59 38.004

DATE OF INSCRIPTION: 2002

CATEGORY: Cultural (Site)

OUTSTANDING UNIVERSAL VALUE
The Mahabodhi Temple is one of the four holy sites related to the life of Lord Buddha, and particularly to his attainment of Enlightenment. The first temple was built by Emperor Asoka in the third century BCE, and the present temple dates from the fifth or sixth century CE.

CRITERIA: (i) (ii) (iii) (iv) (vi)
(i): The Mahabodhi Temple represents the architectural genius of the Indian people in constructing fully developed brick temples in that era.

(ii): It has had a significant influence on the development of architecture in the Indian subcontinent over the centuries.

(iii): The site provides exceptional records for events associated with Lord Buddha and subsequent worship.

(iv): The present temple is one of the earliest and most imposing extant structures built entirely in brick from the late Gupta period.

(vi): The site has a direct association with the life of Lord Buddha, being the place where he attained Enlightenment.

The Mahabodhi Temple marks the spot where Gautama Buddha attained Enlightenment. It is one of the four sacred sites associated with the life of the Buddha.

The footprints of Gautama Buddha are sacrosanct for visitors of all kinds—pilgrims, culture enthusiasts, specialists and others. The Mahabodhi Temple at Bodh Gaya in India, as the place of attainment of Buddha's Enlightenment, is the ultimate destination for this eclectic mix of visitors. Emperor Asoka's transformation into a follower of Buddhism and his subsequent promotion of the early form of the faith is often associated with his remorse over the Kalinga war and his subsequent visit to Bodh Gaya ten years after his coronation. Chinese travellers from the fifth to eighth century CE provide important records of the Mahabodhi Temple, while the plaques at the *stupa*s of Sanchi and Bharhut provide further evidence of the temple and throne constructed here by Asoka.

The first major rebuilding of the original Asokan temple was in the second century CE, according to the original plaque, now in the Patna Museum. In 637 CE, when the Chinese traveller Xuanzang came to the city of Bodh Gaya, he found the grand Mahabodhi temple, 160 feet (50 metres) tall, and a large, fine sanctuary; he mentions the bluish bricks, plaster, niches containing gilded statues of the Buddha, and many other details.

The Mahabodhi Complex comprises a main temple, the Vajrasana throne, and seven sacred sites, including the Bodhi tree, which are associated with activities that happened within seven weeks of Buddha's Enlightenment, as memorialised by Asoka. During and after Enlightenment, the Buddha spent the first week under the Bodhi tree; a present-day descendent of this tree thrives on the same spot. A polished sandstone Vajrasana, or Diamond Throne, is located under the Bodhi tree. An elevated prayer hall (Animeshlochan

Chaitya) is said to be where the Buddha spent his second week. The third week is marked by the Ratnachakrama, or Jewelled Ambulatory, a set of raised stone lotuses to the north of the main temple, marking the eighteen steps that the Buddha walked to and fro. The fourth week was spent at the Ratnaghar Chaitya, to the north-east of the enclosed area. The fifth week, highly important for its cross-cultural engagement, is marked by a pillar to denote the tree (Ajapala Nigrodh tree) under which the Buddha meditated and engaged in discursive sessions with the Brahmans. The sixth week was at the Lotus Pond to the south of the enclosure. The seventh week was spent under the Rajyatana tree, to the southeast of the main temple. Apart from the Rajyatana tree, there is a standing Buddha of a later date but the *pada*s (footprints) date to Asoka's time.

A large number of votive *stupa*s, inscriptions and literary descriptions evidence extensive patronage. The temple was restored and renovated by the Burmese in the eleventh century and then in the nineteenth century. The site is recognised as a singular example of the combined efforts of different countries to conserve an invaluable Buddhist legacy, as shown by the historical records of repair works carried out by Myanmar, Sri Lanka, Thailand and India. The site is today owned by a Trust functioning through the Bodhgaya Management Trust Committee, and protected by the ASI. Its evolution and the continued efforts by all the stakeholders in safeguarding the heritage values of the Temple Complex are critical to its World Heritage inscription. •

Amareswar Galla

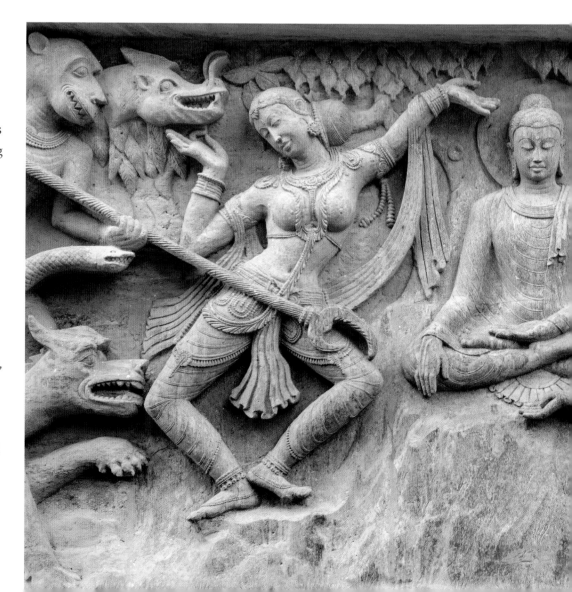

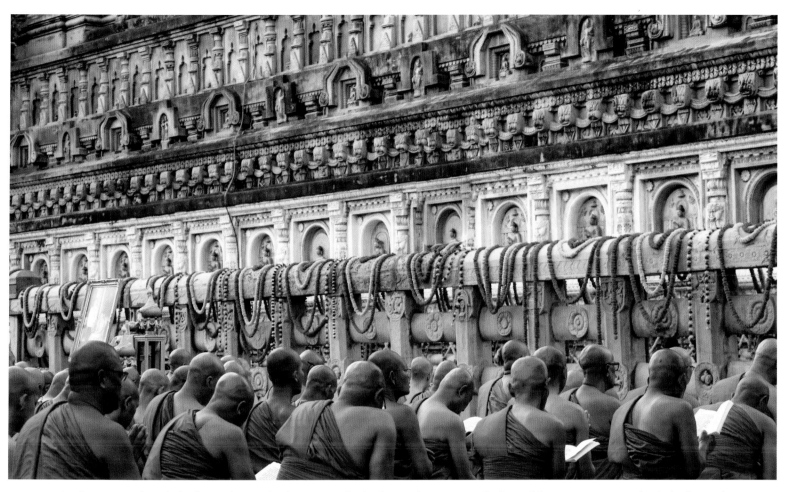

Monks praying at the Mahabodhi Temple. Note the decorative garlands adorning the stone-carved railing and the intricate stucco work in the background.

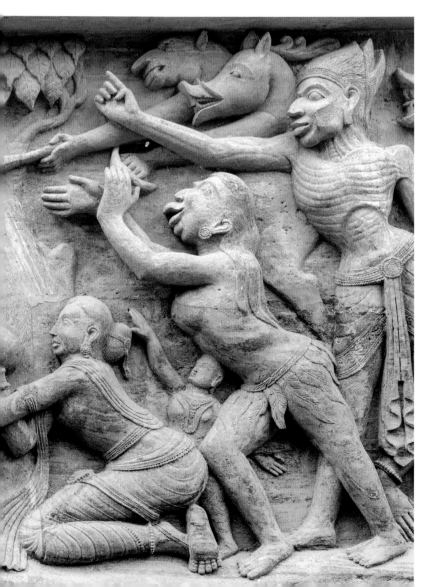

The walls of the Mahabodhi Temple feature sculptural representations of the Buddha from different countries in Asia.

LEFT: An episode from the Buddha's life is carved into stone.

Buddhist Monuments
at Sanchi

LOCATION: Madhya Pradesh, India

COORDINATES:
 N23 28 45.984 E77 44 22.992

DATE OF INSCRIPTION: 1989

CATEGORY: Cultural (Site)

OUTSTANDING UNIVERSAL VALUE
 The site of Sanchi, located around 40 kilometres from Bhopal, comprises a group of Buddhist monuments (monolithic pillars, palaces, temples and monasteries), all in different states of conservation, most of which date to second and first centuries BCE. It is India's oldest extant Buddhist sanctuary and was a major Buddhist centre until the twelfth century CE.

CRITERIA: (i) (ii) (iii) (iv) (vi)
(i): The perfection of its proportions and the richness of the decorative work on its four gateways make Stupa 1 an incomparable achievement.

(ii): From the time that the oldest preserved monument on the site was erected, Sanchi's role as intermediary for the spread of cultures throughout the Mauryan Empire and other parts of the subcontinent was confirmed.

(iii): Sanchi bears unique witness to the period from the third century BCE to the first century CE.

(iv): The *stupas* at Sanchi represent the most accomplished form of this type of monument.

(vi): Sanchi has obvious religious significance and contains the sacred relics of Buddhist preachers.

One of the many representations of the Buddha at the Great Stupa in Sanchi.

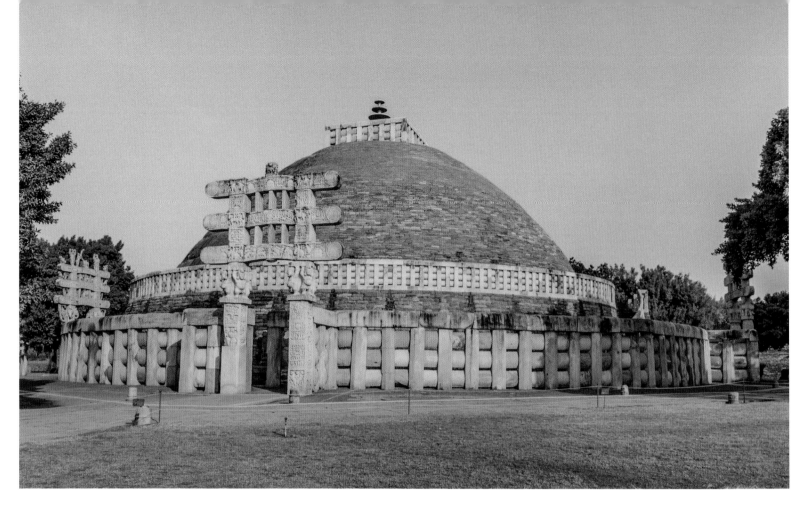

One of the first known emperors to espouse a culture of peace was Asoka, who ruled the Mauryan Empire in the third century BCE. He transformed his empire from one founded on conquest to one based on the spread of Dharma—the key strategy being the propagation of the precepts of Buddhism. Asoka was the first to bring together the diverse peoples of South Asia, and it was during his rule that Sanchi was founded and these significant monuments were built. Sanchi was thus a major representative hub for the spread of Buddhism throughout the Mauryan Empire, and grew to become an important complex of its associated art and architecture.

Asoka was the local governor of Vidisa, six kilometres from Sanchi, before ascending the throne. He spent a significant part of his life at Vidisa, where he met his consort, Devi, and had two children, a son and a daughter, who later took to monastic life and moved to Sri Lanka. This background probably explains the developments at

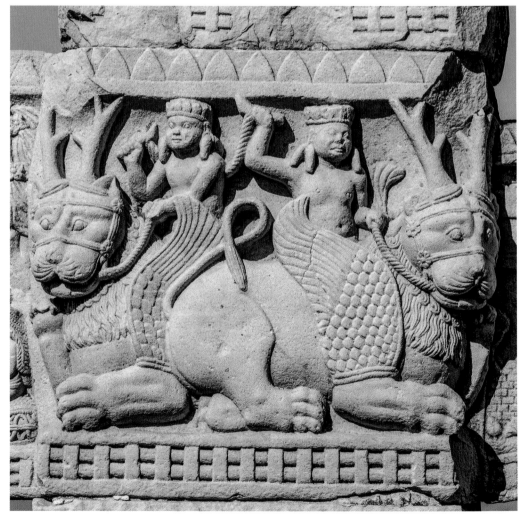

A decorative element on the western gate of the Great Stupa, depicting men on griffins. Other carved panels feature episodes from the Jataka tales or from the Buddha's life.

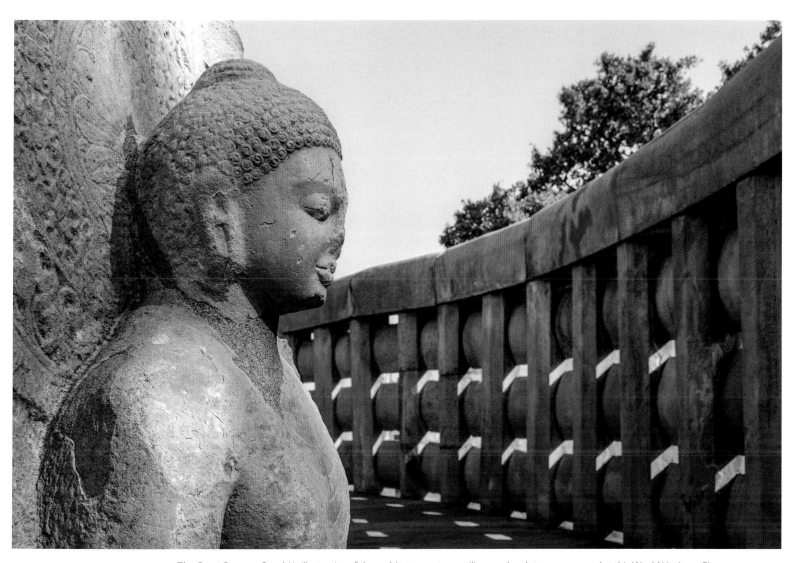

FACING PAGE TOP AND ABOVE: The Great Stupa at Sanchi is illustrative of the architecture, stone railings and sculptures preserved at this World Heritage Site.

Sanchi and surrounding areas, which contain extensive Buddhist remains from Asoka's period, as well as its current association with Sri Lanka's Buddhist community. The site of Sanchi was further augmented during successive dynasties of rulers, especially the Shungas, who encased the Mahastupa. Under the Satavahanas, the four gateways at Mahastupa attained excellence in sculptural achievement and aesthetic value, and provide a major landmark in the history of Indian art.

Sanchi does not carry the footprints of the Buddha. Its outstanding sculptural representation illustrates the transition from Theravada to Mahayana Buddhism. In the former the Buddha was worshipped symbolically, represented by motifs such as his footprints, throne, and the *pipal* tree under which he attained Enlightenment. In the Mahayana tradition, he is represented in human form. Sanchi has several Jataka stories represented in sculptures. These are stories of the previous lives of a person before attaining Buddhahood. Sanchi also contains the remains of his early disciples, Sariputta and Maha Moggallana, whose relics have been found in Stupa No. 2.

The Buddhist monuments at Sanchi—*stupa*s, temples and monasteries—are unique in India for their age, aesthetic value and the evolution of Buddhism, constituting the oldest extant Buddhist sanctuary in India. Its oldest preserved monument is Asoka's column, whose projecting capital of lions demonstrates a fusion of art from India and beyond. Some of the *stupa*s at Sanchi represent the most accomplished forms of Buddhist art. The *stupa*s also represent the evolution from wooden structures to stone, while the *vedika* (railing) and the *torana*s (gateways) bear witness to local iconography and cultural systems.

Sanchi is protected and managed by the ASI. Though the present site boundary is limited to the *stupa*s, palaces and major monuments at Sanchi, it is recommended by the World Heritage Committee that the site be extended to include nearby villages. The safeguarding of surrounding villages and the archaeological landscape will contribute to its integrity while presenting it more holistically as part of a historical cultural landscape. ●

Amareswar Galla

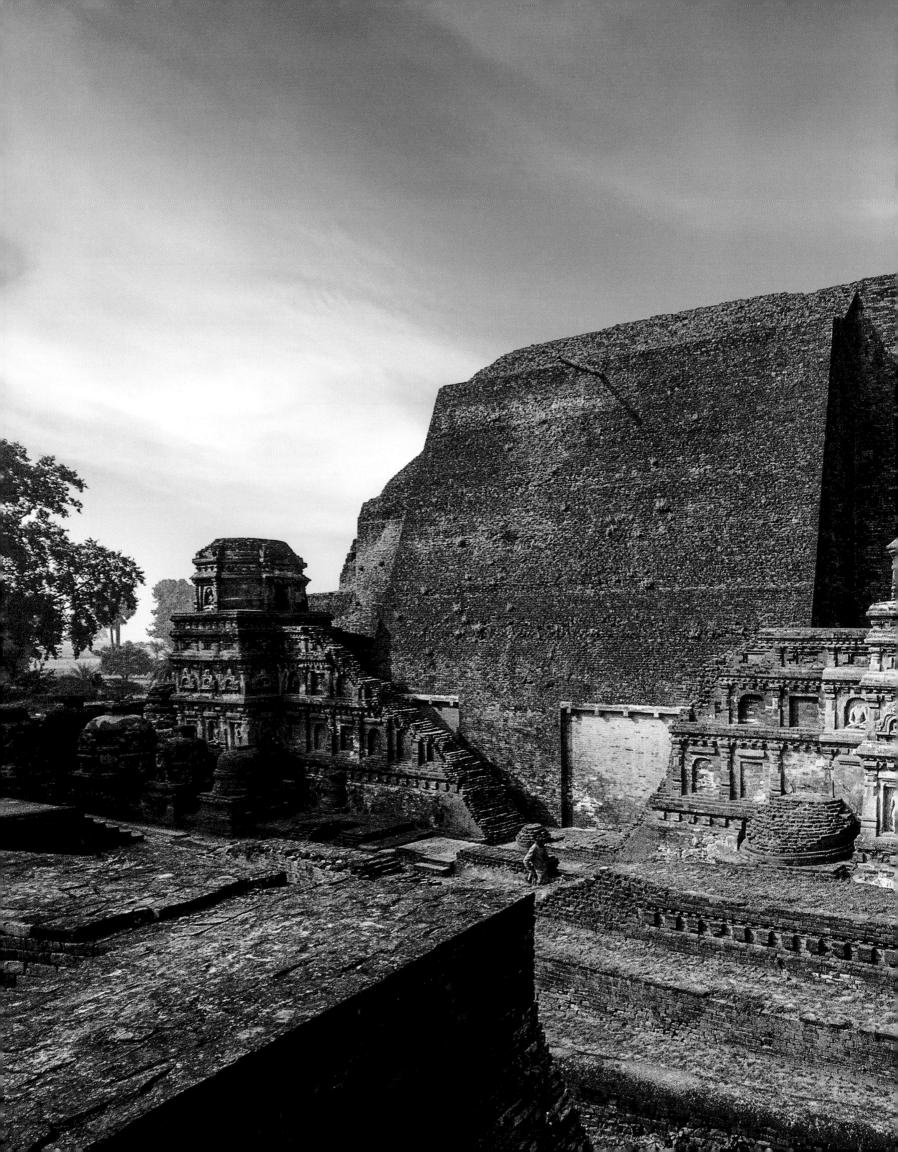

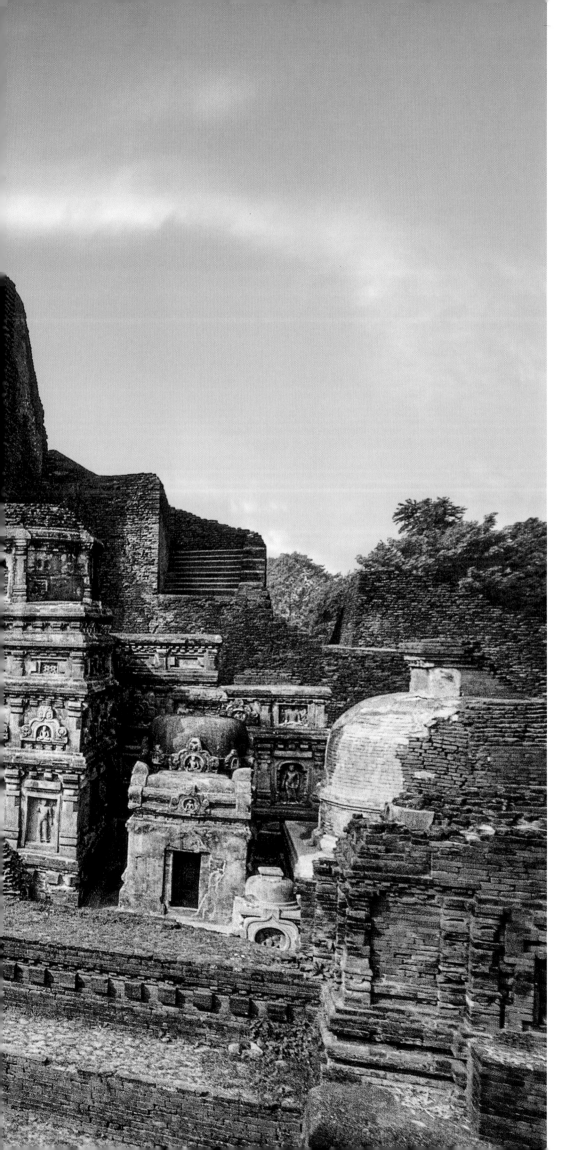

Archaeological Site of
Nalanda Mahavihara,
Bihar

LOCATION: Bihar, India

COORDINATES: N25 8 12 E85 26 38

DATE OF INSCRIPTION: 2016

CATEGORY: Cultural (Site)

OUTSTANDING UNIVERSAL VALUE

Nalanda Mahavihara comprises the archaeological remains of a monastic and scholastic institution dating from the third century BCE to the thirteenth century CE. It includes *stupa*s, shrines, *vihara*s (residential and educational buildings) and important artworks in stucco, stone and metal. Nalanda stands out as the most ancient university of the Indian subcontinent, engaged in the organised transmission of knowledge over an uninterrupted period of 800 years. The historical development of the site testifies to the development of Buddhism into a religion and the flourishing of monastic and educational traditions.

CRITERIA: (iv) (vi)

(iv): Nalanda Mahavihara established and developed planning, architectural, artistic principles that were later adopted by many institutions in South and Southeast Asia.

(vi): Nalanda Mahavihara marks the zenith in the evolution of the *sangharama* (monastic establishment) into the earliest scholastic establishment of early medieval India. Its merit-based approach is said to have embraced all contemporary sources and systems of learning in the Indian subcontinent.

The Great Monument at Site 3 of the Nalanda Mahavihara, with *stupa*s, temples and what some perceive to be "the Great Library".

Literary and travellers' accounts describe Nalanda as one of the largest centres of learning in early South Asia. It is referred to as "the Mahavihara" in all available documentation of the period (third century BCE to thirteenth century CE). Archaeological evidence is ambiguous in yielding adequate corroborative evidence of the place. The story of Nalanda is a web of memories, documented snippets and excavated evidence. Accounts of pilgrims evoke an exceptional place of learning. Hui Li's *Life of Xuanzang* provides for an estimation of 10,000 monks from across Asia. The accounts of Yijing, a few decades later, provide a more realistic number of 3,000, which is validated by the number of monastic cells excavated so far. It is quite possible that Xuanzang's accounts may also prove to be accurate, since the existing site is said to be only a part of the larger Mahavihara, which extended to a network of monasteries in the surrounding villages. Sculptures from Baragaon, immediately to the north, or the seated Buddha in Jagdishpur, a couple of kilometres away, are incremental testimonies as we reconstruct the past of the Nalanda Mahavihara.

In the Mahavihara, the congregation was a place of contemplation, deep learning and dialogue. It is said that when the Buddha was asked where the monks in the Sangha (congregation) came from, he replied that they came from everywhere: like the drops of water that form streams, the streams that become tributaries, which then become the rivers that flow into the great ocean. Nalanda would have been a perfect illustration of such a sea of humanity, beyond the caste, colour, ethnicity and race that we encounter in India's past and present. The monks studied logic, grammar, literature, medicine, the arts and metaphysics, according to *Life of Xuanzang*. Strict monastic rules,

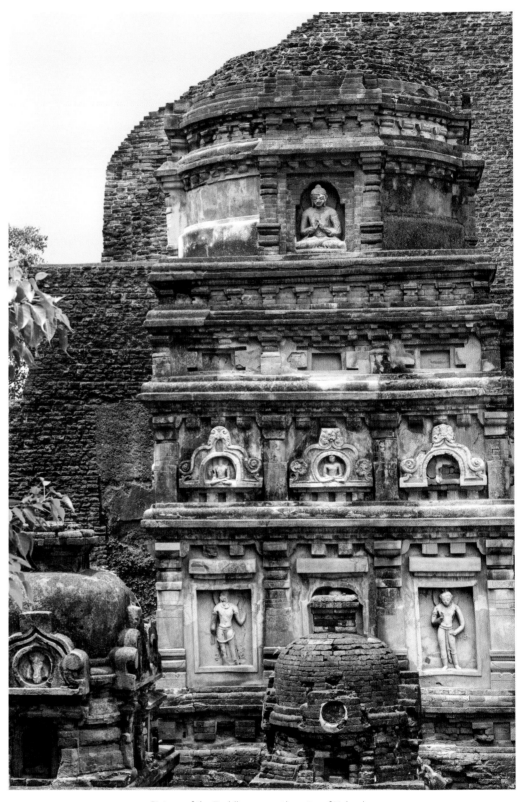

Statues of the Buddha among the ruins of Nalanda.

as evidenced in Buddhist texts, would have ensured a seamless functional and administrative infrastructure. Nalanda also had one of the largest libraries, which served as a great resource for Buddhist scholars across China and Southeast Asia

until it was completely destroyed by the invader Bhaktiyar Khilji in 1200 CE. The descriptions of the library's manuscripts and transportation of copies by Chinese pilgrims help us understand the culture of writing at that time in India and China.

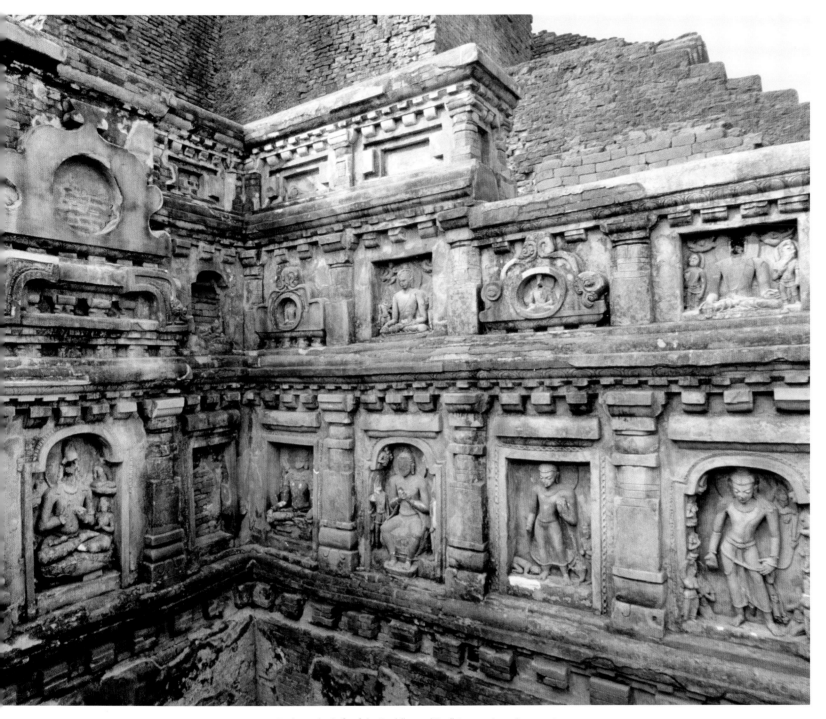

Sculptural reliefs of the Buddha and Bodhisattvas in various postures.

The Mahavihara was located in the birthplace of Buddhism, the hinterlands of the eastern Indian state of Bihar, amidst fertile plains and prosperous trade routes. It has yielded significant artworks in stucco, stone and metal in association with *stupa*s and temples. Excavations have so far revealed six temples and eleven monasteries. They add to its testimony as a place where Buddhism evolved over the eight centuries of its strong presence. In addition to monks and nuns, the Mahavihara would have been frequented by the laity, making for the earliest form of spiritual tourism in the region.

Nalanda is the largest of the various historic Buddhist centres of learning across the Indian subcontinent; the inscribed property represents the excavated remains of 1.8 square kilometres out of a total area of 16 square kilometres. The World Heritage inscription opens up all kinds of possibilities for understanding one of the greatest sites of learning in the ancient world. Responsible tourism could help the sustainable heritage development of the Mahavihara. •

Amareswar Galla

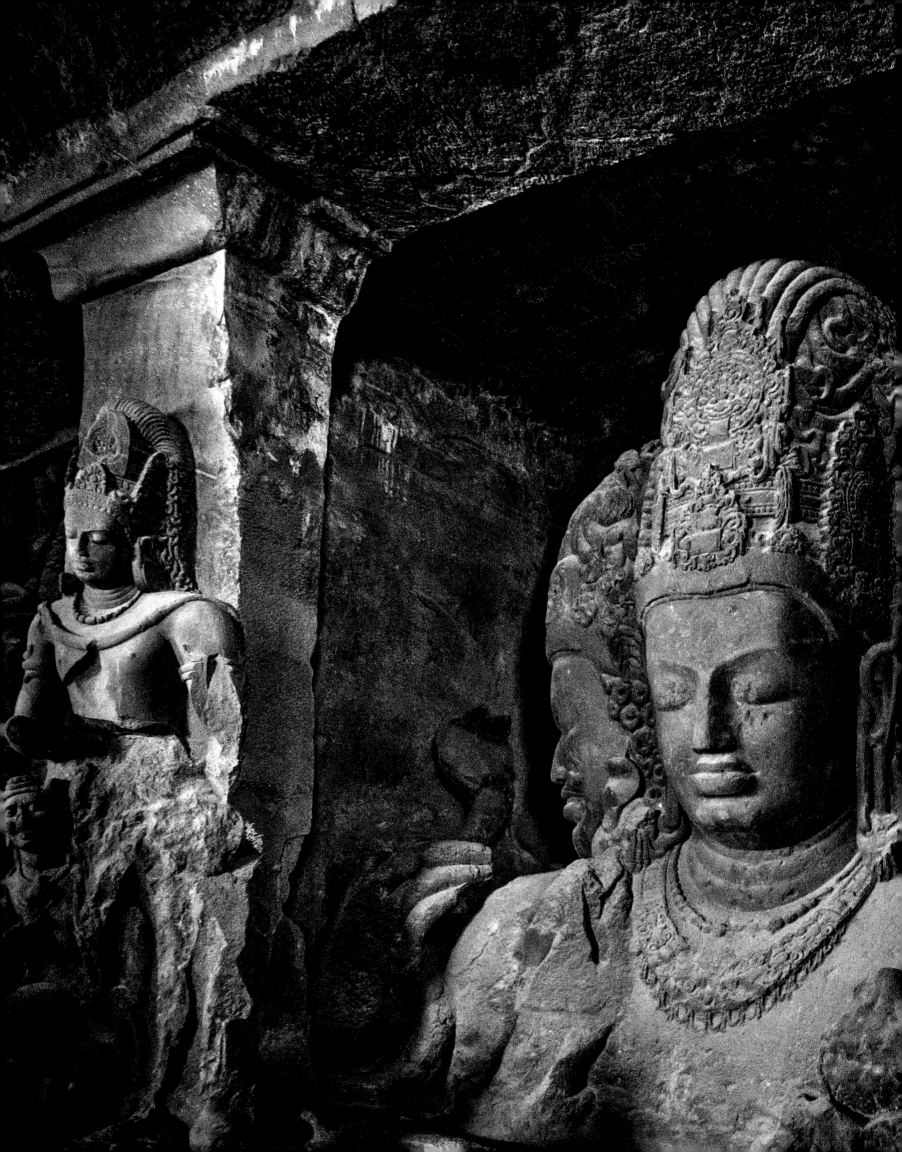

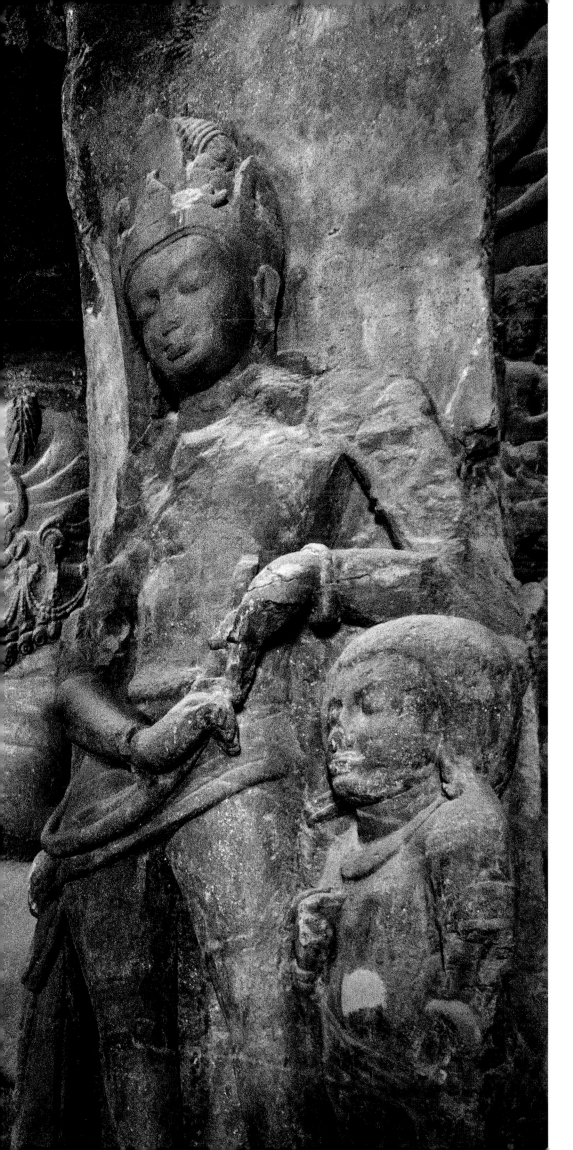

Elephanta Caves

LOCATION: Maharashtra, India

COORDINATES: N18 58 0.012 E72 56 8.988

DATE OF INSCRIPTION: 1987

CATEGORY: Cultural (Site)

OUTSTANDING UNIVERSAL VALUE:
The "City of Caves", on an island in the Sea of Oman close to Mumbai, contains a collection of rock art linked to the cult of Shiva. Here, Indian art has found one of its most perfect expressions, particularly the huge, high reliefs in the main cave. The layout of the caves, including the pillar components, the placement and division of the caves into different parts, and the provision of a *garbhagriha* (sanctum sanctorum) of *sarvatobhadra* (stellar temple-form) plan, are important developments in rock-cut architecture. The combination of aesthetic beauty and sculptural art, replete with respondent *rasa*s (Indian principles of aesthetics), reached an apogee at the Elephanta Caves.

CRITERIA: (i) (iii)
(i): The fifteen large reliefs surrounding the *linga* (phallic representation of Lord Shiva) chapel in the main Elephanta Cave constitute not only one of the greatest examples of Indian art but also one of the most important collections for the cult of Shiva.

(iii): The caves are the most magnificent achievement in the history of rock-cut architecture in western India. The Trimurti and other colossal sculptures, with their aesthetic setting, are examples of a unique artistic creation.

The celebrated, monolithic 20-foot-statue of the Trimurti Sadashiva, or Three-headed Shiva.

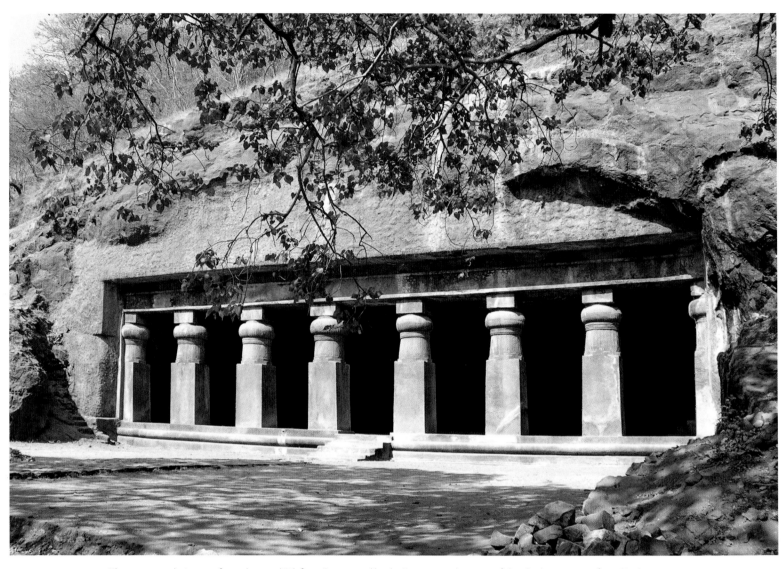

The caves get their name from the word "Elefante", so named by the Portuguese because of the elephant statues found in the caves.

Archaeological evidence and remains of *stupa*s indicate the presence of civilisation on Elephanta Island, near Mumbai, since the Buddhist period, from the second century BCE. However, its World Heritage recognition is credited to the presence of rock-cut temples and iconographical masterpieces from the Shaivite Hindu cult propagated in the sixth century CE, possibly by the region's Konkan Maurya rulers. The warrior king Pulakesin II, of the Chalukya dynasty of Badami, is also attributed with the commissioning of a significant portion of the caves as one of the many early powers that ruled this region. Originally known as Gharapuri, the island was termed "Elephanta" by the Portuguese in the sixteenth century due to the presence of a massive elephant sculpture dating from this period. This monolithic basalt elephant structure is no longer present on the site; it is currently housed in the Bhau Daji Lad Museum in Mumbai.

Elephanta is probably the only known site where Shiva is represented, and was once worshipped, in both the *linga* form and as Pashupata. We also witness the origin of monolithic temples on this site. The contrasts and sensitive sculptural representations are derived from the artisans' experience and ability to draw out human and divine features. There are no known antecedents to Elephanta's Shaivite art and sculpture in terms of scale. The site has several stylistic similarities to Buddhist art of the region. It is likely that shared intangible aspects of creative skills and traditions informed the guilds of sculptors and other artisans who worked on contemporary Buddhist sites in the region. The art of Ajanta, especially Bodhisattva Vajrapani, appears to have influenced the depiction of the sculptures of Elephanta. Shiva as Ardhanariswara, or "the Androgyne", is one of the many exquisite composite sculptural depictions, sensitively contrasting different gendered aspects with finesse par excellence. This finesse is also to be found in the figures

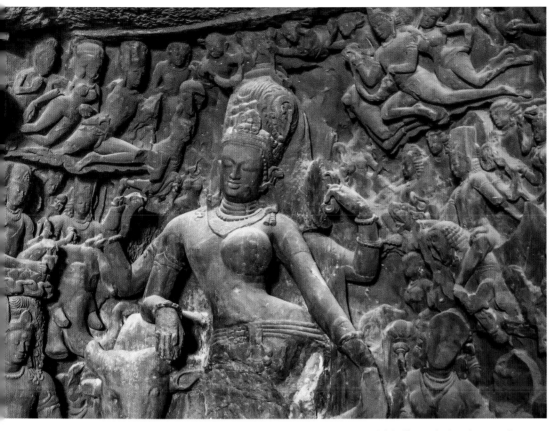

A carving depicting Ardhanariswara (Shiva the Androgyne). Shiva, the left half, rests his hand on Nandi, his *vahana*, or vehicle. Parvati, the right half, is depicted striking a graceful pose.

of the accompanying celestials. Shiva sculptures in various postures, including depictions of him with his consort, Parvati, dominate the iconographical narratives in these Brahmanical caves. In the words of Carsten Niebuhr, a German mathematician, cartographer and explorer, and the author of *Travels through Arabia and Other Countries in the East* (1764):

> "Neither in design, nor in execution, indeed, can these bas-reliefs be compared with the works of Grecian sculptors. But they are greatly superior in elegance to the remains of the ancient Egyptian sculpture. They are also finer than the bas-reliefs from the ruins of Persepolis. No doubt, then, but the arts were cultivated by the ancient Indians with better success than is commonly supposed."

The island is strategically positioned and served as a military outpost of the Portuguese until 1840, as evidenced in the damage done by Portuguese soldiers who often used the sculptural panels for shooting practice. The original stone inscription at the site was taken by the Portuguese for deciphering and it remains untraceable to this day, leading to various interpretations about the creator of the caves.

The World Heritage recognition has brought together all the agencies responsible for the environment of Elephanta Caves, with the main custodian being the ASI. Excavations of the mounds adjacent to the caves, especially the buried *stupa*s, will enrich our understanding and reinterpretation of the significance of this early Indian heritage. ⚬

Amareswar Galla

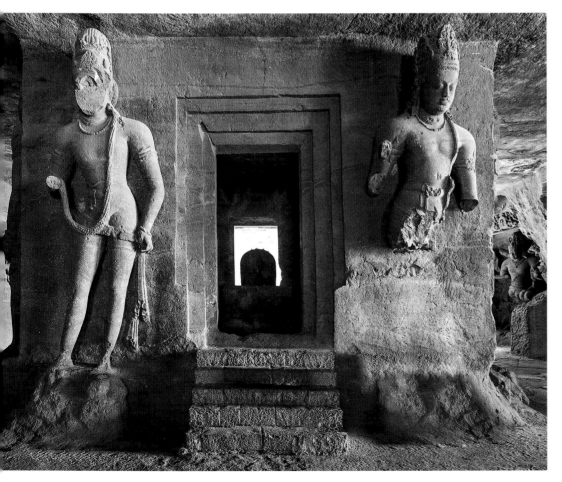

The beautiful statues at Elephanta show a synthesis of Brahmanical and Buddhist iconography.

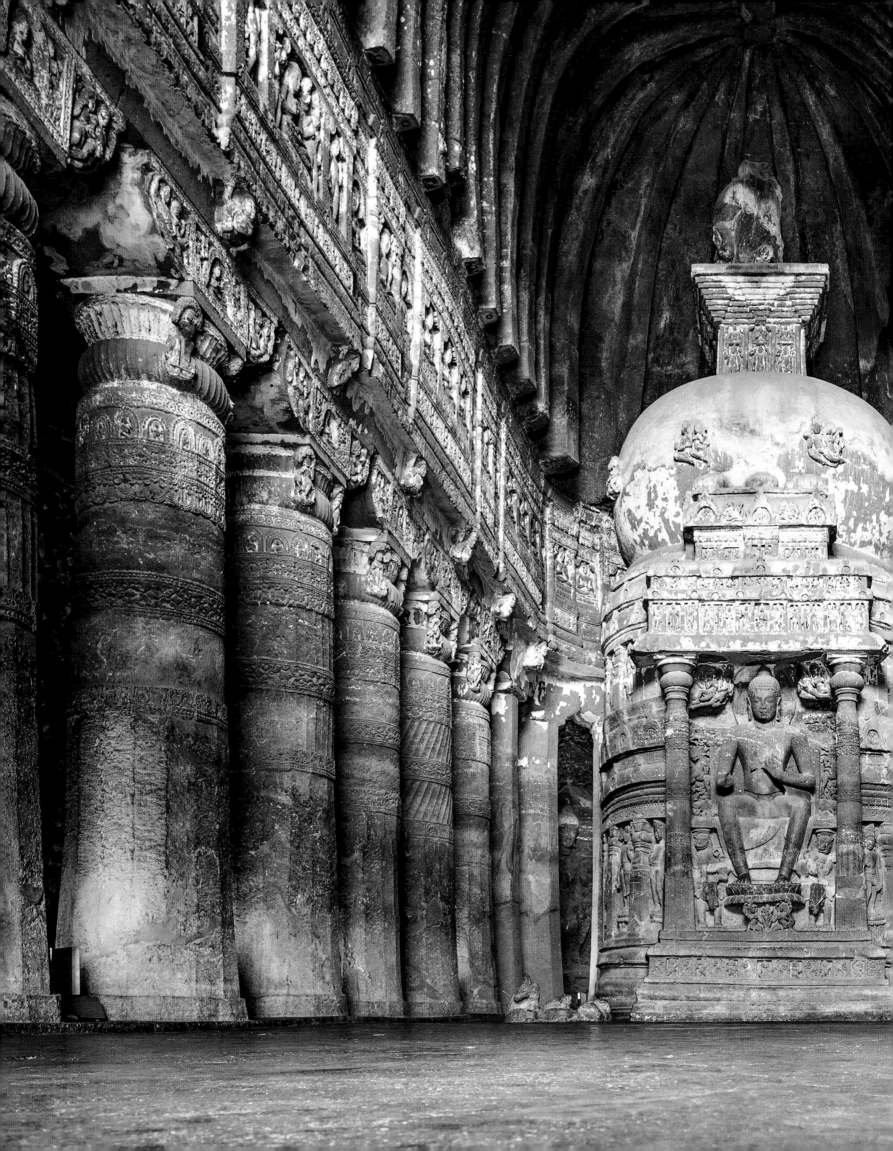

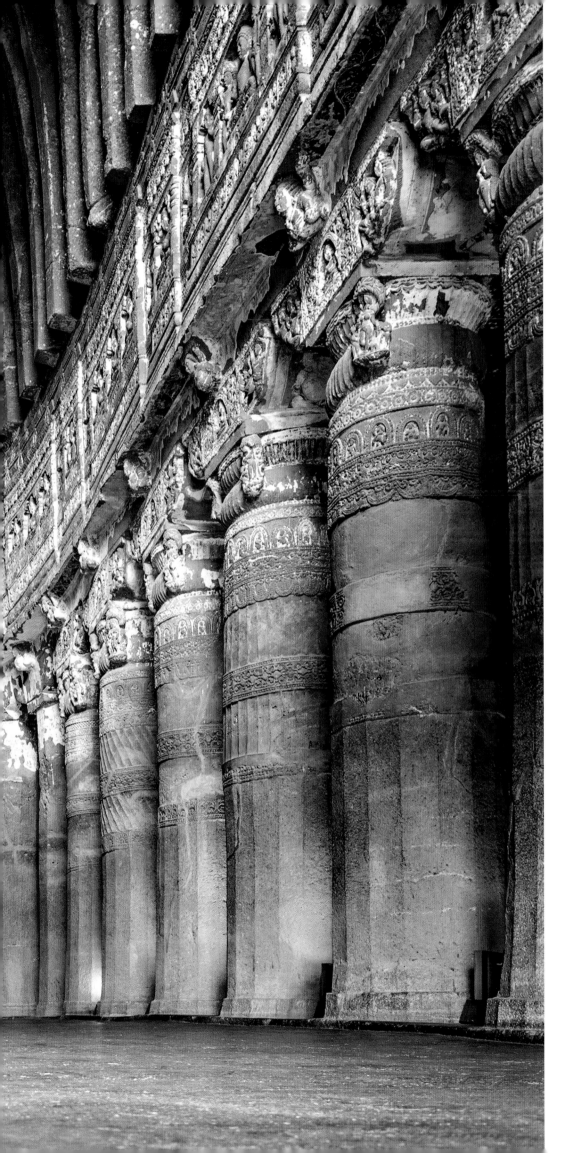

Ajanta Caves

LOCATION: Aurangabad, Maharashtra

COORDINATES: N20 33 11.988 E75 42 0

DATE OF INSCRIPTION: 1983

CATEGORY: Cultural (Site)

OUTSTANDING UNIVERSAL VALUE

The first Buddhist cave monuments at Ajanta date from the second and first century BCE. During the Gupta period in the fifth and sixth century CE, many more richly decorated caves were added to the original group. The paintings and sculptures of Ajanta, considered masterpieces of Buddhist religious art, have had a considerable influence on the arts and aesthetics of the Indian subcontinent and beyond.

CRITERIA: (i) (ii) (iii) (vi)

(i): The caves at Ajanta represent a unique artistic achievement.

(ii): The style of Ajanta has exerted considerable influence in India and elsewhere, extending, in particular, to Java.

(iii): With its two groups of monuments corresponding to two important moments in Indian history, this rupestral ensemble bears exceptional testimony to the evolution of Indian art, as also to the determining role of the Buddhist community, intellectual and religious forums, schools and reception centres in the India of the Guptas and their immediate successors.

(vi): The site is directly and materially associated with the history of Buddhism.

The interior of the cavernous *chaitya* hall in Cave 26. This cave, like many others, consists of profuse carvings and intricate sculptures of significant legends from Buddhist mythology.

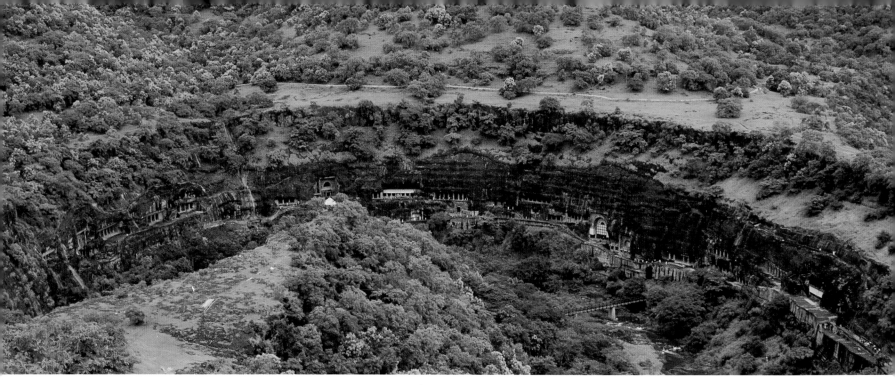

An aerial view of the caves nestled in the side of the cliffs.

The Ajanta Caves are one of the most important historical mountainous landscapes of South Asia. They comprise thirty caves cut into the side of a cliff that rises above the Waghora River. Though accessed today via a road running along a terrace midway up the cliff, each cave was originally linked by a stairway to the edge of the river waters.

The site provides outstanding visual evidence of two distinct phases of Buddhism: Theravada and Mahayana. The former phase at the site dates back to 100 BCE until 100 CE, from the time of the Satavahana rulers, and the latter to 460–480 CE, under the Vakatakas. Ajanta, like many Buddhist sites of significance, flourished along trade routes, from the birthplace of Buddhism in present-day Bihar to the Western Ghats of peninsular India. The Chinese scholar and monk Xuanzang (c. 602–664 CE) provides the earliest known textual evidence of the mountain range, describing a succession of tiered ridges, as well as the lofty halls and deep chambers that were quarried.

The conceptual design of murals and architectural elements from Ajanta have travelled far and wide, with legacy heritage impacts across Asia, from the remains of Sigiriya in Sri Lanka and the Bamiyan Valley in Afghanistan to Mogao Caves, southeast of the Dunhuang oasis in China. The aesthetic movement and precepts of Buddhism travelled further along the Silk Route, influencing the creative traditions of China, Japan and Korea.

The Jataka stories, which recount the previous lives of the Buddha as a Bodhisattva in the Mahayana school of thought, provide exquisite Gupta-period murals in Ajanta Caves. These are illustrative of the doctrines of Buddhism that advocate pursuing a life of compassion and virtue. Some of them, such as the Simhala Avadana, relating to the transformation of Simhaladvipa, and the Visvantara Jataka, on the quality of charity and the fruits of generosity, depict a range of activities in detail. Such portraits yield a representation of the society of the time. The sensitivity of the artists demonstrates empathy for the subject matter, enabling us to postulate that the artists may also have been trained in art forms such as dance, as was depicted in early Indian texts.

The rediscovery and ongoing enhancement of documentation, especially through photography, of the early mural heritage of Ajanta has brought together some of the best minds in South Asian art history. These endeavours have given utmost importance to not only physical conservation but also the atmosphere of the caves that would have been experienced by the monks and visiting laity. This body of knowledge provided the stimulus to appreciate and document elsewhere the subsequent mural heritage of South Asia. The documentation influenced several scholars and artists searching for models of Indian classicism during the last century. Nandalal Bose, a well-known artist and student of Rabindranath Tagore, was deeply influenced by Indian mythology and the murals of Ajanta. It was Ghulam Yazdani who provided published material on Ajanta that influenced several artists.

The inscription on the World Heritage List provides a fillip to the ASI for networking among different agencies, and interdisciplinary scholarship in safeguarding the unique mural legacy of early India. ●

Amareswar Galla

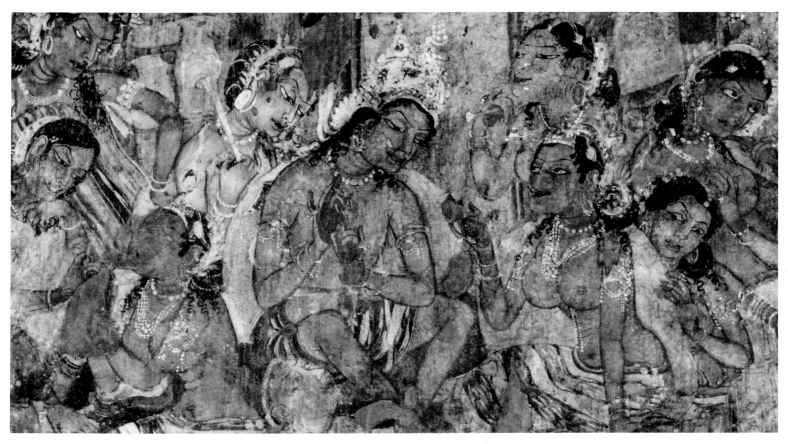

A painting in Cave 1 at Ajanta depicting the Jataka tale of Mahajanaka.

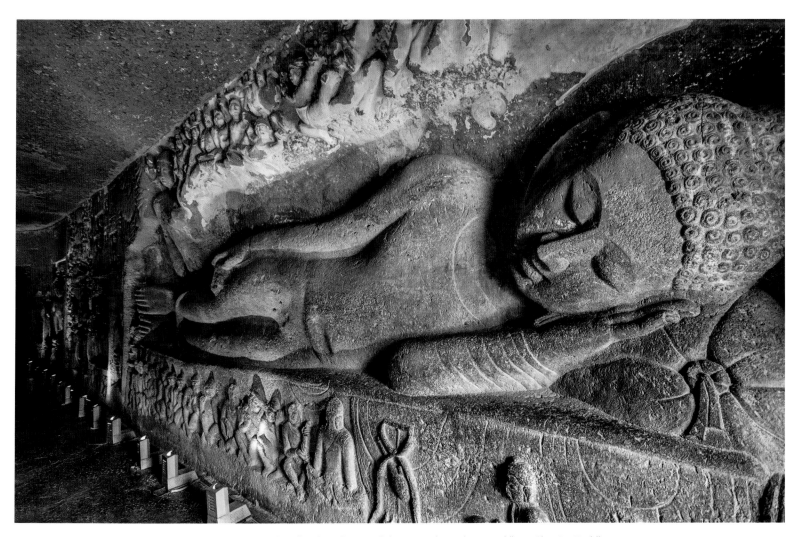

A large carving on the left aisle wall, variously known as the Reclining Buddha or Sleeping Buddha.

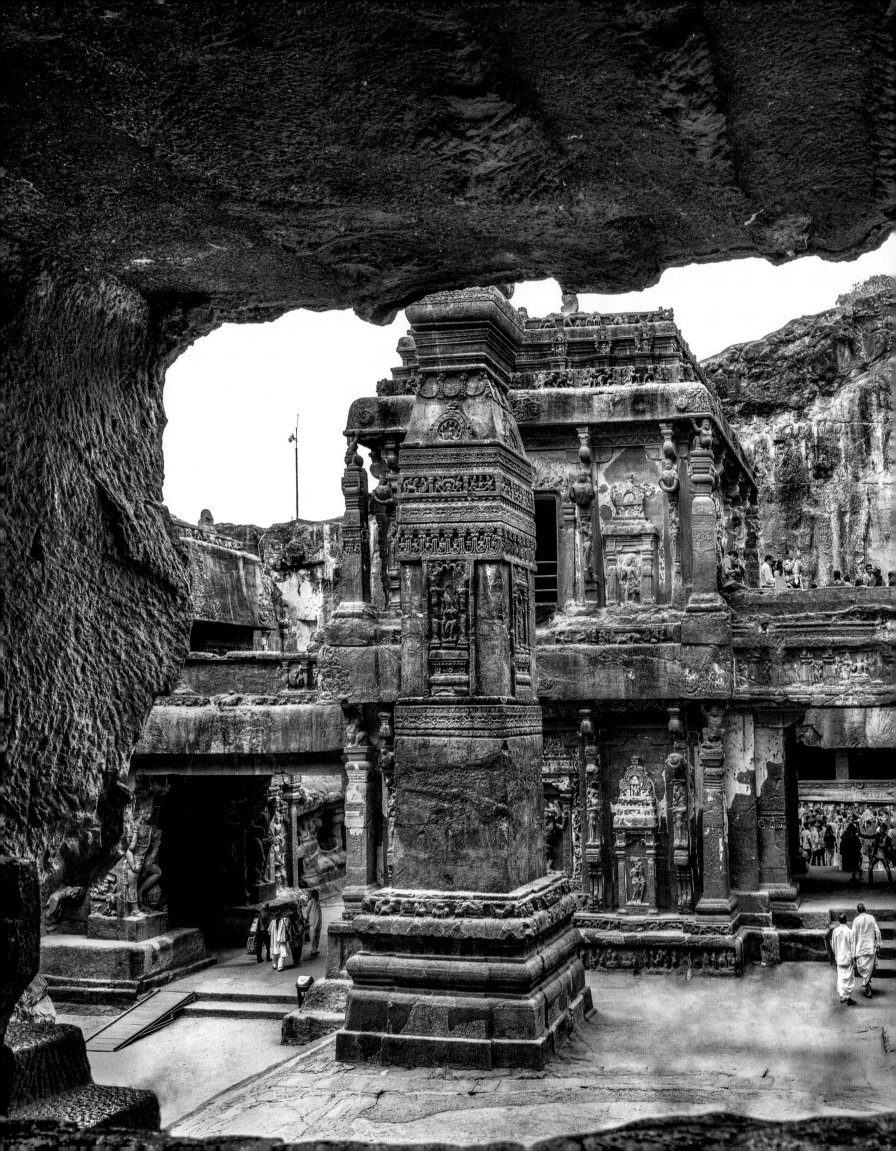

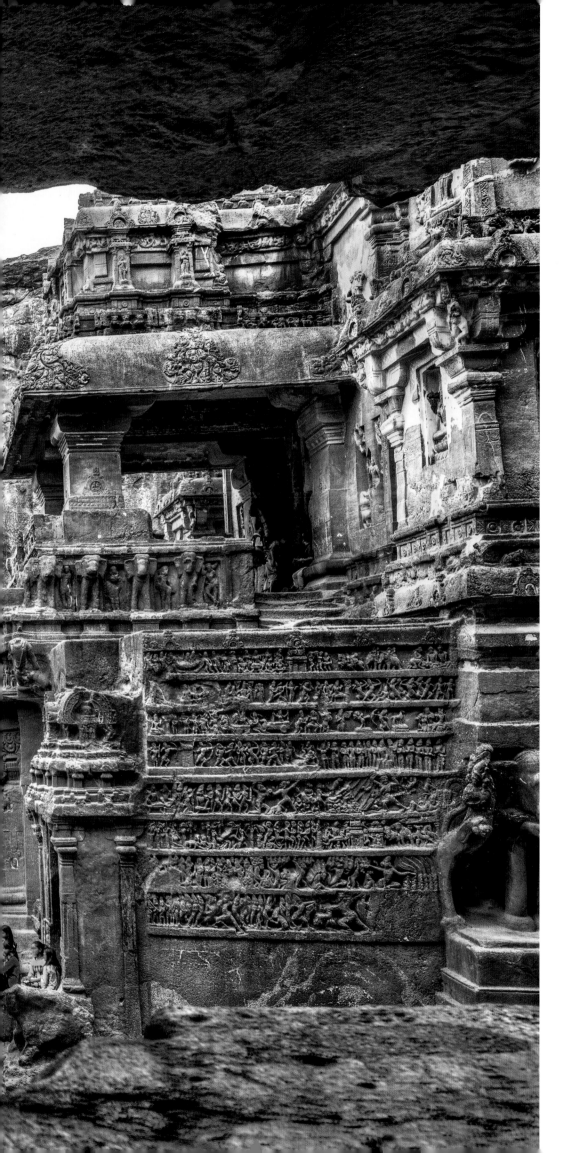

Ellora Caves

LOCATION: Maharashtra, India

COORDINATES: N20 1 35.004 E75 10 45.012

DATE OF INSCRIPTION: 1983

CATEGORY: Cultural (Monument)

OUTSTANDING UNIVERSAL VALUE

These 34 monasteries and temples were dug into the walls of a high basalt cliff in Maharashtra. With its uninterrupted sequence of monuments, dating from 600 to 1000 CE, the site brings the civilisation of ancient India to life. Not only is the Ellora complex a unique artistic creation and a technological exploit but, with its multi-faith sanctuaries, it also illustrates the spirit of tolerance characteristic of ancient India.

CRITERIA: (i) (iii) (vi)

(i): The ensemble of Ellora is a masterpiece of human creative genius. The Kailasa Temple is a technological exploit without equal. This temple, which transposes models from "constructed" architecture, offers an extraordinary repertory of sculpted and painted forms of a very high plastic quality and an encyclopaedic programme.

(iii): Ellora brings to life the civilisation of ancient India with its uninterrupted sequence of monuments.

(vi): The Ellora Caves not only bear witness to three great religions, i.e. Buddhism, Brahmanism and Jainism, but also illustrate and reinforce the spirit of tolerance characteristic of ancient India.

The grand Kailasa Temple, hewn out of a single rock, at the Ellora Caves.

The Ellora Caves are an extraordinary illustration of excellence in Indian art and architecture, located on ancient trade routes near Aurangabad. The site's strategic location was a critical factor that enabled a millennium of creative genius to flourish, especially between the seventh and tenth centuries CE.

The site comprises thirty-four caves spread over two kilometres, excavated adjacent to each other on the basalt cliffs. As compared to Ajanta and its focus on Buddhism, Ellora has layers of significance that draw on the three principal religions of early India. On a north-south axis, there are twelve caves in the Buddhist group (seventh to eighth century CE). Apart from monasteries, there is also a large hall of worship (Cave 10). There are twenty-six caves in the Brahmanical group (seventh to tenth century CE). This group includes the best-known caves, the Dashavatara Temple,

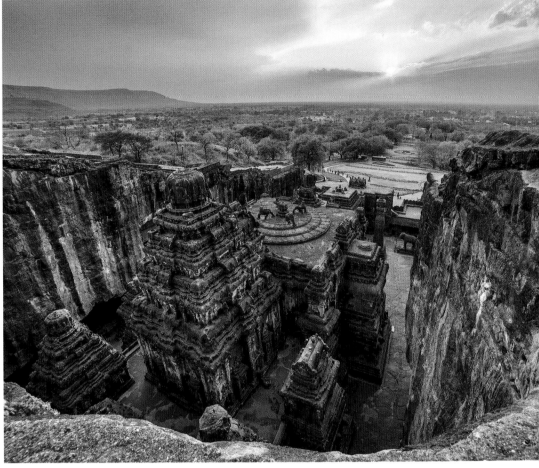

The monolithic Kailasa Temple was carved out of a single rock, marking it as an architectural masterpiece of this time.

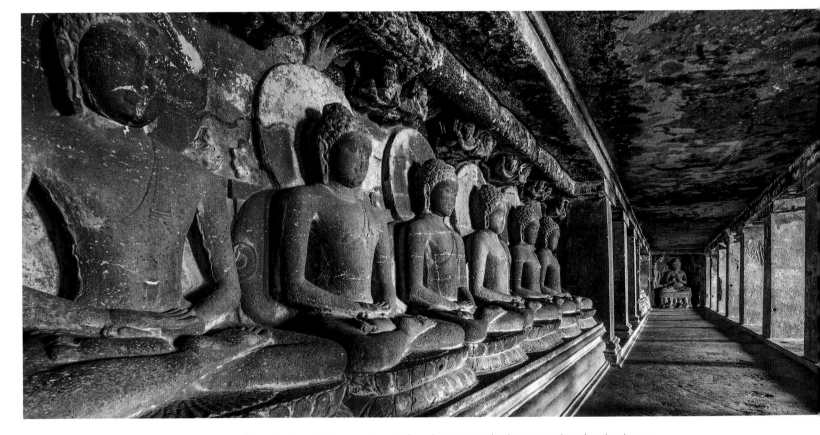

ABOVE AND FACING PAGE: The collective artistic expressions at Ellora demonstrate the diverse, secular cultural exchanges between Brahmanism, Buddhism and Jainism in ancient India.

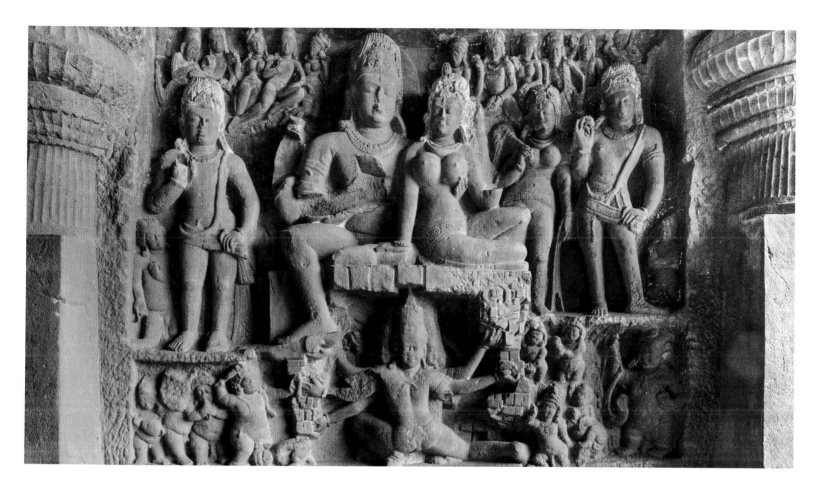

or the "Cavern of the Ten Avatars" (Cave 15) and, in particular, the Kailasa Temple (Cave 16). Then there are the caves (Caves 30–34) of the Jain group (ninth to early tenth century CE) of the Digambara sect.

Collectively, the Ellora Caves evidence the unique artistic achievement and creative genius of early India. They illustrate the complexity of societal belief systems that centre on Buddhism, Brahmanism and Jainism, as well as a togetherness of diverse faith groups.

There are many aspects of the Ellora legacy that merit our appreciation. The site provides evidence of the topographical and geological knowledge accumulated by the range of people who provided the basis for site selection, contextual framework and creative interventions. They must have included skilled labour that already knew how to work stone and rock surfaces, derived from the megalithic cultures of South Asia. They would have been the bulk of the workforce, chipping away with Iron Age tools such as axes and mallets, which are still used in many parts of South India. A range of craftspeople, from carpenters to sculptors, with an understanding of the spiritual and material, would have worked with the lithic workers. The transition from wooden structures to basalt-stone structures is clearly evident in the interior design and architecture.

The next aspect was the intensification of agriculture and trade and the evolution of centres of dominance with urban characteristics, such as Paithan, that enabled the formation of local dynasties, especially the Satavahanas, Rashtrakutas and the Chalukyas of Badami, as well as what one could perhaps call the southern dynasties of India. This sustained patronage enabled the continued evolution of two kilometres of exquisite caves with intricate and evolving faith groups: from Theravada to Mahayana Buddhism; from simple representations to complex and highly evolved spaces of worship and pilgrimage for Brahmanical faiths such as Shaivism and Vaishnavism, along with a whole pantheon of gods and goddesses; and the last and concluding intervention, which exists in the five Jain caves.

The collective and secular expressions in Ellora are reflective of diverse cultural exchanges in ancient India. The unique *chaitya* hall in Cave 10, with its massive Buddha sculpture, and the temple of Kailashnatha in Cave 16, the largest monolithic rock-cut temple of its kind, stand as architectural masterpieces of this time. The site is protected and managed by the ASI. ●

Amareswar Galla

Patrons of Stone Symphonies
The Rise of Temples and Temple Cities

Janhwij Sharma

*"After procuring an abundant supply of water and forming gardens around it, there shall be erected on the spot temples (*prāsāda*) for Devas, for the increase of one's fame and virtue."*

—*Brihat Samhita*, as translated by N. Chidambaram, 1884

"The dynamic formal structure of Indian temples shows irresistible analogies with certain metaphysical ideas recurrent in Indian thought: of the manifestation in transient, finite multiplicity of a timeless, limitless, undifferentiated yet all pervading unity."

—Dr Adam Hardy, *The Temple Architecture of India*, 2007

A Hindu temple is often the most prominent landmark in any traditional Indian settlement, urban or rural, and the socio-cultural life of the inhabitants revolves around the temple. Hindu texts, such as *Brihat Samhita*, *Vastu Shastra* and *Samrangana Sutradhara*, refer to the ideal site where a temple can be built to invoke God and to manifest peace and prosperity for the community. These canonical texts give elaborate specifications about orientation, material, proportions, spatial hierarchies, associated ritualistic practices and other attributes for the construction of the abode of God. Through *prana pratishtha* (the ritual of establishing the deity in a temple), the physical idol of a Hindu deity is consecrated within the confines of a temple when the deity "opens" their eyes for the first time, thus sanctifying the temple. A wider belief prevails among Hindus that God is eternal, omnipotent and forever playful.

The construction of a temple was considered an act of devotion or piety, built as a memorial to the deceased, and was often seen as a service to the community. Temples of all sizes and materials, mostly ephemeral, were constructed by the laity for individual or collective worship, about which hardly any information is available, as these have not survived the vagaries of time. What remains of the temple architecture of the past are Hindu temples constructed out of permanent materials such as brick and stone, mostly built as everlasting constructions in time. Their scale and level of embellishments indicate the generous royal patronage received at that time, and also suggest that Hinduism was being practised as a state religion. Temples, through donations and land holdings, also became a source of revenue, which was largely used to maintain the establishment.

With the progression of time, particularly from the fifth to the eleventh century CE, one witnesses a series of technological and aesthetic advancements in temple architecture as it flourished in different parts of the country. It evolved as a complex organism over these seven centuries, from single-cell structures such as the Gupta-period Temple 17 in Sanchi (in Madhya Pradesh) to the cave architecture of Badami (in northern Karnataka); from the Durga Temple in Aihole (in Karnataka) to the Kailasa Temple of Ellora (in Maharashtra). The zenith of temple architecture was reached by the twelfth century in most parts of the country, as illustrated by other majestic examples, such as the Virupaksha Temple in Pattadakal; the Kandariya Mahadeva in Khajuraho; Shree Jagannath Mandir in Puri; the Hoysaleswara Temple in Halebidu; and the splendid Brihadisvara Temple in Thanjavur, to name a few.

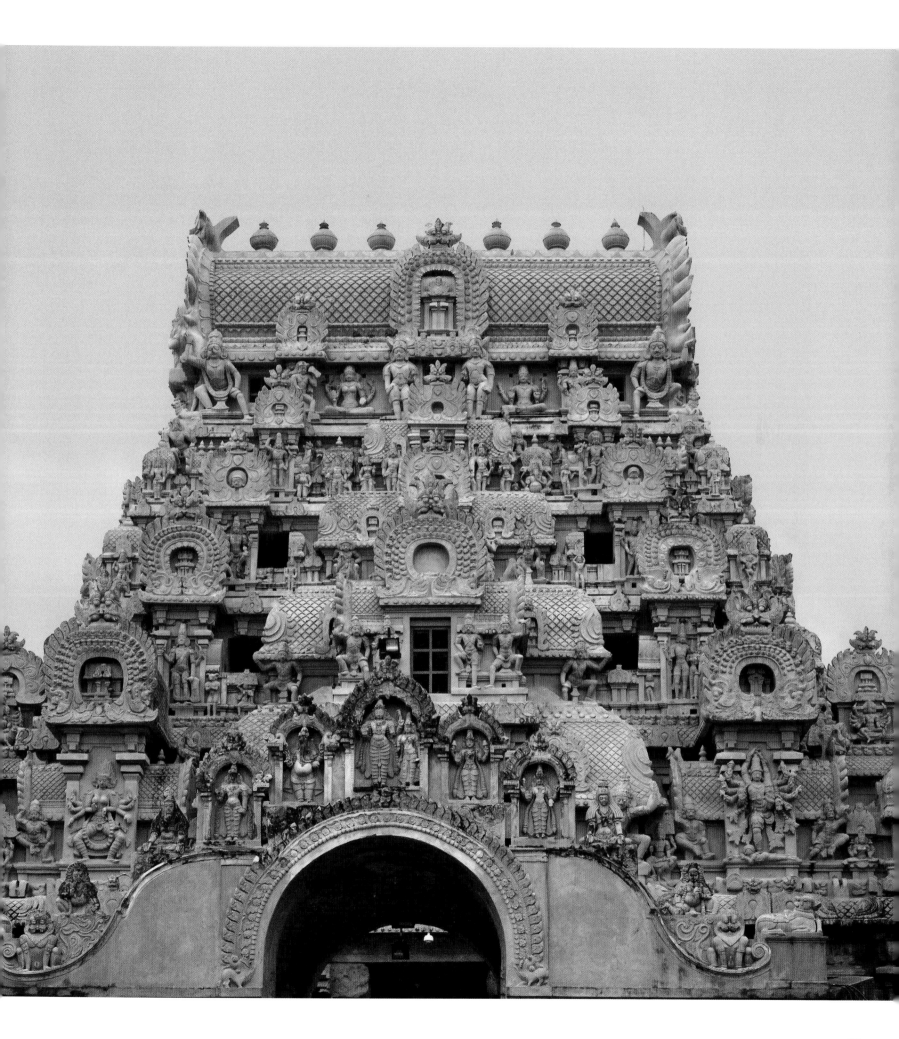

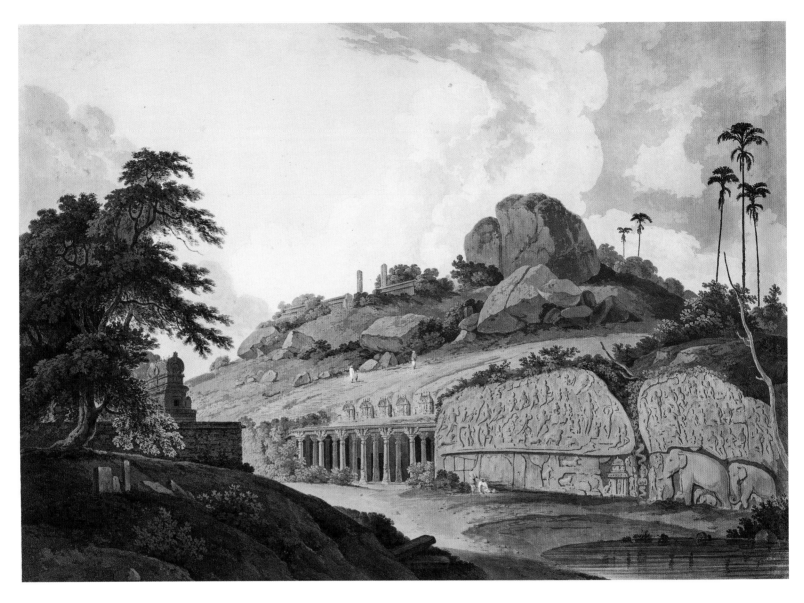

The giant elephants of Arjuna's Penance, an excavated bas-relief at Mahabalipuram, are strikingly captured in this eighteenth-century aquatint.

It is pertinent to mention here that the tradition of Hindu temple architecture, through the medium of trade contacts, also travelled to many parts of South and Southeast Asia between the eighth and thirteenth century CE. Noticeably, wherever Hinduism became the state religion, temple construction received generous patronage. Temples of architectural magnificence can be found across South and Southeast Asia; the temples of Angkor Wat in Cambodia, the My Son Sanctuary in Vietnam, the Prambanan Temple Compounds in Indonesia and the Vat Phou temple complex in Laos are examples of historic Hindu temples outside India, all renowned World Heritage Sites themselves. Interestingly, while these monuments followed the temple architecture and planning principles laid out in ancient canonical Indian literature, the sculptural and ornamental details were indigenised, largely due to the innovations of local artisans.

The construction of a Hindu temple follows strict rules, as mentioned earlier, according to several ancient texts that describe the various attributes of a temple, its site location and orientation, its materials and proportions and its various architectural and iconographical embellishments. These texts prescribe specifications, which cannot be deviated from, for each deity in terms of appearance, posture (*mudra*), costume, hand gestures and the accompanying divine symbols or objects. The role of the architect-builder, the *sutradhar* or *sthapati*, and of the sculptor, the *shilpin*, who chisels and carves the architectural and sculptural elements, is absolutely important.

In the Indian context, there exists a huge variation in the temple styles, factored on a number of reasons, such as geographic distribution and choice of materials. Broadly speaking, there are two recognised

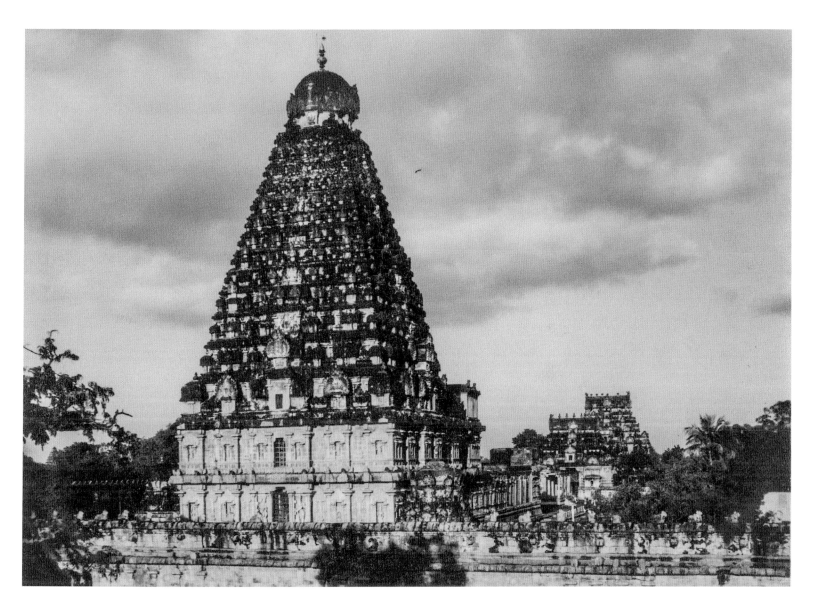

A vintage nineteenth-century photograph from ASI's archives of the towering spire of the Brihadisvara Temple in Tamil Nadu.

styles, the northern and southern, which are in turn further divided into several sub-styles, depending upon the patrons' sense of aesthetics, choice of materials, architectural proliferation of a temple's plan and its superstructure. Stylistic variations can be seen in temples built by kings of the Gupta Empire, followed by patrons of the Chandela, Solanki and eastern Ganga dynasties in the northern region. The southern style was adopted by the patrons of the Vijayanagara, Kakatiya, Hoysala, Chalukya and Chola dynasties.

Considering the vast repository of temple masterpieces in India, it is not surprising that

out of the thirty-eight sites on India's World Heritage List, six are temple complexes from various geographical zones. The list also includes several other iconic temples inscribed as part of larger sites, such as the Champaner-Pavagadh Archaeological Park and the Hill Forts of Rajasthan. The presence of temples on the Tentative List indicates that even more temple complexes could be included in the future, if their outstanding value is demonstrated.

The diverse range of northern and southern Hindu temple complexes currently represented on the list are all protected by the ASI. ◆

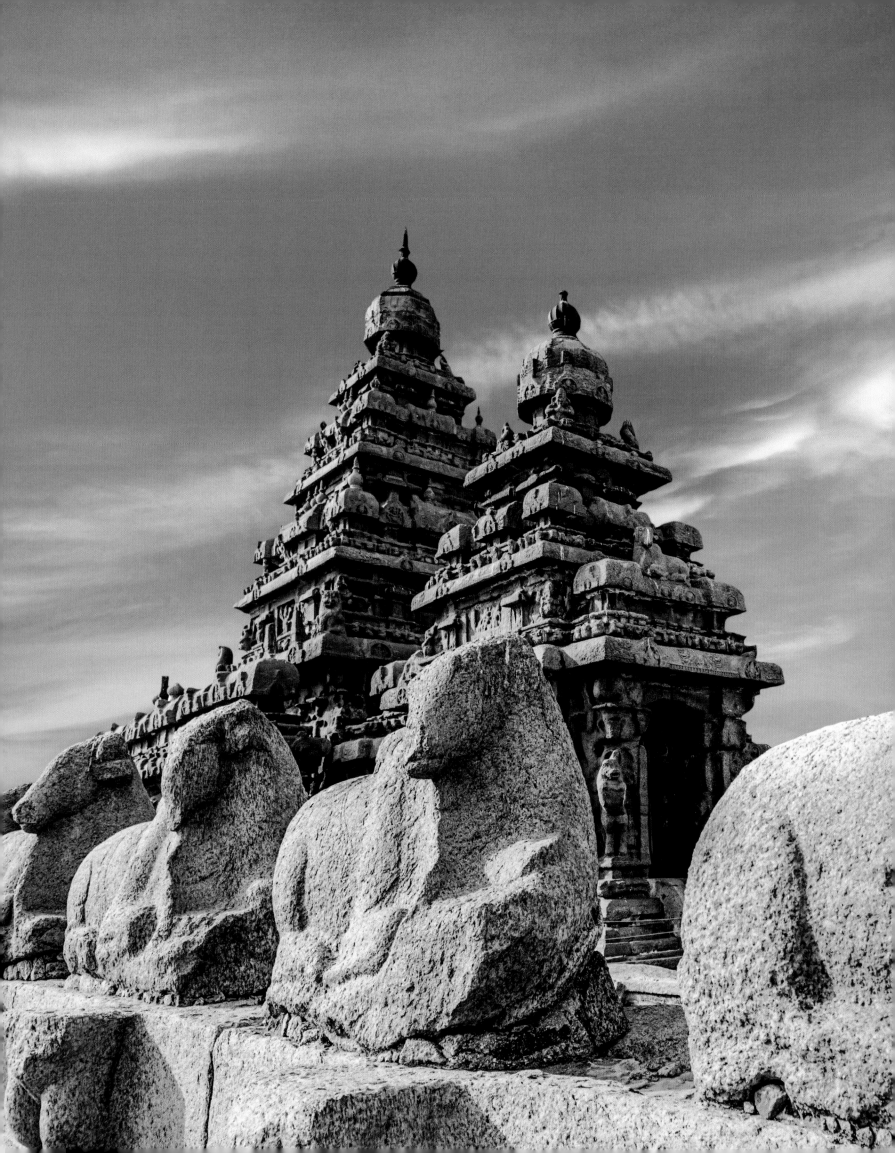

Group of Monuments at
Mahabalipuram

LOCATION: Tamil Nadu, India

COORDINATES: N12 37 0.012 E80 11 30.012

DATE OF INSCRIPTION: 1984

CATEGORY: Cultural (Monument)

OUTSTANDING UNIVERSAL VALUE

The Group of Monuments at Mahabalipuram occupies a distinct position in classical Indian architecture. Mahabalipuram was a celebrated port city of the Pallava dynasty and the monuments here consist of rock-cut cave temples, monolithic temples, bas-relief sculptures and structural temples as well as the excavated remains of temples. These monuments were carved out of rock along the Coromandel Coast in the seventh and eighth centuries. The site is known especially for its *ratha*s (temples in the form of chariots), *mandapa*s (cave sanctuaries), giant open-air reliefs and numerous beautiful temples, with thousands of sculptures to the glory of Shiva.

CRITERIA: (i) (ii) (iii) (vi)

(i): The bas-relief of Arjuna's Penance, also called the Descent of the Ganges, is a unique artistic achievement.

(ii): The influence of the sculptures, characterised by the softness and suppleness of their modelling, spread afar to places such as Cambodia, Annam and Java.

(iii): Mahabalipuram is a pre-eminent testimony to the Pallava civilisation of southeast India.

(vi): The sanctuary is one of the major centres of the cult of Lord Shiva.

The Shore Temple at Mahabalipuram, one of India's oldest structural stone temples.

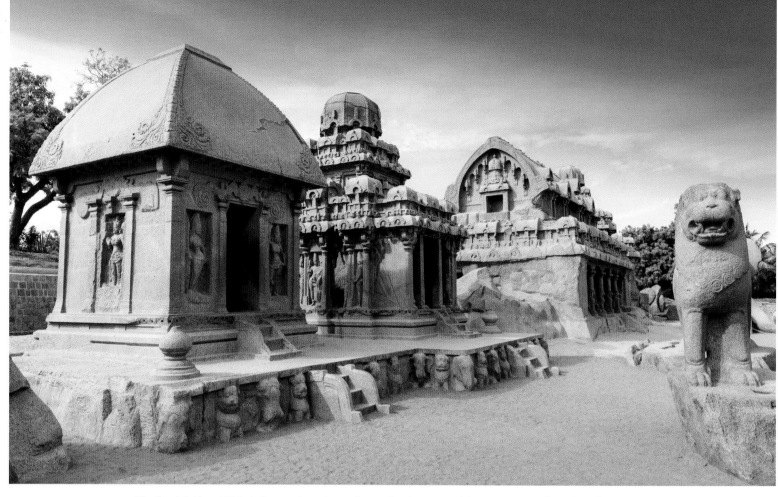

The Panch Rathas at Mahabalipuram show the excellence of rock-cut monolithic stone carving from the Pallava period.

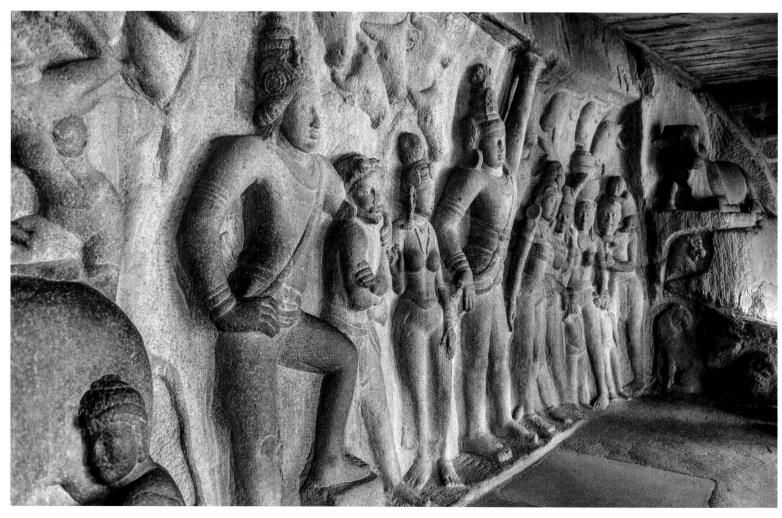

The Krishna Mandapa stone sculptural relief depicts Lord Krishna lifting the Goverdhan Hill to protect the cowherds and milkmaids from heavy rains.

Mahabalipuram, located along the eastern coast of Tamil Nadu, south of Chennai, has been an important strategic seaport, referred to by a Greek navigator in his work *Periplus of the Erythraean Sea* as "a port north of Kaveri". The Chinese scholar Xuanzang, too, mentions the Mahabalipuram port settlement, although he mistakenly refers to it as "Kanchi". Archaeological findings, such as Roman coins and pottery, also attest to the importance of Mahabalipuram as an important trade centre. The Pallava kings used Mahabalipuram's port to launch trade and diplomatic missions to Sri Lanka and Southeast Asia. Marco Polo was perhaps one of the earliest European visitors to Mahabalipuram; many others after him referred to this site as "Seven Pagodas", due to the seven temples that once stood near the shore.

Mahabalipuram, or Mamallapuram (the city of Mamalla), established by Narsimhavarman I in the seventh century CE, is known for its monuments located along the shore and a nearby hill. These can be categorised as monoliths, such as the Panch Rathas; as rock reliefs, such as Arjuna's Penance; and as caves and temples, such as the famous Shore Temple.

The Panch Rathas are a small cluster of five monolithic temples hewn out of a single rock. These free-standing structures are perhaps the earliest such structures in India (even earlier than the Kailasa Temple in Ellora). These temples are excavated and arranged in a linear fashion and are of varying sizes, heights and have different roof profiles.

Arjuna's Penance, probably sculpted in the early seventh century CE, is one of the most unique rock reliefs in India, and

Krishna's Butterball, the giant, naturally balancing rock at Mahabalipuram.

perhaps the largest as well. Also known as the Descent of the Ganges, this panel (measuring approximately 29.5 metres by 13 metres) is sculpted over two giant granite boulders with a natural fissure in between, and shows two themes in tandem—Arjuna's penance and the descent of the Ganges—which give the relief its two names. Replete with symbolism, the panel shows neatly arranged wild and domestic animals such as elephants, lions, tigers and boar, and mythological figures of *gana*s (attendants), *kinnara*s and *gandharva*s (skilled musicians and dancers), *apsara*s (celestial beauties), and *naga*s (semi-divine human-cobra figures). The scene of Arjuna's penance shows a man stretched in a yogic posture, as well as a few monkeys and a cat that lend a humorous dimension to the entire scene.

The Shore Temple is built on the seashore and must have commanded an excellent view from a distance. From the old paintings or lithographs that are available, it seems the temple must have been the cynosure of all seafarers travelling along

the shoreline. The main temple has a five-tiered pyramidal roof and a porch in front with a similar *shikhara* profile. It rises to a height of approximately 18 metres and is made of granite stone blocks. Its exterior walls have been embellished with images that have lost their profile due to the constant abrasion caused by salt-laden winds from the sea. Parts of the temple complex were buried under sand; these have recently been excavated.

The local hill adjoining the panel of Arjuna's Penance within Mahabalipuram has a number of caves, smaller temple structures and a giant, precariously positioned stone ball, popularly known as Krishna's Butterball. Prominent among these caves and temples are Varaha Cave, Olakkanatha Temple, Krishna Mandapa, Dharmaraja Mandapa and Ganesha Ratha.

This World Heritage Site faces substantial challenges in stone conservation, which are meticulously dealt with by the ASI. ●

Janhwij Sharma

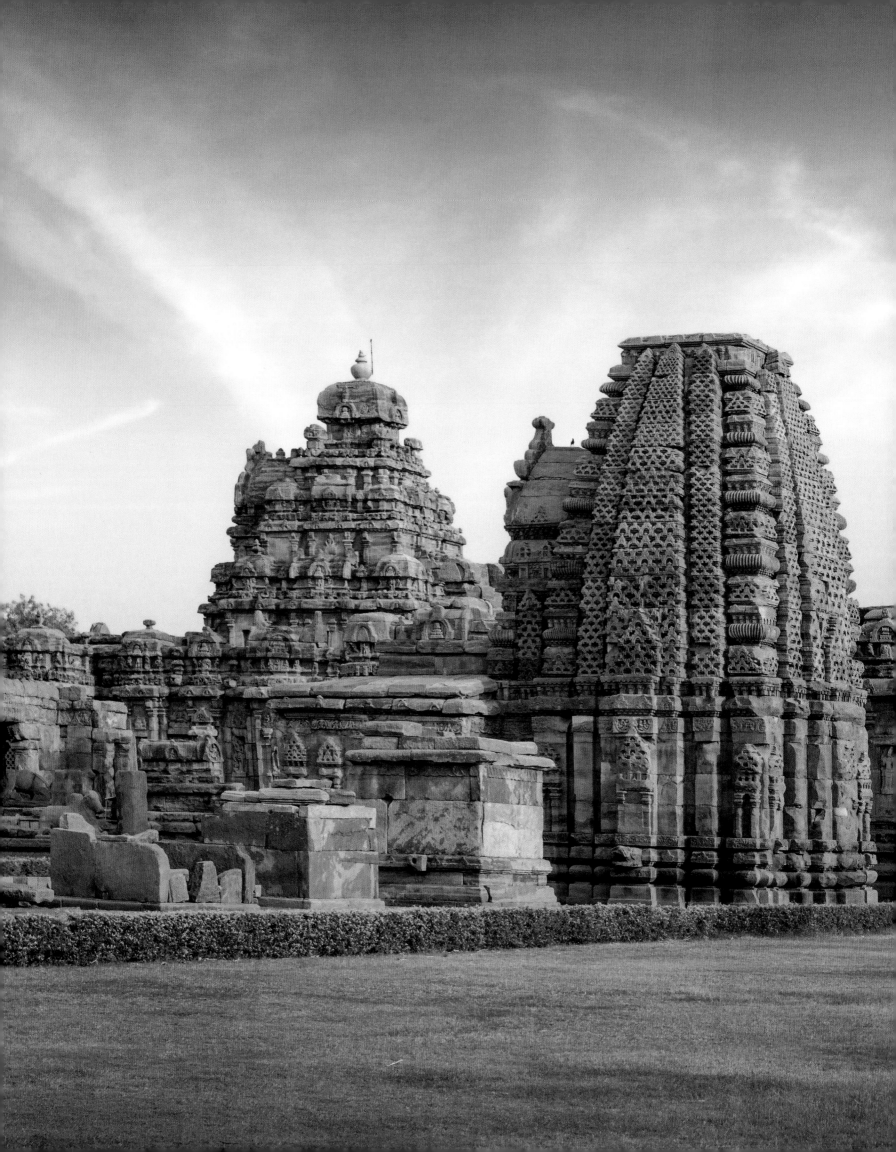

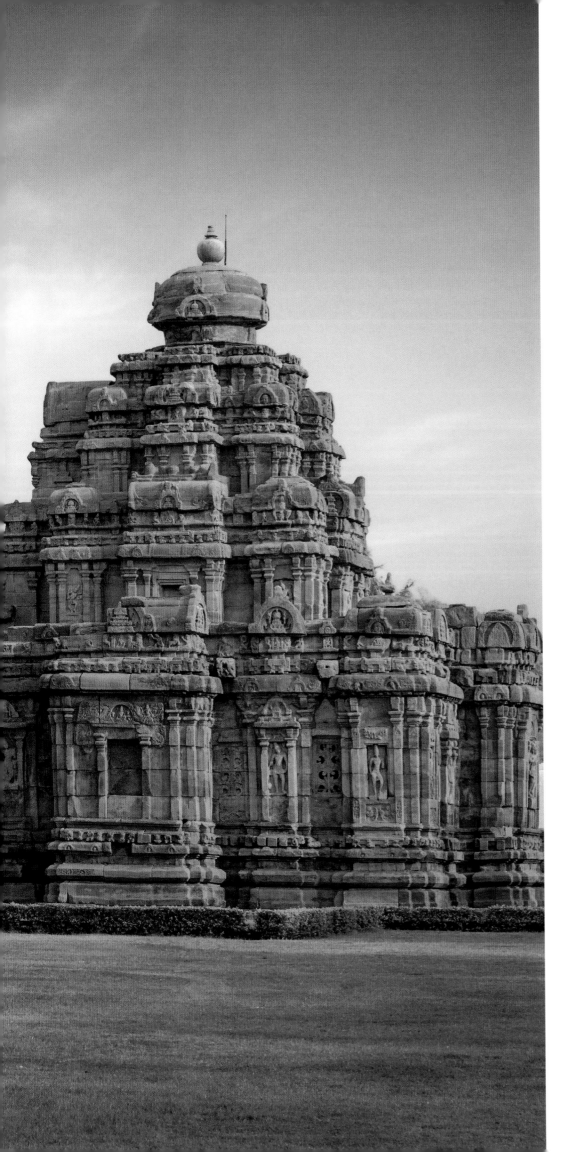

Group of Monuments at
Pattadakal

LOCATION: Karnataka, India

COORDINATES: N15 56 53.988 E75 49 0.012

DATE OF INSCRIPTION: 1987

CATEGORY: Cultural (Group of Monuments)

OUTSTANDING UNIVERSAL VALUE

Pattadakal represents the high point of an eclectic art, which, under the Chalukya dynasty, achieved a harmonious blend of architectural forms from northern and southern India. An impressive series of nine Hindu temples and a Jain sanctuary can be seen there.

CRITERIA: (iii) (iv)

The three sites in this property provide a remarkable concentration of religious monuments dating from the great dynasty of the Chalukyas (c. 543–757). Pattadakal, known as the "City of the Crown Rubies", was briefly the third capital city of the Chalukyan kingdom (c. 642–655). The city of Pattadakal illustrates the apogee of an eclectic art, which, in the seventh and eighth centuries, achieved a harmonious blend of architectural forms from the north and south of India.

[Source: Advisory Body Evaluation (ICOMOS) 1987 (file239rev-ICOMOS-266-en)]

The profusely carved temples and shrines at the Pattadakal temple complex date to the early Chalukyan period. The majestic Virupaksha Temple can be seen on the right.

The Chalukyan kings were great patrons of art and architecture, as is evident in the several temple complexes found in present-day Karnataka. The Pattadakal group of temples is one of the most outstanding Chalukyan temple complexes, reflecting the culmination of the evolution of temple architecture from the earlier rock-cut caves of Badami and apsidal temples of Aihole nearby.

The site comprises various temples, large and small, built between the mid-seventh to the ninth century CE. These temples are a blend of the *rekha-nagara-prasada* (northern Indian temple plan) and *dravida-vimana* (southern Indian roof-over-shrine temple) styles. The Sangamesvara, Virupaksha and Mallikarjuna temples at Pattadakkal exhibit the southerly elements in their *vimana*s (sanctum towers), as crystallised in contemporary Pallava temples. The earliest temple within the complex is the Sangamesvara Temple, built by Vijayaditya Satyasraya (697–733 CE). Other notable temples within the complex include Kadasiddhesvara and Jambulingeswara temples (both built in the seventh century CE), while the Galaganatha Temple was built a century later. The Kasivisvesvara temple was the last to be built in the early Chalukyan style. The Mallikarjuna and Virupaksha temples were commissioned by Queen Lokamahadevi to celebrate Vikramaditya II's victory over the Pallavas. It is believed that the Virupaksha Temple served as a model for the Kailasa Temple at Ellora. The last major addition to the complex was the Jaina Narayana Temple, built during the reign of the Rashtrakuta ruler Krishna II in the ninth century CE.

Virupaksha Temple has a large complex, comprising a tall *vimana*, with axial

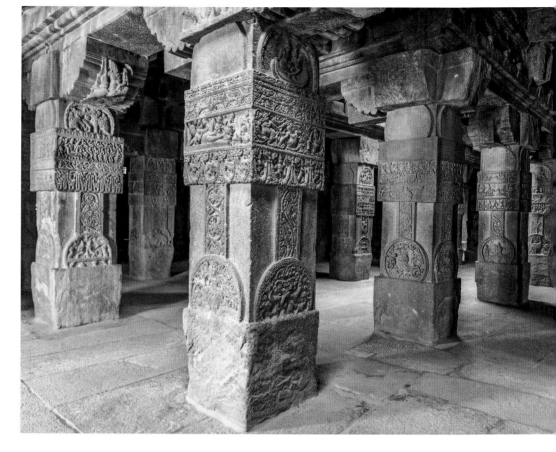

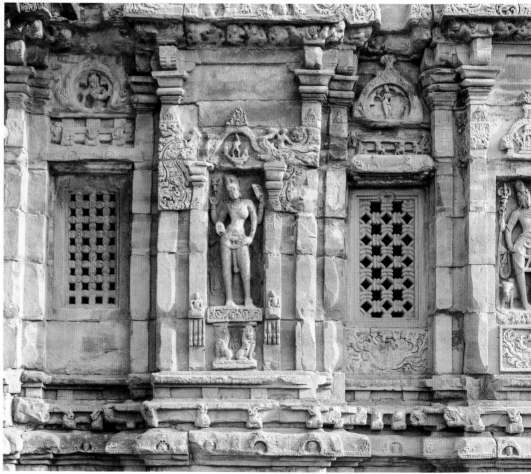

ABOVE AND BELOW: An interior view of the ornate pillars of the Galaganatha Temple. The beautiful carvings on this and other temples in the complex reflect not only traditions of cult worship but also the fine artisanship of the period.

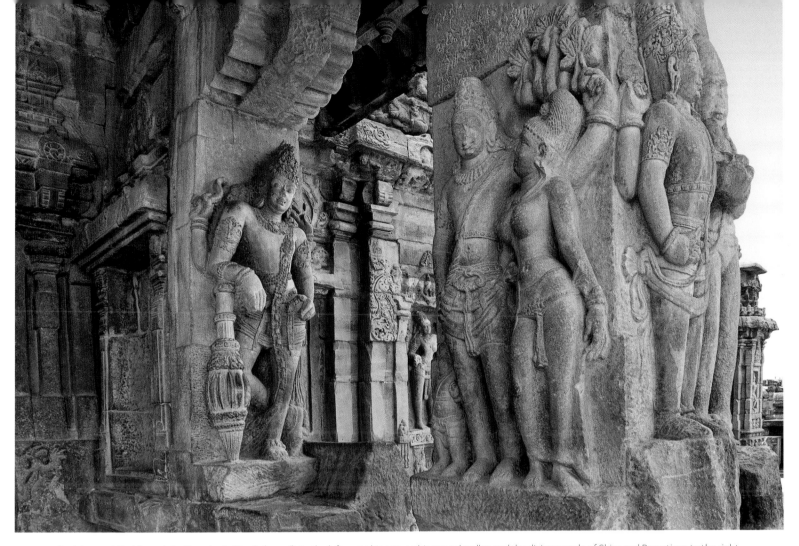

Sculptures at the Virupaksha Temple. A *dikpala* (guard), to the left, rests his arm on his carved mallet, and the divine couple of Shiva and Parvati are to the right.

*mandapa*s (pavilions) and peripheral sub-shrines around the courtyard, enclosed by a wall with *gopura*s (entrances) in the front and back, all perhaps designed and completed at once. This temple is believed to be the earliest extant temple complex in the Chalukyan series. Mallikarjuna Temple, built immediately after and close to Virupaksha, is a smaller temple with a four-storeyed *vimana* and a similar plan.

Kadasiddhesvara Temple is a modest structure, built during the middle of the seventh century and displaying Chalukyan architecture with its *shikhara* being developed along the northern style of curvilinear profile. The *sukanasa* (ornamentation over the shrine) depicts a dancing Shiva with Parvati as a shallow relief in the *chaitya* arch. Sangamesvara Temple, with a three-storeyed *vimana*, was built by Chalukya Vijayaditya

(697–733 CE) and is closer to the Pallava form as there is no *sukanasa*.

Galaganatha Temple, one of the last to be built, in around 750 CE, possesses an exquisitely developed superstructure in the northern style, as adopted by early Chalukyan architects. It is well preserved, with the *amalaka* (a notched stone disk) and the urn-shaped *kalash* at the top of the *shikhara*, save for the partially damaged *sukanasa* at the front. The *pradakshinapatha* (circumambulatory passage) is closed on three sides but the large open space atop the plinth, in front of the temple, suggests the regrettable loss of the *mandapa* to the ravages of time. The plinth, with three mouldings, is luxuriously decorated with playful figures and other common motifs. Stories from *Panchatantra* and the Puranas, especially the account of Shiva slaying Andhakasura,

are variously depicted. The entrance to the sanctum is flanked by river goddesses on both sides, with the lintel featuring a Nataraja.

The sculptural art of the early Chalukyas is characterised by graceful, delicate details. The ceiling panels of the *navagraha*s (nine heavenly bodies) and *dikpala*s (door guards), the dancing Nataraja and the wall niches containing statues of Lingodbhava, Ardhanariswara, Tripurari, Varahavishnu and Trivikrama reflect not only cult worship in vogue but also fine artisanship.

The ASI plans to extend this World Heritage Site to include its predecessor temple complexes at Aihole and Badami, as recommended by UNESCO.

Janhwij Sharma

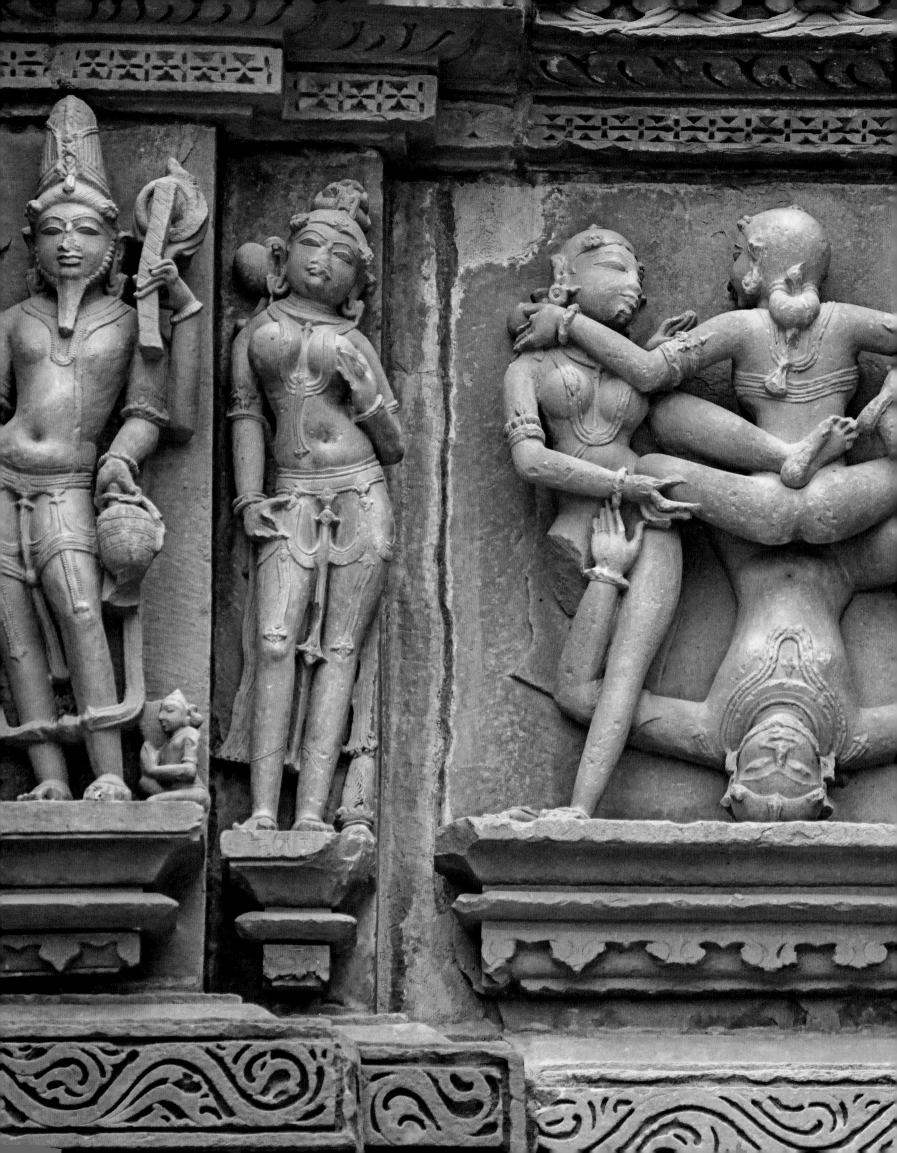

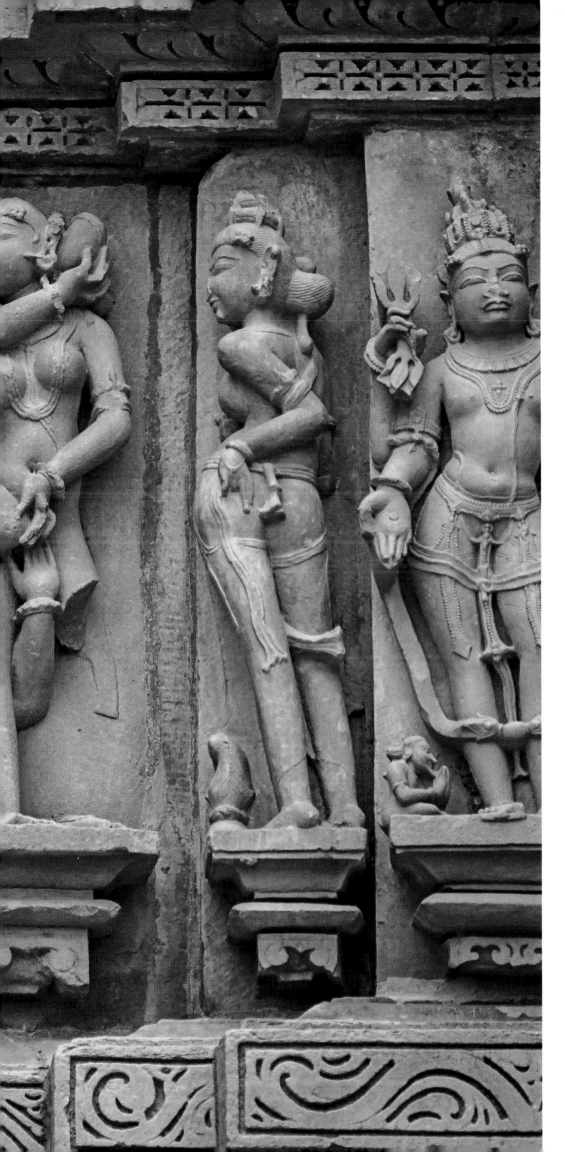

Khajuraho
Group of Monuments

LOCATION: Madhya Pradesh, India

COORDINATES: N24 51 7.992 E79 55 19.992

DATE OF INSCRIPTION: 1986

CATEGORY: Cultural (Monument)

OUTSTANDING UNIVERSAL VALUE

The temples at Khajuraho were built during the reign of the Chandela dynasty, and they fall into three distinct groups and belong to two different religions—Hinduism and Jainism. Striking a perfect balance between architecture and sculpture, all temple surfaces are profusely carved, depicting acts of worship, clan and minor deities, and couples in union, all reflecting the sacred belief system. The composition and finesse achieved by the master craftsmen give the stone surfaces of the Khajuraho temples a rare vibrancy and sensitivity to the warmth of human emotions.

CRITERIA: (i) (ii)

(i): The complex of Khajuraho represents a unique artistic creation, as much for its highly original architecture as for the high-quality sculptures, made up of numerous scenes susceptible to various interpretations, sacred or profane.

(ii): These temples bear an exceptional testimony to Chandela culture, which flourished in central India before the establishment of the Delhi Sultanate at the beginning of the thirteenth century CE.

An erotic scene carved on the outer wall of the famous Kandariya Mahadeva Temple in the Khajuraho complex.

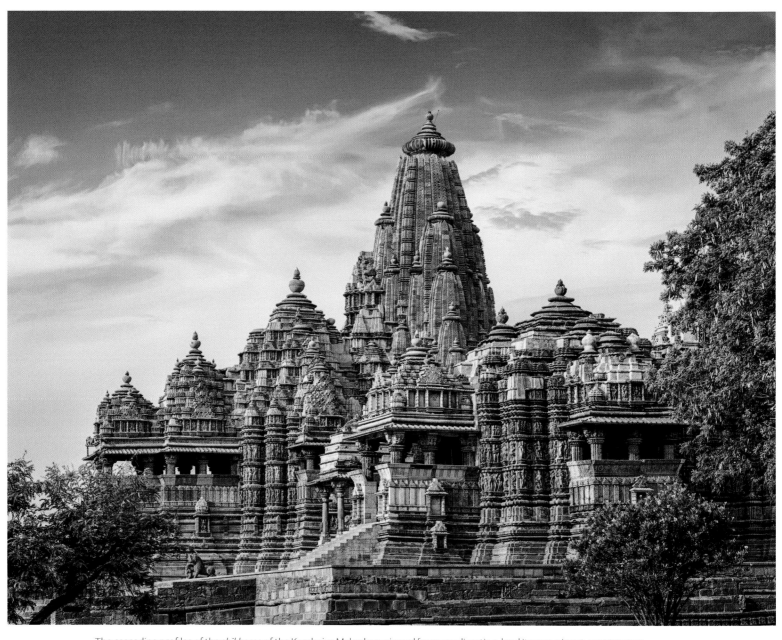

The cascading profiles of the *shikhara*s of the Kandariya Mahadeva, viewed from any direction, lend it a prominent countenance.

The Khajuraho temples are attributed to the powerful Chandelas who reigned over central India from the ninth to the thirteenth century CE. Although their reign is credited with the construction of many forts, palaces, temples and tanks, they are most renowned for the construction of around eighty-five temples in and around their capital city, Khajuraho, of which only twenty-five survive today. Most temples built by the Chandelas date from the tenth century onwards, coinciding with the resurgence of Hinduism in the region. The *nagara* (north Indian temple) style of architecture reached its zenith during their period.

The temples of Khajuraho are of three major groups—the western, eastern and southern groups. Of these, the western group of temples, located adjoining a large water tank, contains the most renowned temples, such as the Lakshmana, the Kandariya Mahadeva, and the Vishvanatha and Chitragupta temples. The eastern group comprises temples such as the Vamana, the Javari and the Adinatha temples, and the southern group has the famous Duladeo and Chaturbhuja temples. According to the author of *World Heritage Series: Khajuraho*, Krishna Deva, collectively, these temples "are manifestations of a distinctive and concerted architectural movement, differing

only in details". These temples "mark the culmination of the central-Indian building style that has certain peculiarities of plan and elevation".

Most temples in all three groups comprise hierarchical progression in plan and elevation. Raised on a high plinth, these temples are entered through a small porch, and through a progression of spaces—from the *ardha mandapa* (half-pavilion hall) to *mandapa* to *maha mandapa* (grand pavilion) (present in case of larger temples only) to *antrala* (antechamber) and, finally, the *garbhagriha*. There is a corresponding progression discernible in the elevation

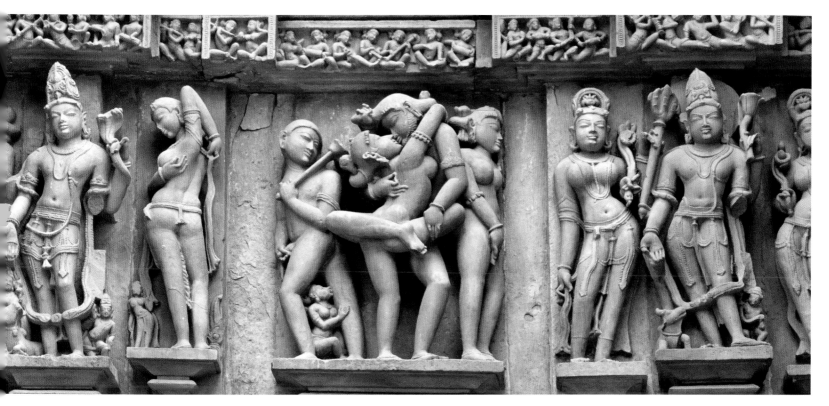

An exceptional sculptural panel on the Kandariya Mahadeva Temple showing a couple in perfect union, alongside other panels depicting daily rituals.

A sculpture of a mythical lion and a female figure at the Kandariya Mahadeva Temple.

divinities and their families; *apsara*s and *sursundari*s (celestial beauties); secular themes such as ascetics; the tradition of *guru* (teacher) and *shishya* (pupil); dancers and musicians; erotic couples or groups; and mythical *vyala*s (creatures combining features of two animals). Images of gods and goddesses conform to strict canonical proportions and postures. From architectural and art historical perspectives, Khajuraho is believed to be the epitome of Indian temple architecture.

The Kandariya Mahadeva temple is considered the finest and the most evolved example of temple architecture in North India. Its main *shikhara* has a rhythmic ascendance of eighty-four miniature *shikhara*s that lend it a strong visual expression. This temple is the most ornate in terms of sculptural profusion on its exterior and interior walls, columns and ceilings. The ASI has worked substantially on the conservation and landscaping of this site. ●

Janhwij Sharma

of the temples, wherein one witnesses the ascending profile articulating itself in the *shikhara* outlines. The *shikhara*s of these temples are multi-tiered and have a beautiful cascading profile. Miniature *shikhara*s embellish the main *shikhara* with a gradually receding contour, thus lending it a curvilinear profile. The walls of the temples, unlike temples from other regions, are punctuated by large balconies, thus creating an interesting solid-void alternating interface.

The hallmark of the Khajuraho temples is the profusion of sculptures on their elevations. These comprise cult images;

Great Living
Chola Temples

LOCATION: Tamil Nadu, India

COORDINATES: N10 46 59 E79 7 57

DATE OF INSCRIPTION: 1987 Extension: 2004

CATEGORY: Cultural (Group of Monuments)

OUTSTANDING UNIVERSAL VALUE

The site includes three great eleventh- and twelfth-century temples of the Chola Empire. The Brihadisvara Temple at Gangaikondacholisvaram has a 53-metre *vimana* (sanctum tower) with recessed corners and a graceful upward-curving movement, contrasting with the straight and severe tower at Thanjavur's Brihadisvara Temple. The Airavatesvara Temple at Darasuram features a 24-metre *vimana* and a stone image of Shiva. The temples illustrate the brilliant achievements of the Cholas in art and architecture.

CRITERIA: (i) (ii) (iii) (iv)

(i): The three temples represent an outstanding achievement in the architectural conception of the pure form of the *dravida* type of temple.

(ii): The Brihadisvara Temple at Thanjavur became the first great example of the Chola temples, followed by a development to which the other two properties also bear witness.

(iii): The three temples are an exceptional and most outstanding testimony to the development of the architecture of the Chola Empire and the Tamil civilisation in southern India.

(iv): These temples are outstanding representations of the Chola ideology.

A Hindu pilgrim communes with Lord Ganesha at the Brihadisvara Temple in Thanjavur.

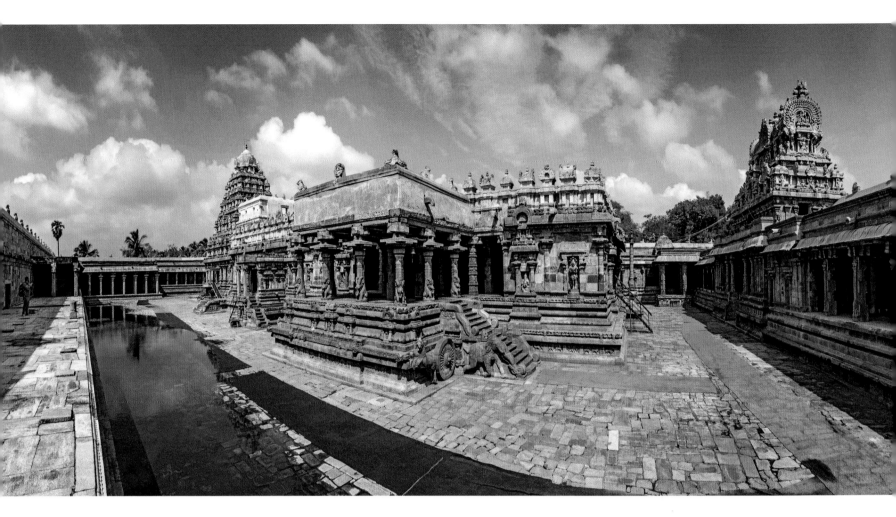

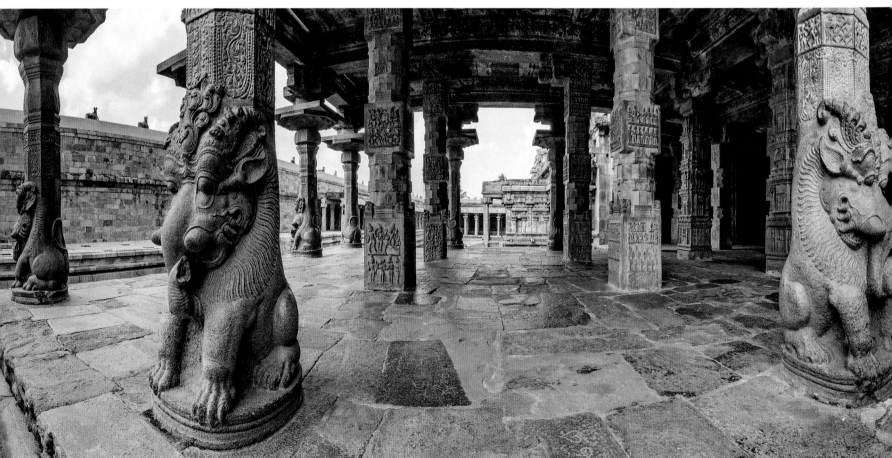

ABOVE AND BELOW: A view of the Airavatesvara Temple complex, with its carved shikhara, chariot-like plinth and sculptured pillars.

The Chola kingdom originated in southern India and flourished from the ninth to the thirteenth century, with its influence extending across the Indian Ocean to other parts of Southeast Asia. Renowned for their patronage of literature, art and architecture, the Cholas built nearly 300 lavishly carved stone temples. Chola temple architecture is marked by scale, technology and artistic embellishment; three in particular are recognised to be of outstanding value.

The legendary Chola king Rajaraja I built the magnificent Brihadisvara Temple, dedicated to Lord Shiva, in the early eleventh century. Inscriptions on the temple plinth extol his and other Chola rulers' generous patronage. The temple complex is set within the fortified town of Thanjavur, with a moat and entrance gateways. The main temple has a series of *mandapa*s aligned in succession: Nandi *mandapa*, *mukha mandapa* (frontal pavilion), *maha mandapa*, *ardha mandapa*, *antrala* and *garbhagriha*, along with a circumambulatory passage. The most impressive aspect of this temple is its sheer scale and monumentality, marking it as the grandest of temples ever built in Indian history. The highlight is its colossal *shikhara*, with a height of nearly 61 metres, and thirteen receding tiers. At the peak of the *shikhara* is the twenty-five-tonne *amalaka*, resting on a heavier stone block weighing eighty-one tonnes. The stones, presumably brought from quarries by rolling them with the help of elephants and an army of labour, were positioned on the *shikhara* via a 6.5-kilometre-long temporary ramp, indicating the unmatched engineering skill of this period. The Brihadisvara Temple is also famous for its sculptures of divinities, as well as the paintings within the circumambulatory passage of the *garbhagriha*.

Rajendra I, son of Rajaraja I, built another capital 55 kilometres northwest of Thanjavur, named Gangaikondacholisvaram, meaning "the city of the Chola who conquered the Ganges", to celebrate the expanding Chola Empire. The temple here is also a rich repository of Chola sculptural art. The Chandesanughraha *murti* (idol) is set within a niche and prominently located at the southern entrance of the temple. Nataraja, Brahma flanked by Saraswati and Savitri, Mahishasuramardini, and a dancing Ganesha are other images sculpted on the walls of the temple.

Darasuram was another important centre of Chola administration, and it is here that the third great temple, Airavatesvara, was built by Rajaraja II. Built sometime in the middle of the twelfth century, it is smaller in scale compared to the other two, and is likewise bound by a large *prakara* (wall) and a cloister. The *mandapa*, unlike in the other two temples, is a profusely carved pillared hall, divided into two parts. The *agra mandapa* is followed by the *ardha mandapa* and *antrala* before leading to the *garbhagriha*. The *agra mandapa* plinth has a chariot-like stance, indicated by wheels and galloping horses carved in relief. Prominent sculptures include the Koshtha image of Lingodbhava; a panel depicting Ravana shaking the Kailasha; Shiva-Parvati; Nataraja; and scenes of yogic postures and dwarf *gana*s.

All three Chola temples are protected and managed by the ASI. ●

Janhwij Sharma

The life-size carving of the Chandesanughraha *murti* depicts Shiva and his consort Parvati blessing Rajendra Chola I, the founder of Gangaikondacholisvaram.

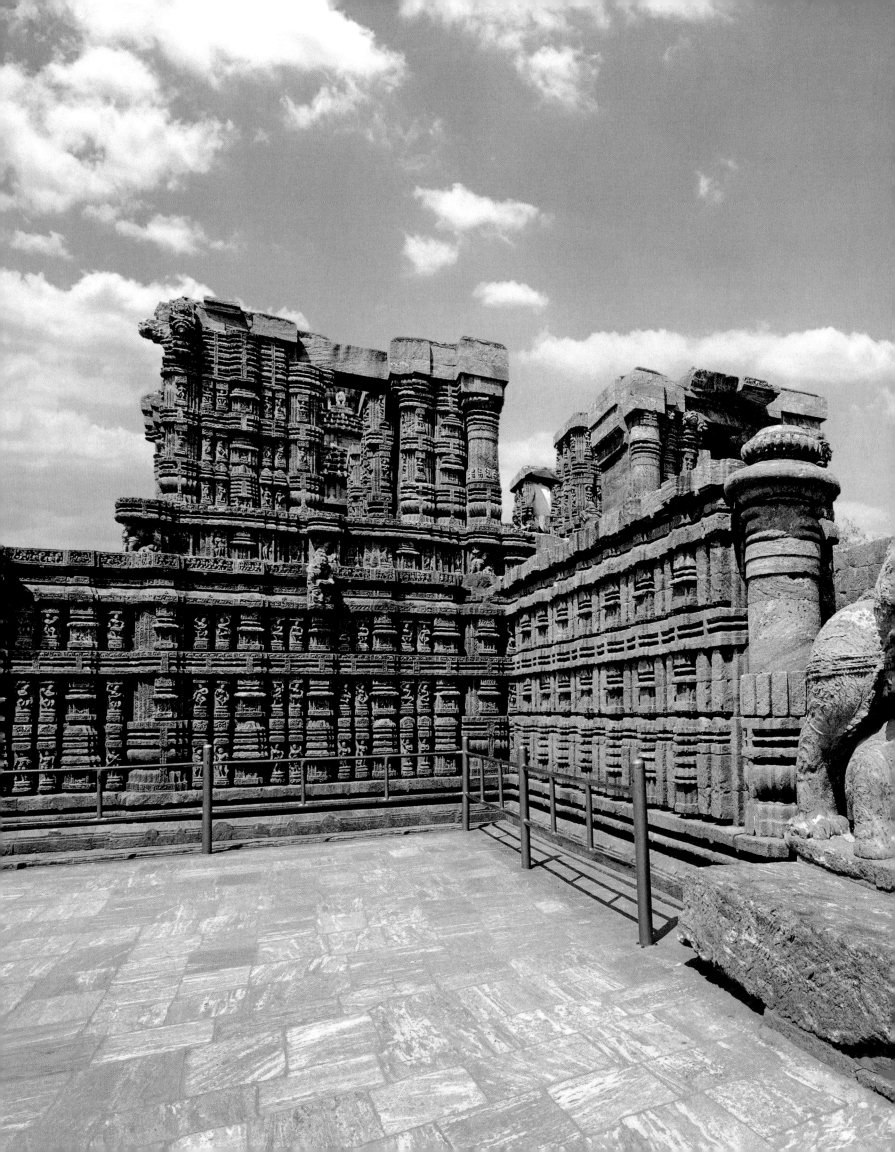

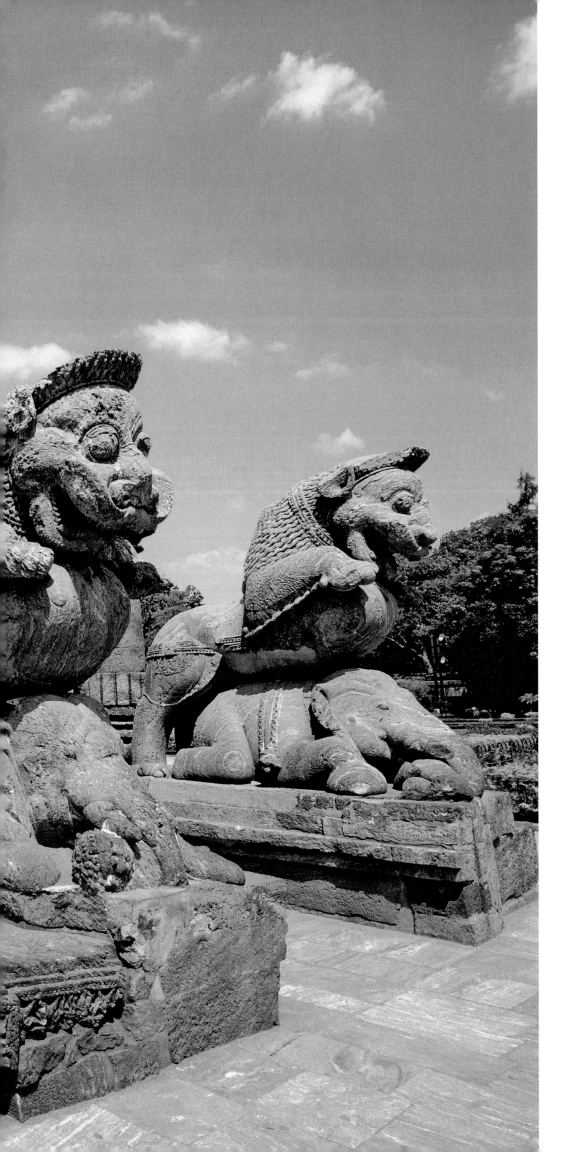

Sun Temple, Konârak

LOCATION: Odisha, India

COORDINATES: N19 53 15 E86 5 40.992

DATE OF INSCRIPTION: 1984

CATEGORY: Cultural (Monument)

OUTSTANDING UNIVERSAL VALUE

On the shores of the Bay of Bengal, bathed in the rays of the rising sun, the temple at Konârak is a monumental representation of the sun god Surya's chariot; its twenty-four wheels are decorated with symbolic designs and it is led by a team of six horses. Built in the thirteenth century, it is one of India's most famous Brahman sanctuaries.

CRITERIA: (i) (iii) (vi)

(i): A unique artistic achievement, the temple has raised up those lovely legends that are affiliated everywhere with absolute works of art; its construction caused the mobilisation of 1,200 workers for twelve years. The chief architect, Bisu Moharana, left his family and home to devote himself to his work, but died before he was able to complete the construction of the temple's cupola. His son, who became part of the workshop, finished building the cupola and then immolated himself.

(iii): Konârak is an outstanding testimony to the thirteenth-century kingdom of Orissa (now Odisha).

(vi): Directly and materially linked to Brahman beliefs, Konârak is an invaluable link in the history of the diffusion of the cult of Surya, which originated in Kashmir during the eighth century and subsequently reached the shores of eastern India.

The main entrance of the *natya mandapa* (dance pavilion) of the Sun Temple, with its stone Gajasimha—*gaja* meaning "elephant" and *simha* meaning "lion"—depicting two massive lions crushing the elephants beneath them.

The western side of the *jagmohana* features a stone carving of Surya, the sun god.

major spokes and eight thin ones. The hub of the wheel is circular and has a "wheel cap", and the spokes are also elaborately designed and carved. These depict images of, variously, a deity, a king on an elephant, or even an erotic or amorous figure. Another noticeable feature is the elaborate eastern doorway, with jambs divided into eight gradually projecting bands giving it a tapering profile. The doorjambs are profusely carved with depictions of foliated leaves, coiled serpents and a vertical succession of panels with dancing figures and amorous couples. The lintel, in the middle, has niches with an image of Lakshmi in the lowest one.

The plinth of the *jagmohana* has a profusion of sculptures that include divinities of the Hindu pantheon such as Mahishasuramardini, Vishnu in Jagannatha form, Shiva as a *linga*, Parvati, Gajalakshmi and Narsimha, and Vedic deities such as Indra, Agni and Kuber. Other themes on display on the plinth walls include military processions, musicians playing instruments, palanquin bearers, and various facets of the life of the people. The plinth has images of *maithuna*s (amorous union) from the *Kamasutra*, showing couples in stages of courtship and intimacy. The *shikhara* of the *jagmohana* features life-size images of animals and women in various dancing *mudra*s. A few of these images do catch one's eye, in particular that of a giraffe, an animal not native to India. While various theories exist on this matter, it is perceived as an "expensive gift" to India, brought through the old seafaring tradition.

UNESCO has recognised the significant legends of the Sun Temple's own artistic creation—the most evocative being its construction over twelve years using 1,200

Rabindranath Tagore's famous quote on the Sun Temple states: "Here the language of stone surpasses the language of man." Sir John Marshall, the first Director-General of the ASI, said, "There is no monument of Hindustan, I think, that is at once so stupendous and so perfectly proportioned as the Black Pagoda and none which leaves so deep an impression on the memory."

The Sun Temple, termed as "the Black Pagoda" by the British, was built in the thirteenth century by King Narsimhadeva of the Ganga dynasty. Conceptualised as a grand chariot of the sun god Surya, the *jagmohana* (main platform) stands on twelve carved stone wheels drawn by seven richly caparisoned horses. The twelve pairs of giant wheels correspond to the months of Hindu calendar, with eight

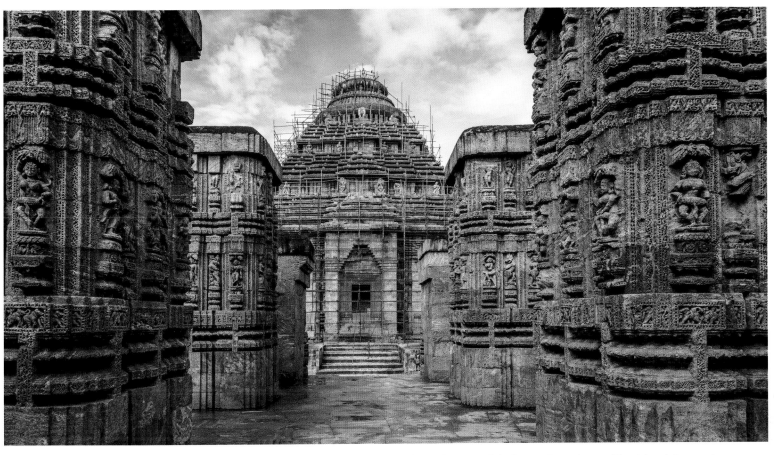

Built in the thirteenth century, the Sun Temple remains an example of the outstanding architecture of the Eastern Ganga dynasty. The elaborately carved stone chariot wheel (below) is a marvellous example of craftsmanship and skill.

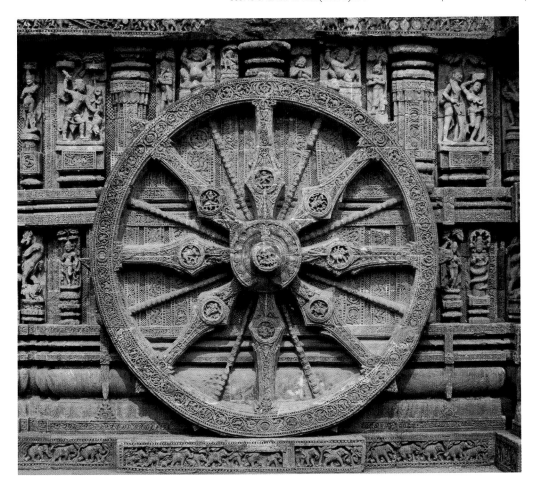

artisans—and the stories about the deep commitment of its master builder, Bisu Moharana, to the project, followed by his son, who continued with this tradition.

The main portion of the temple, the sanctum sanctorum that is the hallmark of an Odishan-style temple *shikhara*, does not survive. It is believed to have been nearly 60 metres tall. Its collapse is attributed to either the subsistence of the foundation or to lightning.

While some temple repairs were attempted in the nineteenth century, the major conservation works were carried out by the ASI in the early twentieth century. ●

Janhwij Sharma

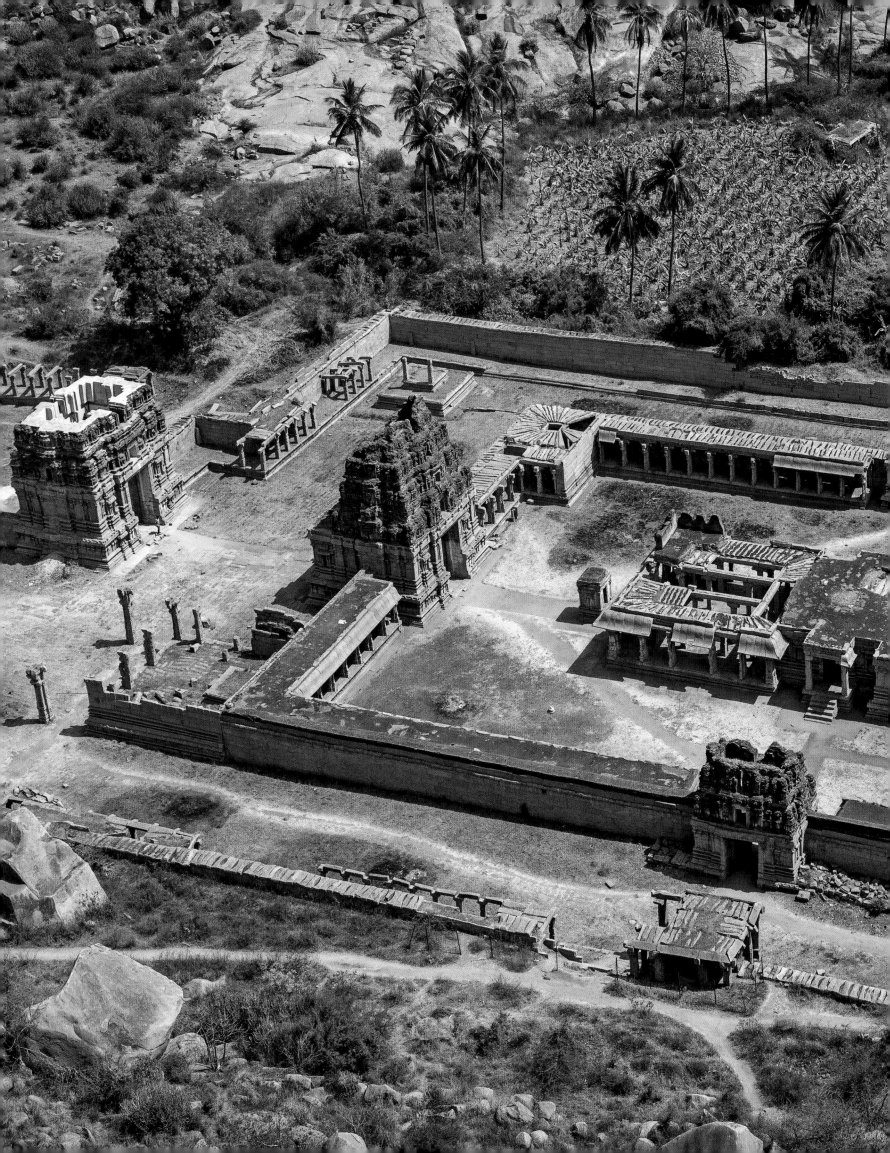

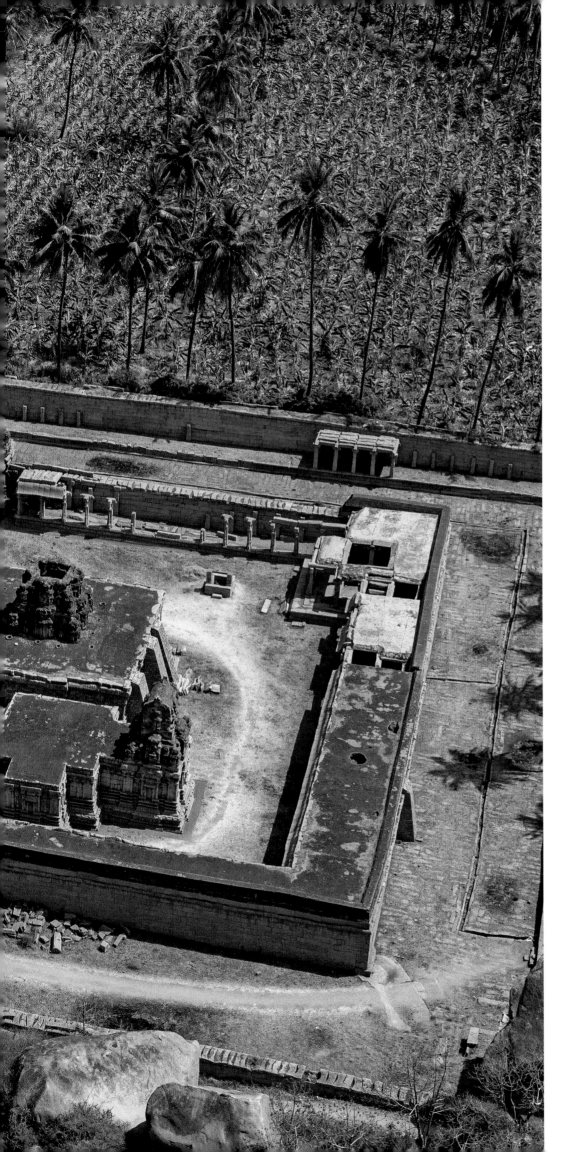

Group of Monuments at
Hampi

LOCATION: Karnataka, India

COORDINATES: N15 18 51.984 E76 28 18.012

DATE OF INSCRIPTION: 1986

CATEGORY: Cultural (Group of Monuments)

OUTSTANDING UNIVERSAL VALUE

The austere, grandiose site of Hampi was the last capital of the last great Hindu kingdom of Vijayanagara. Its fabulously rich princes built Dravidian temples and palaces, which won the admiration of travellers between the fourteenth and sixteenth century. Conquered by the Deccan Muslim confederacy in 1565, the city was pillaged over a period of six months before being abandoned.

CRITERIA: (i) (iii) (iv)

(i): The remarkable integration between the planned and defended city of Hampi, with its exemplary temple architecture and its spectacular natural setting, represents a unique artistic creation.

(iii): The city bears exceptional testimony to the vanished civilisation of the kingdom of Vijayanagara, which reached its apogee under the reign of Krishna Deva Raya (1509–1530).

(iv): This capital offers an outstanding example of a type of structure that illustrates a significant historical situation: the destruction of the Vijayanagara kingdom at the Battle of Talikota (1565 CE), which left behind an ensemble of living temples, magnificent archaeological remains in the form of elaborate sacred, royal, civil and military structures, as well as traces of its rich lifestyle, all integrated within its natural setting.

An aerial view of the ruins of Achyutraya Temple in Hampi.

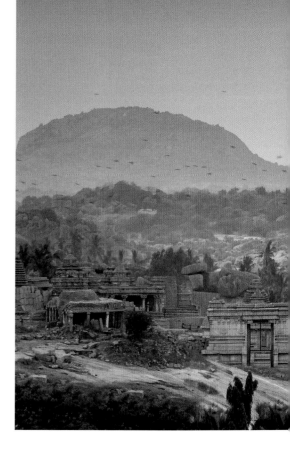

Nature reclaims a ruin at the temple complex in Hampi.

Hampi, also identified as Kishkindakshetra, a small village located along the Tungabhadra River in present-day Karnataka, was the seat of the Vijayanagara Empire. The site was probably selected for its denuded boulders and craggy hills that offered natural defences. The majority of ruins are strewn within an area of 25 square kilometres, between Hampi and Kamalapuram villages, and are encircled by concentric fortification walls entered through gateways.

Though Hampi was under the rule of several dynasties, from the Mauryans to the Kadambas, Chalukyas, Rashtrakutas and Hoysalas, it was the Vijayanagara Empire, from the mid-fourteenth to the early seventeenth century, which left an indelible architectural and cultural imprint on its landscape. Vijayanagara kings, in particular Devaraya II (1422–1446 CE), Krishnadeva Raya (1509–1529 CE) and Achyuta Raya (1529–1542 CE), are credited with the construction of a number of magnificent structures, including temple complexes, palaces, fortification walls and other defence features, innumerable smaller shrines and a complex irrigation system that criss-crossed the entire landscape. By the early seventeenth century, the city was brutally plundered by the Bahmanis, thus leaving it in ruins.

Walking through the ruins of this erstwhile capital city, with architectural masterpieces scattered through its rugged riparian landscape punctuated by banana plantations, there is a sense of travelling back in time. European travellers from the fifteenth century have left elaborate descriptions of its beauty and expanse, claiming that its circumference was nearly 100 kilometres. According to the Persian traveller Abdul Razzaq, who visited in 1443, the empire possessed 300 seaports and maintained trade links with Malaysia, Burma, China, Arabia, Persia, East Africa, Abyssinia and Portugal.

The bazaars—large, cloistered markets with wide streets—which precede temple complexes further attest to the presence of thriving trade. The builders and planners of Hampi executed a network of canals for carrying water to distant lands from the Tungabhadra River, with water reservoirs that fed the settlements and supported their agrarian practices. This historic water system is still active in many places.

Hampi's civil architecture can be observed in the ruins of its palaces and related spaces within the citadel area and all its superstructures. These were mostly wooden and one can see merely the remains of plinths or fragments of walls now. Primary structures within the citadel include Mahanavami Dibba, a 12-metre-high stone plinth, with an elaborate flight of steps, and plinth walls decorated with animal friezes, street scenes and dancing figures. Some of the carved figures—which include people of possible Chinese origin with long braided hair, and animals like the camel—indicate flourishing trade contacts. The citadel area had other noticeable structures, such as the king's palace, audience hall and stables. The walled

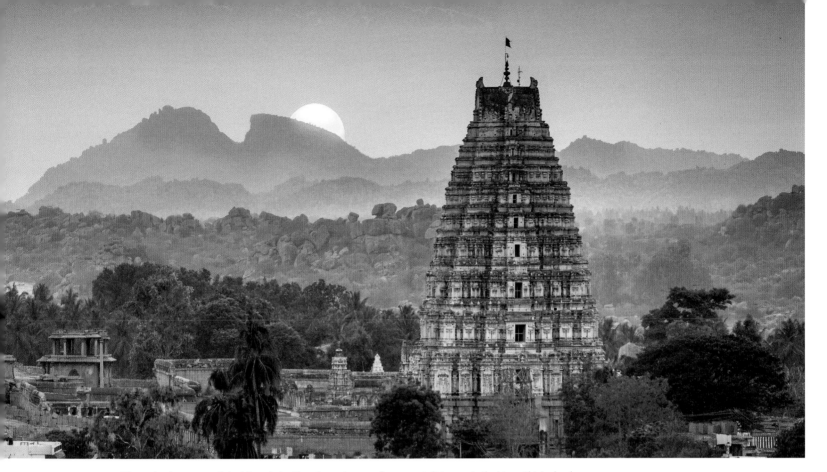

The majestic *gopura* of the Virupaksha Temple can be seen from great distances in the Hampi hinterland.

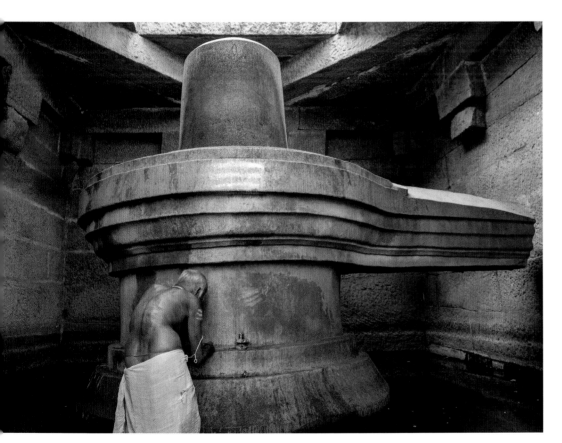

A priest cleans the Shiva *linga* in the historic Badavilinga Temple. The three whitish lines visible on the *linga* represent the three eyes of Shiva.

profusion of sculptural embellishments on the elevations of the *gopura* or temple *shikhara*, as well as the columns, ceilings and walls of the temple. Granite is the most common building material for the bases of the temple structures while the upper portions of the *gopura* are made of brick, with stucco figures decorating the elevations. The most prominent examples are the architecturally and artistically exquisite temples of Virupaksha, Vitthala, Achyutraya, Krishna and Hazara Rama. The Vitthala temple complex is noticeable for two features: the magnificently carved *ratha* within the complex and its musical columns, a set of pillars that produce a melodious sound when struck.

This World Heritage Site is managed by a special authority, the Hampi World Heritage Management Authority, recognised under a special act. •

Janhwij Sharma

zenana enclosure, a space exclusively for royal ladies, comprises the Lotus Mahal, with prominent stucco arches, two watchtowers and a water pavilion.

The temple forms at Hampi largely borrowed elements from later Chalukyan temple styles, although they evolved into a distinct style of their own. There is a

95

Creators of A Syncretic Legacy
Monuments, Mausoleums, Forts and Cities

Amita Baig, Shikha Jain and Jyoti Pandey Sharma

"Indo-Islamic art was neither merely a local variety of Islamic art nor a modified form of Hindu architecture. It derives its character from both sources though not always in an equal degree."

—Sir John Marshall, "The Monuments of Muslim India",
in *The Cambridge History of India*, Vol. III, 1922

While temple building flourished in southern and central India and reached its peak in the tenth century, a parallel development was taking place in western India, largely in the present-day states of Rajasthan and Gujarat, with the rise of the Maru-Gurjara style. Just before the fusion of architectural styles with the advent of Islam, the initial phase of the twelfth century is etched by masterpieces such as Rani-ki-Vav, or the Queen's Stepwell, a subterranean architectural typology of the stepwell inscribed on the World Heritage List for its excellence in Indian artisanship of this period.

The coming of Islam to the Indian subcontinent in the late twelfth century, when Muslim invaders began to settle in the region rather than plundering wealth and returning home, introduced novel forms of architectural expressions to the region. This corpus predominantly included syncretic built-form types, blending with the existing indigenous ones of local Hindu rulers in the construction of forts, cities and stepwells, along with new typologies of *masjid* (mosque), *makbara* (mausoleum), *madarsa* (school), *serai* (guesthouse), *qila* (fort) and *bagh* (garden).

It also introduced new architectural elements such as the arch, dome, minaret, squinch and pendentives as well as non-figural ornamentation in keeping with the tenets of Islam, including calligraphy, arabesque and geometric patterns. These were distinctly apart from the temple-type beam-column constructions

of earlier periods. The foreign built-forms and their concomitant building practices encountered the Indian subcontinent's robust indigenous building tradition that went back centuries. This encounter between two disparate building cultures led to the flowering of an architectural style that has popularly been referred to as Indo-Islamic architecture. Indeed, the term encapsulates the two major cultural traditions that define it, one being determined by the Muslim faith and the other by the place of its evolution and subsequent refinement, i.e. the Indian subcontinent following the introduction of Islam to the region. Thus, Indo-Islamic architecture on the one hand embodies influences from regions where Islam originated and flourished, such as Central Asia, Persia and Turkey, and on the other represents the regional diversity of building expression from across the Indian subcontinent where Islam found a home. This architectural style is broadly categorised by most historians into two distinct phases, the Sultanate period and the Mughal period.

The Sultanate period marks the beginning of the Indo-Islamic architectural style, following the establishment of the rule of successive Muslim dynasties in different parts of the subcontinent, such as Bengal, the Deccan, Delhi, Gujarat, Kashmir and Malwa. This style therefore acquired a regional character courtesy of the Indian artisans who executed the building works. Furthermore, as the artisans built novel architectural elements such as arches, domes and minarets for the first time, they

relied on experimentation to realise the patron's vision. This resulted in a rudimentary execution of these forms that was refined with the passage of time. Clearly, the patrons of buildings, particularly the ruling Muslim powers, were aware of these influences and did not reject them. Even as their only stipulation entailed strict compliance with the tenets of Islam for the design of the *masjid*, the earliest mosques in many regions were in fact built by reassembling the architectural components of pre-existing structures. In the context of surface decoration, the two traditions were a case of contrasts, as Islam forbade figural representations of animate beings and relied on a somewhat restrained, flat, two-dimensional surface-patterning approach, while the Indian tradition, on the other hand, was exuberant, sculptural and used a lot of figural representations. The Sultanate period produced a large corpus of built-forms, including forts, palaces, gardens and tombs, and later included mosques, institutions of learning, rest houses, tanks, reservoirs and canals.

There are three World Heritage Sites in India that bear testimony to the important cultural exchange, urban planning and architectural developments in

the Sultanate period. These are the Qutb Minar and its monuments, attributed to the Delhi Sultanate; the multicultural city of Ahmedabad, or Ahmadabad, established in the fifteenth century; and the archaeological park of Champaner-Pavagadh, which includes an earlier Hindu fort-town and a sixteenth-century Islamic city patronised by the Gujarat Sultanate.

Mughal architecture began with the patronage of the Mughal dynasty's founder, Babur, in the sixteenth century and pinnacled with the works of Shahjahan in the seventeenth century, following which it began to decline in the eighteenth century as the dynasty weakened. Building patronage was imperial and sub-imperial in nature, with architectural creations across the empire that demonstrated a refinement from the Sultanate-era buildings in terms of design, execution, construction systems and material usage. Two Mughal *badshah*s, or emperors, can be singled out for their interest in architecture, i.e. Akbar and Shahjahan. The former can be credited with laying the foundation of the Mughal architectural style and the latter for taking it to its zenith of refinement. The former's patronage can be identified through the robustness and solidity that results from the extensive usage of red sandstone as construction material.

The Humayun's Tomb complex, just before Akbar's phase of construction, brings forth two important aspects. Firstly, it shows how role models from Persia, such as the monumental Tomb Garden complex, with all its intricate artwork, were transported to India by engaging a Persian architect to introduce new typologies. Secondly, it reflects the role of women, with Humayun's wife as the patron of his tomb complex, in a case similar to the Rani-ki-Vav stepwell, commissioned by Rani Udaymati in memory of her departed husband.

Akbar's patronage demonstrated influences from several regional styles as artisans from across the Mughal Empire were engaged in architectural works, be it his capital, Fatehpur Sikri, with its assortment of buildings, or other structures like *qila*s, *masjid*s, *makbara*s and *bagh*s.

"The Taj Mahal at Agra", an engraving by Thomas Daniell, made at the turn of the nineteenth century.

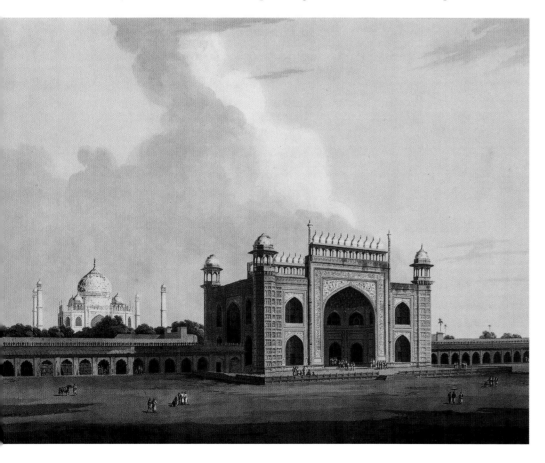

Shahjahan's architectural patronage was centred on opulence, with the usage of white marble sourced from Makrana forming its defining characteristic. His architectural enterprise moved away from Akbar's legacy of robustness towards delicacy and visual weightlessness, attained through the use of marble and rich ornamentation, in particular carving and *parchin kari* (*pietra dure*) with precious and semi-precious stones. Further, Shahjahan's penchant for building, coupled with a heightened awareness of the role architecture played as a marker of dynastic identity, resulted in the appropriation of certain design elements exclusively for imperial use. These included the baluster column with semi-circular arch and *bangladaar* roof (adapted roof form from vernacular Bengali houses) finished in white marble, or in highly polished white-lime stucco that emulated marble. Shahjahan's architectural patronage comprised, among others, the building of a capital city, Shahjahanabad (Old Delhi); forts, such as those at Agra, Lahore and Shahjahanabad; mosques, including Shahjahanabad's Jami Masjid; tombs, such as the Taj Mahal; and pleasure gardens based on the Persian *charbagh* archetype, especially those in Kashmir and Lahore (in Pakistan).

Beyond the Sultanate and Mughal styles, there is space for the distinct regional idioms that surfaced in various princely states in Rajasthan and Madhya Pradesh, where primarily Hindu rulers aspired to create their own architectural legacy that borrowed from the Mughal imperial style yet tried to retain its indigenous flavour. Rajput rulers were clearly at the forefront in this endeavour, as is exemplified by the Hill Forts of Rajasthan; Ranthambore, Gagron, Amber and Jaisalmer forts show elements of Islamic vocabulary, while Chittorgarh and Kumbhalgarh retain their original Hindu features intact. These forts were important witnesses to the battles and sieges between local Rajput rulers and the Sultanate and Mughal invaders, and record significant military attributes that evolved in fort architecture of that period as a result.

An attempt to go beyond simple emulation of the Mughals is well evidenced in the architecture of Amber and Jaipur, the two capitals of the princely state of

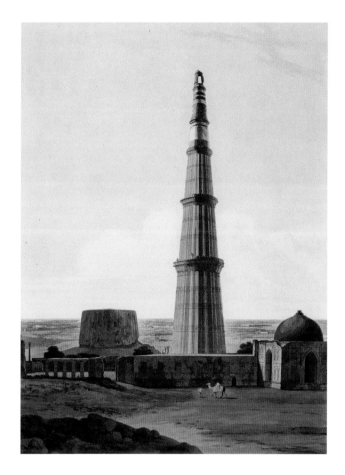

Dhoondhar. While the Amber palace exhibits a most innovative adaptation of the symmetrical Mughal palace plan, stretched on multiple levels in the hilly terrain of the Amber Fort, with exquisite artwork and gardens, the city of Jaipur is an exemplar of an extraordinary plan and monumental grandeur deriving from an intermingling of various cultures. Though serving as commanders to the Mughal emperors, the architectural legacy of these Rajput rulers is a subtle expression of their defiance of imperial power. The unique observatory at the Jantar Mantar in the centre of Jaipur clearly shows the visionary reach and global outlook of these princely states.

The buildings of this period became recipients of conservation measures during the colonial period, with Viceroy Curzon's obsession with Mughal historic sites being legendary. A large part of the corpus of these buildings continues to survive to the present day, with several historic sites being recognised as monuments of national significance, while a few more, such as Orchha in Madhya Pradesh, aim to be on the World Heritage List in the future. ◆

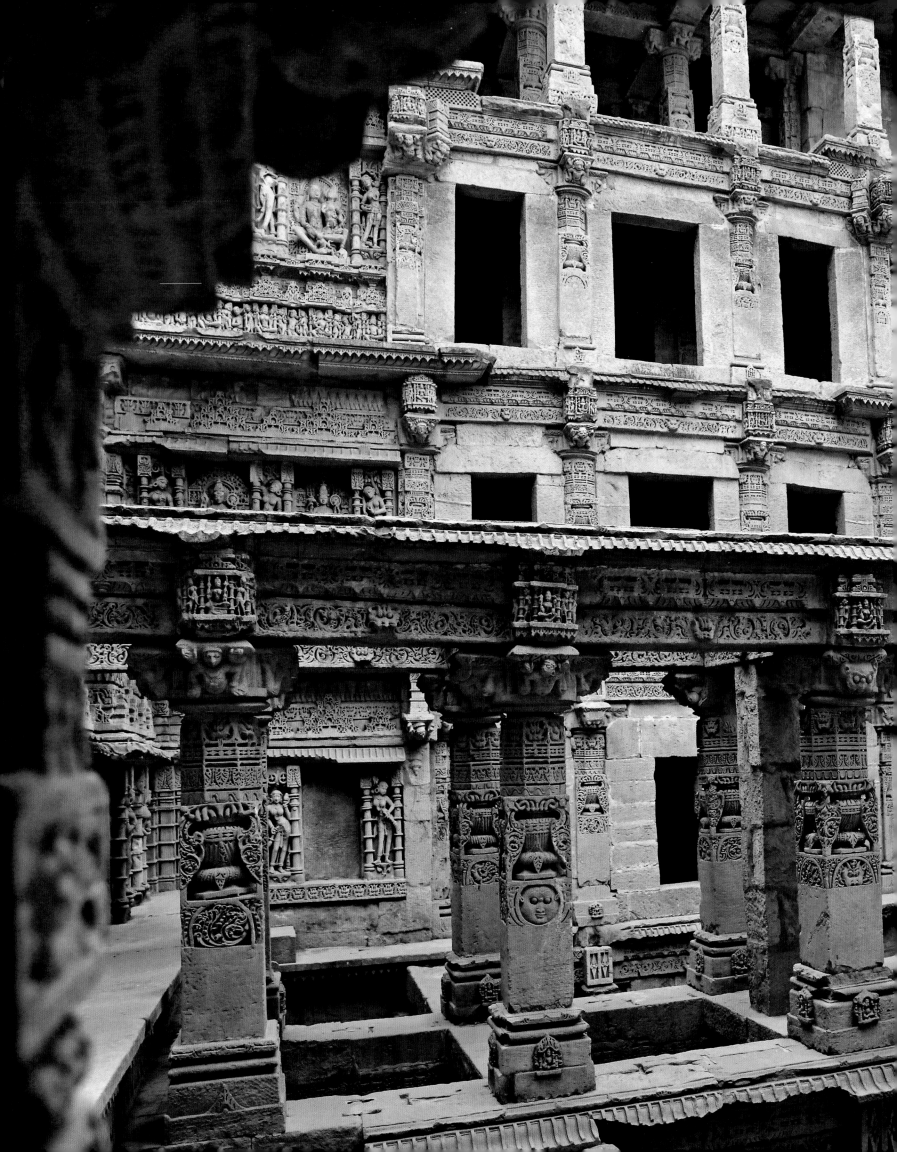

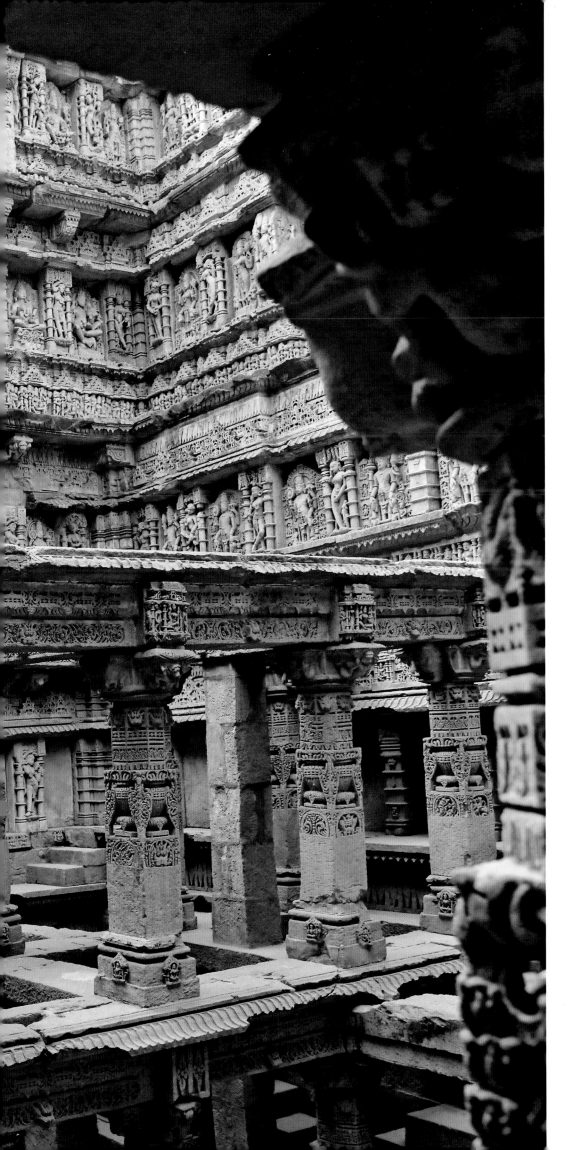

Rani-ki-Vav
(the Queen's Stepwell)
at Patan, Gujarat

LOCATION: Gujarat, India

COORDINATES: N23 51 32 E72 6 6

DATE OF INSCRIPTION: 2014

CATEGORY: Cultural (Monument)

OUTSTANDING UNIVERSAL VALUE

The Rani-ki-Vav is an exceptional example of the stepwell, a distinctive form of subterranean water architecture of the Indian subcontinent. It is divided into seven levels of stairs and sculptural panels of high artistic and aesthetic quality. It combines all of the principal components of a stepwell, including a stepped corridor beginning at ground level, a series of four pavilions with an increasing number of storeys towards the west, a tank and the well in tunnel shaft form.

CRITERIA: (i) (iv)

(i): It is an example of the artistic and technological height of the stepwell tradition, illustrating a true mastery of artisanship and figurative expression.

(iv): It represents a prime example of an architectural type of water resource and storage system; its functional aspects have been combined with a temple-like structure, celebrating the sanctity of water as a venerated natural element.

The sculptured panels adorning the walls of Rani-ki-Vav, as seen through pillared frames from the seventh and last level of stairs as one moves down the stepwell.

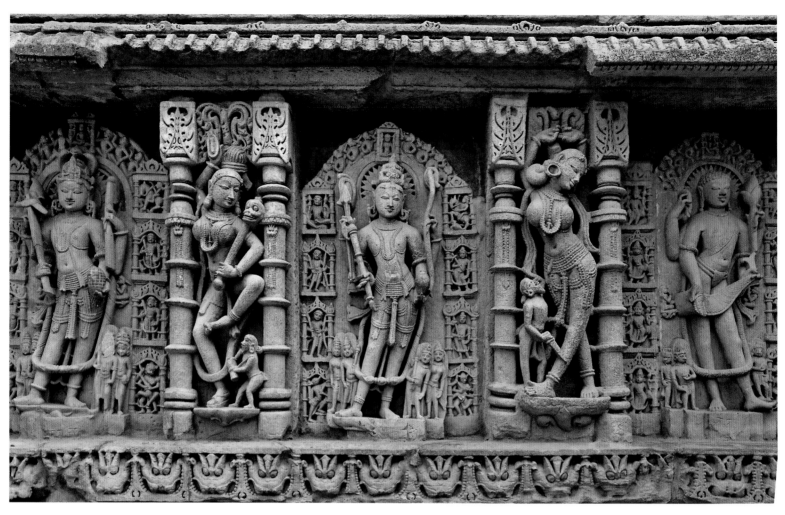

Sculptural panel showing three of the ten *avatars* (manifestations) of Lord Vishnu, punctuated by carved piers with *sursundaris* in different postures.

Stepwells are a ubiquitous feature of central and western India, given the dry and warm climate with low and often erratic rainfall. Stepwells conserved water and were sometimes imbued with religious and cultural symbolism as showpieces for sculptural and architectural innovation. Water being a sacred element in Indian society, the stepwell (called *vav* or *baoli*) is an important typology of traditional Indian architecture, found in abundance in the arid and semi-arid zones of the country.

The Rani-ki-Vav is popularly called "the Taj of Stepwells" since it surpasses any other stepwell in terms of beauty and ornate sculptures, a fact well recognised by UNESCO while inscribing it on the World Heritage List as a "masterpiece

of human genius". It was constructed by Queen Udaymati in memory of her husband, the Solanki king Bhimdev I, at Patan in present-day Gujarat, much before Shahjahan built the Taj Mahal as a symbol of love on Indian land. She commissioned the well in the last decade of the eleventh century, after his death in 1064 CE.

This stepwell originally had seven storeys, interjected by colonnaded pavilions at each level, followed by a descending row of steps and terminating in the rounded portion at the bottom of the well, which was the source of water. This subterranean architecture is often interpreted as an inverted temple form, considering the reverence for water in Hindu culture, besides its utilitarian features. This aspect

seems obvious with the number of Hindu gods depicted in the sculptural artwork of the Rani-ki-Vav.

Its most unique feature are the extraordinary sculptures (more than 700) that decorate not only its sides but also the curves of the rounded structure at the end of the well area. The iconography covers an interesting mix of Hindu gods in various forms, besides *sursundaris* (celestial female beauties) in a wide range of postures. Scholarly interpretation of these forms indicates these are sculptures of Hindu gods such as Vishnu, Shiva, Brahma and others. The stepwell also has more than fifteen sculptures of Goddess Parvati (wife of Shiva), depicting the story of her penance upon her separation from

Shiva, linking it to Queen Udaymati's grief for her departed husband and her yearning for a reunion. It is also noted that the junctions of walls and pavilions at every level are selectively adorned by placing sculptures of gods in pairs or divine couples such as Hari Hara. The sculptures at the culminating rounded portion of the well incorporate the interesting Hindu story of the eight Vasus (sons of the Ganges). These sculptures are strategically located at the bottom level of the well in postures that depict worship of the well water, symbolising that this water is as sacred as the Ganges itself.

The Rani-ki-Vav currently holds no water. Its fascinating story of discovery shows that the entire structure lay buried beneath sand silt deposits, due to flooding by the Saraswati River in the thirteenth century, until its excavation by the ASI the 1960s. Its meticulous restoration by ASI took over two decades and is accepted as an exemplary case of excavation and preservation of this monument that stands as a testimony to the water architecture of India. Its buffer zone covers the adjoining archaeological remains of the Sahastralinga reservoir that was built some years before the Rani-ki-Vav and possibly had links with its water table. ●

Shikha Jain

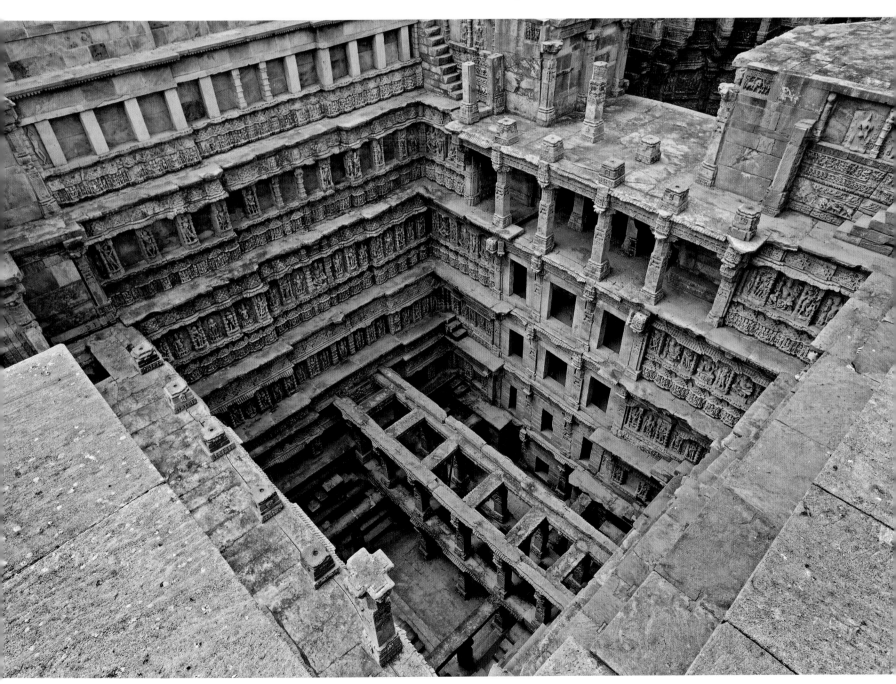

An aerial view of the Rani-ki-Vav, showing the complexity of the multi-level structure adjunct to the apsidal well, with colonnades and extensive carvings on the walls.

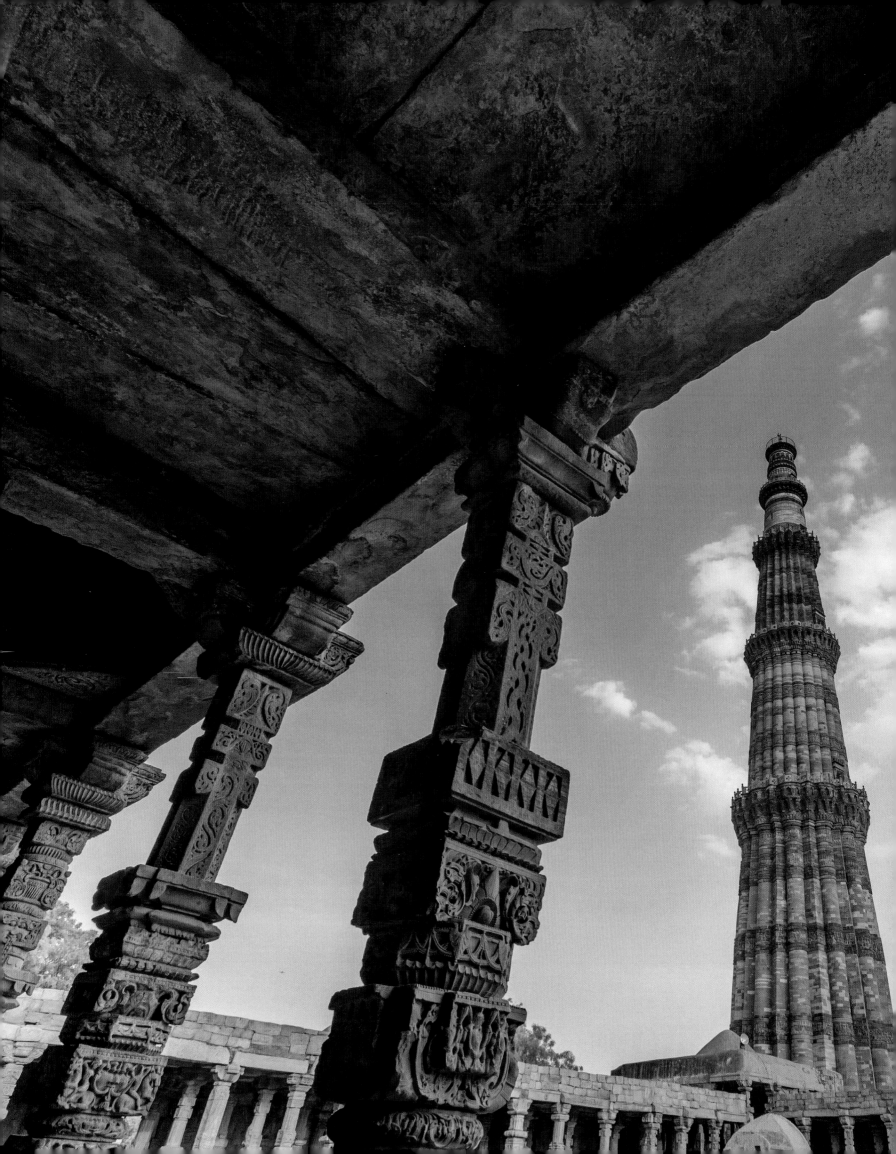

Qutb Minar and Its Monuments, Delhi

LOCATION: New Delhi, India

COORDINATES: N28 31 32.988 E77 11 7.008

DATE OF INSCRIPTION: 1993

CATEGORY: Cultural (Monument)

OUTSTANDING UNIVERSAL VALUE

Built in the early thirteenth century, the red sandstone tower of the Qutb Minar is 72.5 metres high, with alternating angular and rounded flutings. The surrounding archaeological area contains funerary buildings, notably the magnificent Alai Darwaza gate, and two mosques, including the Quwwat ul-Islam, the oldest in northern India, built of materials reused from pre-existing structures. The rust-free Iron Pillar is standing testimony to the metallurgical skill of ancient Indians.

CRITERIA: (iv)

(iv): The religious and funerary buildings in the Qutb Minar complex represent an outstanding example of the architectural and artistic achievements of early Islamic India.

[Source: Advisory Body Evaluation (ICOMOS) 1993, (file 233-ICOMOS-259-en.pdf)]

The Qutb Minar as seen from within the cloister of the adjoining Quwwat ul-Islam mosque.

For eight centuries, the Qutb Minar has stood tall above the landscape of Delhi. It bears the name of Qutb al-Din Aybak, the founder of the Mamluk dynasty in India, the first of five successive yet distinctive ruling houses of Delhi and its environs that expanded eastwards and south from their capital. Despite ruling for less than two and a half centuries, their contributions were unique and their impact endured long after their reign. The names roll off the tongue—the Mamluks, Khaljis, Tughlaqs, Sayyids and the Lodis, a quintet known to historians as the Delhi Sultanate.

Visible from afar, this 73-metre free-standing minaret is the tallest brick minaret in the world. It is a part of a complex of mosques, ceremonial entrance gates, tombs, *dargah*s (mosques), a serai, water reservoirs and retreats. The complex was enlarged as successive dynasties added buildings and initiated the beginnings of what would evolve as a synthesis of diverse architectural and cultural perspectives.

The minaret itself tapers upwards with its five-tiered balconies in red sandstone. By the thirteenth century, Iltutmish had added three tiers, each in a style different from the first one started by Qutb al-Din Aybak. The fifth tier, decorated with rounded flanges, was added later by Firuz Shah Tughlaq in the fourteenth century. While the Minar bears similarity to the Minar in Jam, Afghanistan, the surrounding buildings reflect a similar mix of Indian and foreign elements. The adjunct mosque, Quwwat ul-Islam, for example, was based on the established sanctuary-courtyard-cloister spatial archetype, and was raised by reassembling columns and beams of pre-existing structures to form the cloister. The sanctuary, whose screen alone survives today, was an entirely new

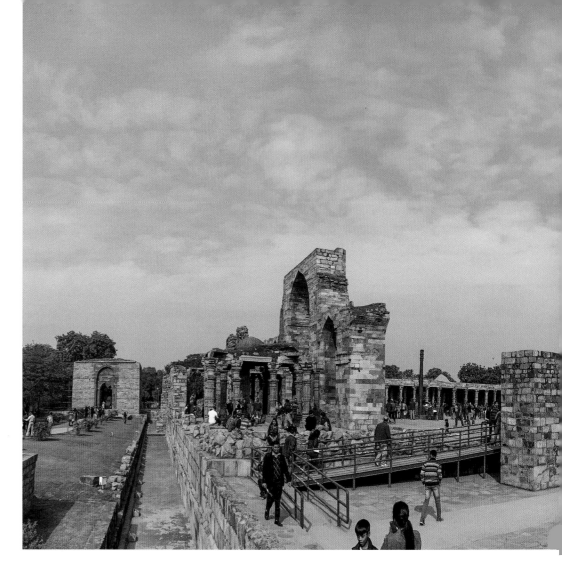

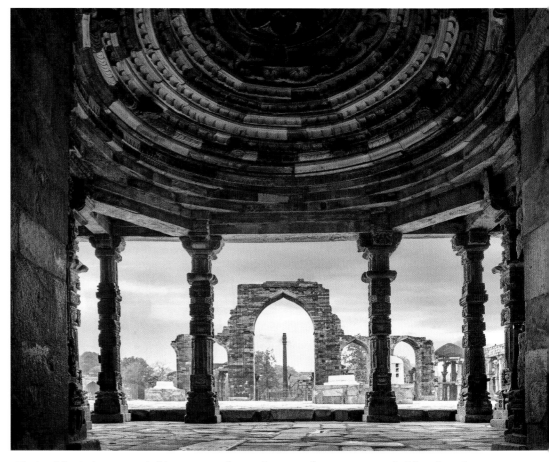

The Iron Pillar, in the courtyard of the mosque, is famous for its metallic composition, which has allowed it to resist rust and corrosion through the centuries.

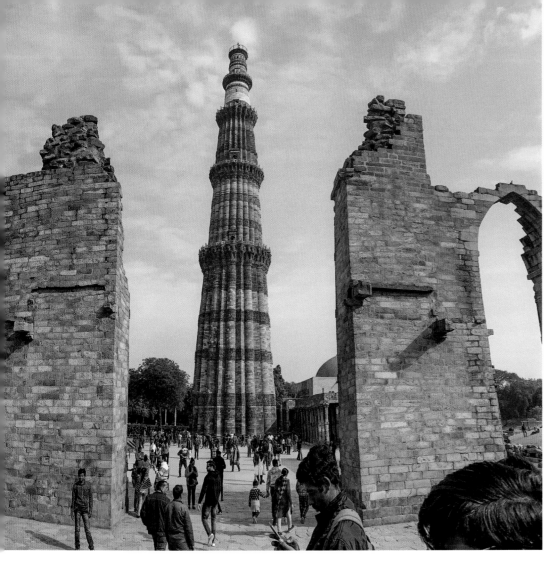

LEFT: The Qutb Minar is believed to have been inspired by the minaret of Jam in Afghanistan, also a UNESCO World Heritage Site, with which it has many features in common, such as an extensive surface ornamentation.

conception. Architectural styles from minarets in Afghanistan, Iran and Central Asia were beautifully translated by local craftspeople on Indian soil, laying the foundation for a long association between indigenous and foreign building traditions that defined Indo-Islamic architecture. The design and execution of the mosque and Minar demonstrated the exuberance of Indian styles and the restraint of Islamic traditions.

The later Mughals, constrained by territory and resources and confined to the vicinity of Delhi, turned to Mehrauli as a leisure retreat. Subsequently, British administrators and military men took to picnicking in the Qutb complex. In the 1820s, a Major Robert Smith repaired the Minar, damaged due to lightning and an earthquake in 1803, and added a Gothic-style balustrade topped with a red sandstone *chhatri* (cupola) of his own creation. The cupola was removed in the early twentieth century and placed beside the Minar as a monument called Major Smith's Folly. The mosque's cloister was subsequently repaired in preparation for the 1911–12 Delhi Durbar.

Since then, the ASI and the Delhi Government have cared for the Qutb complex—which forms a part of a larger historical precinct known as the Mehrauli Archaeological Park—and protected and restored its structures to their former glory. It is among the most visited of UNESCO's World Heritage Sites in India. •

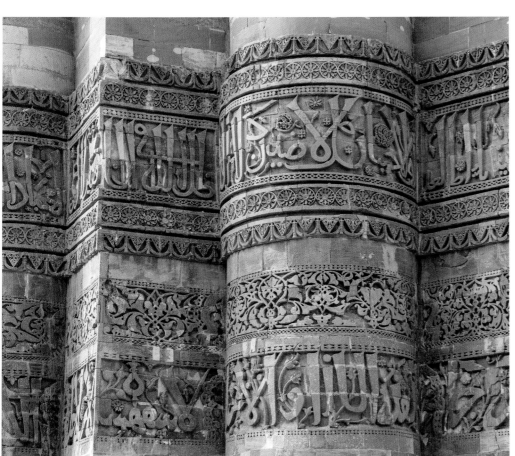

Calligraphic panels provide surface ornamentation on the Minar.

Jyoti Pandey Sharma

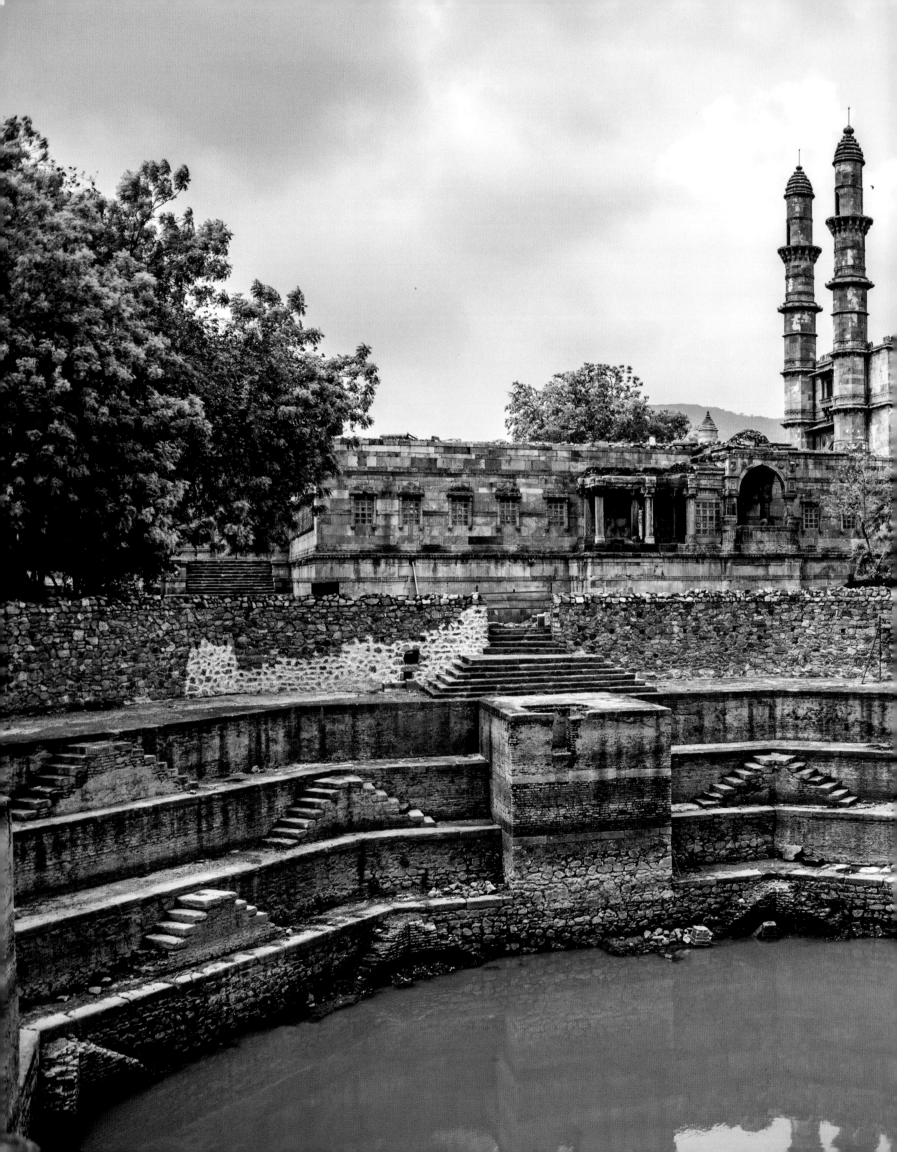

Champaner–Pavagadh
Archaeological Park

LOCATION: Gujarat, India

COORDINATES: N22 28 60 E73 31 60

DATE OF INSCRIPTION: 2004

CATEGORY: Cultural (Site)

OUTSTANDING UNIVERSAL VALUE

The site is a concentration of largely unexcavated archaeological, historic and living cultural heritage properties, including prehistoric (Chalcolithic) sites, a hill fortress of an early Hindu capital, and remains of the sixteenth-century capital built by Mehmud Begada. The site also includes fortifications, palaces, religious buildings, residential precincts, agricultural structures and water installations from the eighth to the fourteenth century. The Kalikamata Temple on the Pavagadh hill is an important shrine and attracts large numbers of pilgrims throughout the year.

CRITERIA: (iii) (iv) (v) (vi)

(iii): The site—with its ancient Hindu and Islamic religious, military and agricultural structures—represents cultures that have disappeared.

(iv): The structures represent a perfect blend of Hindu-Muslim architecture.

(v): It is an outstanding example of a very small living capital city, making the best use of its setting, topography and natural features.

(vi): It is a place of worship and continuous pilgrimage for Hindu believers.

The Jami Masjid, also known as Jama Masjid, in Champaner, lies behind an octagonal stepwell, one of the largest in a complex water harvesting and management system.

The Champaner-Pavagadh Archaeological Park comprises a fascinating, secluded series of forts enclosing cities, water systems and royal and sacred structures, at the base of the Pavagadh hill in the state of Gujarat. Champaner is a historical Islamic city at the foot of the Pavagadh hill. In the thirteenth century, the Khichi Chauhans established their capital at Champaner-Pavagadh for a short period before it was conquered by Mahmud Begada in 1484.

The Pavagadh hill is the highest point on site at a height of 2,400 feet, surrounded by several smaller hillocks. High escarpments to the west and south render it virtually impenetrable. Within this area there are clear demarcations: a military zone and a civic one, the latter having clearly defined recreational, commercial and sacred areas. The outstanding feature are the layers of fortifications, each reinforced with bastions and gateways. The outer walls of the fort have provision for canons and other

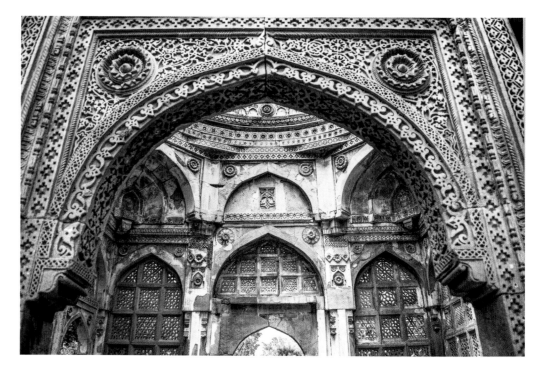

medieval military machinery. Guarded by barbicans and catapult stands, these walls are so wide that the army could move along them with ease. At the next level is the *atak* fortification, most noteworthy for its exceptional catapult frames—a series of huge trapezoidal structures called *manjanik* or *makaryantra*. The fortifications of

Pavagadh facilitate a panoramic view from where the approaching enemy could easily be sighted. In the event of an attack there were, in effect, three levels of military installations to be navigated.

The Champaner-Pavagadh site is distinguished by highly sophisticated

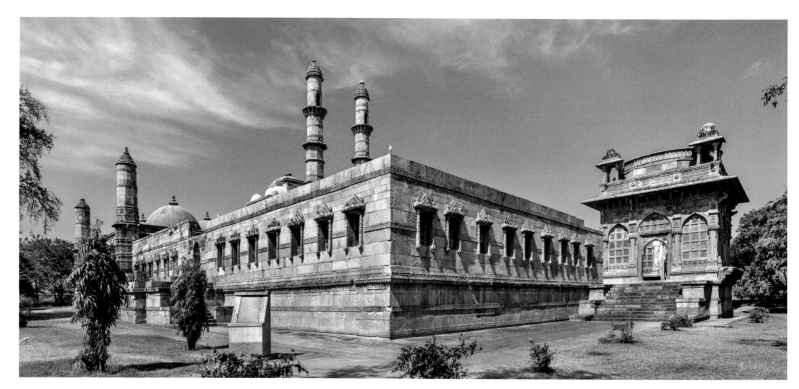

The Jami Masjid has a single dome, flanked by two minarets and no less than seven *mihrab*s (niches in the wall of a mosque indicating the direction of Mecca). Its intricate carving showcases a synthesis of Hindu and Islamic art and architecture.

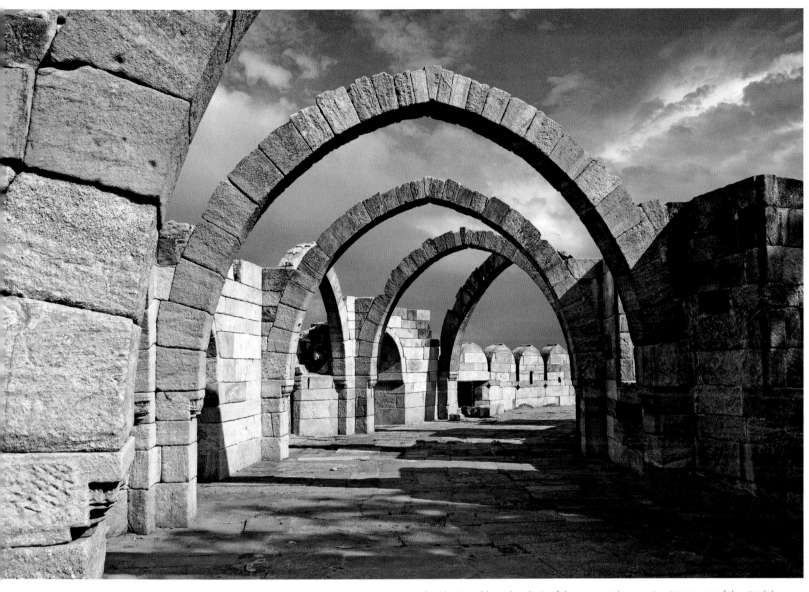

FACING PAGE TOP AND ABOVE: Saat Kamaan, or Seven Arches, is a prominent structure within the site, although only six of the seven arches survive. It was part of the citadel of Mahmud Begada, who also built the Kevda Masjid (facing page, top), which showcases exceptional carving and embellishment.

water-harvesting schemes, with *baoli*s, or tanks, which were often connected to underground channels and served a very large population of civil and military residents, as well as the royal enclosures. The survival of a fort depended on a secure water supply; this site has a complex network that utilises the contours of the land to harness its resources. The value ascribed to this is evident from the names: Ganga, Yamuna and Saraswati *kund*s (water tanks), each one a unique architectural gem. Of particular importance is the *patha* (sacred route) to the Kalikamata Temple, a major pilgrimage destination at the summit of the Pavagadh hill. It is the spine of the Champaner-Pavagadh site, trodden for centuries by devotees and much of it still paved with the original stone.

At the foothills of Pavagadh lies the royal enclosure, Hissar-i-Khas—an oblong quadrangle fortified by high stone walls, with towers at regular intervals—and the Jahanpanah, with gardens and *hamam*s (bath houses) attached to the *zenana*, with a mosque for the royal family. Beyond is the prosperous city of Champaner and agricultural fields. Visible in Champaner's royal and sacred architecture is a new vocabulary, heralded by Mahmud Begada, a prolific builder. This new style was deeply embedded in the great tradition of Gujarati artisanship, and would substantively influence the development of Indo-Islamic architecture in India. The site was abandoned in the sixteenth century and is believed to be the only complete and unchanged pre-Mughal Islamic city, even though much of it is yet to be excavated.

The site is managed by the ASI via a Site Management Plan that was prepared in 2012. •

Amita Baig

Historic City of
Ahmadabad

LOCATION: Gujarat, India

COORDINATES: N23 1 35 E72 35 17

DATE OF INSCRIPTION: 2017

CATEGORY: Cultural (Historic City)

OUTSTANDING UNIVERSAL VALUE

The walled city of Ahmadabad, or Ahmedabad, founded by Sultan Ahmad Shah, presents a rich architectural heritage from the Sultanate period as well as important Hindu and Jain temples of later periods. The urban fabric is made up of densely packed traditional houses in gated traditional streets with characteristic features. Its religious symbolism expressed through wood carvings and canonical bearings is an ingenious example of habitat. The city has continued to flourish as the capital of the state of Gujarat for six centuries, up to the present.

CRITERIA: (ii) (v)

(ii): The historic architecture of the city exhibited an important interchange of human values, reflecting the culture of the ruling migrant communities and overseeing the growth of an unparalleled regional architectural expression.

(v): The city's settlement planning is representative of local wisdom and a sense of strong community bonding, with self-sufficient residential units, making it an outstanding example of human habitation.

The Bhadra Fort in Ahmedabad, which has seen the reign of the Sultanates, the Mughals, the Marathas and the British. Today, it houses government offices, including an ASI office.

A traditional house in Ahmedabad displays the beautiful wooden detailing that is typical of Gujarati artisanship.

The city of Ahmadabad, or Ahmedabad, was founded by Sultan Ahmad Shah in 1411 on the banks of River Sabarmati to serve as his capital. It was built on the site of a former capital, Ashaval, of the Solanki rulers in the eleventh century. Ahmedabad has an uninterrupted history as an urban centre since the fifteenth century, ruled successively by the Delhi and Gujarat Sultanates, Mughals, Marathas and the British. Its chequered past, coupled with architectural patronage, has resulted in a wide variety of built-form expressions in its urban fabric from the pre-Sultanate era onwards. The city's urban morphology

continues to carry a strong imprint of its rich past, reflected in its urban elements, notably the traditional residential neighbourhood, i.e. the *pol*. The *pol* has a humane street network and infill of residential buildings, from the modest house to the *haveli* (opulent mansion), besides elements of public architecture, characterised by a gate, shrine, *chabutaro* (bird feeder), well and toilets. Further, the city has a rich corpus of imperial and sub-imperial buildings, like the Bhadra Fort, tombs, mosques and temples. The city's built environment exhibits an architectural syncretism where buildings

associated with Muslim rulers were built by indigenous craftspeople, who employed their own cultural traits while respecting the sensibilities of their rulers.

The architectural pluralism that defines the city has been recorded by many in the past, such as James Fergusson stating that in Ahmedabad "the Hindu influence continued to be felt throughout. Even the mosques are Hindu, or rather Jaina, in every detail." Likewise, John Murray's popular travel guidebook described the city as ranking "next to Delhi and Agra for the beauty and extent of its architectural

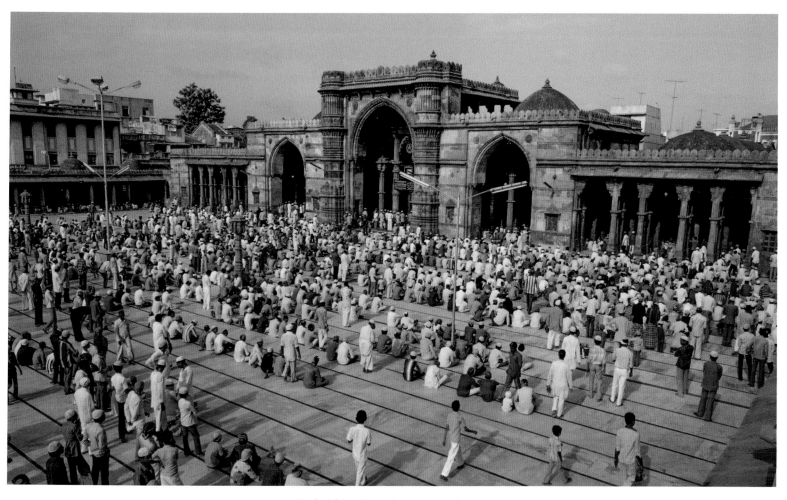

The faithful gather at the Jama Masjid to pray.

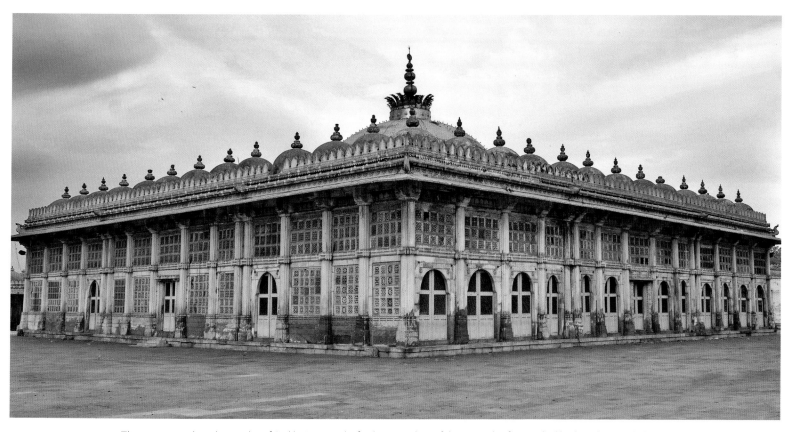

The mosque and tomb complex of Sarkhej Roza is the final resting place of the revered Sufi saint Shaikh Ahmed Ganj Baksh, who
is said to have inspired Ahmad Shah to establish his capital city, Ahmadabad (or Ahmedabad).

remains. Its architecture is an interesting and striking example of the combination of Hindu and Mohammedan forms." The guidebook particularly described the city's utilitarian structures, i.e. its *baoli*s, and *chabutaro*s, or "Jaina feeding-places for birds" that were to be found "in many of the streets".

Ahmedabad initiated an urban heritage conservation programme that went beyond protected monuments to include the city's modest buildings and urban infrastructure. The city's municipal corporation constituted a Heritage Cell in 1996 to undertake this initiative with community participation, which included inventorying the heritage, undertaking heritage walks and repairing historic buildings and structures. It also resulted in formulating Heritage Regulations for the historic city that required permissions for demolition, alteration and repair of the buildings. The city's conservation initiative has been listed as a case of good practice in urban heritage conservation by the National Institute of Urban Affairs in the category "Institutional Infrastructure for Urban Heritage". At present, a comprehensive Heritage Management Plan for the walled city is under preparation by the Ahmedabad Municipal Corporation. ●

Jyoti Pandey Sharma

One of the most famous symbols of the city is this intricate *jaali* (carved screen) of the Sidi Saiyyed mosque, which features the Tree of Life motif.

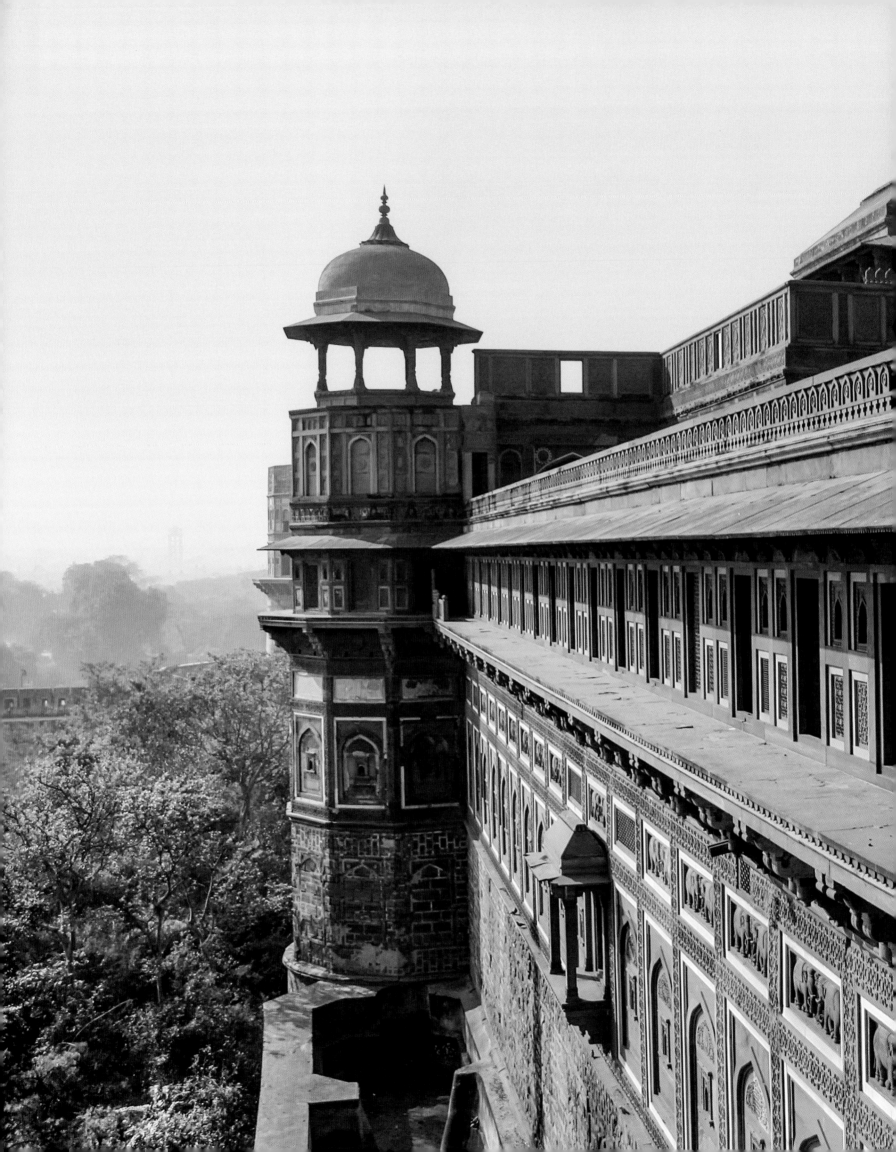

Agra Fort

LOCATION: Uttar Pradesh, India

COORDINATES: N27 10 47.302 E78 1 17.501

DATE OF INSCRIPTION: 1983

CATEGORY: Cultural (Monument)

OUTSTANDING UNIVERSAL VALUE

The Red Fort of Agra is a powerful sixteenth-century fortress founded by Emperor Akbar on the right bank of the Yamuna river. It is sited today on the northwest extremity of the Shahjahan Gardens, which surround the Taj Mahal, and forms, with them, an evident monumental unity. This fortress of red sandstone encompasses, within its 2.5-kilometres-long enclosure walls, the imperial city of the Mughal rulers. It comprises many fairy-tale palaces, such as the Jahangir Palace and the Khas Mahal, built by Shahjahan; audience halls, such as the Diwan-i-Khas; and two very beautiful mosques. All of these monuments mark the apogee of Indo-Muslim art, strongly marked by influences from Persia, which already manifested itself in Timurid art.

CRITERIA: (iii)

(iii): The Agra Fort is significant for the Mughal rule of the seventeenth century and may not be artificially dissociated from the Taj Mahal, despite the commemorative nature of the latter. In addition, the Agra Fort bears an exceptional and complementary testimony to a civilisation that has since disappeared, that of the Mughal emperors.

The Jahangiri Mahal at the Agra Fort was completely rebuilt by Akbar to celebrate the birth of his firstborn son.

Initially built as a mud fort along the Yamuna by the Chauhan Rajputs, the Agra Fort has seen successive dynasties and powerful rulers, including all of the six great Mughals who lived there for varying periods of time. In its 1,300 years of existence, the Agra Fort has been witness to turbulent times, pomp, intrigue and extravagance, as well as some irony. However, the existing architectural grandeur of this fort can be attributed to a span of seventy years, reflecting the collective wisdom of three of the six Mughals—Akbar, Jahangir and Shahjahan—who built this majestic fort and embellished it with elaborate palace spaces.

It was during the reign of Akbar in the 1560s that this fort was rebuilt for military purposes. The fortifications, 70 feet high, were completed in 1562 and dominated the countryside. It was a fort and stronghold, always ready for war. When the gates were thrown open and the Mughal army sallied forth, conches blew and flags and pennants flew. It was a magnificent sight and spectacle, designed to intimidate.

The Agra Fort has monumental gateways, *burj*s (bastions), palaces and durbar halls. Inside its austere red sandstone walls was a pulsating city with people, markets, leafy avenues and large open spaces. The stables housed elephants, 6,000 of them, and horsed cavalry. The Agra Fort also marks the beginning of the synthesis of Rajput and Timurid architecture. There are long halls, arched recesses, pavilions and courtyards carved with Islamic and Hindu motifs— "five hundred buildings in the wonderful designs of Bengal and Gujarat", as recorded by Abul Fazl, Akbar's court historian. The Jahangiri Mahal, built for Akbar's Rajput wife, showcases the amalgam of Central Asian arches and intricate Rajput carving.

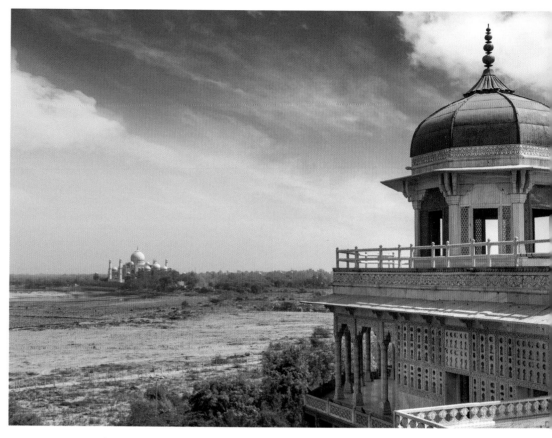

A much-romanticised view of the distant Taj Mahal, as probably was visible to Shahjahan from Mussaman Burj, where he spent his last days as a captive of his son.

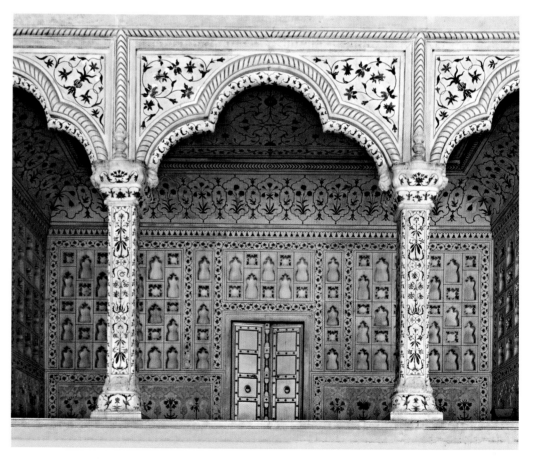

Shahjahani architecture is characterised by the introduction of richly decorated palaces with the extensive use of marble inlay and carvings.

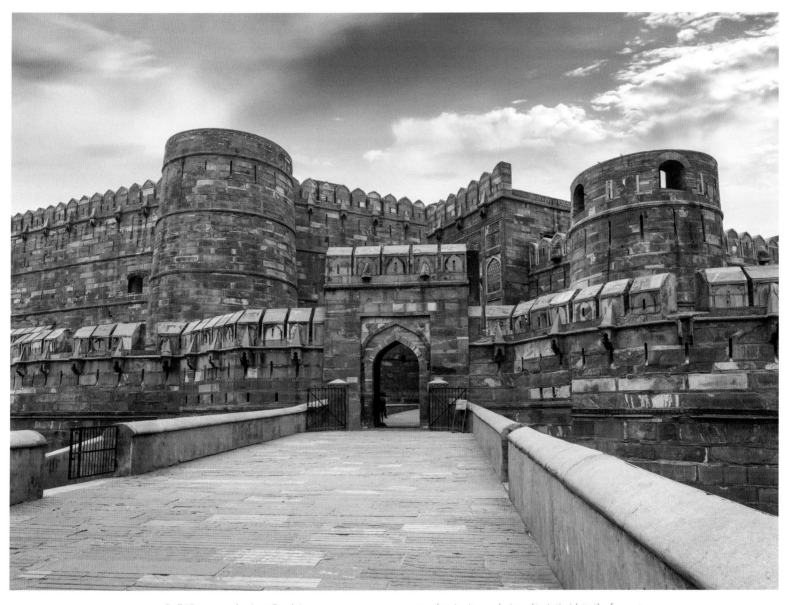

Delhi Darwaza, the Agra Fort's immense entrance gateway to the city. It was designed to intimidate the fiercest enemy but, ironically, fell to Shahjahan's own son Aurangzeb.

Shahjahan embellished palaces and mosques with finely etched and inlaid pristine white marble. He designed the many-pillared Diwan-e-Aam and installed the opulent and envied Peacock Throne, with the Kohinoor diamond as its centrepiece. The Mughals were no longer hard-riding horsemen in tents, and their austere forts had given way to elegant palaces, all in a single century. In other words, the Mughals had arrived and their transformation was now complete.

The marble domes of the fort rise above the ramparts, visible from afar. The Khas Mahal, the emperor's private chambers of audience and his own chambers, is capped with gilded domes. The Mussaman Burj, built for Mumtaz Mahal, is an octagonal tower overlooking the Yamuna. Beyond are the *hamam*s and the Sheesh Mahal, inlaid with glittering mica mosaic.

Ironically, Shahjahan, in the evening of his by then lonely life, was imprisoned by his son Aurangzeb in the fort, from where he could barely see the Yamuna. He would not leave the fort alive and was finally buried alongside Mumtaz Mahal in the Taj Mahal. The Agra Fort stands as one of the pillars of the region's triumvirate of World Heritage Sites, somewhere between the elegant saga of the Taj Mahal and the lost dreams of Fatehpur Sikri. It is protected and managed by the ASI. ●

Amita Baig

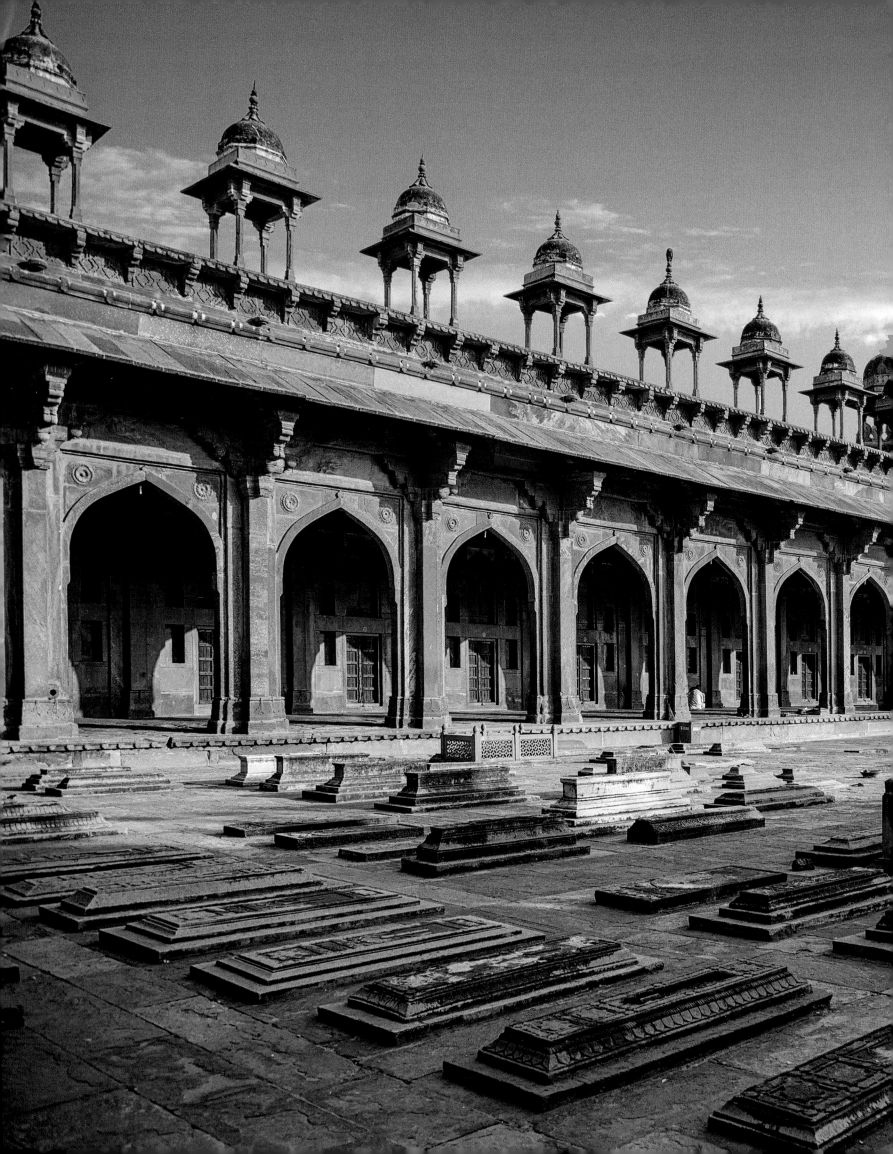

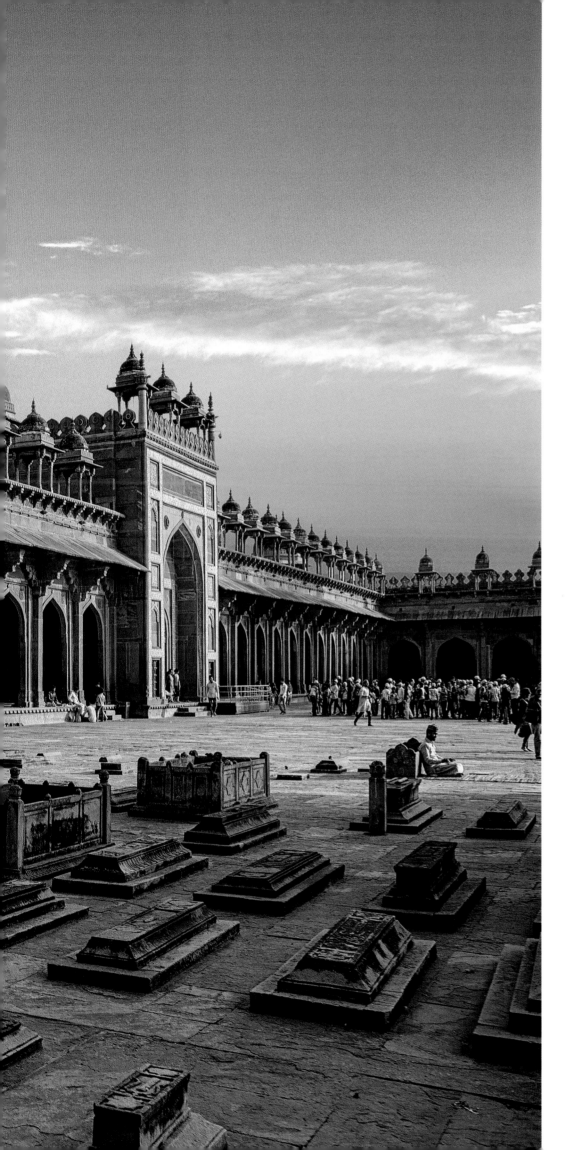

Fatehpur Sikri

LOCATION: Uttar Pradesh, India

COORDINATES: N27 5 51.101 E77 39 59.4

DATE OF INSCRIPTION: 1986

CATEGORY: Cultural (Monument)

OUTSTANDING UNIVERSAL VALUE

Fatehpur Sikri was made capital by the Mughal emperor Akbar and was the first planned city of the Mughals to be marked by magnificent administrative, residential and religious buildings. The city, which is bounded on three sides by a long, formidable wall, fortified by towers and pierced by nine gates, includes a number of impressive edifices of secular and religious nature that exhibit a fusion of Indo-Islamic styles. It is by far the greatest monumental structure of Akbar's entire reign and also one of the most perfect architectural achievements in India.

CRITERIA: (ii) (iii) (iv)

(ii): The construction of Fatehpur Sikri exercised a definite influence on the evolution of Mughal town planning.

(iii): Fatehpur Sikri bears an exceptional testimony to the Mughal civilisation at the end of the sixteenth century.

(iv): The city is a unique example of architectural ensembles of very high quality constructed between 1571 and 1585.

The Jama Masjid's capacious courtyard, dotted over time with tombs of various *pir*s, including Islam Shah, a disciple of Salim Chisti.

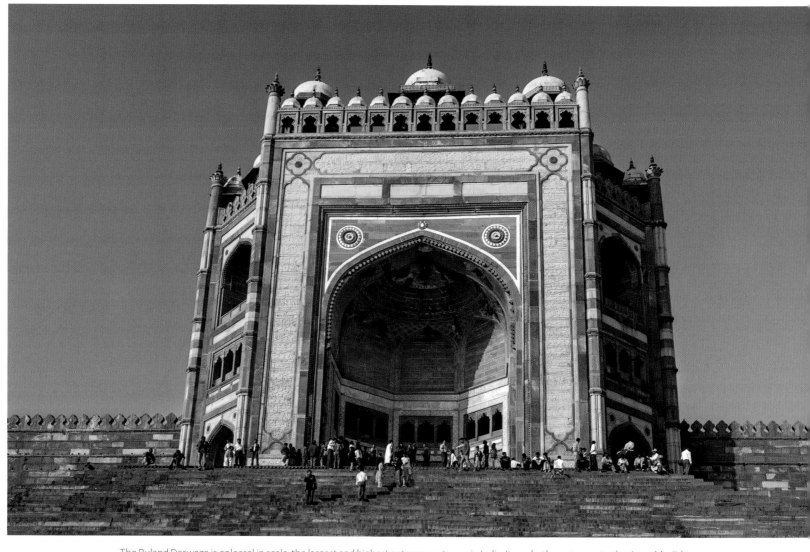

The Buland Darwaza is colossal in scale, the largest and highest entrance gateway in India. It marks the entrance to the Jama Masjid.

Fatehpur Sikri is inexorably identified with Akbar, Emperor of Hindustan for five decades (1556–1605). It was planned as a city, an example of the syncretic culture that Akbar wished to foster, an inclusive ethos that sprang from the soil of India. Akbar was a successful ruler, enlarging his domains and building a prosperous and culturally rich empire. He achieved this through conquest, strategic and matrimonial alliances and an assemblage of diverse and talented advisors at his court. In a few decades the Mughal Empire controlled much of the subcontinent, a realm of many ethnicities and faiths.

Fatehpur Sikri was built to mark a string of military successes, but most of all it was an act of reverence acknowledging the Sufi saint Salimuddin Chisti and his blessings for Akbar to have a son. Indeed, the construction of Sikri began in 1572 as a celebration of the birth of a male heir, the future emperor Jahangir, in 1569. He was born to Empress Jodha Bai, a Hindu Rajput princess from the House of Amber.

Six kilometres of fortifications ring the structures. Sikri is built largely of locally sourced red sandstone; the delicately carved buildings are the contribution of craftspeople from Gujarat. The Diwan-e-Aam is at the centre of the palace complex. There is a large courtyard facing a pavilion with multiple *jharokha*s (projected windows), the largest being that of the emperor. Beyond lies the Diwan-e-Khas, supported by a massive central pillar with

Pale sunlight filters through the delicate filigree of a *jaali* at Salim Chisti's tomb, an elaborately carved marble structure.

carved brackets. Four passages radiate outward with gracefully engraved railings.

The Anup Talao, a large tank with a platform, approached by four walkways, was where musicians, dancers, singers and poets performed before Akbar and his discerning court. The Ibadatkhana (house of worship), flanks the courtyard, and behind it are the personal chambers of the emperor. The *zenana* is a series of richly carved chambers with verandahs and blue-tiled roofs. The most distinguished of these was Maryam's, embellished with carvings,

frescoes and gilding. Nearby, the Panch Mahal, a tapering five-storey pavilion, rises strikingly over the complex, supported by eighty-four pillars, each distinctively carved. It was intended exclusively for Akbar's *zenana*. Beyond the palace walls is the Jama Masjid; at its main entrance is the Buland Darwaza, once flanked by stone elephants, rising to an immense height.

After Salim Chisti's death in 1571, the grief-stricken Akbar commissioned a red sandstone tomb for the saint in the courtyard of the Jama Masjid. It was

transformed by Shahjahan into a delicate white marble structure. The *dargah* remains a pilgrimage destination to which the faithful flock; it is still looked after by the descendants of the Sufi saint.

Fatehpur Sikri was abandoned by the time it was completed. In recent decades, the ASI has painstakingly recovered most of the complex; even today new archaeological discoveries emerge to enrich its narrative. ●

Amita Baig

Anup Talao, at the heart of the palace complex, was where poets, writers and musicians once gathered to perform for the emperor.

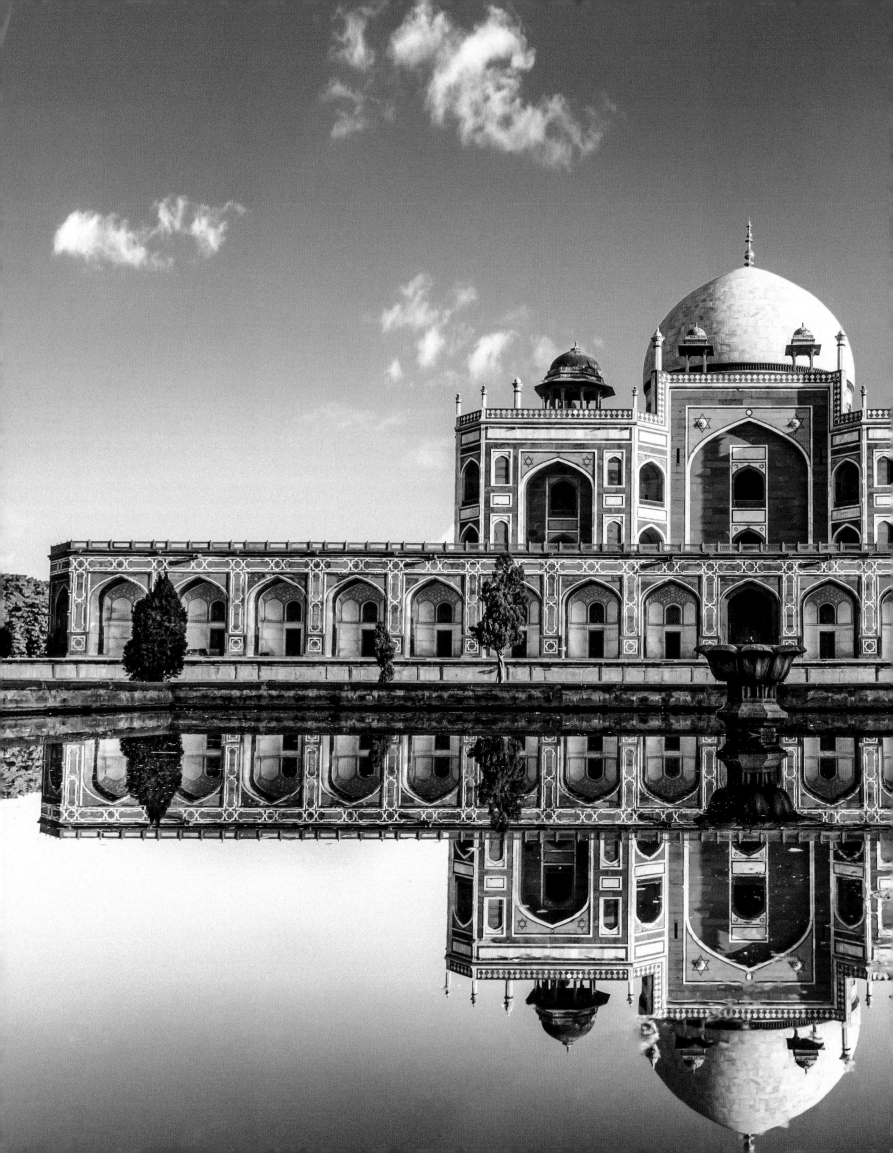

Humayun's Tomb, Delhi

LOCATION: New Delhi, India

COORDINATES: N28 35 35.988 E77 15 2.016

DATE OF INSCRIPTION: 1993

CATEGORY: Cultural (Monument)

OUTSTANDING UNIVERSAL VALUE

This tomb, built in 1570, is of particular cultural significance as it was the first garden-tomb in the Indian subcontinent. It inspired several major architectural innovations, culminating in the construction of the Taj Mahal.

CRITERIA: (ii) (iv)

(ii): Humayun's garden-tomb is built on a monumental scale, with grandeur of design and a garden setting that had no precedence in the Islamic world for a mausoleum. Here for the first time, important architectural innovations were made including creating a *charbagh*—a garden setting inspired by the description of paradise in the Holy Quran. The monumental scale achieved here was to become characteristic of Mughal imperial projects, culminating in the construction of the Taj Mahal.

(iv): Humayun's Tomb and the other contemporary sixteenth-century garden-tombs within the property form a unique ensemble of Mughal era garden-tombs. The monumental scale, architectural treatment and garden setting are outstanding in Islamic garden-tombs. Humayun's Tomb is the first important example, and above all else, the symbol, of the powerful Mughal dynasty that unified most of the Indian subcontinent.

Humayun's Tomb is reflected in the waters of the *charbagh* pool, intended as paradisiacal imagery.

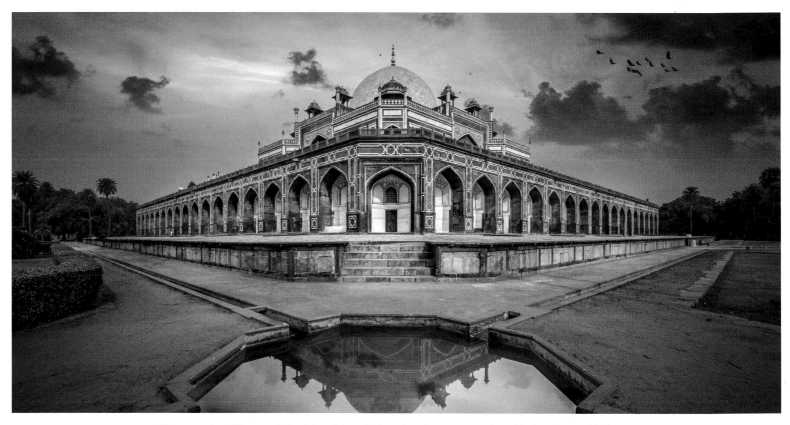

The symmetry of Humayun's Tomb is striking, with its red sandstone contrasting with the white marble dome.

Humayun's Tomb commemorates Humayun, the second Mughal emperor, who succeeded his father, the founder of the Mughal dynasty, Babur. The tomb was commissioned to the Persian architect Mirak Mirza Ghiyas by Humayun's senior widow, Haji Begum, after his death. The tomb is located in the middle of a *charbagh* and is a part of a much larger complex. It was built in close proximity to the *dargah* of the fourteenth-century Sufi saint Nizamuddin Auliya, venerated by Mughal rulers. This *dargah* formed the fulcrum of a necropolis, with several imperial and sub-imperial tombs, which reflected the rulers' wish to seek interment in close proximity to the revered saint. Being the first Mughal garden-tomb to be executed on a grand scale, Humayun's Tomb is significant as an archetype used for subsequent tomb-building enterprises that pinnacled with the Taj Mahal.

While the design and patterns draw from the popular octagonal archetype used for imperial tomb-building in the Islamic world, especially Persia, its execution was largely undertaken by Indian craftspeople. The use of rubble stone masonry, finished in red sandstone, and the sparing use of white marble (notably in its dome) points towards the architectural syncretism of the indigenous and foreign, and became a defining character of Mughal patronage.

The tomb was regularly visited by successive Mughal rulers to pay obeisance to their departed forefather. It also attracted the admiring attention of Europeans travelling through the Delhi region in the eighteenth and nineteenth centuries. Thomas Twining, an official of the British East India Company, commented that he "had seen nothing so beautiful, excepting at Taje-Mehal". Decades later, James Fergusson, while conceding that it was a "noble tomb" that formed the "principal and most striking object" among the ruins of the city and "must be considered a wonder", also observed that it lacked "the depth and poetry of that celebrated building", i.e. the Taj Mahal.

During the events of the 1857 Uprising in Delhi against British rule, the incumbent Mughal ruler, Bahadur Shah Zafar, sought refuge in Humayun's Tomb before surrendering and being held captive in the Red Fort. By this time, both the tomb and the garden had deteriorated, the former with crumbling walls and the latter being used to cultivate cabbage and tobacco.

It was not until the early twentieth century that conservation measures were initiated at the behest of Viceroy Curzon. Once completed, the garden was leased out for cultivation to a farmer who planted turnips in the newly laid-out lawns, while his cows broke the water channels, thereby inviting Curzon's displeasure.

The tomb complex was accorded statutory protection under the Ancient Monuments and Preservation Act of 1904. It was conserved by the ASI as part of the colonial state's preparation for the third Delhi Durbar of 1911–12. Subsequently in independent India, it was accorded

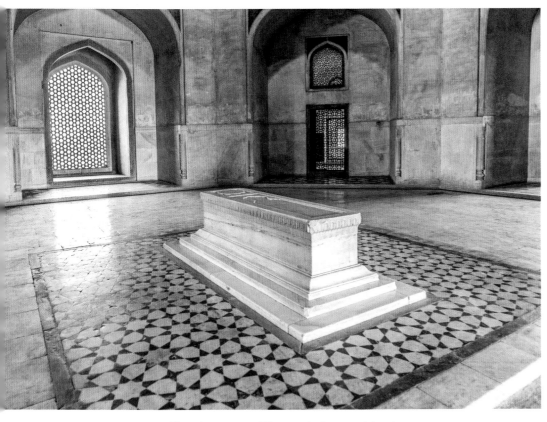

The *qabr*, or grave, of Humayun in the central chamber.

protection under the Ancient Monuments and Archaeological Sites and Remains Act of 1958. Beginning in 1997, the tomb and the gardens were conserved by the ASI via a partnership enterprise with the Aga Khan Trust for Culture. In 2007, this was expanded into a project called the Humayun's Tomb-Nizamuddin Basti-Sundar Nursery Urban Renewal Initiative, aiming at heritage conservation, environmental improvement and socio-economic betterment of the urban precinct. ●

Jyoti Pandey Sharma

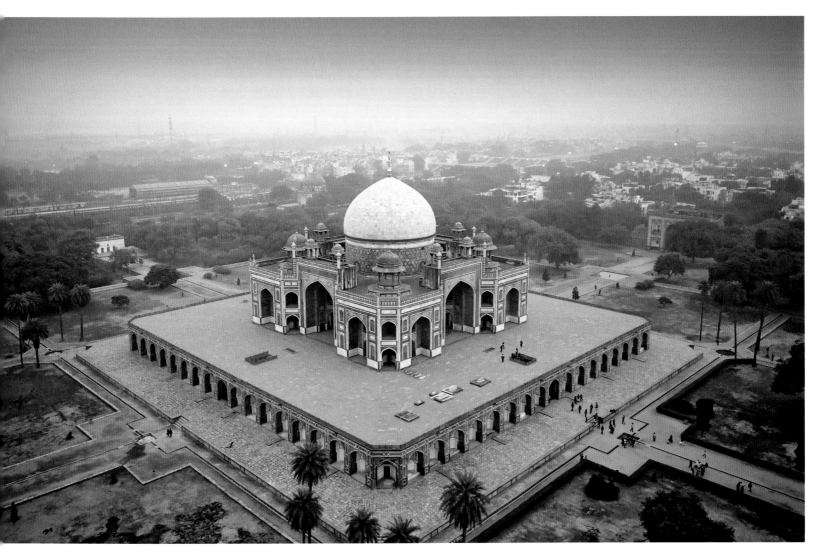

An aerial view shows the serene beauty of Humayun's Tomb in its *charbagh* setting, surrounded by the bustle of New Delhi.

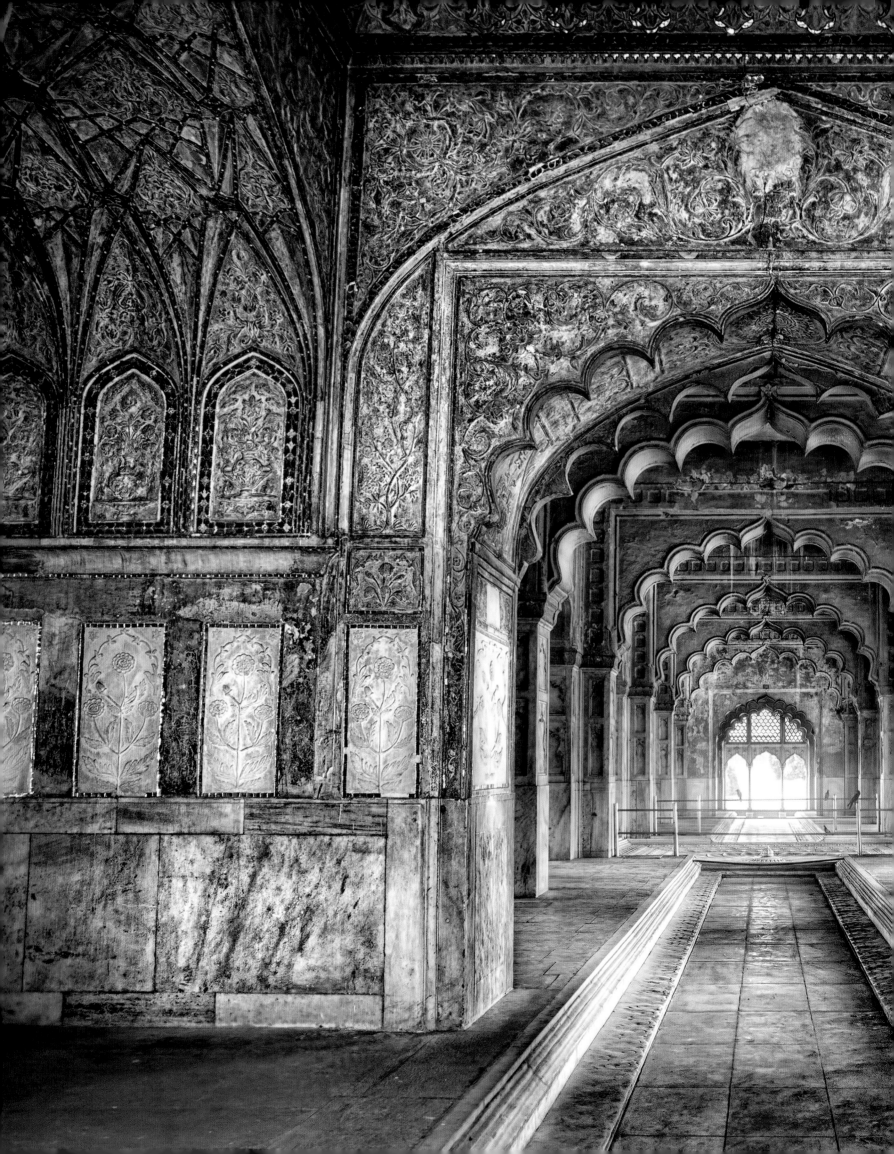

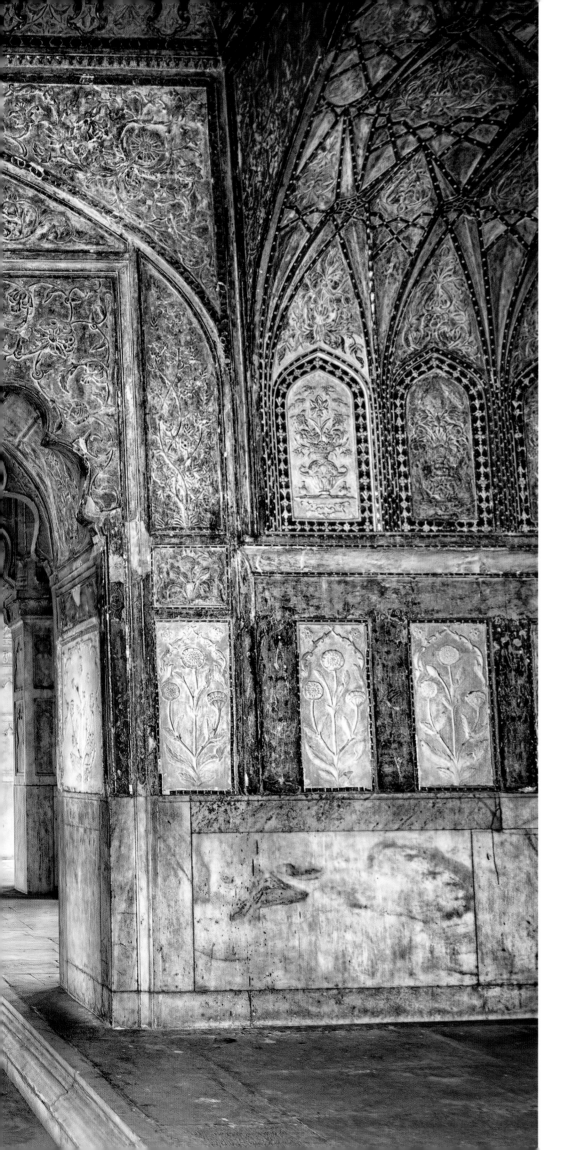

Red Fort Complex

LOCATION: New Delhi, India

COORDINATES: N28 39 20 E77 14 27

DATE OF INSCRIPTION: 2007

CATEGORY: Cultural (Monument)

OUTSTANDING UNIVERSAL VALUE

The Red Fort was built as the palace fort of Shahjahanabad, the new capital of the Mughal emperor Shahjahan. Named for its massive enclosing walls of red sandstone, it is adjacent to an older fort, Salimgarh, with which it forms the Red Fort Complex. The private apartments consist of a row of pavilions connected by a continuous water channel, known as the Nahr-i-Behisht (Stream of Paradise). The Red Fort is considered to represent the zenith of Mughal creativity.

CRITERIA: (ii) (iii) (vi)

(ii): The Red Fort demonstrates the outstanding results achieved in Mughal planning and architecture by fusing Persian, Islamic, Timurid and Hindu traditions.

(iii): The innovative planning and architectural style of the Red Fort strongly influenced later structures in the subcontinent. It also reflects the phase of British colonial military occupation.

(vi): The Red Fort has been a symbol of power since the reign of Shahjahan, and was the place where Indian independence was first celebrated, and is still celebrated today. The Red Fort Complex has thus been critical to the shaping of regional and political identity in India.

The Red Fort's lavishly decorated Rang Mahal was initially used as Shahjahan's harem. It included the Sheesh Mahal, which featured extensive mirror work and intriguing water channels along the floor.

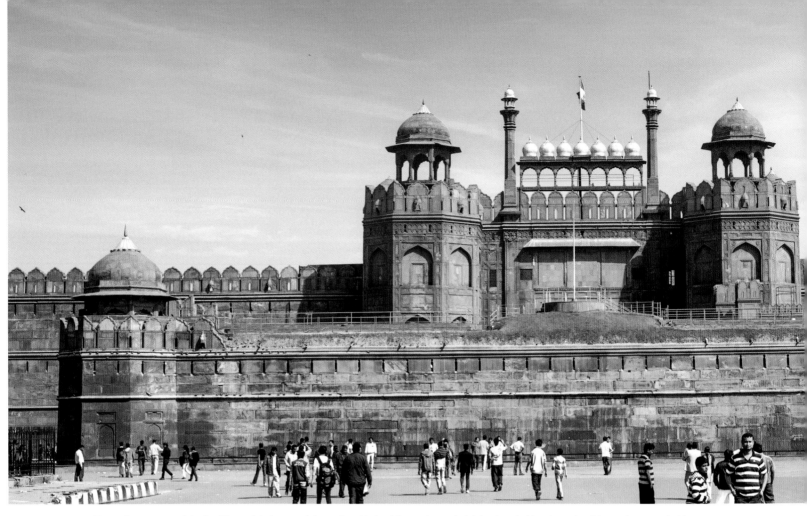

The main entrance of the Red Fort, with the grand three-tiered Lahori Gate, adorned with *burj*s and *chhatri*s on the sides and crowned with a series of small white marble *chhatri*s in the centre. The national flag flies proudly atop this symbol of India's independence.

With a multi-layered Mughal-British past, the Red Fort is today rooted in the national consciousness as a symbol of India's democracy. A *qila* built in 1639 on the banks of River Yamuna by Shahjahan, it marked the culmination of the quintessential Mughal fort planning and design that borrowed from diverse traditions, notably Persian and Timurid. It epitomises the Shahjahani architectural style and served as a model for later endeavours across northern India.

The Red Fort, designed by the architect Ustad Ahmad Lahauri, took eight years and ten months to build. It served as the royal residence of Mughal emperors from 1648 to 1857, taking over from the Agra Fort when Shahjahan decided to shift his capital from Agra to Delhi. The Red Fort, named thus by the British after the 1857 Uprising, derives its name from its red sandstone walls, which make it almost impregnable.

The large and grand fortified precinct comprised sub-imperial and imperial buildings, and royal residential buildings occupied pride of place on a terrace overlooking the Yamuna. A *nahr* (canal) drawn from the river flowed through it, including its gardens, creating paradisiacal imagery. While public and semi-public buildings were finished in red sandstone, those meant for private use of the royal household were finished in marble. The Red Fort displays some of the best examples of the Mughal art of *parchin kari*, with ornamentation themes from Indian, Persian, Timurid and European sources.

The Red Fort remained a fount of power well into the eighteenth century, even as the Mughal dynasty waned and Delhi came under British occupation. The precinct became a battleground during the 1857 Uprising in Delhi, suffering damage. Following British victory, it was turned into a garrison and militarised—through the demolition and re-adaptation of Mughal buildings and the addition of new infrastructure, like infantry barracks raised on the pleasure garden, Hayat Baksh Bagh—destroying most of the original planning.

Castigating this vandalism, Viceroy Curzon initiated conservation measures in 1902, aimed at restoring some of its original glory. The Red Fort hosted some events of the second and third Delhi Durbars in 1902–03 and 1911–12, respectively.

The announcement of India's independence was made from the Red Fort's ramparts at midnight on 15 August 1947, by the first Prime Minister of independent India, Pandit Jawaharlal Nehru. All successive prime ministers have addressed the nation on Independence Day from its ramparts ever since. After Independence, the ASI remained in charge of the "Archaeological

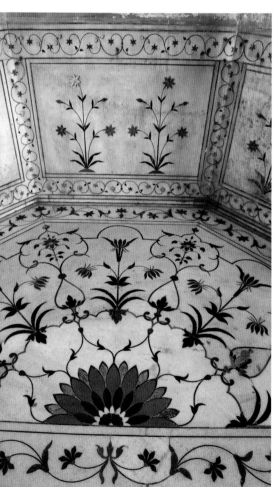

The imperial *hamam*, with elaborate *parchin kari* on the floor and dado panels.

The Diwan-e-Aam contains the marble *jharokha*, which would have held the *badshahi* (imperial) throne.

Area" monuments, delineated thus in the colonial era, while the Indian Army controlled the rest of the precinct till it moved out in 2003. In 2006, a Comprehensive Conservation Management Plan was commissioned for the Red Fort to devise a strategy, which is currently being implemented. More recently, ASI has undertaken major conservation works in the Fort in 2018–19 and opened four new museums in the British-period barrack buildings, besides adding a number of visitor facilities. ●

Jyoti Pandey Sharma

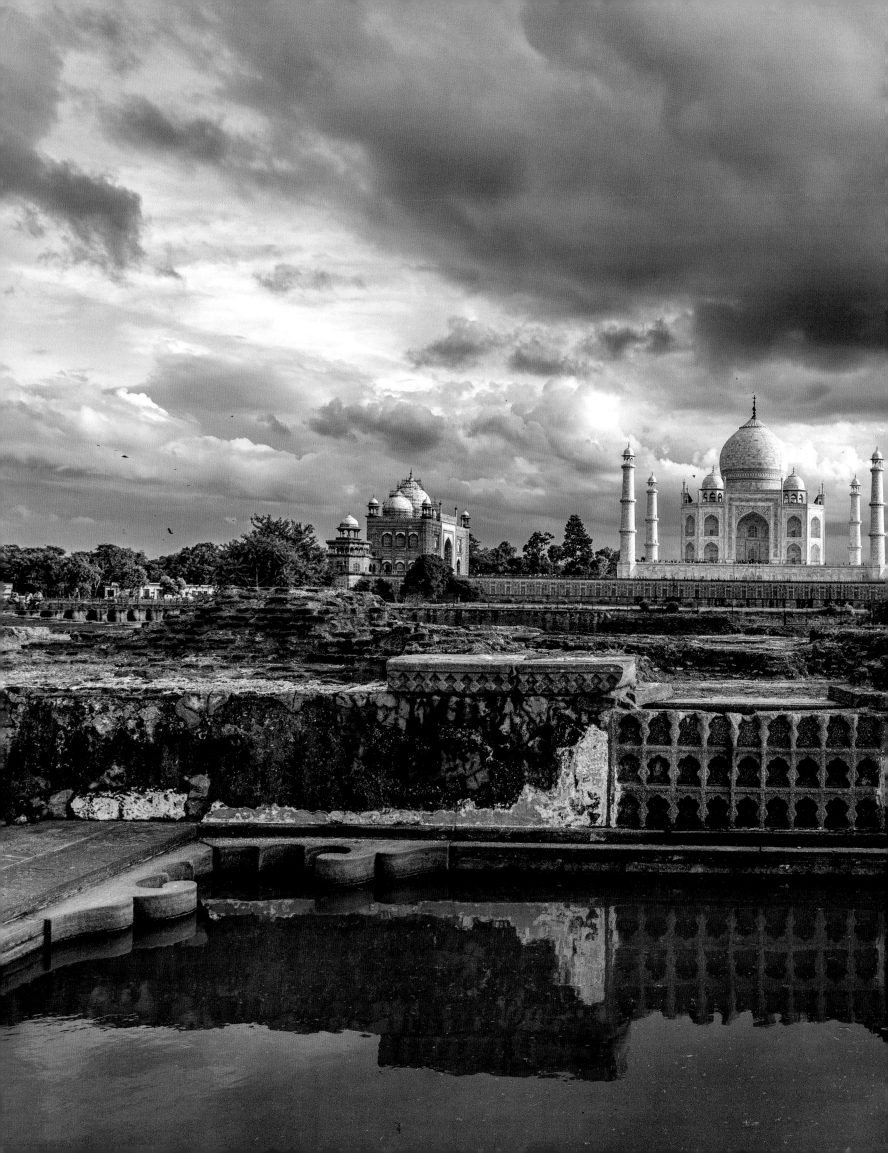

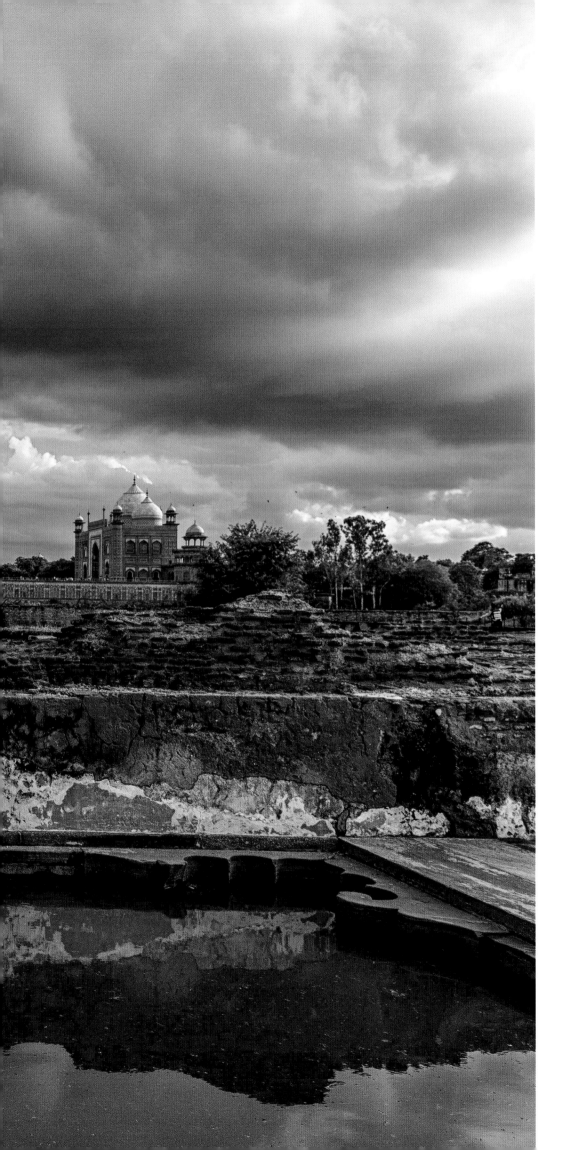

Taj Mahal

LOCATION: Uttar Pradesh, India

COORDINATES: N27 10 27.012 E78 2 31.992

DATE OF INSCRIPTION: 1983

CATEGORY: Cultural (Monument)

OUTSTANDING UNIVERSAL VALUE

The Taj Mahal was built by the Mughal emperor Shahjahan in memory of his wife Mumtaz Mahal, with construction having started in 1632 and ended in 1648. The mosque, the guesthouse, the main southern gateway and the outer courtyard and its cloisters were added subsequently. The architectural innovations marking the uniqueness of the Taj Mahal include the horticultural planning of the gardens; the perfect geometric symmetry of the cenotaphs; the *pietra dure*; the four free-standing minarets; and the majestic main gate. The Taj Mahal is a perfect, symmetrically planned building, with an emphasis on bilateral congruity along a central axis on which the main features are placed.

CRITERIA: (i)

(i): The Taj Mahal represents the finest architectural and artistic achievement, through perfect harmony and excellent artisanship, in a whole range of Indo-Islamic sepulchral architecture, with unique aesthetic qualities in balance, symmetry and harmonious blending of various elements.

The Taj Mahal, seen from Mehtab Bagh (the Moonlight Garden). The Yamuna is an integral part of the grand plan, with the sacred mausoleum and *charbagh* to the north and the picturesque garden to the south.

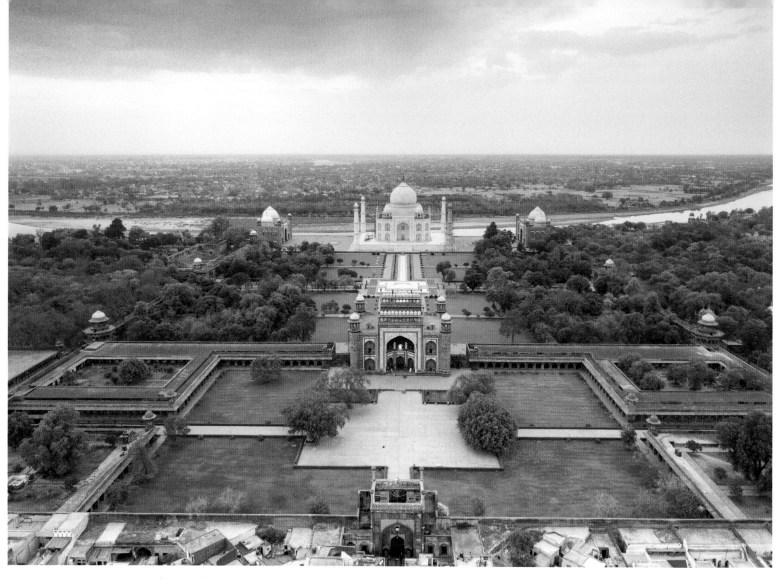

The Taj Mahal is poised at the edge of the river, its symmetry and planning unsurpassed anywhere in the world.

Romanticised over the centuries, eulogised by poet laureates and itinerant travellers, the Taj Mahal is undoubtedly India's most iconic monument. The Taj Mahal, in its white-marble glory, stands today as a symbol of love. It was built as a sacred tomb by the Mughal emperor Shahjahan for his beloved wife, Mumtaz Mahal, who died in 1632.

Shahjahan always travelled from the Agra Fort to the construction site of the Taj by long boat along the Yamuna. Thus, it was natural that he envisioned this monument from the riverside, its "heaven-soaring dome" rising above the mist and the fresh waters of the Himalayas lapping at the edge. This aspect is often invisible to present-day visitors, who approach the site from the city. The riverfront wall, once richly embellished and carved, is now lost to the

changing landscape. There was also a small door with marble steps for him to enter the crypt and offer his prayers. It is probable that he appropriated the fast-flowing river as the centre of his grand plan, with the mausoleum to the right, a truly sacred space, and the Mehtab Bagh, or Moonlight Garden, on the other side as a pleasure garden. It is laid out in perfect cardinal direction conforming to Quranic texts, with the graves in faultless alignment. Even the calligraphy over the entrance *pishtaq* (rectangular frame around an arched opening) unequivocally reads "Enter Thou My Paradise".

Construction of this architectural masterpiece took twenty-two years and is recognised as the zenith of Mughal architecture in India. The brilliance of the Taj Mahal is its pure, luminescent

white marble façade and the minutest detail inscribed and inlaid upon it. For this, marble requisitioned from Makrana, over 800 kilometres away, was transported on an endless train of bullock carts. Lapis lazuli, agate and carnelian were transported from Afghanistan and beyond. It is said that over 20,000 workers were engaged and a city sprang up on its periphery as artisans, masons and calligraphers were summoned to Agra to build arguably the finest building ever.

At the centre lies the grave of Mumtaz Mahal, inscribed with ninety names of Allah as well as a profusion of flowers and arabesques. Below, in the crypt, the actual graves (of Mumtaz Mahal and Shahjahan) are identical but situated in an absolutely plain and austere room. And here lies the abiding mystery. What did Shahjahan

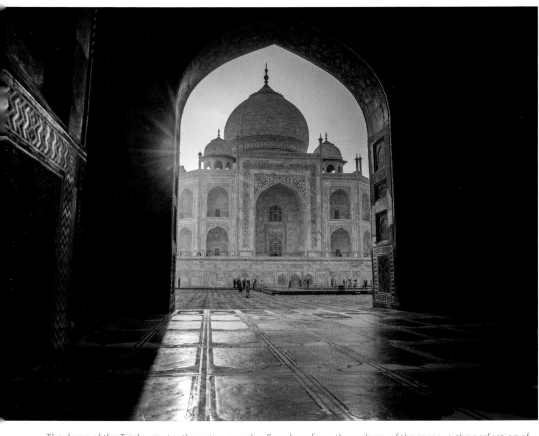

plan for himself? Surely not a grave, which although placed alongside Mumtaz Mahal's, is in fact the only asymmetrical element in the entire complex? The Taj still retains mysteries to be unravelled by those who seek its depths and read its metaphors.

Over the last century, significant work has been done to safeguard and restore the Taj Mahal. The *charbagh* was completely cleared almost a hundred years ago but the spirit of its design was retained. In a historic Supreme Court judgment in 1996, a 500-metre green belt around the complex was ordered to protect the marble from the impact of environmental pollution. Today, the ASI continues to manage the ever-increasing number of visitors, and a site of this importance remains at the forefront of site management concerns. ●

The dome of the Taj dominates the entire complex. Seen here from the archway of the mosque, the perfection of scale and proportion is easily visible from every angle.

Amita Baig

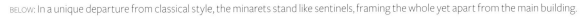

BELOW: In a unique departure from classical style, the minarets stand like sentinels, framing the whole yet apart from the main building.

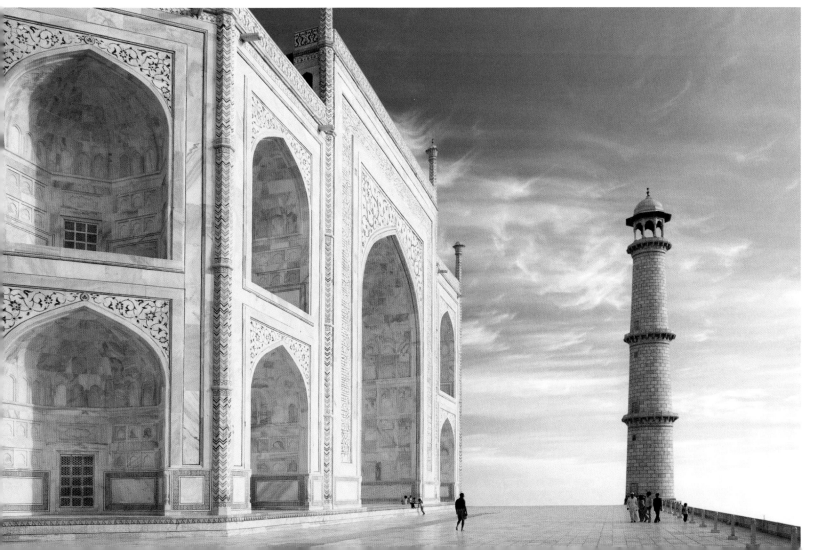

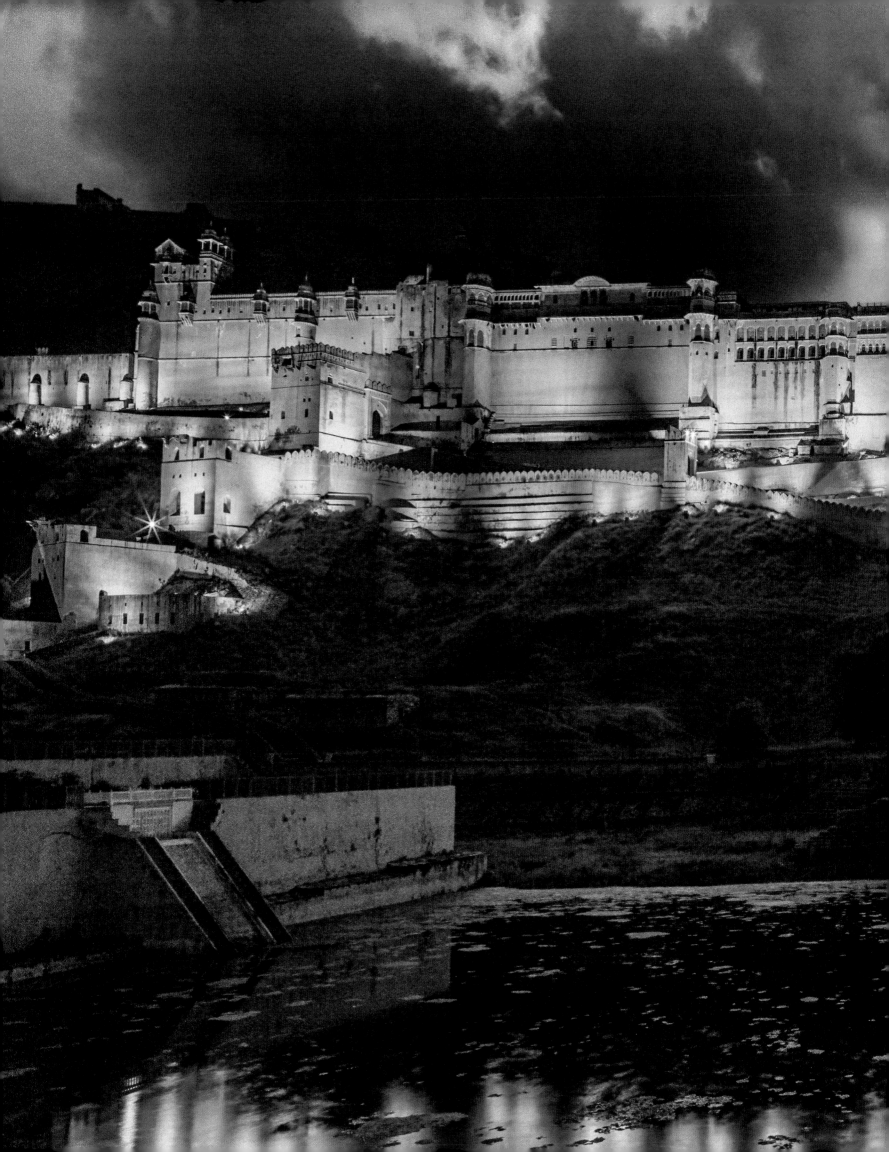

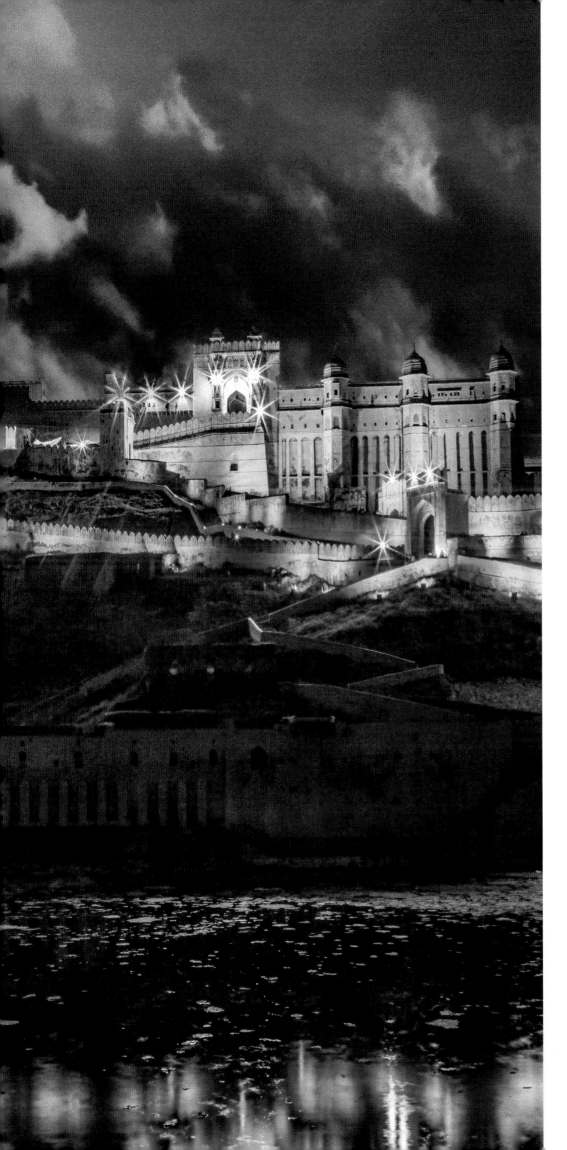

Hill Forts of Rajasthan

LOCATION: Rajasthan, India

COORDINATES: N24 52 60 E74 38 46

DATE OF INSCRIPTION: 2013

CATEGORY: Cultural (Serial Site)

OUTSTANDING UNIVERSAL VALUE

This serial site includes six majestic forts in Chittorgarh, Kumbhalgarh, Sawai Madhopur, Jhalawar, Jaipur and Jaisalmer, within which developed elaborate courtly cultures. The eclectic architecture of the forts bears testimony to the power of the Rajput princely states that flourished in the region from the eighth to eighteenth centuries. Enclosed within defensive walls are major urban centres, palaces, trading centres and temples, which often predate the fortifications. The forts use the natural defences offered by the landscape: hills, deserts, rivers and dense forests. They also feature extensive water harvesting structures, largely still in use today.

CRITERIA: (ii) (iii)

(ii): These properties exhibit an important and eclectic interchange of Rajput ideologies in fort planning, art and architecture from the early to late medieval period, within the varied physiographic and cultural zones of Rajasthan.

(iii): These hill forts are architectural manifestations of Rajput valour, bravery, feudalism and cultural traditions.

The majestic Amber Fort sits in the valley of the Aravalli Range, north of Jaipur, with the Maota lake at its base. Its lavishly decorated palaces, especially the Sheesh Mahal, with its extraordinary glass inlay work, and the Kesar Kyari garden are some of its unique features.

Rajasthan, in northwestern India, comparable in area to France, has hundreds of forts that were strongholds of Rajput warrior-rulers from the eighth to the early twentieth century. They vary in typology, construction and scale across the range of geographical and cultural zones within Rajasthan.

Though important as strategic military centres, these forts also served as residential headquarters of the rulers, as well as towns with markets and houses of civil populations.

The six hill forts—Amber, Gagron, Ranthambore, Kumbhalgarh, Chittorgarh and Jaisalmer—are from varied geographic, physiographic and cultural zones within Rajasthan. Historically, all six forts were capitals of the Rajputs of the Kachchwaha, Khinchi Chauhan, Sisodia and Bhatti clans, and located on important historic trade routes passing through the area of Rajasthan.

Each fort exhibits a distinct interaction with its natural setting, and reveals construction techniques that exploit natural and topographical features for defence. Chittorgarh sits on one of the largest plateaus of the Aravalli Range, covering an area of 3.4 square kilometres by fortifying the entire plateau for its defence. Kumbhalgarh, also located on the Aravalli Range around 150 kilometres from Chittorgarh, is enclosed in a sanctuary area and shows a very different response to its topography spread along the hill slope. Ranthambore utilises the dense forest and the hill amidst it to be classified as an excellent example of a hill-forest fort. Gagron uses natural waters for its defence, as the hill on which it is located is surrounded by river waters on three

sides, while a man-made moat linking the waters was created to make it inaccessible from the fourth side. Amber is a typical example of a hill-valley fort, where the main palace structures are located in the valley area and enclosed by fortifications in the surrounding hills. The Jaisalmer Fort is located on an outcrop in the middle of a desert area, where the hill is completely ensconced within strong fortifications. Societal associations, whether life at Rajput courts or the assimilation of local and tribal ways of life, find a reflection in the layout, construction and creative embellishment in these forts. The structures inside the fortifications in each case show sophisticated and evolved examples of secular Hindu Rajput architecture and technological adaptations utilising the wealth of natural resources in an extraordinary geographical setting.

Each fort within its geographic zone epitomises the resistance of erstwhile Rajput kingdoms to outside incursions and attacks. Each fort also shows an interesting assimilation of local and foreign influences in fortifications, temples, palace architecture and water systems.

Chittorgarh is recognised for its vast repository of architectural icons, dating from the eighth to the sixteenth century, besides being the largest fort in India.

ABOVE: Chittorgarh is one of the largest hill forts of India. The Gaumukh Kund, one of its largest water bodies, part of an extensive water-management system, is seen here against fortifications, with the Vijay Stambh (Victory Tower) in the distance.

BELOW: The Jaisalmer Fort is a marvel, carved in golden sandstone on an outcrop in the Rajasthan desert. More than 3,000 people still reside inside this living World Heritage Site.

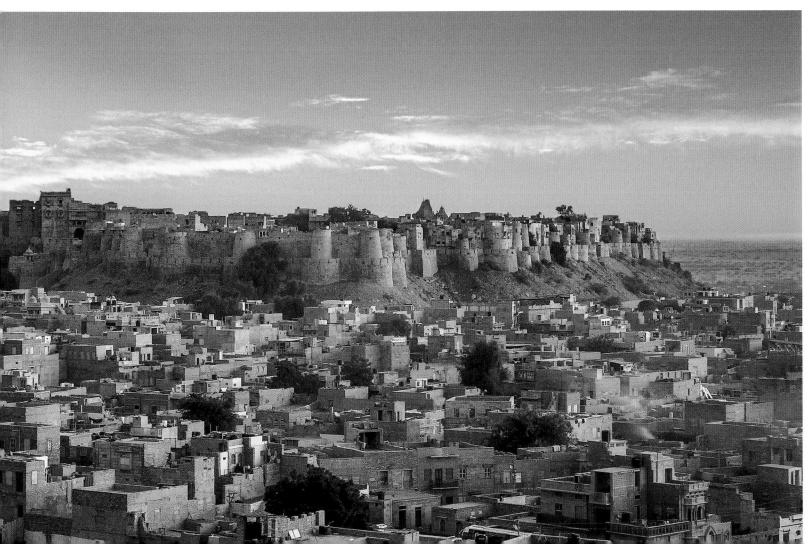

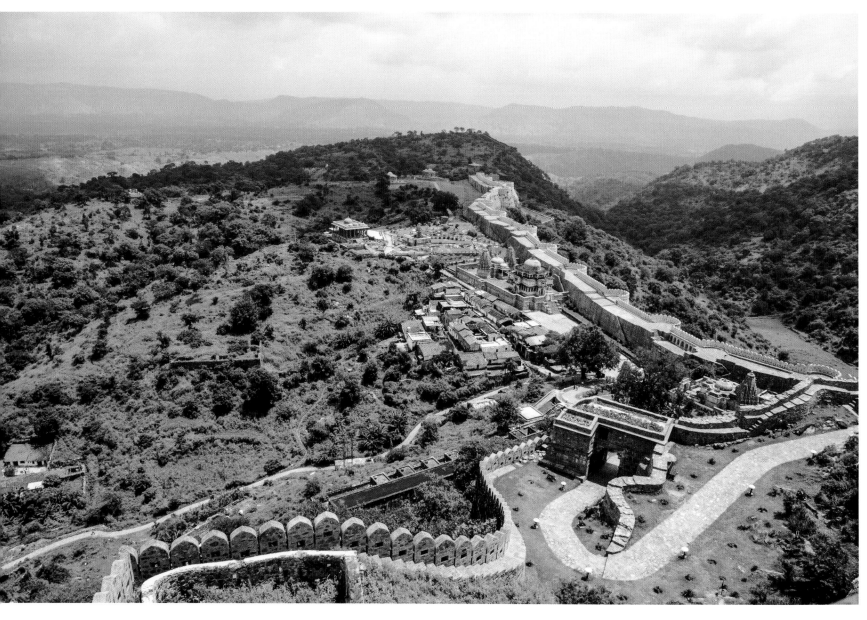

ABOVE: The magnificent fort of Kumbhalgarh was built
in a single span in the fifteenth century, based on new
principles outlined for fort building in this period.

RIGHT: The water fort of Gagron, located at the confluence
of two rivers on an outcrop of the Vindhyan Hills.

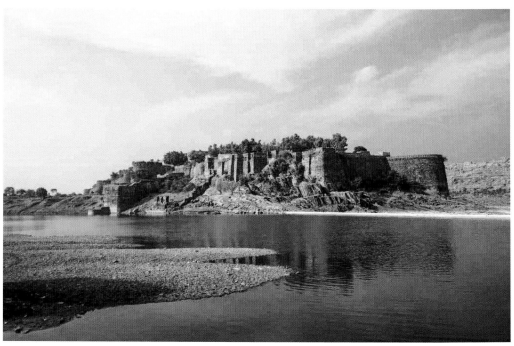

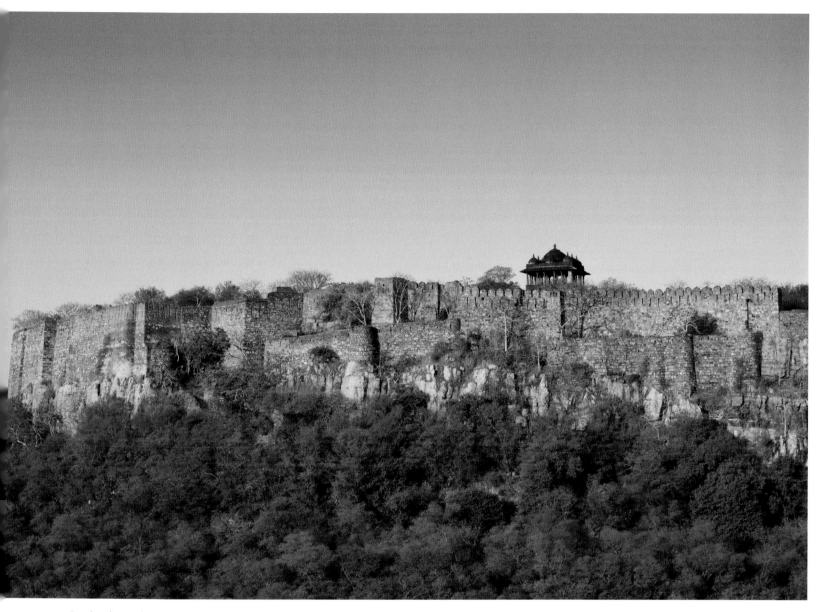

Ranthambore is home to a thriving population of tigers. The fort rises above the thick jungle, seen here with its fortifications and Battis Khamba Chhatri (cenotaph).

Kumbhalgarh is a fairytale fort in one of the most picturesque settings, built in a single phase of construction in the fifteenth century as per fort-building guidelines of the master architect Mandana.

Ranthambore stands apart as a dominant hill-forest fort in the midst of a National Park. The palace of Hammir at Ranthambore is the oldest surviving pre-Islamic palace structure in India.

Gagron, the hill fort with water defences, is the smallest among the six, remaining unconquered by Alauddin Khilji when he attacked it in the fourteenth century.

The Amber Fort is representative of exemplary Rajput-Mughal palatial architecture with exquisite glass inlay work, besides the adaptation of *charbagh* gardens and water systems.

Jaisalmer, the desert fort, retains its original houses, *haveli*s, as well as the ninety-nine bastions with exceptional fortifications, constructed in dry masonry of local ochre-coloured dressed stone. The golden hue of the Jaisalmer Fort has lead to its popular name Sonar Kila (Golden Fort).

Chittorgarh, Kumbhalgarh, Ranthambore and the Jaisalmer forts are protected as Monuments of National Importance of India by the ASI. The Gagron and Amber forts are designated as State-Protected Monuments of Rajasthan. All six are managed as a single serial property through a state-level Apex Advisory Committee. ●

Shikha Jain

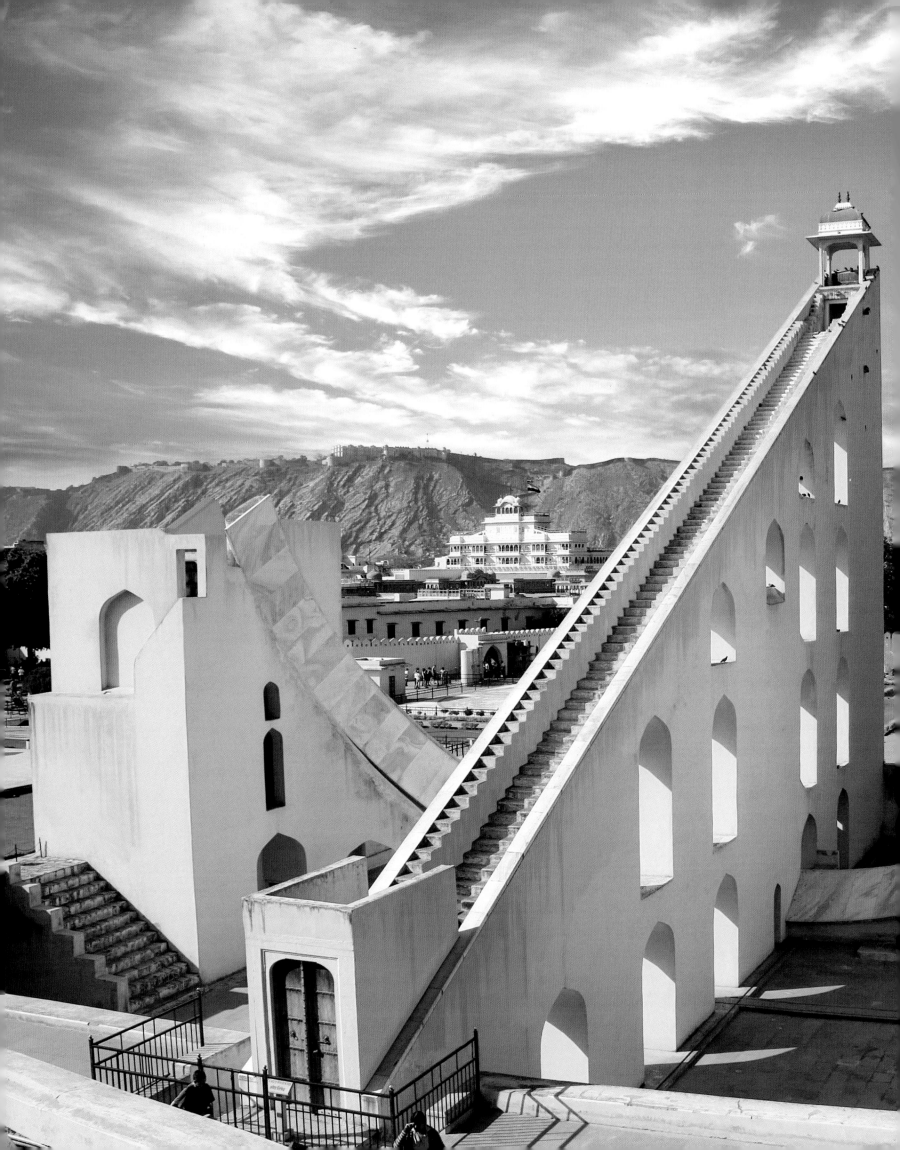

The **Jantar Mantar**, Jaipur

LOCATION: Rajasthan, India

COORDINATES: N26 55 29 E75 49 30

DATE OF INSCRIPTION: 2010

CATEGORY: Cultural (Monument)

OUTSTANDING UNIVERSAL VALUE

This site constitutes the most significant and best-preserved set of fixed monumental instruments built in India in the eighteenth century. Part of a tradition of Ptolemaic positional astronomy, the Jantar Mantar is a late and ultimate monumental culmination of this tradition and gave rise to widespread social practices linked to cosmology. Through the impetus of its creator, Sawai Jai Singh II, the observatory was a meeting point for different scientific cultures and was also a symbol of royal authority through its urban dimensions, its control of time, and its rational and astrological forecasting capacities.

CRITERIA: (iii) (iv)

(iii): It is an outstanding testimony to the culmination of scientific and technical conceptions of the great medieval observatory.

(iv): It is an outstanding example of a very comprehensive set of impressive astronomical instruments, some of which are the largest ever built in their category.

The great sundial, called the Brihat Samrat Yantra. The largest functional masonry sundial in the world today, dating from the early eighteenth century, it is renowned for its ability to measure time up to an accuracy of two seconds.

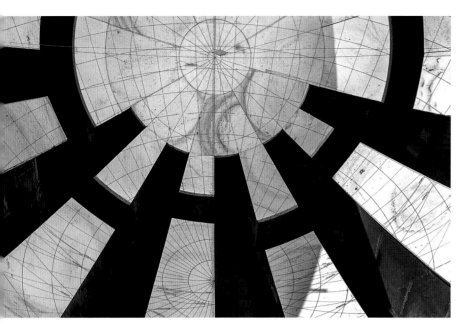
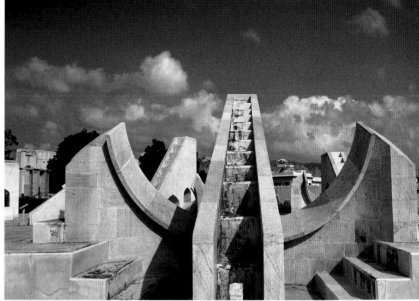
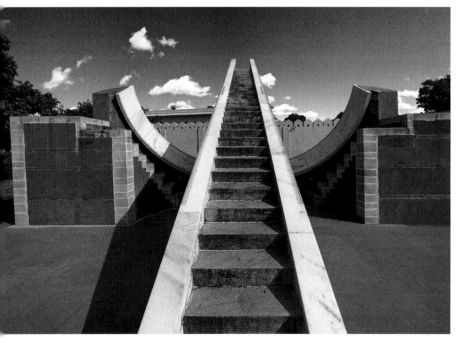
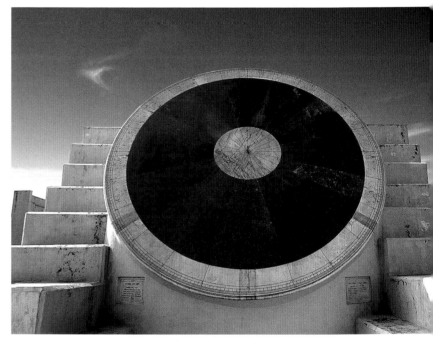

(Clockwise from top left) The Jai Prakash Yantra; the Rashivalaya Yantra; the Laghu Samrat Yantra; and the Nadivalaya Yantra. These were used to calculate solar time, chart the movements of celestial bodies or mark constellations.

This visually compelling observatory is a part of the legacy of Sawai Jai Singh, the Rajput ruler of the erstwhile Amber kingdom. He was an extraordinary man who inherited the throne at the age of eleven in 1699. He pursued his interests in mathematics, architecture and astronomy, and also established the planned city of Jaipur. The sundial at the Jantar Mantar determined the city plan, with roads aligned at the same angle. Initially sited against the backdrop of the Aravalli Range, this modern and timeless monument is now surrounded by Jaipur's busy bazaars.

It was in 1702, during the course of a military campaign for the Mughals in the Deccan, that Jai Singh met Jagannatha, a Brahmin scholar from Maharashtra. Thereon, Jagannatha became the chief advisor to Jai Singh for all his astronomical experiments. He not only translated contemporary Arabic and English texts on astronomy into Sanskrit but also wrote the canonical eighteenth-century text *Samrat Siddhant*, which methodically explains the construction of all astronomical instruments at the Jantar Mantar.

The making of the Jantar Mantar required the study of all Hindu astronomical texts, Islamic calendars and European tables available in the eighteenth century. Jai Singh

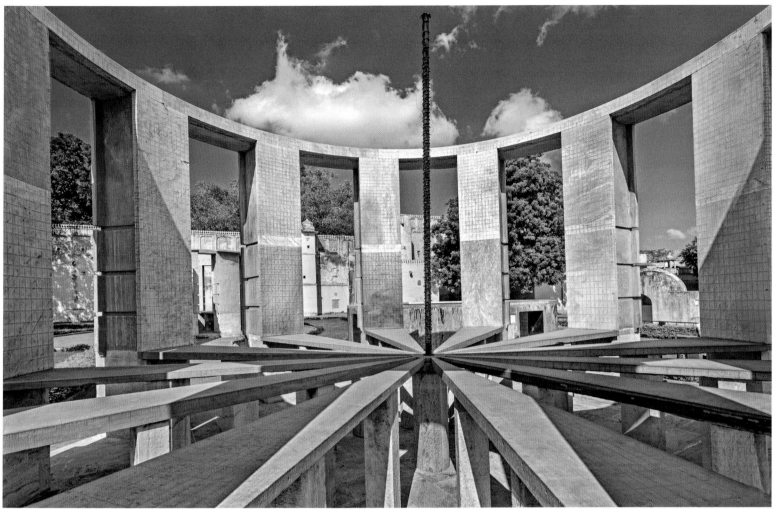

The Ram Yantra was designed with the purpose of measuring the local coordinates of the celestial bodies.

realised that the astronomical tables used across various civilisations at that time needed updating, and convinced the Mughal emperor Muhammed Shah that the construction of large-scale observatories would make it possible to do so. He first experimented with smaller brass and wooden models before building larger masonry instruments for the proper recording of celestial bodies. Calendars such as the Islamic Ziz were important to calculate the auspicious time for initiating battles, royal journeys and other important affairs of administration. No such initiative for astronomical studies had been undertaken since 1428, when Mirza Ulugh Beg, the grandson of Timur Leng, constructed his observatory at Samarkand. Inspired by him, Jai Singh's first experiment

for the Jantar Mantar thus began with the site in Delhi, under Mughal patronage. Five observatories were simultaneously constructed across India, of which four still exist in their original locations at Varanasi, Ujjain, Delhi and Jaipur, with the last being the best preserved.

The Jaipur observatory was completed between 1726 and 1734, having the maximum number of instruments, totalling twenty in number. Astronomers from various cultures were invited to take readings and provide their expertise for the Jantar Mantar. One European astronomer even recorded that "Jai Singh's invitation for a passport held more weightage than the Mughal Emperor's own letter at that time."

Most of the instruments continue to be functional at this time and the site is a living, learning observatory.

While visitors are often captivated by the Jantar Mantar's abstract and minimal forms and their association with celestial bodies, UNESCO's recognition of the scientific contribution of this monument to world history has led to a greater awareness of its function. The monument is protected by the State Archaeology Department of Rajasthan and monitored through an elaborate management plan that guides all conservation, use and interpretation works on the site and surrounding buffer zone. ●

Shikha Jain

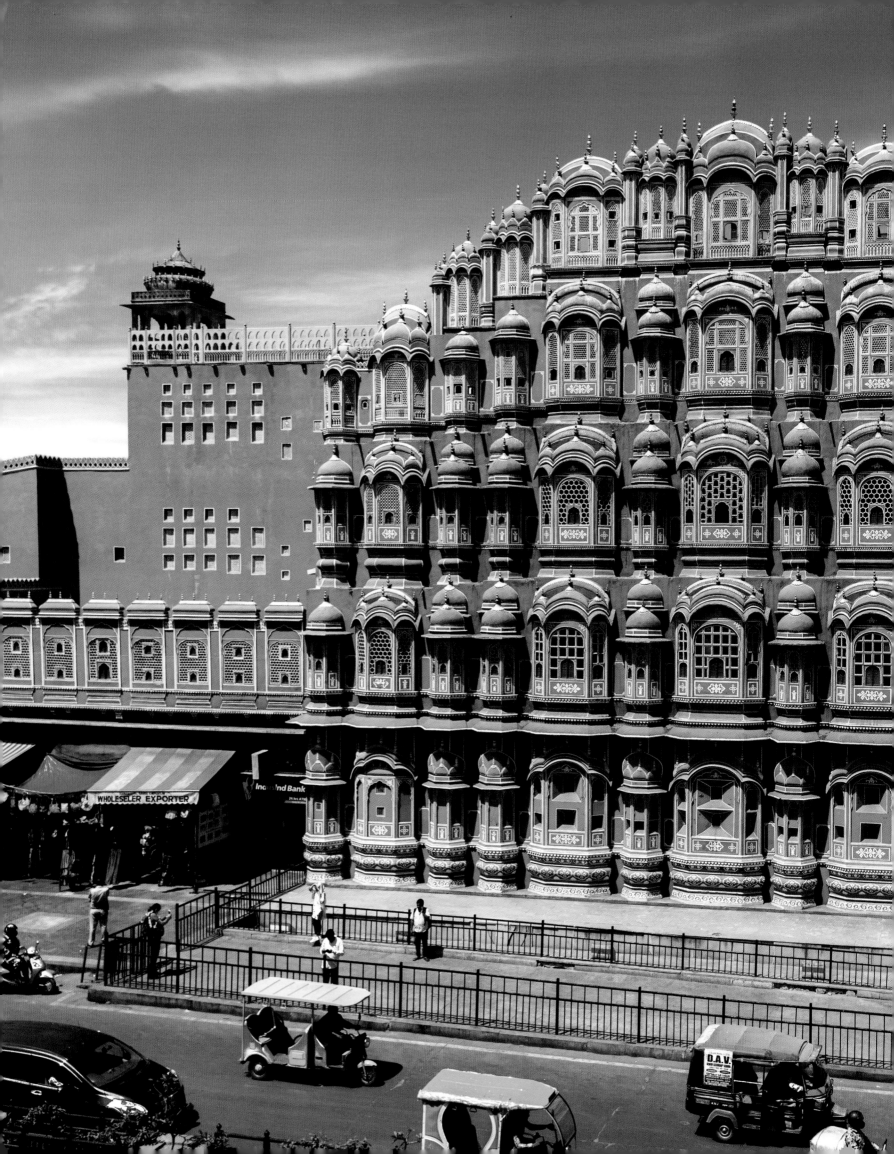

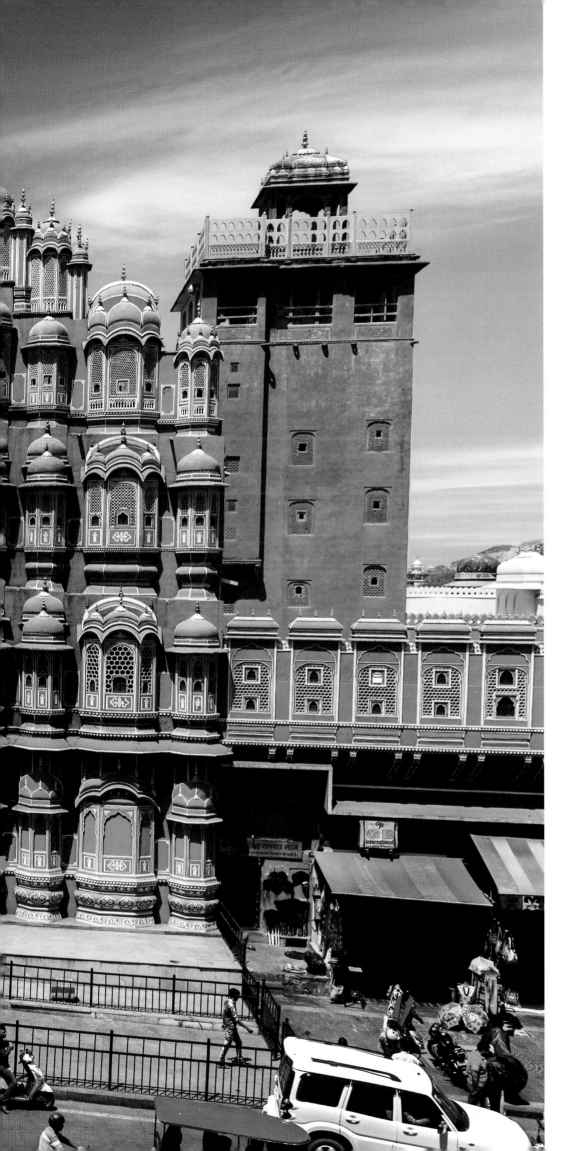

Jaipur City, Rajasthan

LOCATION: Rajasthan, India

COORDINATES: N26 55 27.4 E75 49 18.7

DATE OF INSCRIPTION: 2019

CATEGORY: Cultural (Monument)

OUTSTANDING UNIVERSAL VALUE

Jaipur was established on the plains and built according to tenets of Vedic architecture. The city's urban planning shows an extraordinary exchange of ideas from Hindu, Mughal and Western cultures. Designed to be a commercial capital, the city has maintained its local commercial, artisanal and cooperative traditions to this day.

CRITERIA: (ii) (iv) (vi)

(ii): Jaipur is an exemplary development in town planning and architecture that demonstrates an interchange of ancient Hindu, Mughal and contemporary Western ideas in the late medieval period.

(iv): The city planning of Jaipur, with its monumental gridiron pattern and peculiar urban form, makes it unique in the history of urban planning in India.

(vi): Historically, the city is said to have housed *chattis karkhana*s (thirty-six industries), each dealing with a particular craft, in a tradition that continues into the present, thus contributing to their conservation.

The Hawa Mahal (the Palace of Winds) is the most iconic architectural masterpiece of Jaipur city. It was built in 1799 as a palace from where royal ladies could watch the royal procession below as it passed through the main Sireh Deori Bazaar.

Jaipur, established in the eighteenth century, is named after the visionary ruler Sawai Jai Singh. It was acclaimed the world over for its grandeur and for its meticulous planning. It soon became a centre of learning, visited by a range of travellers, scholars and astronomers, as well as men of science and letters from India and abroad. Its crafts comprised *chattis karkhana*s (thirty-six industries), with artisans migrating from places such as Lahore, Gujarat and Kashmir. The city was funded by Marwari traders, who were personally invited by Jai Singh and allocated prime land for their *haveli*s. Jai Singh's extraordinary vision to build a new trade centre that competed in magnificence with the previous imperial Mughal cities was successfully realised in Jaipur's city plan and its iconic monuments.

The sandy site on the plains south of the earlier capital, Amber, served as an ideal place for Jaipur's plan. The site facilitated a clear, open iron-grid framework for the city, with commercial streets of monumental scale. Jai Singh's vision was translated into a city plan that integrated guidelines from traditional Vastu Shastra texts with contemporary planning and showcased a political will to define new concepts for a trade capital.

The building of the city and its surrounding walls and gates was started with due propitiatory rites on 18 November 1727. In 1729, invitation letters were despatched to merchants, and by 1732 the construction of palaces and major *haveli*s was complete.

The main avenues of the city were designed as markets, which remain characteristic bazaars of the city. *Chaupar*s, or large public squares designed at the intersection of roads, are another feature distinctive to Jaipur, as are its single- to multi-court *haveli*s and *haveli*-temples. Marking of the two north-south and east-west axes was completed with clearly defined *chowk*s (public squares), at each crossing; these were later named Badi Chaupar (Manek Chowk), Choti Chaupar and Ramganj Chaupar. Historically, the *chaupar*s not only served as important community spaces but also housed the main water source for the city with huge underground reservoirs in the centre linked to the Mansagar Lake. These water reservoirs were closed during the reign of Sawai Ram Singh II in the nineteenth century, with the introduction of piped water supply to the city. Additionally, the iconic monuments of Jaipur, such as the Govind Devji Temple, the City Palace, the Jantar Mantar and the Hawa Mahal, excel in the artistic and architectural artisanship of the eighteenth century. Its living crafts, including the lime and stone works, have also helped in placing the city on UNESCO's Creative Network as a City of Crafts and Folk Arts in 2015.

Over the centuries, the changing façades of Jaipur bazaars and inner streets have shown distinct stylistic layers.

The architectural typologies of the eighteenth century are exemplified in the *haveli*s; *haveli*-temples and temples with *shikhara*s; square-based and round

ABOVE: Aerial view of the Chhoti Chaupar, a city square, in Jaipur.

BELOW: Aerial view of the Tripoliya Bazaar and the Choti Chaupar.

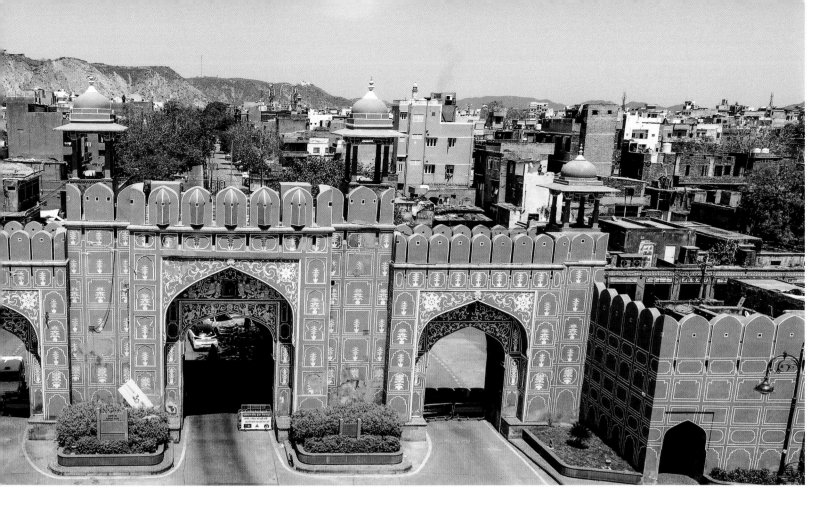

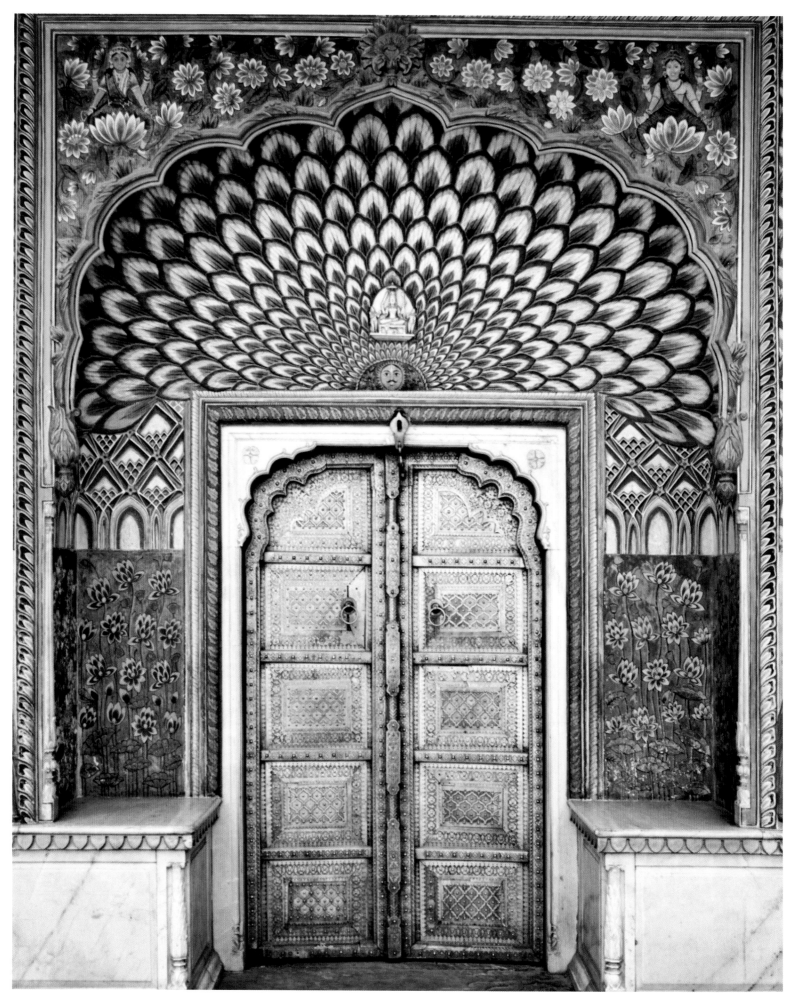

One of the four beautiful gates in Pritam Niwas Chowk is this Lotus Gate, dedicated to Lord Shiva and his consort Parvati.

The many crafts of Jaipur: block printing (above), hand-painted ceramics (centre) and textile embroidery (below).

*chattri*s; cusped and multi-foliated arched openings and niches; and lime *jaali*s inspired by Rajput-Mughal architecture.

In the mid-nineteenth century, as the city of Jaipur expanded under the rule of Sawai Ram Singh II, there was a definite colonial influence in architectural styles. This period saw the introduction of classical elements such as semicircular arches, small pediments, pilasters and stone railings adapted in a unique, localised Rajput-British style, which also gets covered under the pan-India Indo-Saracenic movement. The façades of Jaipur's bazaars changed from lemon yellow (lime wash) to red (sandstone shade wash), giving Jaipur its moniker, Pink City.

In the early twentieth century, structures in the Art Deco style brought more change; this is reflected in the continuous verandah of the shops in Chandpol, Kishanpol and Tripoliya bazaars.

Jaipur city has undertaken a conscious approach to conservation since 2005 and has recorded several benchmark initiatives for urban conservation in India since then.

As per commitment to the World Heritage Committee in 2019, it is in the process of preparing a detailed Special Heritage Area Plan for the inscribed property. All previous heritage plans for Jaipur's Walled City, including the Built Heritage Management Plan (prepared in 2007 and revised in 2018), Smart City Plan and any other sectoral plans, are now converged and guided by tri-level monitoring committees to address the protection of its criterion and universal value as a World Heritage Site. ●

Shikha Jain

Colonial Designers and Modern Architects
New Forms for an Old Civilisation

Kiran Joshi

"'She [India] is waking up... intact at a time when all is possible,' wrote Le Corbusier to Nehru. 'But India is hardly a brand new country: it has lived through the highest and most ancient civilisations. It has an intelligence, moral philosophy and conscience of its own.' India also happened to possess one of the greatest architectural heritages in world history, and of this too Le Corbusier was fully aware. This was another side of his task: to acknowledge India's spiritual and artistic traditions but without lapsing into superficial imitation or Orientalism."

—William J.R. Curtis, *Le Corbusier Rediscovered: Chandigarh and Beyond*, 2018

The Westernisation of the Indian people and colonisation of their territory began with the discovery of a new sea route from Europe by the Portuguese explorer Vasco da Gama, and his historic landing at Calicut on 20 May 1498. By 1530, the Portuguese had set up a chain of trading stations along India's western coast and established their new capital in Goa. Marrying Indian women to secure a permanent Portuguese population, they had also established the Portuguese Indian Church; a few of these magnificent specimens are collectively recognised as a World Heritage Site, known as Churches and Convents of Goa.

The early seventeenth century saw a European rush—by the Dutch, the English, the French and the Danes—to monopolise India's maritime trade and to colonise Indian territories. Vestiges of their trading posts, factories and fortifications still exist all along the Indian coastline. Many of the original colonial settlements—including Danish Tranquebar and Serampore, French Chandernagore and Pondicherry, and British Fort St. George and Fort William—continue to thrive as parts of contemporary towns. Dutch colonies in India lasted till the eighteenth century, while the Danes had to leave in the mid-nineteenth century. The influence of the Portuguese and the French continued into the twentieth century but was limited to small coastal territories.

It was only the British East India Company that expanded relentlessly, covering inland tracts of the country. By mid-nineteenth century, it had gained direct or indirect control over almost the entire Indian subcontinent, more or less functioning in an autonomous manner. Following the losses suffered during India's First War of Independence in 1857, the British Crown dissolved the East India Company whilst also putting an end to the Mughal dynasty. British India was formally brought under the British Crown, in the person of Queen Victoria, who, when proclaimed Empress of India in 1876, promised to work to "better" her Indian subjects.

The nineteenth-century proliferation of new industrial products in Britain and the introduction of the factory system in Europe compelled the British to find new markets for their finished products in India. They also wanted to get an uninterrupted supply of raw materials for their factories. This led to further penetration by the British into Indian life through infrastructural developments, which were, however, meant only to serve British interests.

Transport is indispensable for the developmental process of a country. The introduction of railways, one of the legacies of British rule in India, brought about profound changes in the habits and outlook of the people by increasing the ease and speed of

A sculpted relief of a woman farmer on Mumbai's New India Assurance Building, built in 1936. The designers stylised Western Art Deco within the cultural context of India.

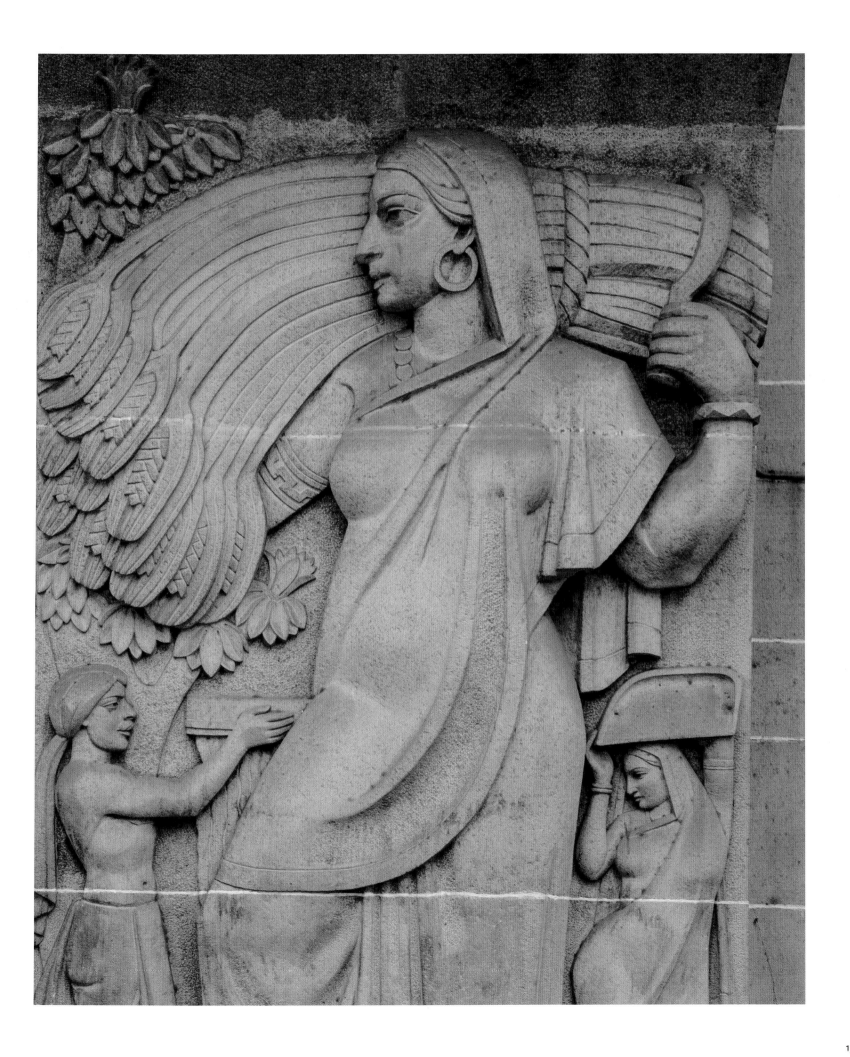

communication. Although the British may not initially have intended it to do so, the Indian rail network played a vital role in the economic development and national integration of the country. The Indian railway system is today the largest state-owned enterprise in Asia and the second-largest state-owned railway system in the world. The innovative British technology that connected hinterlands and mountains across India in the early twentieth century is well recognised today under the serial world heritage property, the Mountain Railways of India.

European and Indian cultures intersected in many other ways. Their co-existence and interdependence became particularly evident in the shared legacy of art and architecture of this era. Policies for the revival of literature, science and other courses led to the opening of universities and colleges for the native population. The architecture of the nineteenth-century British Raj was a vehicle to propagate the colonial mission of modernising India. All public and government buildings—courthouses, universities, museums, town halls, and railway stations—were intentionally built on

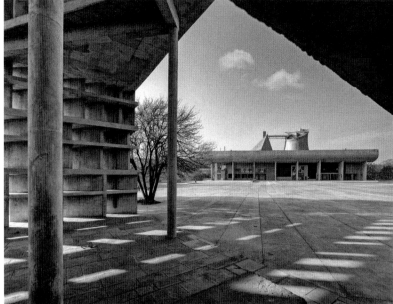

This photograph of The Architectural Work of Le Corbusier
© Fondation Le Corbusier has been published with permission.

a grandiose scale, their European architectural origin visibly modified to suit the local climatic, cultural and aesthetic context. Gothic and classical European Revivalist arches, turrets and spires were fused with motley elements of traditional Indian architecture and sculptures of Indian men in traditional costumes. This eclectic interplay became the hallmark of the nineteenth-century Victorian Gothic, the Indo-Saracenic and, later, even twentieth-century Art Deco buildings, as visible in Mumbai's two World Heritage properties, the Chhatrapati Shivaji Terminus and the Victorian Gothic and Art Deco Ensembles.

Working for European patrons, Indian artists fused traditional miniature art with Western rendering techniques, producing a distinctive "Company Style". Travancore's Raja Ravi Varma pioneered subjective interpretations of traditional themes using European academic techniques. Reacting against this perceived mimicry of Western art techniques by Indian artists, a nationalist movement in Indian modern art was

advanced in the early twentieth century by some avant-garde proponents of the Bengal school of art. Interestingly, this was supported by their British art teacher, E.B. Havell. Clearly, colonial dominance was giving way to cross-cultural dialogue in various spheres of life.

The story of India's East-West communion also extends beyond Independence, in the building of the modern city of Chandigarh and the unconventional sculptural forms of its Capitol Complex, showcasing an ingenious synthesis of modern means and materials with local culture and constraints. The stage had been set for the Indian Modern, relevant both within and outside its territorial borders. The large-scale impact of Modernism was truly felt in India when the Swiss-born French architect Le Corbusier and his three-member team were invited by the then Prime Minister Jawaharlal Nehru to design and build the city of Chandigarh, while also training a young generation of architects inducted into the project. This post-Independence decision to invite a foreign architect to design Punjab's new capital city in a specifically modern idiom (and equip young Indian architects for the same) not only marked a turn in South Asian architectural history but also recorded an important international phenomenon in world architecture. ◆

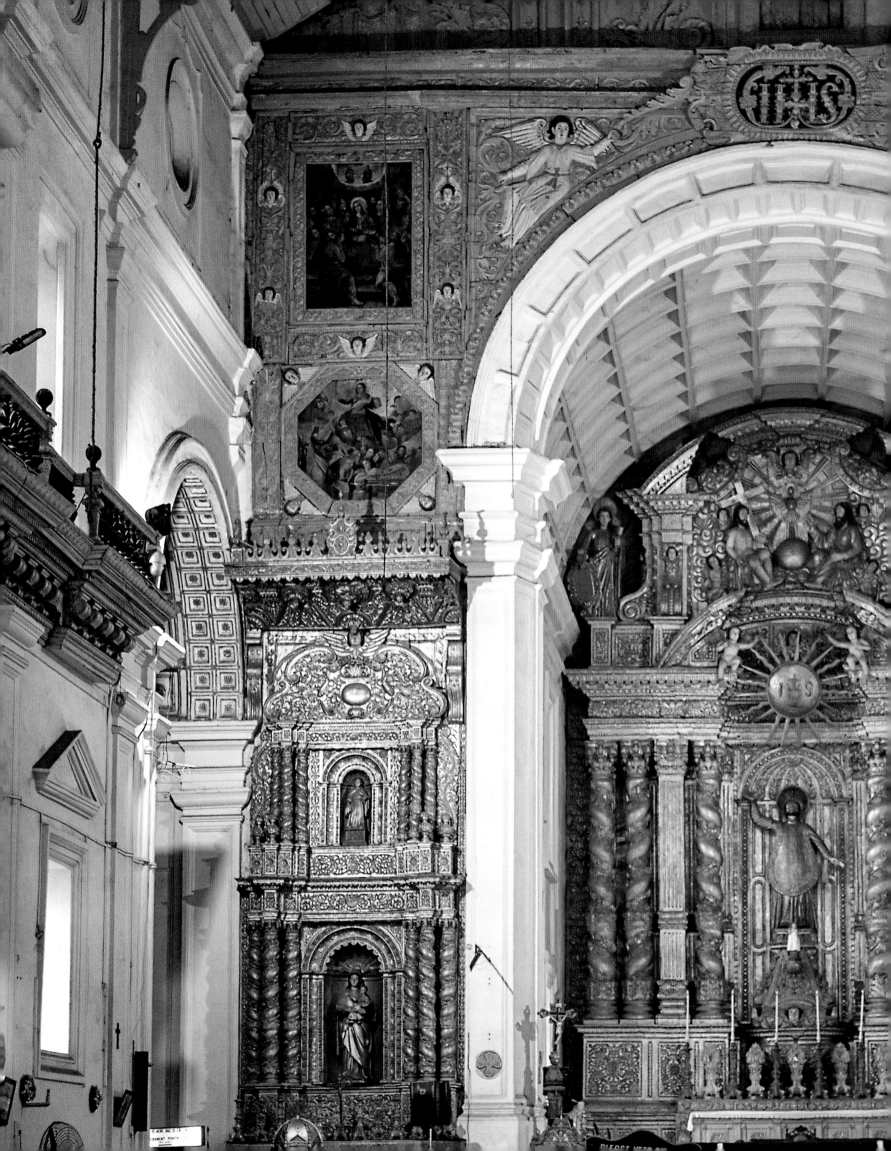

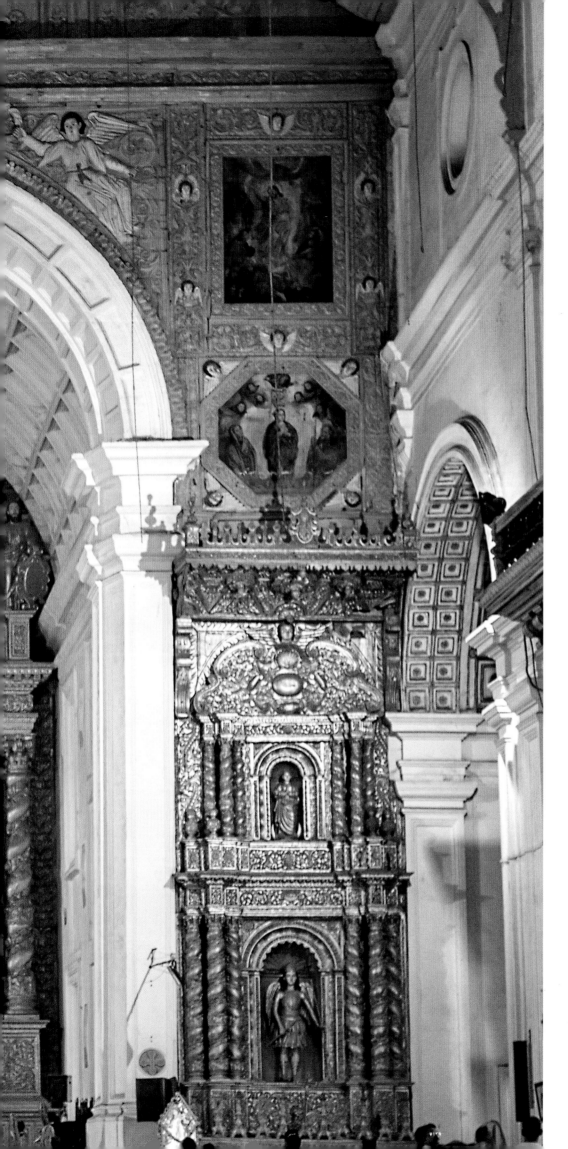

Churches and Convents of Goa

LOCATION: Goa, India

COORDINATES: N15 30 7.992 E73 54 42.012

DATE OF INSCRIPTION: 1986

CATEGORY: Cultural (Monument)

OUTSTANDING UNIVERSAL VALUE

The Churches and Convents of Goa form a serial property located in the former capital of the Portuguese Indies. These seven monuments eminently illustrate the work of Catholic missionaries in Asia. They represent the roots of a unique style that developed during Portuguese control of the territory, and which spread to missions beyond Goa, creating a unique fusion of Western and Eastern traditions.

CRITERIA: (ii) (iv) (vi)

(ii): These monuments exerted great influence from the sixteenth to eighteenth century on the development of art and architecture across Asian countries with Catholic missions.

(iv): The monuments are an outstanding example of an architectural ensemble that illustrates the work of missionaries in Asia. Its wealth compares with the Latin American ensembles in the World Heritage List.

(vi): The Basilica of Bom Jesus conserves Saint Francis Xavier's tomb. Beyond its fine artistic quality, the tomb symbolises the influence of Catholicism in Asia in the modern period.

Inside the Basilica of Bom Jesus, which serves as the final resting place for the mortal remains of Saint Francis Xavier.

The churches and convents of Goa geographically illustrate the evolution and development of Portuguese architecture in India, subsequently influencing other Portuguese colonies in Asia. Saint Francis Xavier, one of the founders of the Society of Jesus, a religious order of the Catholic Church headquartered in Rome, reached Goa in 1542 to spread Christianity, and brought in new ideas of architectural style to construct grand religious buildings with large columns, decorated pediments, gilded altars and colourful frescos. The churches and convents of Goa operated in an Indian setting, built by local artisans using indigenous material while reflecting distinct Portuguese Catholic customs and traditions. Some churches and convents were dedicated to Catholic patron saints favoured by the religious orders of Franciscans, Jesuits, Dominicans and Augustinians.

The Chapel of St. Catherine was built to commemorate the triumphant entry, on St. Catherine's Day, of Afonso de Albuquerque into Goa. It was granted the status of a cathedral by Pope Paul III in 1534 and was subsequently rebuilt.

To mark a military victory, Afonso de Albuquerque also built Se Cathedral, the largest church in Asia, which took eighty years to build and was completed in 1652. One of the cathedral's five bells is the famous Golden Bell, used during the sixteenth century.

The Church of St. Francis of Assisi was established by eight Portuguese Franciscan friars in 1517 and dedicated to the patron saint of Italy, Francis of Assisi. It was consecrated in 1602, and the present-day church is a reconstruction from 1661 with ornamented interiors in Baroque style.

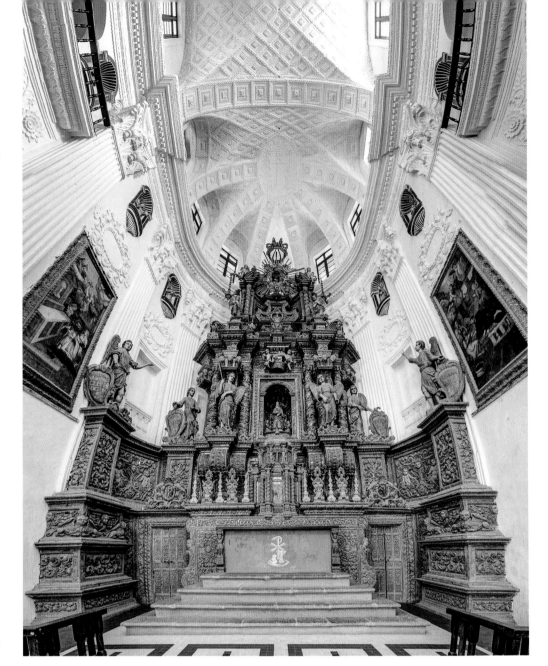

The beautiful interiors of St. Cajetan Church, said to have been modelled on St. Peter's Basilica in Vatican City, under the patronage of Cosimo III de' Medici.

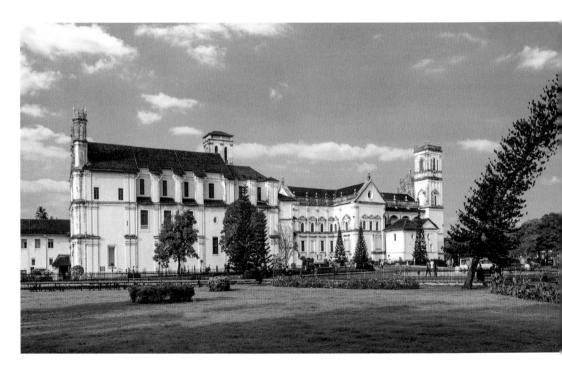

The Church of Our Lady of the Rosary was built in 1549 as a token of gratitude to the Virgin Mary. It is characterised by high-altitude windows that lend it the impression of a fortress, with fantastical use of ornamentation.

The Church of St. Augustine was established by twelve Augustinian friars in 1572. The historic building stands today in the ruins of a four-storey, 46-metre-high bell tower. Fallen bricks and mortar surrounding the tower only hint at the earlier grandeur of this church.

The Basilica of Bom Jesus has the mortal remains of Saint Francis Xavier, the Jesuit who lived and worked in Goa. Buried and exhumed twice, in China and Malacca, his mummified body is laid out in this basilica, constructed in 1605. To this day, he is the patron saint of many villages in Goa, and people feel protected by the fact that his body is amidst them.

The Church of Divine Providence, or St. Cajetan Church, is named after Saint Cajetan of Thiene, who founded the Theatine order in 1524. It was built in 1661 by Italian Theatine friars, and its hemispherical dome reflects the inspiration from St. Peter's Basilica, Rome. This chapel is a radiant symbol of the accomplishments of Italian friars in Old Goa.

These churches and convents of Goa were influential in spreading new forms of art, architecture and religious orders, and are the assimilation of Manueline, Mannerist and Baroque styles with local practices. In 1986, they were collectively inscribed as a World Heritage Site. The serial property is protected and regulated by the Planning and Development Authority (Development Plan) Regulations (1989, 2000). It is also managed and protected at the national level by the ASI. •

Rohit Jigyasu, with inputs from Richa Pandey Dwivedii

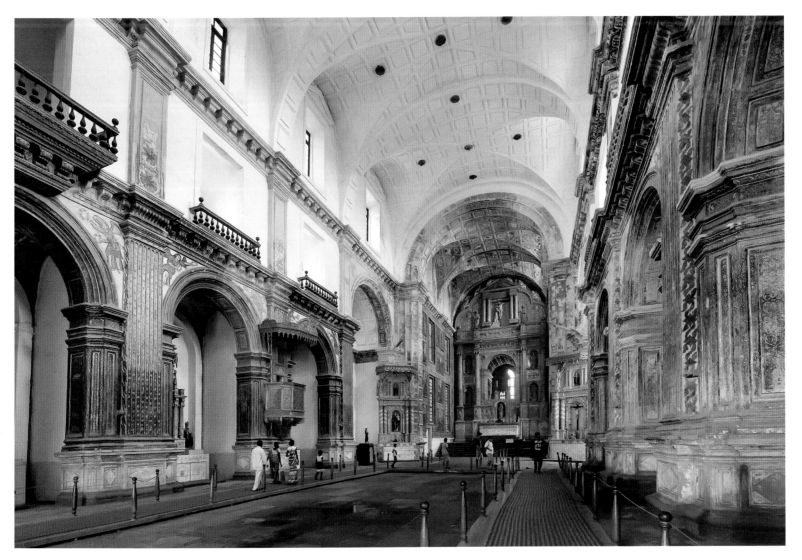

ABOVE AND FACING PAGE BELOW: The convent adjoining the Church of St. Francis of Assisi now houses the Museum of Archaeological History. The interiors of the church itself feature lavish sculptures and paintings depicting scenes from the life of St. Francis of Assisi.

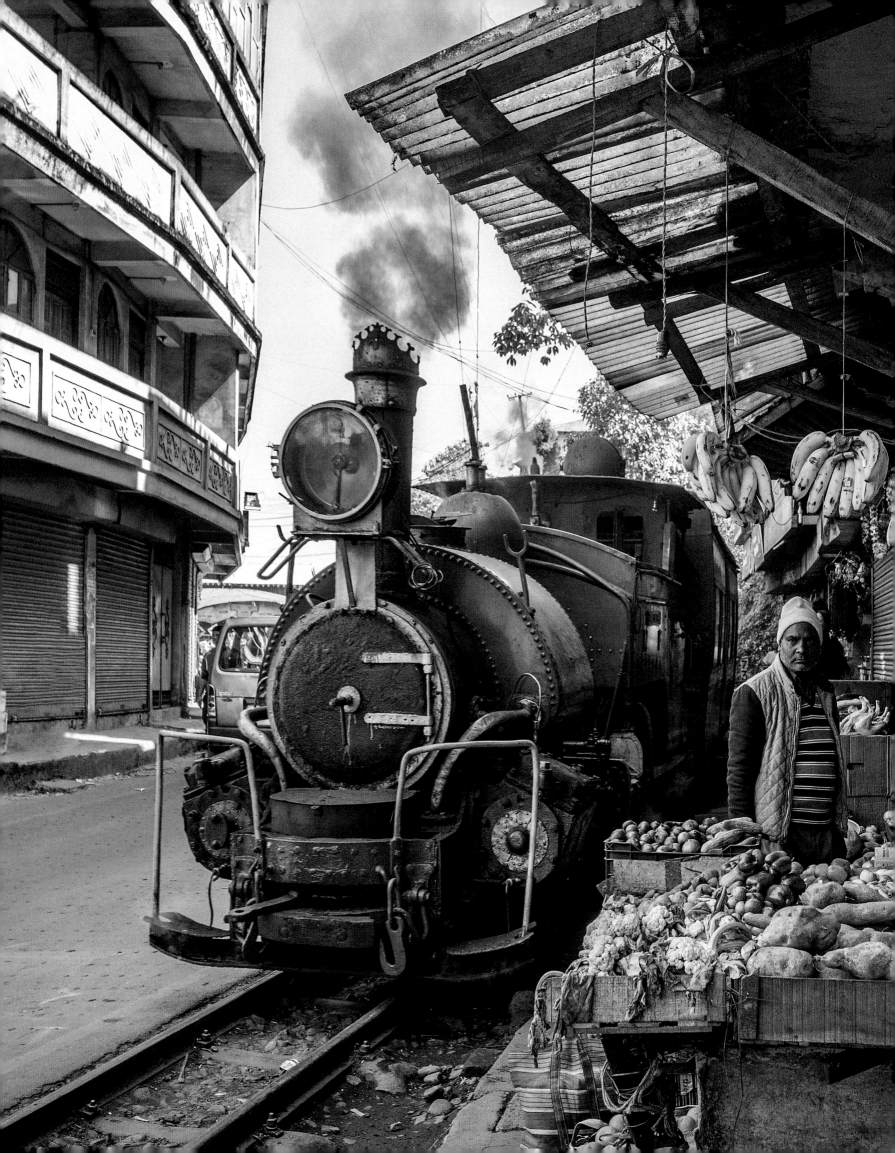

Mountain Railways of India

LOCATION: Shimla, Nilgiris and Darjeeling, India (serial national site)

COORDINATES: N11 30 37.008 E76 56 8.988

DATE OF INSCRIPTION: 1999 (Extension: 2005, 2008)

CATEGORY: Cultural (Serial Site)

OUTSTANDING UNIVERSAL VALUE

The Darjeeling Himalayan Railway, opened in 1881, was the first example of a hill passenger railway, and is still the most outstanding. The Nilgiri Mountain Railway, completed in 1908 and scaling an elevation of 326–2,203 metres, represented the latest technology of the time. The Kalka-Shimla Railway, built in the mid-nineteenth century, is emblematic of the technical and material efforts to dis-enclave mountain populations. All three railways are well maintained and remain fully operational examples of bold and ingenious engineering solutions to the problem of establishing effective rail links across mountainous terrains.

CRITERIA: (ii) (iv)

(ii): These railways are outstanding examples of the interchange of values on technological developments and the impact of an innovative transportation system on the social and economic development of a multicultural region.

(iv): These properties are outstanding examples of a technological ensemble, representing different phases of development in high-altitude areas.

Machine meets Man: A unique attribute of the Darjeeling Himalayan Railway are its narrow passageways through towns, offering close encounters with this multi-cultural region's people and their activities.

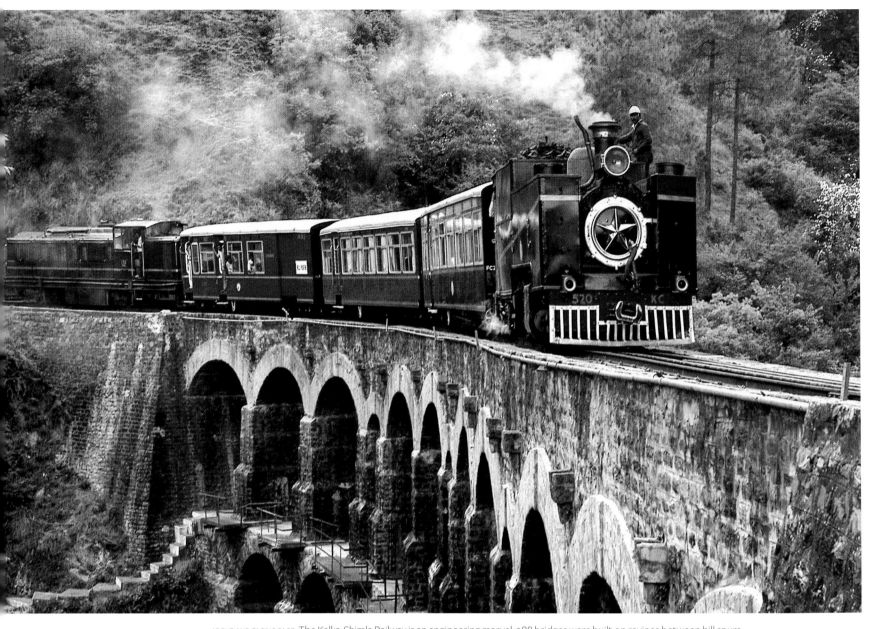

ABOVE AND FACING PAGE: The Kalka-Shimla Railway is an engineering marvel; 988 bridges were built on ravines between hill spurs during its construction. It offers a thrilling snow-bound journey in winter.

There are five examples of mountain railways across India, three among which are inscribed as a serial property. The remaining two, the Matheran Light Railway, in Maharashtra, and the Kangra Valley Railway, in Punjab and Himachal Pradesh, have been proposed as an extension to the already inscribed series, which are the Darjeeling Himalayan Railway, the Nilgiri Mountain Railway and the Kalka-Shimla Railway. All these were built during the British Raj to facilitate colonial control and administration over

India, although, ironically, these very railway connections were used strategically by Mahatma Gandhi to spread the ideals of freedom and overturn British rule.

Construction of the 61-centimetre gauge Darjeeling Himalayan Railway, India's celebrated Toy Train and the world's first steam-propelled hill passenger railway, started in 1880. It owes its origin to the development of Darjeeling as the main tea-growing area in British India and the failure of the then-existing rudimentary

road transport to cope with the increased traffic. The 88.48-kilometre-long journey from Siliguri to Darjeeling passes through a varied natural landscape, mesmerising its passengers with scenic views of agricultural tracts, dense forests, tea gardens and the splendid snow-capped Khangchendzonga Range. The Toy Train repeatedly crosses the Hill Cart Road, its narrow passageway through the towns offering, en route, close, amusing encounters with their residents' daily life. The most famous station on the line is Ghoom, which, at an altitude

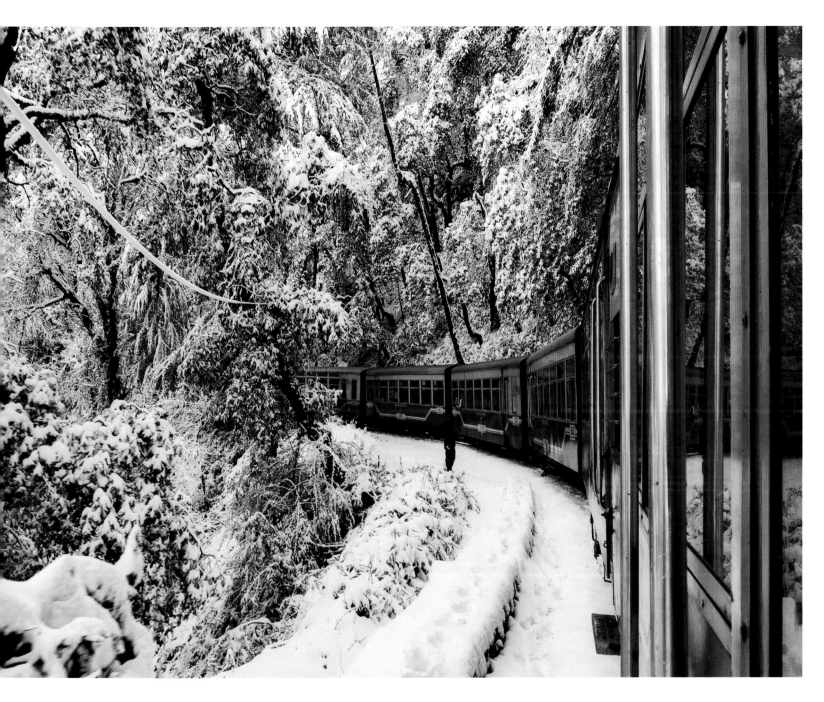

of 2,258 metres, is the second-highest railway station in the world. The Darjeeling Himalayan Railway uses sinuous curves, including the hairpin turn between Sukna and Rongtong, to wind its way uphill through the steep mountainous region. The engineers also designed six reverses and three loops on the line, the most famous of these being the Batasia (32) Loop between Ghoom and Darjeeling.

The Nilgiri Mountain Railway, constructed between 1891 and 1905, is the shortest of the series, merely 45.88 kilometres long. This is a metre-gauge, single-track railway, connecting Mettupalayam to Udagamandalam (Ooty), once the summer capital of the Madras Presidency and a British hill resort. The variety of landscapes that passengers on board the Nilgiri Mountain Railway get to enjoy range from betel-nut plantations and an almost uninhabited tropical jungle on steep slopes to the eucalyptus and acacia forests planted by the British. Though built to substitute laborious pony tracks then used for transporting men and materials, this railroad also helped connect the indigenous tribes to the urban mainstream. As one of the largest and most authentic rack-and-pinion railways in the world, also adopting the Abt rack system from Austro-Hungarian and Swiss examples, the Nilgiri Mountain Railway is a highly significant chapter of India's engineering history. Special braking systems and locomotives were designed to negotiate the steep gradients and hostile weather conditions. Today, it is the world's

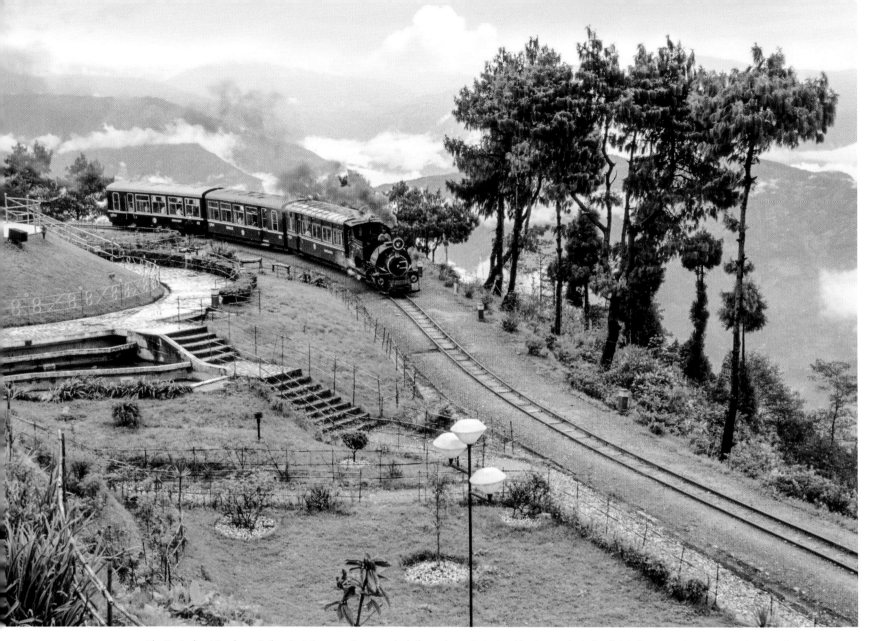

The Darjeeling Himalayan Railway's picturesque journey winds through a varied natural landscape, including fields, forests and snow-capped mountains.

A vintage photograph of the Batasia Loop near Ghoom on the Darjeeling Himalayan Railway.

largest and most authentic steam-rack locomotive fleet. Since brakesmen are also stationed in individual wagons to operate friction and rack brakes on whistle codes from the driver, the passengers are directly exposed to the Nilgiri Mountain Railway's unique technology. Most of it remains as built, especially the signalling system, the cash boxes and ticket racks. Even the original ticketing system, using Edmondson card tickets, continues to be used.

The longest but the least steep of the series is the roughly 100-kilometre-long narrow-gauge Kalka-Shimla Railway. It was constructed from 1899–1903 to connect Kalka, at the foothills of the Shiwalik Hills, to Shimla, the erstwhile summer

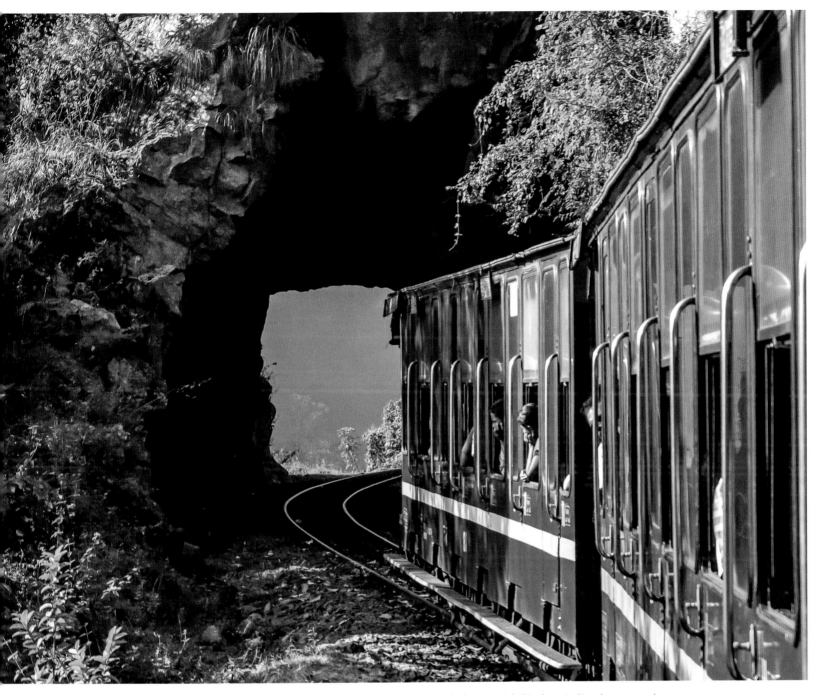

The Nilgiri Mountain Railway traverses a variety of landscapes, including an uninhabited tropical jungle on steep slopes.

capital of the British Government, adding comfort and convenience to their annual movement from Kolkata. With other global examples of similar narrow-gauge adhesion mountain lines being just around 10 kilometres long, the Kalka-Shimla Railway is indeed unique. With two-thirds of the line running through exceptionally challenging mountain terrain and climatic conditions, it became an ambitious undertaking deploying experimental constructions and traction techniques. The journey was made possible through the construction of almost a thousand bridges and viaducts, some with multi-level, multi-arch galleries, and over a hundred tunnels, including one as long as 1,143 metres. The Kalka-Shimla Railway halts at twenty-one railway stations built in the charming style of colonial hill architecture. Four of the original four-wheeled carriages and several bogie-type carriages of 1910, as well as steam engines and a luxurious saloon car built in 1912, are still in use.

The serial site of the Mountain Railways of India is managed by the Department of Railways, who are also responsible for preparing and implementing an effective management plan for this site. •

Kiran Joshi

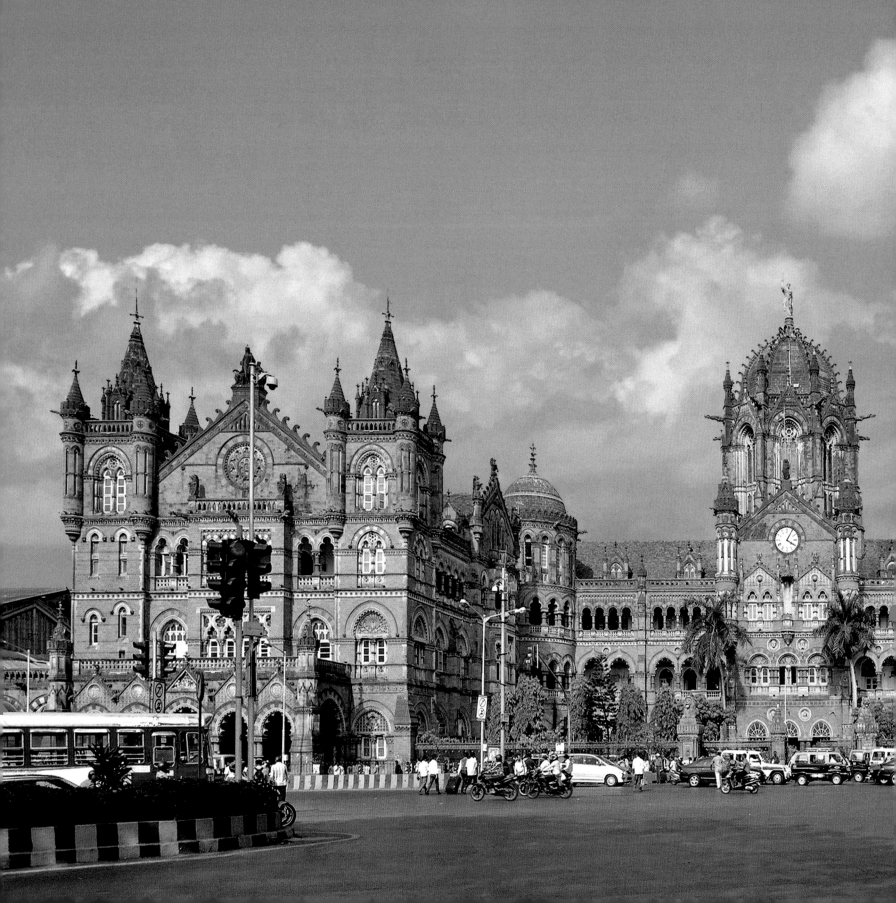

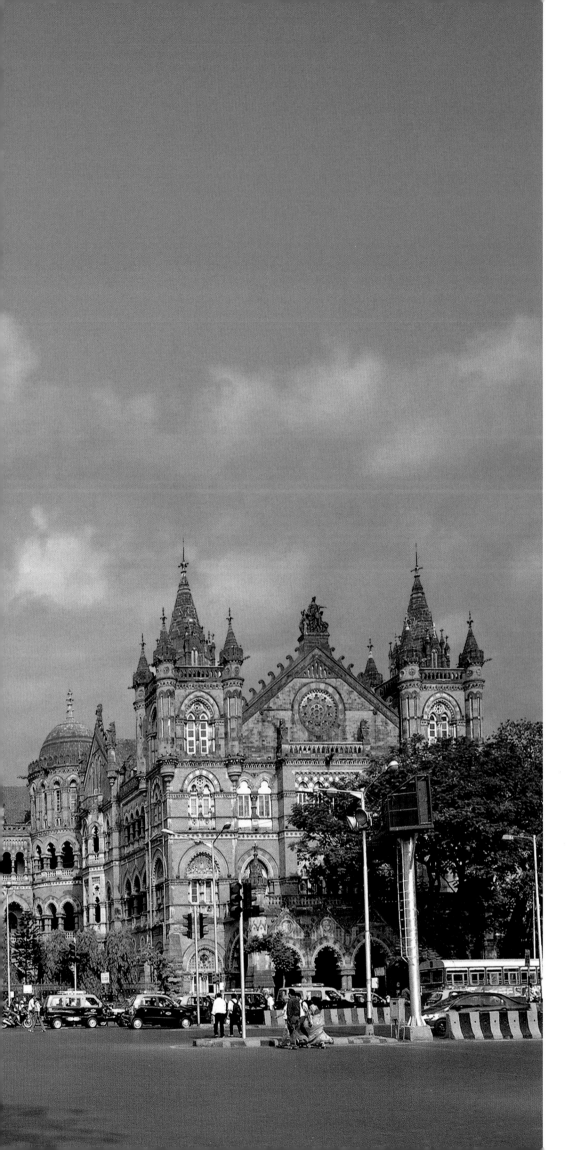

Chhatrapati Shivaji Terminus
(formerly Victoria Terminus)

LOCATION: Maharashtra, India

COORDINATES: N18 56 24.44 E72 50 10.33

DATE OF INSCRIPTION: 2004

CATEGORY: Cultural (Monument)

OUTSTANDING UNIVERSAL VALUE

The Chhatrapati Shivaji Terminus, formerly known as Victoria Terminus, in the city of Mumbai, is an outstanding example of Victorian Gothic Revival architecture in India, blended with themes deriving from traditional Indian architecture. The building became the symbol of Bombay (now Mumbai) as the "Gothic City" and the major international mercantile port of India. The terminal was built over ten years, starting in 1878, and is an outstanding example of the meeting of two cultures, as British architects worked with Indian craftsmen, thus forging a new style unique to the city.

CRITERIA: (iii) (iv)

(ii): The Chhatrapati Shivaji Terminus exhibits an important interchange of influences from Victorian Italianate Gothic Revival architecture and from traditional Indian buildings.

(iv): It is an outstanding example of railway architecture in the British Commonwealth in the late nineteenth century.

The imposing façade of the Chhatrapati Shivaji Terminus has typical Victorian Gothic features, with a grand central dome, pointed arches, coloured stones and stained-glass windows.

Inside the Chhatrapati Shivaji Terminus, a large stone lion displays the coat of arms of the Great Indian Peninsula Railway, now Central Railway, headquartered here.

appointed as an engineer by the Great Indian Peninsula Railway to design and rebuild a new terminus at the Bori Bunder railway station, envisaged to become a hub and the administrative headquarters of Bombay's railway systems. Upon completion in 1888, it was named Victoria Terminus, after the reigning queen. Almost eleven decades later, the city and the people reclaimed the Terminus; it is now the Chhatrapati Shivaji Maharaj Terminus, named after the seventeenth-century icon of Maharashtra and founder of the Maratha Empire, Shivaji Maharaj.

The architectural style is latter-day Gothic. Local materials and craftspeople helped adapt the style and technique to something more appropriate to the environs of the rapidly growing city. The overall effect, as East met West, was aesthetically pleasing as well as functional. Every day, travellers and city folk stop to stare and take in the vaulted ceilings, arches, buttresses and stained-glass windows. The Terminus is one among the ensemble of remarkable Gothic buildings constructed in the second half of the nineteenth century.

The amalgamation of Victorian Gothic revival and traditional architecture in the Terminus represents harmony, totality and indigenous embellishment. The design is rich in symmetry and proportion, drawing inspiration from Indian temple architecture. The rich interiors contain ornate decorations, with an emphasis on vertical elements and natural light. The use of stained-glass windows and coloured stone creates a striking effect. The ceilings of this historic building are high, giving a sense of expansive space such that, even when there is heavy traffic and the hallways are crowded, passengers do not feel claustrophobic. Other notable features

For centuries, Bombay (renamed Mumbai) has been a vibrant centre of commerce, finance and industry, one that inevitably attracted migrants from all over the Indian subcontinent. Not long after the first iron horses made their appearance in 1853, it was apparent that a railway terminus was needed—functional and imposing, unmistakeably colonial in appearance and intent—one that would reflect the perceived grandeur of the British Empire.

In 1876, Queen Victoria assumed the title and throne of Empress of India. That same year, Frederick William Stevens was

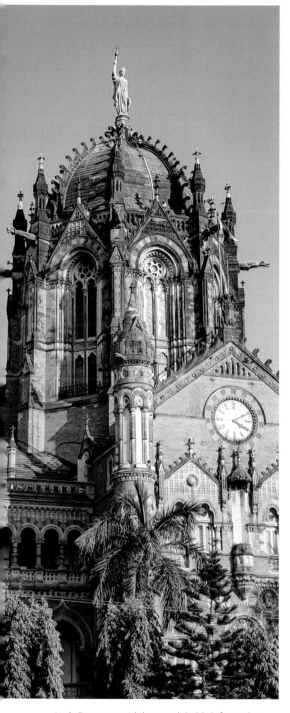

Lady Progress, with her torch held aloft, on the
dome of the Terminus.

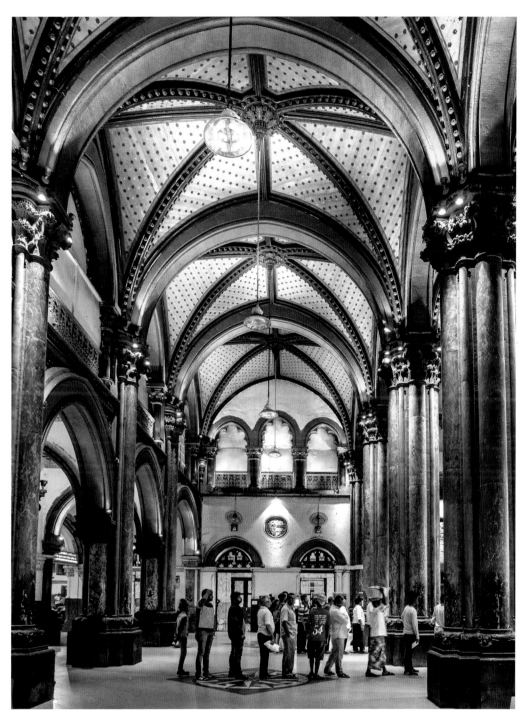

Passengers wait in line for a train at the Chhatrapati Shivaji Terminus, making it not only a World Heritage Site but
also the nerve centre connecting various parts of Mumbai city.

are the gargoyles, which are seen adorning
all corners of the building. Tropical
animals mitigate the European effect and
reflect Anglo-Indian architecture.

At the apex of the central dome is a
colossal statue, more than 16 feet high,
of a lady holding a flaming torch pointed
upwards in her right hand and a spoked

wheel low in her left; together they
symbolise progress. The two columns at
the entrance, with a lion and a tiger at the
top, represent an amalgam of British and
Indian culture.

The Chhatrapati Shivaji Terminus was
inscribed as a World Heritage Site in
2004, and is one of the few such sites

in India that are still in active service.
The monument is protected by heritage
legislations of local bodies in Mumbai,
while the property is managed by the
Ministry of Railways. ●

Rohit Jigyasu, with inputs from **Richa Pandey Dwivedii**

Victorian Gothic and Art Deco Ensembles of Mumbai

LOCATION: Maharashtra, India

COORDINATES: N18 55 47.3 E72 49 48.3

DATE OF INSCRIPTION: 2018

CATEGORY: Cultural (Urban Ensemble)

OUTSTANDING UNIVERSAL VALUE

Having become a global trading centre, the city of Bombay (now Mumbai) implemented an ambitious urban planning project in the second half of the nineteenth century. It led to the construction of ensembles of public buildings bordering the Oval Maidan open space, first in the Victorian Neo-Gothic style and then, in the early twentieth century, in the Art Deco idiom. The Victorian ensemble includes Indian elements suited to the climate, including balconies and verandahs. The Art Deco edifices, with their cinemas and residential buildings, blend Indian design with Art Deco imagery, creating a unique style that has been described as Indo-Deco. These two ensembles bear testimony to the phases of modernisation that Mumbai underwent in the course of the nineteenth and twentieth centuries.

CRITERIA: (ii) (iv)

(ii): Both these ensembles exhibit an important exchange of European and Indian human values.

(iv): These ensembles reflect developments in architecture and urban planning over two centuries, culminating in two major urban expansions of Mumbai, which led to the city becoming an internationally important mercantile city of the twentieth century, up to the present.

The Chhatrapati Shivaji Maharaj Vastu Sangrahalaya (formerly the Prince of Wales Museum) is an outstanding example of the Indo-Saracenic style of architecture. The foundation stone for this museum was laid by the Prince of Wales (later King George V) in 1905.

Spread over less than one square kilometre (0.66 square kilometres), the irregularly shaped Victorian Gothic and Art Deco Ensembles are located within two heritage zones, the Fort Precinct and the Marine Drive Precinct, in South Mumbai. The Ensembles were developed as a consequence of the flourishing cotton trade in the mid-nineteenth century, which invited an influx of wealth and the launch of ambitious urban planning, including land-reclamation schemes.

The geographic and symbolic locus of the property is the large, north-south oriented Oval Maidan, created in the mid-nineteenth century after the demolition of Bombay Fort's ramparts. The Oval is flanked by a group of nineteenth-century Victorian Gothic public buildings to its east. The Oval also has some independent structures located to its north, while some

The Victorian Gothic library of the University of Mumbai.

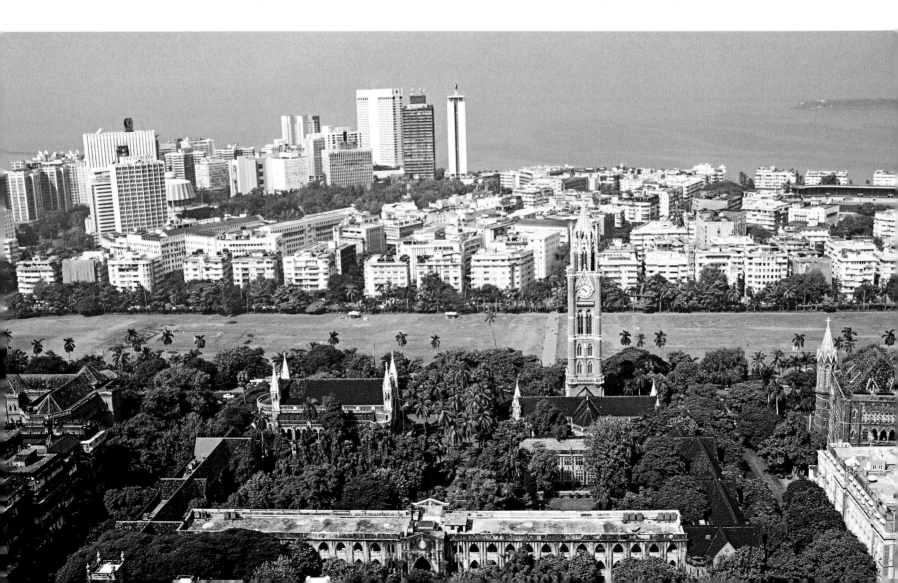

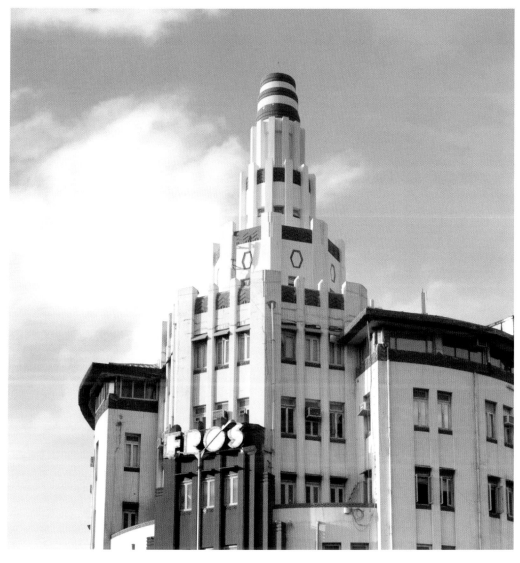

Eros Cinema, a movie theatre in the Art Deco style in Mumbai, noted for its grand lobby and lavish staircases.

roofs, verandahs, balconies and Indian motifs and sculptures of Indian men in traditional costumes. The profusely ornate Indo-Saracenic architecture was devised around the turn of the twentieth century to create a pan-Indian style. It blends modern design with motley architectural features such as domes, *chattri*s, *jaali*s and *jharokha*s, which are largely derived from Mughal and Rajput precedents. It became popular in the dominant princely states and major urban centres. The façades of Neoclassical buildings are characterised by classical elements such as round arches, pediments, Corinthian columns, double-height pilasters and classical motifs over openings. The Art Deco buildings, considered pioneers of the style in India and constructed during the 1930s and 1940s, introduced modern materials and building typologies. The use of reinforced concrete enabled high-rise buildings and free forms, which were particularly favoured for modern apartments, commercial buildings and new forms of entertainment such as cinemas. Indian motifs, constructed in plaster and locally available wood, marble, tiles and terrazzo, on Mumbai's Art Deco architecture gave rise to a unique variation of the style, also referred to as "Mumbai Deco".

others are located towards its southeast. A cohesive row of Art Deco buildings, the first in India, were built in the 1930s to line the opposite, western edge of the Oval Maidan. The 1940s saw this group's extension, through a short perpendicular artery, to a dense cluster along the Marine Drive. All were designed by Western-educated Indian architects and reflect the major societal modernisation of the city, including the growth of the middle class and the introduction of the notion of living in apartments.

The Ensemble contains ninety-four historic buildings designed in four distinct styles, accommodating various activities and representing the functional and formal modernisation of the city. The nineteenth-century Victorian Gothic buildings were constructed of igneous basalt from the Deccan Plateau, while the soft Porbunder limestone was used for carved ornament. Their forms fused Gothic Revivalist elements (turrets, spires, pointed arches, trefoils, gargoyles and vaulted ceilings) with the local vernacular of terracotta-tiled sloping

The Victorian Gothic and Art Deco Ensembles of Mumbai are fully functional, living properties, protected and managed by the Mumbai Metropolitan Region Development Authority. Given the intensity of urban development and environmental pressures in Mumbai, careful monitoring of the property is required. •

Kiran Joshi

FACING PAGE BELOW: The Oval Maidan is a historic cricket ground that continues to be used for recreational purposes. Its surroundings show Mumbai's two distinct styles, with its eastern edge flanked by a series of Victorian Gothic buildings from the nineteenth century and the western edge lined with Art Deco structures from the early twentieth century.

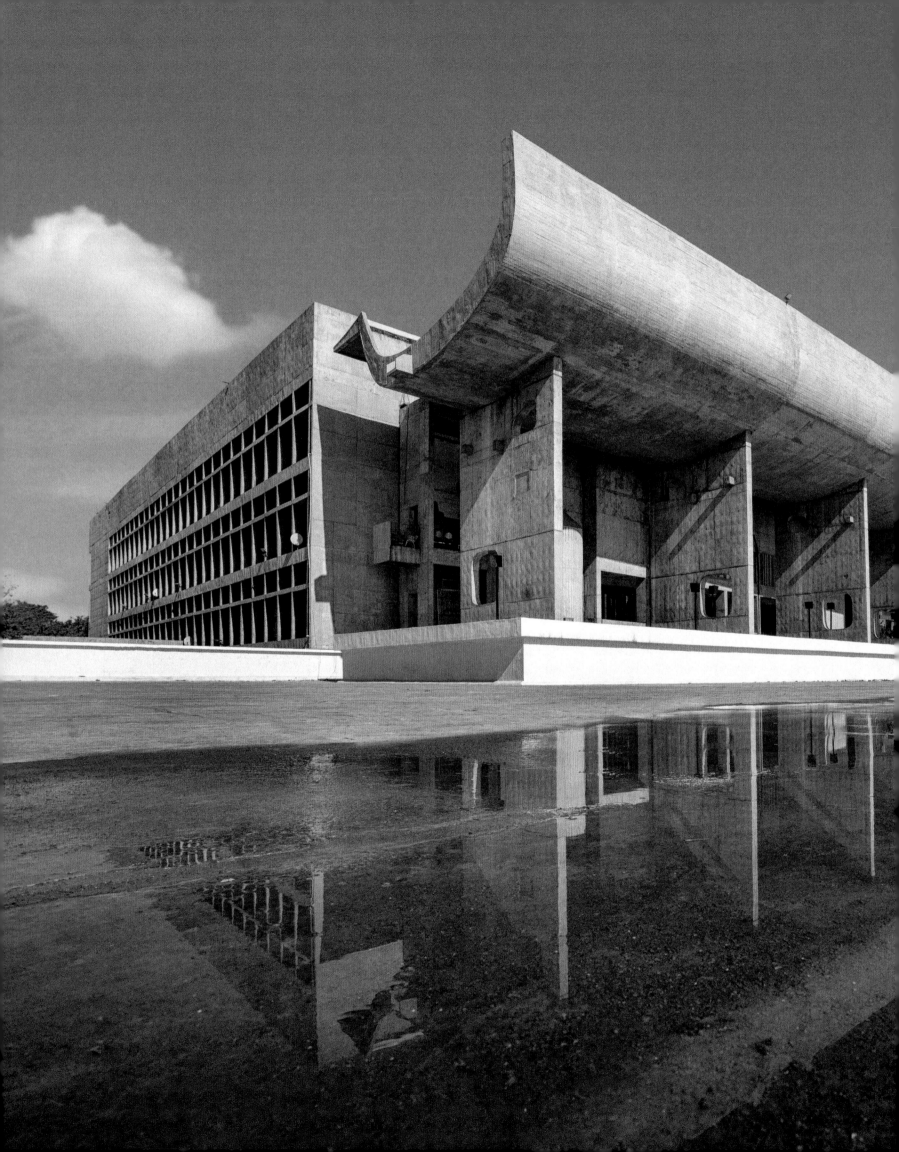

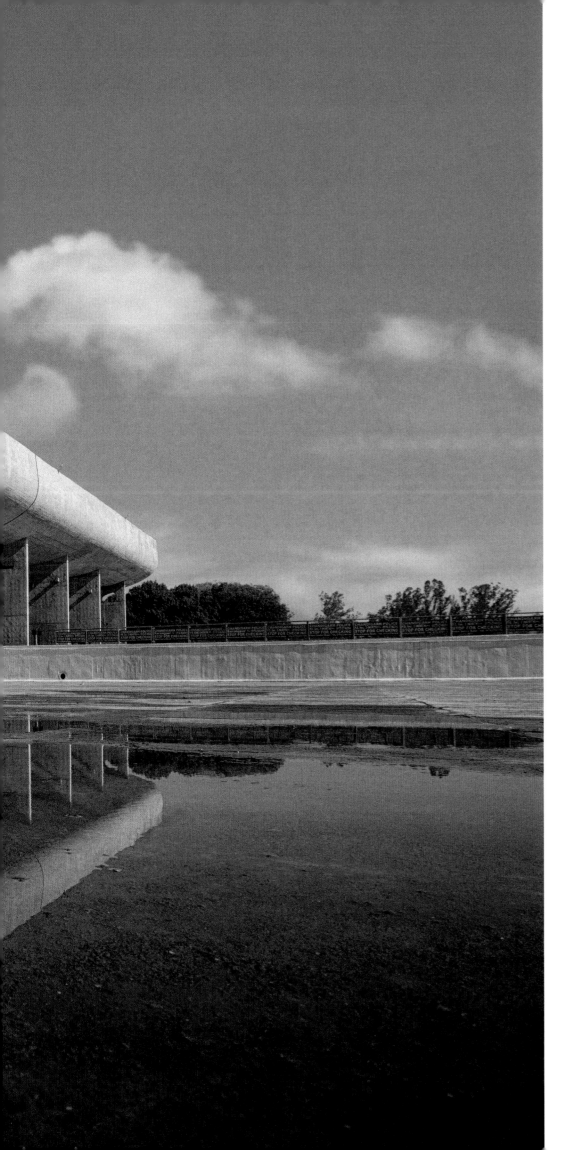

The Architectural Work of Le Corbusier,

an Outstanding Contribution to the Modern Movement

LOCATION: Chandigarh, India
 (serial transnational site)

COORDINATES: N46 28 6.29 E6 49 45.61

DATE OF INSCRIPTION: 2016

CATEGORY: Cultural (Transnational Serial Site)

OUTSTANDING UNIVERSAL VALUE
 Chosen from the work of Le Corbusier, the seventeen sites comprising this transnational serial property are a testimonial to the invention of a new architectural language that made a break with the past. The Capitol Complex in Chandigarh (India), like his other structures, reflects the architectural solutions that the Modern Movement sought to apply during the twentieth century to respond to the needs of society.

CRITERIA: (i) (ii) (vi)
(i): The properties represent a masterpiece of human creative genius, providing an outstanding response to certain fundamental architectural and social challenges of the past century.

(ii): The properties exhibit an unprecedented interchange of human values on a worldwide scale over fifty years, and also marks the birth of three major trends in modern architecture: Purism, Brutalism and sculptural architecture.

(vi): They are directly and materially associated with ideas of the Modern Movement, which possessed outstanding universal significance in the twentieth century.

The unconventional form of the Legislative Assembly in Chandigarh displays the immense potential of raw concrete. The reflecting pools were inspired by the Mughal-era gardens in Delhi and Pinjore.

The loss of Lahore after India's independence and partition in 1947 prompted the founding of Punjab's capital city of Chandigarh and its *raison d'être*, the Capitol Complex. Symbolising the celebration of democracy by the newly independent India and its march towards modernity, the Capitol was conceived as a monumental place of prestige. The search began, as reported by Norma Evenson, for "a good modern architect who was not severely bound by an established style and who would be capable of developing a new concept originating from the exigencies of the project itself and suited to the Indian climate, available materials and the functions of the new capital". Starting with the team of the American planner Albert Mayer and the Polish architect Matthew Nowicki, the trail ultimately led to the revolutionary Swiss-French architect Le Corbusier and his three associates.

Though remaining the "spiritual director" of the entire enterprise, Le Corbusier's abiding contribution to the city is the Capitol Complex, the "head" of the city, befittingly located at Chandigarh's northern top against the backdrop of the Shiwalik Hills. It was conceived as a cohesive group of four Edifices and six Monuments, all arranged within a park-like environment, visually connected through an invisible geometry of interlocking squares, the consistent use of exposed concrete, indigenous construction techniques and non-mechanical systems of climate control. The three realised Edifices, i.e. the High Court, the Legislative Assembly and the Secretariat, embody the major functions of a democracy—decision-making, implementation and justice.

Construction began with the High Court. Completed by 1955, it immediately became

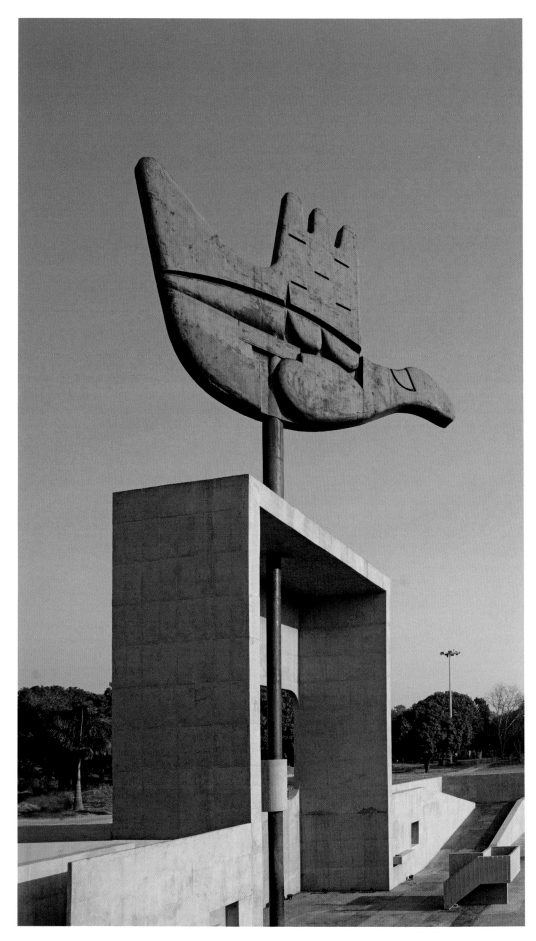

The *Open Hand* rotates with the wind: "Open to receive the created riches... open to distribute them to its people".

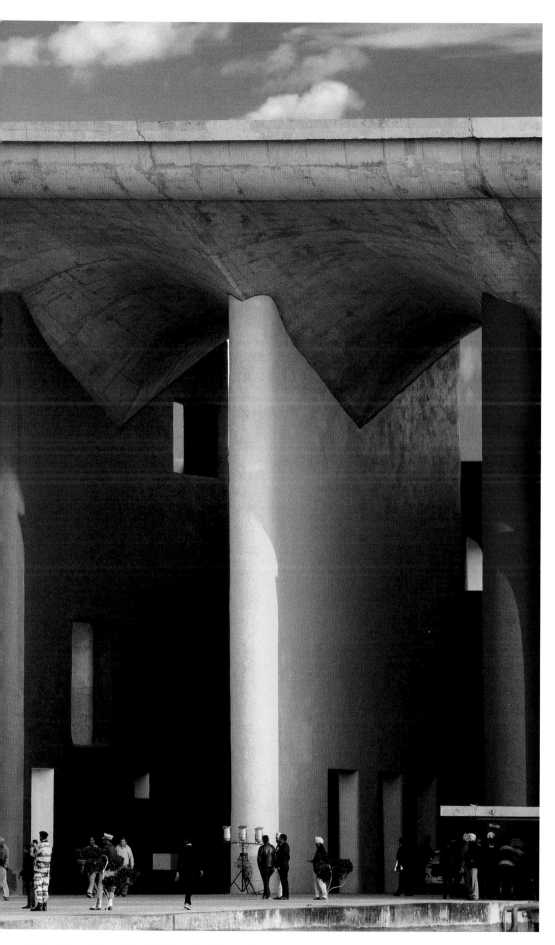

The entrance foyer of the High Court building in the Capitol Complex is marked by three grand concrete pillars. It has since become an iconic example of Corbusier's unconventional designs.

a modern architectural icon, visited by architects from the world over for its unconventional aesthetics, sculptural roof canopies and massive sun-breakers in exposed reinforced concrete. Nine large tapestries, woven in a workshop specially set up in Kashmir, added human interest to the stark interiors, their vibrant colours and stylised motifs symbolising justice and the local landscape.

The nine-storeyed Secretariat, the tallest structure in Chandigarh, pioneered the idea of prominently displayed pedestrian ramps for facilitating vertical movement without elevators. An elaborately shaded façade was devised to naturally cool the interior spaces, while the rooftop cafeteria and terrace garden allow social interaction between workers during office breaks.

The Legislative Assembly is the most elaborate structure of the group, amazing visitors with its avant-garde top-lit Forum; the sickle-shaped Portico; and the thin hyperboloid shell of the immense, column-free, circular Assembly Hall. The incredible play of light and colour in the interior spaces, the vibrant hues of the huge woollen tapestries, as also the monumental ceremonial enamel door personally painted by him, are all testimony to Le Corbusier's unmatched creative genius. The fourth Edifice, the Governor's Palace, later replaced by the Museum of Knowledge in the interest of democratic functioning, remains unrealised. The Edifices are also connected through pedestrian walkways, including the vast concrete esplanade between the High Court and the Assembly, also the stage for his six Monuments.

The Monuments are outdoor sculptures, expressing Le Corbusier's design precepts and the spirit of the new republic. The best

The ceremonial entrance gate of the Assembly Hall, as painted by Le Corbusier.

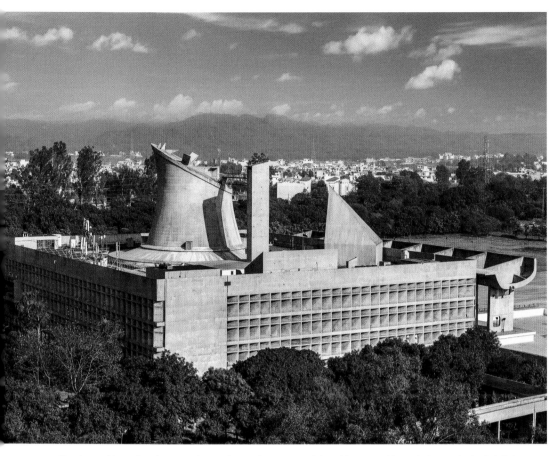

The Assembly Hall at the Capitol Complex, with its pyramidal roof forms and hyperbolic paraboloid skylights.

known is the monumental *Open Hand* that stands proudly above the "Trench of Consideration" to proclaim the city's ideology: "Open to receive the created riches… open to distribute them to its people". The unrealised *Modulor* was to contain the "Modulor Man", Le Corbusier's "harmonic measure to the human scale" illustrating the pervasive visual order of Chandigarh. The sculptures comprising the *Martyrs' Memorial* symbolised the fall of the British Empire and the rebirth of the spirit of the Indian people. The remaining three, *24 Solar Hours*, *Tower of Shadows* and *Course of the Sun*, together underscore the sun's influence on people's daily life and the challenges presented by the complex climate of Chandigarh.

Chandigarh's Capitol Complex is a fully functional heritage site, serving multiple stakeholders. The challenge lies in balancing the mounting demands for the modernisation of existing facilities with the critical need for conserving the authenticity of the Edifices, Monuments and the Esplanade, and their connections with the landscape. •

Kiran Joshi

The ceiling of the Assembly Hall, with amorphous acoustic panels on the inside of the hyperbola, and a skylight above it.

The Sylvan Landscapes of India
From the Himalayas and Eastern Forests to the Western Ghats

Sonali Ghosh and V. B. Mathur

"India has many huge mountains which abound in fruit-trees of every kind, and many vast plains of great fertility intersected by multitude of rivers... It teems at the same time with animals of all sorts—beasts of the fields and fowls of the air—of all different degrees of strength and size."

—J.W. McCrindle, *Ancient India As Described by Megasthenes and Arrian*, 1960

As per reports by the International Union for Conservation of Nature (IUCN), natural heritage sites cover more than 2.7 million square kilometres of land and sea, or over eight per cent of the world's total Protected Area. The reports also suggest that two-thirds of natural sites on the UNESCO World Heritage List are crucial sources of water; about half of them help prevent natural disasters such as floods or landslides; and over ninety per cent of listed natural sites provide employment and income from tourism and recreation. Globally, there is established evidence that natural heritage sites provide several benefits, besides being irreplaceable for sustaining biodiversity.

The natural formation of the highlands, lowlands, plateaus and forests of India is a result of the Earth's geological movements and the shifting of land masses some 270 million years ago. The land mass of India transformed into an island some 90 million years ago, finally shaping up into the present peninsular landscape around 55 million years ago, when it collided northward with the Eurasian plate. This collision pushed the Tethys seabed upwards, resulting in the formation of the Great Himalayas, a fact that is evidenced by the presence of marine fossils, shells and pebbles in the limestone beds of the Himalayas. Other natural and environmental factors, such as changes in sea levels, determined the peninsular coastline of India.

A historical perspective of these formations broadens our understanding of the rich natural beauty,

ecosystems and biodiversity of our country that has led to the recognition of seven natural World Heritage Sites till now.

The Great Himalayan National Park Conservation Area, in the western part of the Himalayan Range, is characterised by high alpine peaks, alpine meadows and riverine forests. The property, measuring 905 square kilometres, includes the upper mountain glacial and snowmelt sources of several rivers, and the catchments of water supplies that are vital to millions of downstream users. The Great Himalayan National Park Conservation Area protects the monsoon-affected forests and alpine meadows of the Himalayan front ranges. It is part of the Himalayan biodiversity hotspot and includes twenty-five forest types, along with a rich assemblage of faunal species, several of which are threatened. This gives the site outstanding significance for biodiversity conservation.

Nestled high in the western Himalayas, the Valley of Flowers National Park is renowned for its meadows of endemic alpine flowers and outstanding natural beauty. Its gentle landscape complements the rugged mountainous wilderness of the Nanda Devi National Park. Together, they encompass a unique transition zone between the mountain ranges of the Zanskar and the Great Himalayas, praised by mountaineers and botanists for over a century and in Hindu mythology for much longer. The Great Himalayan National Park Conservation Area and the Nanda Devi and Valley of Flowers National

Parks protect one of the largest expanses of Himalayan ecosystems that are critical for securing our glaciers and perennial rivers against the threat of climate change.

The Manas and Kaziranga forests in the northeast harbour species found in no other place in the world. On a gentle slope in the foothills of the Himalayas, where wooded hills give way to alluvial grasslands and tropical forests, the Manas Wildlife Sanctuary is home to a great variety of wildlife, including many endangered species, such as the tiger, pygmy hog, Indian rhinoceros and Indian elephant. The Kaziranga National Park is inhabited by the world's largest population of the one-horned rhinoceros, as well as many mammals, including tigers, elephants, panthers and bears, in addition to thousands of birds.

The Sundarbans National Park, on the eastern borders of the country, covers the largest expanse of mangroves in the world, thereby providing food and shelter to millions. The Sundarbans covers 10,000 square kilometres of land and water (at least forty per cent of it in India, the rest in Bangladesh) in the Ganges delta.

The Keoladeo National Park reminds us that charismatic transcontinental migratory birds do require breeding and refuelling refuges that transcend national boundaries. This former duck-hunting reserve of the Rajput kings is one of the major wintering areas for large numbers of aquatic birds from Afghanistan, Turkmenistan, China and Siberia. Some 364 species of birds, including the rare Siberian crane, have been recorded here.

Older than the Himalayan mountains, the mountain chain of the Western Ghats represents geomorphic features of immense importance, with unique biophysical and ecological processes. The site's high-montane forest ecosystems influence the Indian monsoon weather pattern. Moderating the tropical climate of the region, the site presents one of the best examples of the monsoon system on the planet. It also has an exceptionally high level of biological diversity and endemism and is recognised as one of the world's eight "hottest hotspots" of biological diversity.

This site includes some of the best representatives of non-equatorial tropical evergreen forests and are home to at least 325 globally threatened species. It is not only for these wild elements that these natural sites are of importance but also for the survival of all humankind, as almost all of them host a number of wild relatives of our domesticated varieties of crops and livestock genes. The sites also provide protection and management to other internationally designated sites and may overlap in their combined values of being a Biosphere Reserve, an Important Bird Area, a Ramsar Wetland of International Importance, and a Key Biodiversity Area.

India's seven natural World Heritage Sites truly represent the spirit of India's unparalleled conservation success story, complemented by our cultural ethos and values, in addition to our unique geographical location and exceptionally high elements of biodiversity. As India's finest biodiversity areas, these sites are further secured as National Parks and Sanctuaries under national legislation such as the Wild Life (Protection) Act, 1972 and the Biological Diversity Act, 2002.

Natural heritage sites offer a chance for peace and stability due to their transnational significance, and clearly demonstrate the soft power of species. They support nature-based solutions and protect healthy ecosystems, thereby buffering natural hazards and combating climate change by storing and capturing carbon. Beyond conservation, they also provide other essential services—clean water and air, carbon storage, genetic reservoirs of food, disaster mitigation and prevention, tourism and livelihood support. If well managed, these natural networks can provide connections across landscapes and transcontinental resilience against catastrophic events, including pandemics. Natural heritage sites also manifest cultural affirmation and a sense of pride for indigenous communities, thereby ensuring the nature-culture continuum over generations. Therefore, it is promising that, in addition to the existing sites that are practising model conservation approaches, India has proposed several other sites for consideration on the Tentative List.

◆

Great Himalayan National Park
Conservation Area

LOCATION: Himachal Pradesh, India

COORDINATES: N31 49 60 E77 34 60

DATE OF INSCRIPTION: 2014

CATEGORY: Natural

OUTSTANDING UNIVERSAL VALUE

The Great Himalayan National Park Conservation Area lies within the ecologically distinct western Himalayas at the junction between two of the world's major biogeographic realms, the Palaearctic and Indomalayan realms. The property protects the monsoon-affected forests and alpine meadows of the Himalayan front ranges, which sustain a unique biota comprising many distinct altitude-sensitive ecosystems. The diversity of species present is rich; however, it is the abundance and health of individual species' populations, supported by healthy ecosystem processes, where the Conservation Area demonstrates its outstanding significance for biodiversity conservation.

CRITERIA: (x)

(x): This property is located within a globally significant eco-region, providing habitat to a large number of threatened floral and faunal species and shielding them from the impacts of climate change.

Geometrical patterns come alive along the lush green tree gradient.

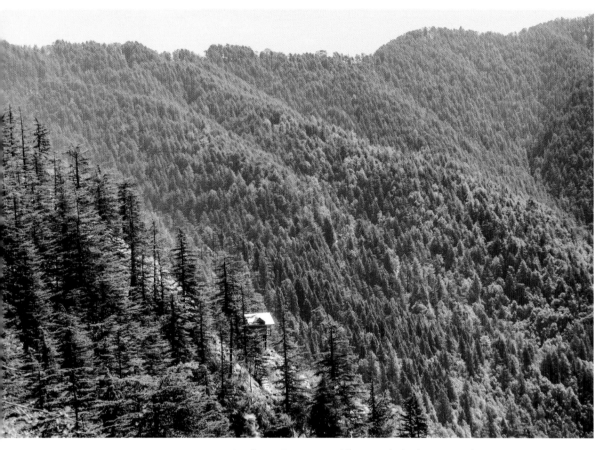

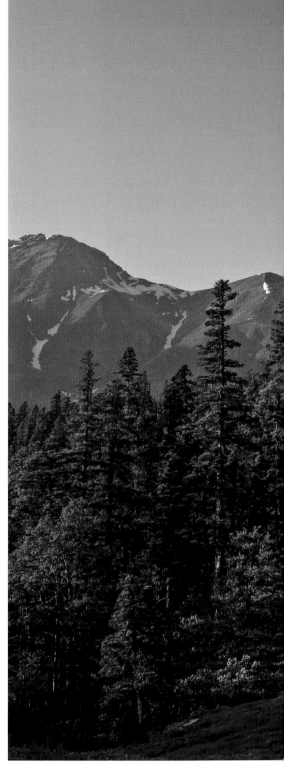

ABOVE AND RIGHT: Conifers, oaks, spruce and firs paint the landscape a verdant green.

The Great Himalayan National Park Conservation Area is located in the catchment of the Beas River in Himachal Pradesh. Its remoteness, ruggedness and inaccessibility have contributed to its preservation. The Himalayan peaks that turn golden in the morning sun infuse infinite channels of high cosmic energy during the day. From its snow-clad peaks and glaciers issue forth several perennial rivers, notably the Tirthan, Sainj, Jiwa and Parvati, which fall into the Beas River.

Its unique location at the junction of tropical and temperate, combined with a spectacular altitudinal gradient ranging from 1,300 to 6,000 metres, means that a diversity of habitat and species exist. These range from temperate oaks to pines, fir, spruce and birch in the valleys, along with alpine scrub and grass patches in the south-facing slopes.

Western tragopan, or *jujurana*, as it is known locally, is that beautiful bird of the pheasant family that enjoys a special place in every Himachali's heart. The *jujurana* is found in great numbers at the site, and folklore has it that it was conceived when the other birds donated one feather each; hence the array of colours and the title "the King of Birds"!

The astonishing floristic diversity of 832 plant species represents nearly a third of the flora of Himachal Pradesh. The stately deodars, blue pine and numerous *Abies* (fir) and *Taxus* (yew) species are the main conifers, whereas broad-leaf forests include oaks (*ban moru, kharsu*), horse chestnut, walnut, maple, alder, birch and ash. The tree line is mixed with sub-alpine scrub of rhododendron and juniper species. Alpine meadows have a preponderance of herbaceous, medicinal and aromatic plants preserved in their natural surroundings.

The mammalian fauna is just as diverse, with over thirty species, including the snow leopard, musk deer, blue sheep (*bharal*), Himalayan tahr, ibex, Himalayan brown bear and *goral*, the sure-footed mountain goat. There are five species from the pheasant family, and the largest

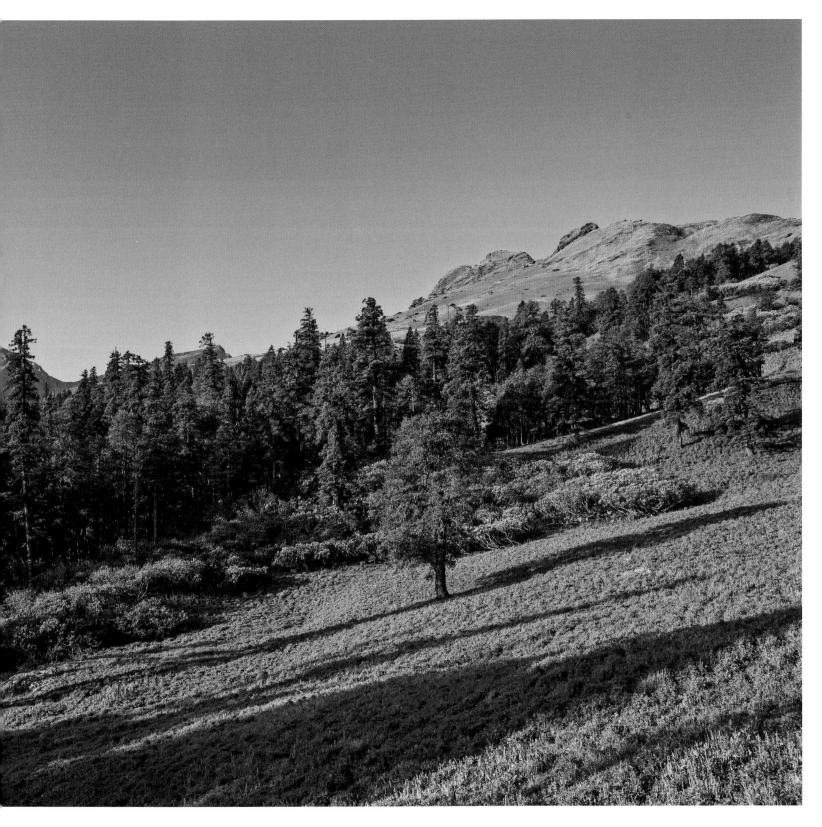

population of Western tragopan in the world. Other spectacular birds include the *cheer*, *monal*, *koklass* and *kaleej* pheasants and the snow partridge, hill partridge and the Himalayan snowcock, each inhabiting its own specialised niche along the vertical altitudinal gradient.

The landscape is a true wilderness area, and there is a need to progressively increase the size of the World Heritage property, as it is contiguous with the Rupi Bhaba Wildlife Sanctuary, the Pin Valley National Park and the Kanawar Wildlife Sanctuary. These areas together constitute the single-largest contiguous area (over 2,300 square kilometres) of pristine wildlife habitat in the northwestern Himalayas, undoubtedly worth preserving for generations to come. •

Sonali Ghosh

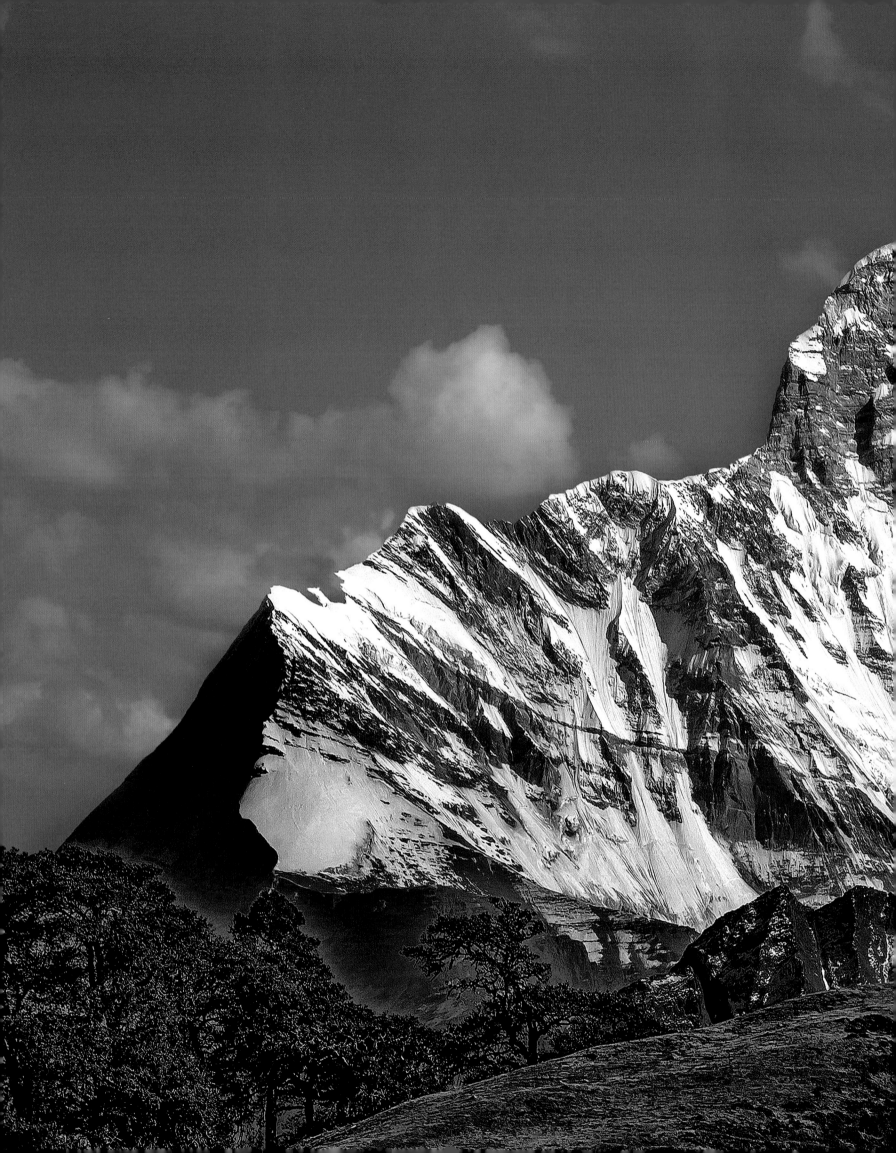

Nanda Devi and Valley of Flowers
National Parks

LOCATION: Uttarakhand, India

COORDINATES: N30 43 0.012 E79 40 0.012

DATE OF INSCRIPTION: 1988, Extension: 2005

CATEGORY: Natural

OUTSTANDING UNIVERSAL VALUE

This property consists of beautiful, high-altitude landscapes with outstanding biodiversity. The Nanda Devi National Park is dominated by the 7,817-metre peak of Nanda Devi, while the Valley of Flowers National Park features beautiful meadows of alpine flowers. Both parks contain high diversity and density of flora and fauna, with significant populations of globally threatened species. Due to minimal anthropogenic pressure, this property acts as a control site for the maintenance of natural processes, and is of high significance for long-term ecological monitoring in the Himalayas.

CRITERIA: (vii) (x)

(vii): The Nanda Devi National Park is renowned for its remote mountain wilderness, dominated by India's second-highest mountain and protected on all sides by spectacular topographical features, including glaciers, moraines and alpine meadows.

(x): The Valley of Flowers National Park holds significant populations of flora and fauna. It is important on account of its diverse alpine flora, representative of the West Himalayan zone.

The lofty peak of Nanda Devi, with forests and meadows in the foreground.

निचले हर शिखर पर देवल:
ऊपर निराकार तुम केवल...

Beneath each of the peaks are temples,
while you formless remain on top forever ...

For the poet Agyeya, Nanda Devi was so alluring that he wrote at least fourteen verses in praise of its ethereal beauty, and yet his heart yearned for more.

The twin-peaked massif of Nanda-Sunanda, the second-highest in the country, has captivated mountaineers, conservationists, poets and photographers. The people of the high Himalayas continue to revere the peaks and the surrounding landscape; numerous temples and shrines line the access way and nestle in their shadow. It is an arduous trek, traversing deep gorges along the Rishiganga and Goriganga Rivers, forested country and steep and stiff climbs.

More than three decades ago, the ecologically fragile landscape of the Nanda Devi National Park was closed to all, except scientists and wildlife researchers. Since then, the inner sanctuary has been almost entirely free of human interventions. Decadal ecological research expeditions have provided useful insights on the effectiveness of setting aside such wildernesses. The presence of the snow leopard, musk deer, Himalayan tahr, blue sheep and Himalayan black bear, as well as of a multitude of high-altitude aromatic and medicinal plants has also been reported.

Not far is the enchanting Valley of Flowers, a national park that was subsequently added to the nomination as a serial site. It is a botanical treasure trove of alpine flora, with as many as 520 species reported from the core zone. Each year post monsoon, nature's vibrant palette comes into play, and

the park is painted with a riot of colours as the numerous flowers come into joyous and synchronous bloom. There are the high-altitude primulas, poppies, daisies and anemones that carpet the ground, and rare flowering herbs such as *brahmakamal* and the medicinal *kutki*, *patish* and *hathpanja*, which are known to have therapeutic properties. Both the Nanda Devi and Valley of Flowers national parks have a large buffer zone, where the local communities eke out a livelihood from its

A satellite image captures the rugged terrain of the Nanda Devi National Park.

natural resources. This makes the entire region a living landscape where culture and traditions intertwine with nature.

Tourism is the biggest (and only) source of income here and there was a time when unregulated tourism and the resultant pollution became a looming threat to these ecologically fragile landscapes. Locals still live with evocative memories of flash floods and landslides that resulted in death and displacement in the Kedarnath Valley.

Localised eco-development activities that helped waste collection, segregation and safe disposal led to a remarkable turnaround. Similarly, pilgrims going to the Hemkund Sahib (a Sikh shrine), en route to the Valley of Flowers, have been sensitised towards adopting safer measures of waste disposal.

Places such as Nanda Devi and the Valley of Flowers remind us that reconstruction works being carried out must take into account the preservation of the delicate

natural elements as this is the only way forward for survival in the fragile Himalayas.

Sonali Ghosh

A lush carpet of Himalayan balsam paints the Valley of Flowers pink.

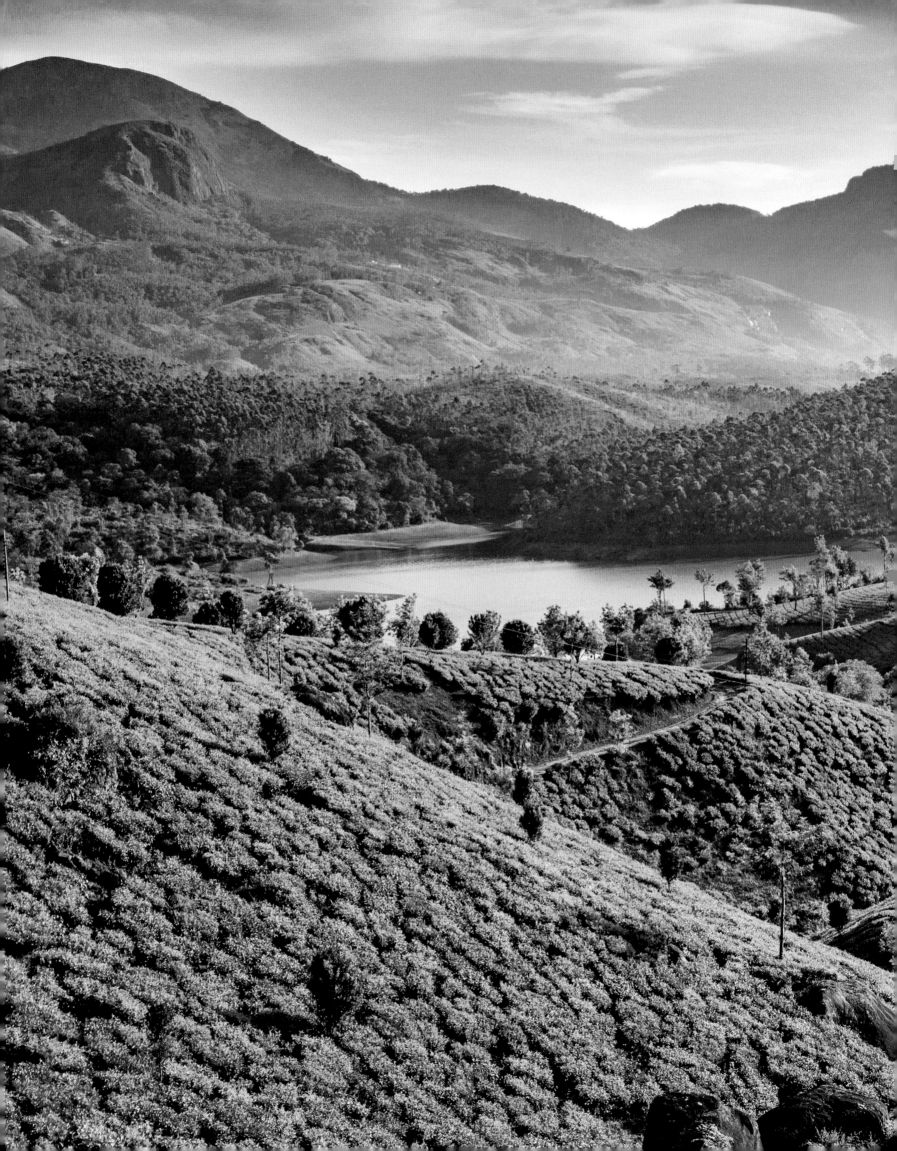

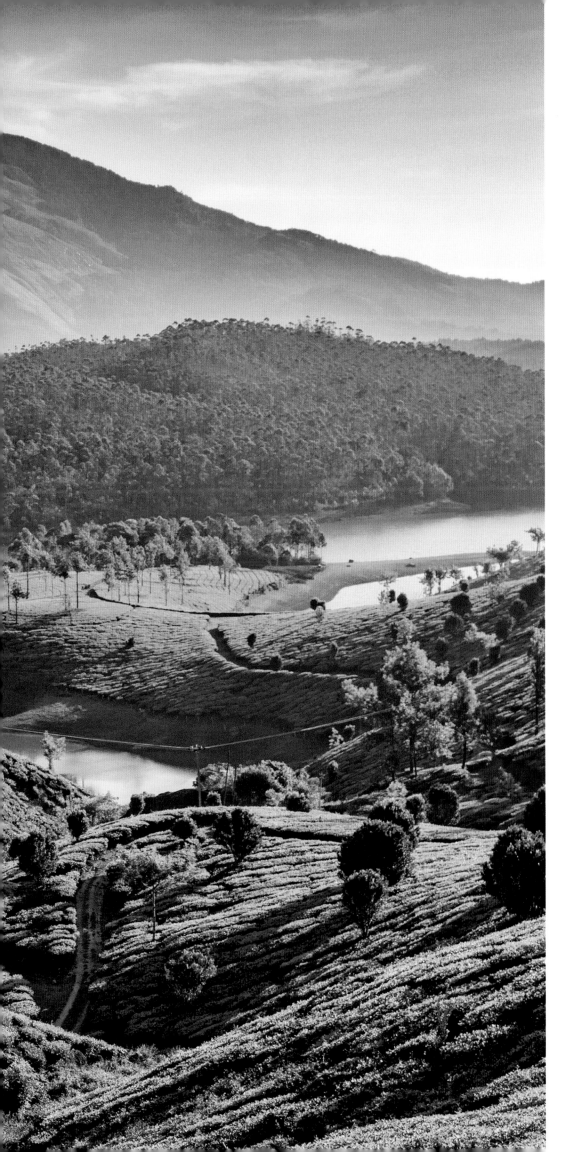

Western Ghats

LOCATION: 39 Serial Sites in Maharashtra, Karnataka, Tamil Nadu and Kerala, India

COORDINATES: N8 31 47 E77 14 59

DATE OF INSCRIPTION: 2012

CATEGORY: Natural

OUTSTANDING UNIVERSAL VALUE

A chain of mountains running parallel to India's western coast, the Ghats are older than the great Himalayan mountain chain. They influence Indian monsoon weather patterns that mediate the warm tropical climate of the region. A significant characteristic is their exceptionally high level of biological diversity and endemism, making them a region of immense global importance for nature conservation.

CRITERIA: (ix) (x)

(ix): The Western Ghats demonstrate, first, speciation related to the breakup of the ancient land mass of Gondwanaland in the early Jurassic period; second, the formation of India into an isolated land mass; and, third, the Indian land mass being pushed together with Eurasia. The Western Ghats are an "Evolutionary Ecotone" illustrating the "Out of Africa" and "Out of Asia" hypotheses on species dispersal and variance.

(x): The Western Ghats contain exceptional levels of plant and animal diversity and endemicity for a continental area.

Tea plantations in the hills of Munnar, with the Muthirappuzhayar River flowing serenely in the background.

Squirrelling together! Two Malabar giant squirrels (*Ratufa indica*) burrow close.

In 2012, India won a historic conservation milestone as a cluster of thirty-nine Protected Areas in four different states came together to be recognised as one! The road to success was complex and required a great deal of groundwork, including years of consultative processes to convince politicians, social scientists and ecologists to come together with the single objective of nature preservation under the umbrella of the World Heritage Convention.

As the World Heritage Committee meeting that year in St Petersburg, Russia, acknowledged, "[T]he Western Ghats forests include some of the best representatives of non-equatorial tropical evergreen forests anywhere and are home to at least 325 globally threatened flora, fauna, birds, amphibians, reptiles and fish species. Its ecosystems influence the Indian monsoon weather pattern. Moderating the tropical climate of the region, it presents one of the best examples of the monsoon system on the planet."

Older than the Himalayas, the Ghats (the name possibly derives from the Marathi word *ghat*, meaning "passage") are the longest chain of mountains running parallel to India's western coast. They extend from the Dangs (bamboo forests) on the Maharashtra-Gujarat border to cover an area of around 1,40,000 square kilometres in a 1,600-kilometre-long stretch that is interrupted only by the 30-kilometre Palghat Gap, along the border of Tamil Nadu and Kerala.

The designated sites include several Protected Areas, prominent among these being the Sahyadri cluster in Maharashtra, the Kudremukh cluster in Karnataka, the Mukurti-Kalakad-Mundanthurai cluster in Tamil Nadu and the Silent Valley-Periyar cluster in Kerala.

These Protected Areas are intensively managed by the forest departments in the four states to protect specific endangered and iconic species found nowhere else in the world. Besides displaying an exceptionally high level of biological diversity and endemism, the site is also known as a global biodiversity hotspot, where several wild and cultivated species originated and are currently subject to human-induced developmental threats and local extinction.

ABOVE: The monsoonal cascade of the Sathodi Falls in Karnataka.

RIGHT: *Neela kurunji* blossoms in the Eravikulam National Park in Kerala.

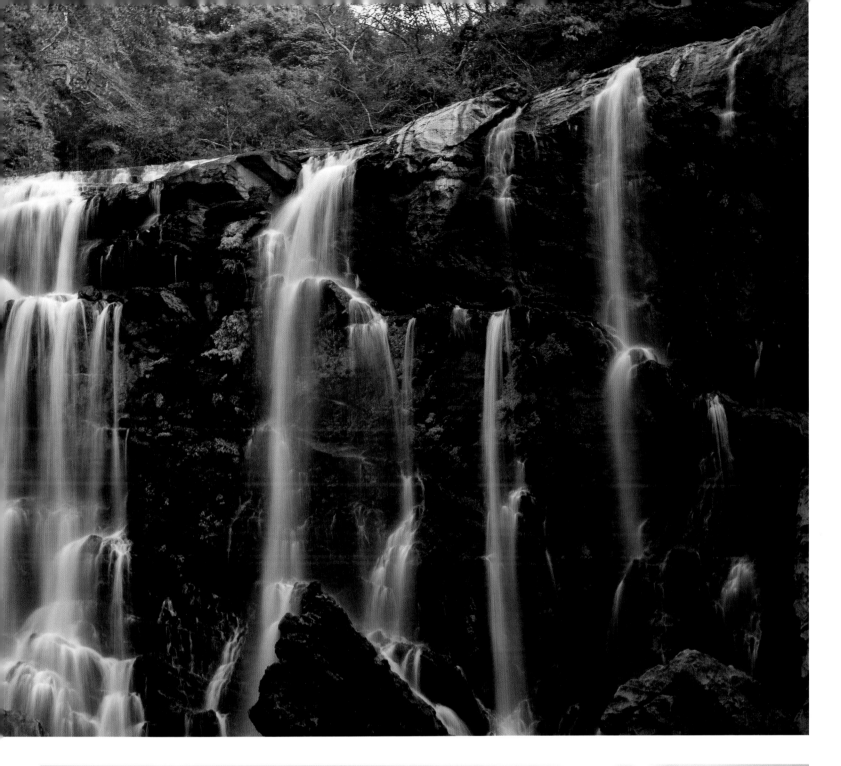

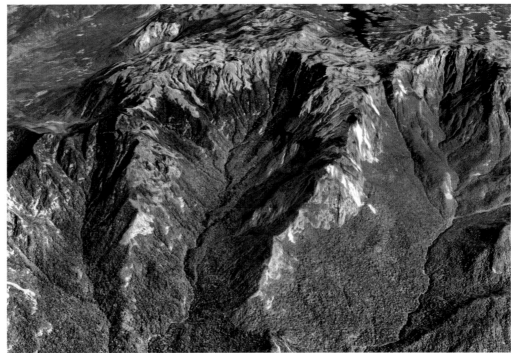

A satellite image shows the fertile green slopes of the Western Ghats.

The Ghats act as a key barrier, intercepting the rain-laden monsoon winds that sweep in from the southwest during late summer, and the forests act as a stabilising agent, inducing heavy rains. These forests also form one of the most important catchment areas for numerous perennial rivers and their tributaries, such as Godavari, Kaveri, Krishna, Tungabhadra, Kabini, Periyar, Bharathappuzha, Pamba, Netravati, Sharavathi, Mandovi and Zuari, thereby ensuring irrigation waters for over 200 million people dependent on these natural resources for their survival.

Local communities have benefitted from the "World Heritage" tag as people flock to catch a glimpse of the floristic vistas of the *neela kurunji* (*Strobilanthes kunthiana*), which only flowers once in twelve years, at the Munnar or Grass Hills National Park in Kerala; or the seasonal *karvi* (*Strobilanthes callosal*), which flowers once in eight years, at the Kas plateau in Maharashtra. Along with several other flowering herb and shrub species, they form a carpet-like vista of nature's colours against the backdrop of lush green.

Community-based tourism has provided an alternate source of income to several of these local communities that are primarily agriculturalists. At the regional and national scale, the World Heritage inscription has meant that developmental projects (such as roads, railways and power lines) consider the ecological sensitivity of natural ecosystems at the design, planning and implementation stage. At the global level, there is growing recognition and scientific evidence that the Western Ghats forests and the coastal mangrove ecosystems play a vital role in carbon sequestration and the reduction of global warming. ●

Sonali Ghosh

LEFT: Rain and water in the Western Ghats—life-givers for the millions who live here.

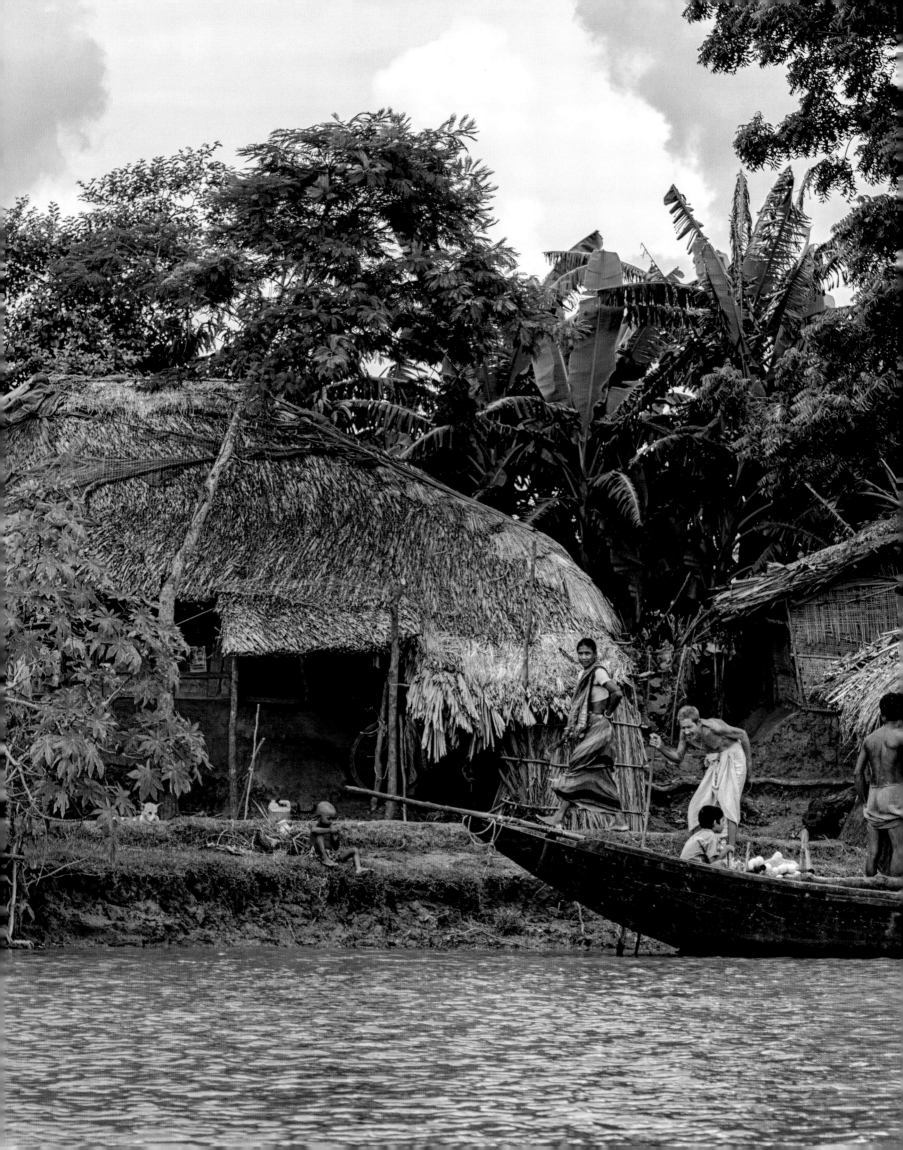

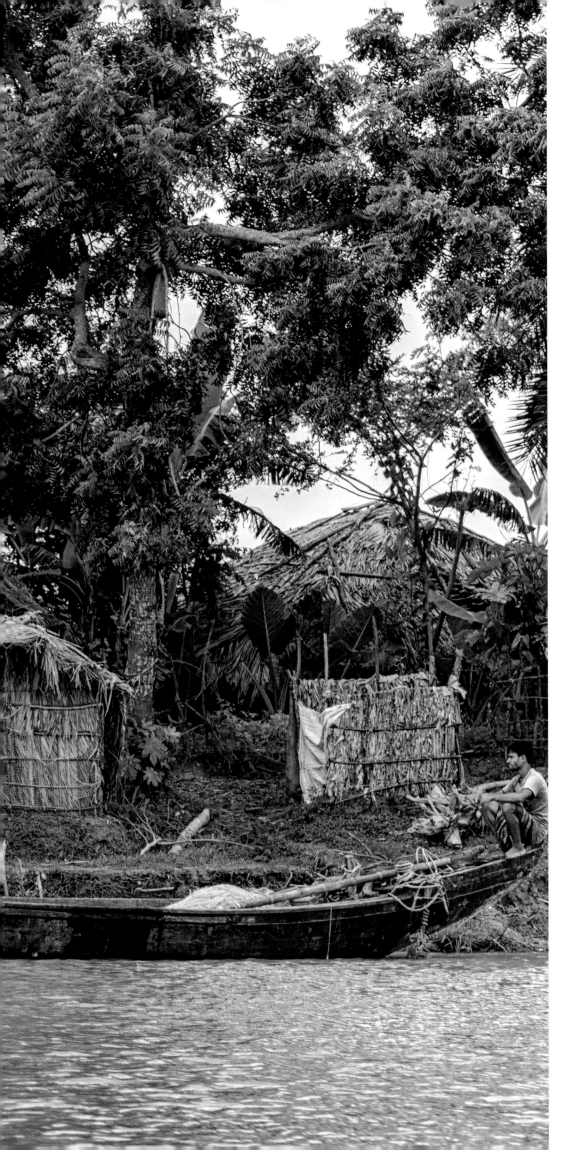

Sundarbans
National Park

LOCATION: West Bengal, India

COORDINATES: N21 56 42 E88 53 45

DATE OF INSCRIPTION: 1987

CATEGORY: Natural

OUTSTANDING UNIVERSAL VALUE

The trans-boundary Sundarbans contains the world's largest mangrove forests and one of the most biologically productive of all natural ecosystems. Located at the mouth of the Ganga and Brahmaputra Rivers between India and Bangladesh, its forests and waterways support a wide range of fauna, including a number of estuarine and marine species threatened with extinction.

CRITERIA: (ix) (x)

(ix): The Sundarbans is the largest area of mangrove forest in the world and the only one that is inhabited by the tiger. Its role as a wetland nursery for marine organisms and as a climatic buffer against cyclones is a unique natural process.

(x): The mangrove ecosystem of the Sundarbans is considered to be unique because of its immensely rich mangrove flora and mangrove-associated fauna, as well as a wealth of threatened animal species.

Glimpses of local habitats along the coast of the Sunderbans, the largest mangrove forest in the world.

The Sundarbans, literally "beautiful forests", spans two countries across one of the world's largest alluvial deltas. Its extensive mangrove habitat is a carbon sink that protects the coast from surges and erosion; it will continue to be one of the first lines of defence, a natural protector against the climate change that now looks increasingly inevitable. The site also derives its name from the *sundari* tree, one of almost fifty mangrove species that flourish in its numerous islands and sandbanks.

The Sundarbans exemplifies the importance of conservation of our natural heritage and its criticality for human survival. The site supports a sizeable population of tigers and other wildlife, and is also an ecologically fragile and climatically vulnerable region, home to over five million people.

The legend of Bonbibi, a guardian goddess, and Dakkhin Rai, a demon king, is synonymous with the Sundarbans. Venerated by Hindu and Muslim residents, she provides protection and strength to honey collectors and woodcutters who venture into the lush, green environs of this unique ecosystem for their livelihood.

Global warming and sea-level rise have led to an increase in the numbers of ecological refugees as people have nowhere else to go. For all the natural hazards that the region is prone to, the Sundarbans acts as a natural shelter belt. For the ecosystem services it provides, the Sundarbans has suitably earned its place as a benchmark case study for global-level disaster reduction and climate change adaptation strategies.

The Sundarbans tiger gets a villainous image through popular media as that of a man-eating beast. Contrary to this idea, it is here that this supreme predator exhibits its extraordinary ability to survive and adapt to a harsh climate. Over the years, human–tiger conflict has been minimised and rapid-response measures formulated. Well-trained forest personnel are always on standby, and outreach measures include the prompt deployment of response and recovery teams for rescuing conflict animals. Some ingenious ways, such as the use of nylon net fencing to prevent tigers from straying into villages, have reduced

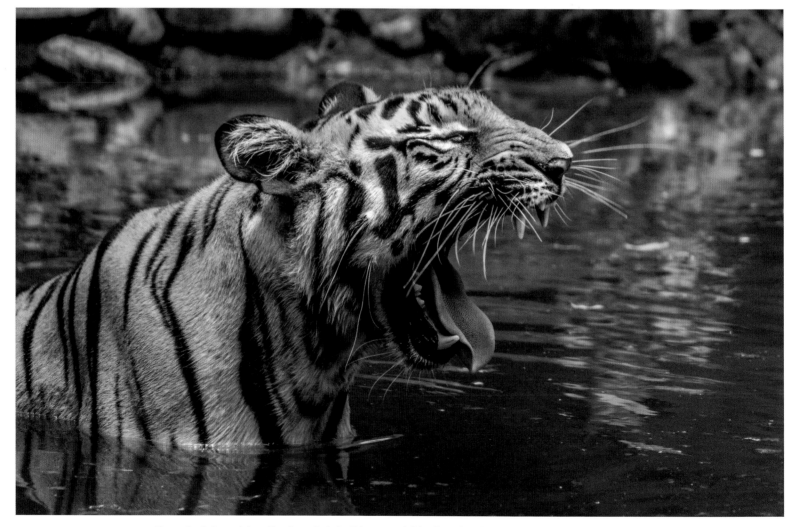

The majestic Bengal tiger (*Panthera tigris tigris*) has remarkably adpated to the marshy habitat of the Sundarbans.

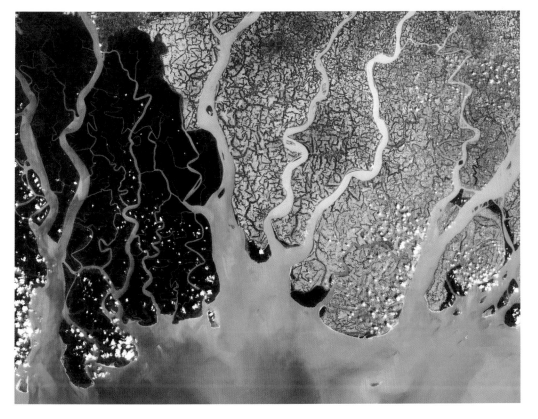

injuries and fatalities. The various other designations, such as the Sundarbans Tiger Reserve and Biosphere Reserve, have also helped serve the multiple objectives of community-led conservation without compromising on the requirement of an inviolate tiger habitat.

Poaching, snaring, oil spills and destruction of natural habitat remain some of the known trans-boundary threats for which greater surveillance and monitoring channels have been formalised. It is a message for "conservation beyond borders" that the "World Heritage" tag has been able to convey in recent years. ●

Sonali Ghosh

ABOVE AND BELOW: A satellite image (above) shows the many rivers that snake through the dense foliage and deep forests (below) of the Sundarbans.

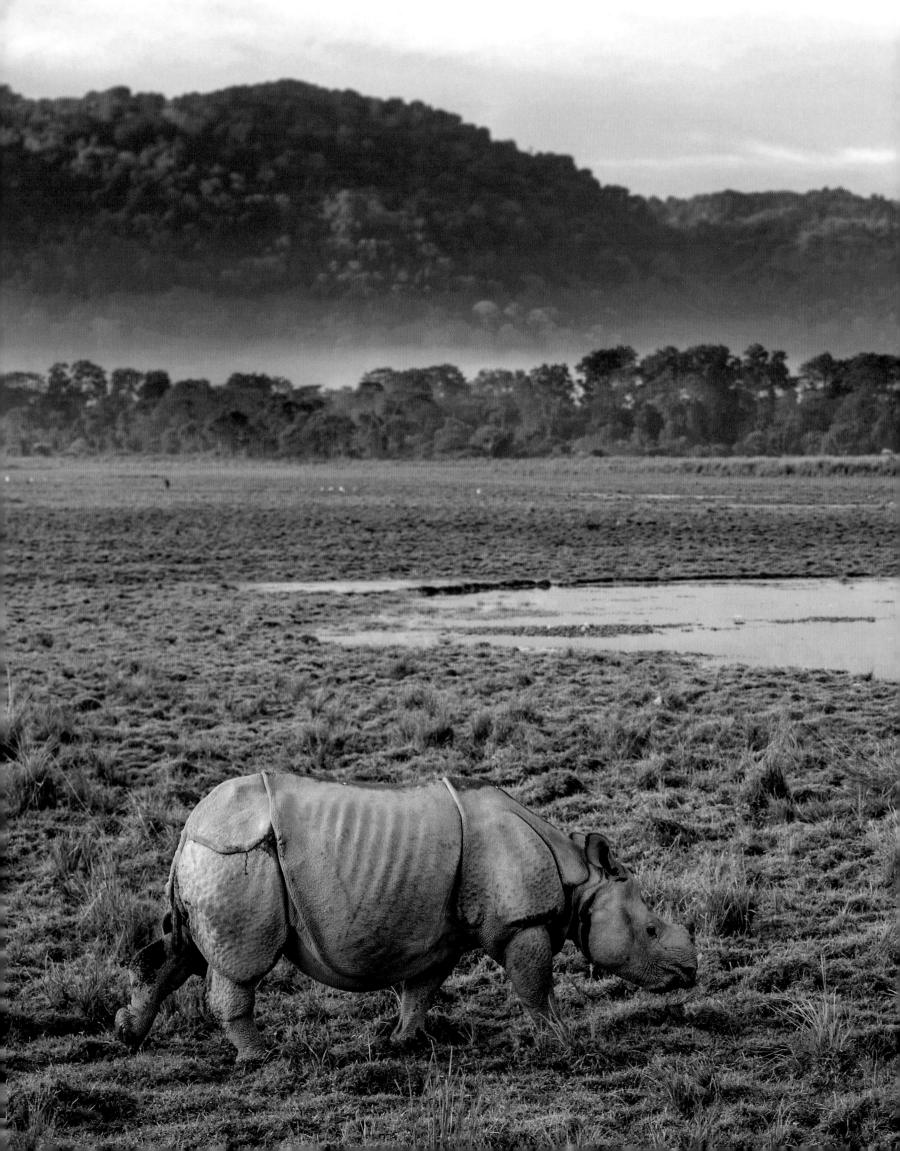

Kaziranga National Park

LOCATION: Assam, India

COORDINATES: N26 40 0 E93 25 0

DATE OF INSCRIPTION: 1985

CATEGORY: Natural

OUTSTANDING UNIVERSAL VALUE

The Kaziranga National Park is the single-largest undisturbed wilderness area of the Brahmaputra Valley floodplains in the state of Assam. It provides a spectacular example of riverine and fluvial processes and is inhabited by the world's largest population of the greater one-horned rhinoceros and other mammals, and thousands of migratory and resident birds. Its contribution in saving the one-horned rhino from the brink of extinction at the turn of the twentieth century to harbouring the single-largest population of this species today is a phenomenal conservation success story.

CRITERIA: (ix) (x)

(ix): River fluctuations by the Brahmaputra river system result in riverine and fluvial processes that support the formation of new lands as well as new water bodies. These natural processes create complexes of habitats, which are also responsible for a diverse range of predator/prey relationships.

(x): The site is the world's major stronghold of the *Rhinoceros unicornis*. It also provides ideal habitat for other globally threatened species

The Kaziranga National Park has the world's largest population of the endangered one-horned rhinoceros. A hundred years ago the count was down to a dozen; today it is over 2,500.

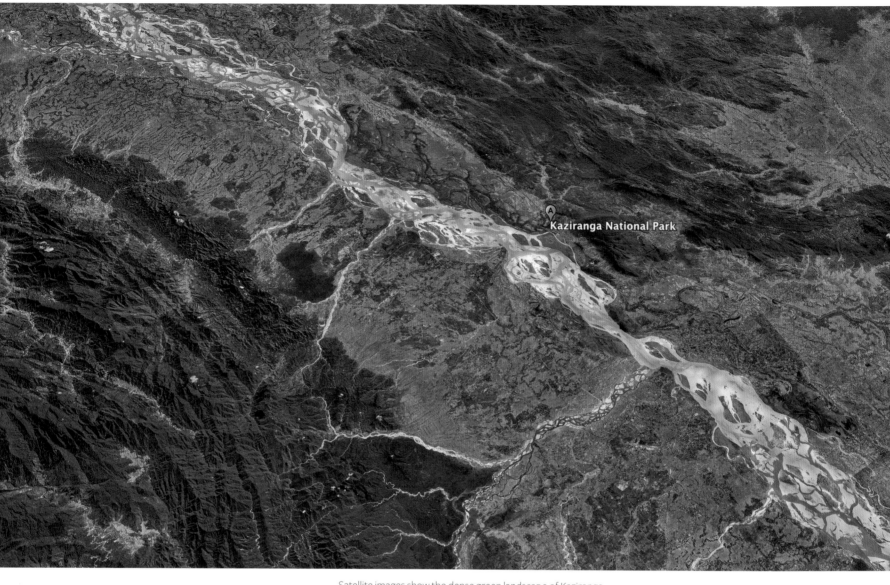

Satellite images show the dense green landscape of Kaziranga.

The Kaziranga National Park is an icon, a beacon of revival and hope for wildernesses and wildlife. Sited on the south bank of the Brahmaputra River, its unique mosaic of grassland and woodland ecosystems has enabled a panoply of flora and fauna to thrive.

Kaziranga is sandwiched between low hills and the river. It is a spectacular example of riverine and fluvial processes that enrich the sanctuary. Wet, alluvial tall grasslands are interspersed with shallow pools fringed with reeds. There are patches of deciduous and semi-evergreen woodland, enabling populations of wild ungulates and thousands of migratory and resident birds to flourish.

It is a remarkable sanctuary, one in which the "big five" of northeast India—the one-horned rhinoceros, tiger, wild buffalo, swamp deer and Asian elephant—can all be viewed in their natural surroundings. For every visitor, there is something wild to see at any time, on any day. Early winter mornings are misty and, against the golden sun, the tall grasses and gently waving *beel*s, or wetlands, look magical, mystical. Further north, towards the Brahmaputra, it is another world, formless, serene and peaceful.

Regarded with awe and respect, the Brahmaputra has shaped and nurtured its valley. At times braided, a muddy torrent in season and on other occasions a stately journey to the as yet distant ocean, it is celebrated in Assamese lore and legend and literature. The river and its floods are a blessing, much needed to recharge the numerous *beel*s and grasslands; yet again proving that Mother Nature does no harm.

Kaziranga is home and habitat to several threatened and rare species, and among them are the capped langur, Gangetic river dolphin, Bengal florican and Asian small-clawed otter. Its wetlands play a crucial role

in the conservation of threatened migratory bird species; among them are raptors that thrive on the burgeoning fish stock of perennial water bodies.

Kaziranga is best known for its greater one-horned rhinoceros, the largest such population in the world. It is an astonishing success story, one best told over campfires by foresters, the unsung sentinels who patrol the sanctuary's interiors, and by the stoic *mahout*s, who each day, rain or shine, lead the camp elephants out on patrols and vigils.

The range of this mythical beast once extended far and wide. The Mughal emperor

Babur hunted them near Peshawar and wrote about it in his memoirs. In the nineteenth century, colonial administrators decimated populations; early in the twentieth century, the rhino count was down to a dozen.

Demarcated as a Reserved Forest in 1905, years of preservationist, proactive management systems, foot and elephant patrols and, in recent decades, modern surveillance systems have brought the population to over 2,500. Translocation from Kaziranga, hesitantly at first but now backed by positive evidence, has enabled the beginnings of re-population in some of the rhino's former habitats.

It has been a remarkable turnaround, a success story that needs to be told. And retold.

There are fresh challenges. Poachers have replaced the colonists. Better armed, knowledgeable of the routines that rhinos follow and familiar with terrain and topography, they supply horn (and some hard-to-distinguish fakes) to lucrative markets. The struggle between protector and poacher is not over yet, but Kaziranga remains beautiful as ever, enthralling visitors with its magic through the seasons. ●

Sonali Ghosh

A herd of *barasingha* deer, now sadly extinct in Pakistan and Bangladesh, graze in Kaziranga.

Manas Wildlife Sanctuary

LOCATION: Assam, India

COORDINATES: N26 43 30 E91 1 50

DATE OF INSCRIPTION: 1985

CATEGORY: Natural

OUTSTANDING UNIVERSAL VALUE

The Manas Wildlife Sanctuary spans the Manas-Beki River and shares a contiguous international boundary with Protected Areas of the eastern Himalayan foothills in Bhutan. The site's scenic beauty includes a range of forested hills, alluvial grasslands and tropical evergreen forests. The site provides critical and viable habitats for rare and endangered species and has exceptional importance within the Indian subcontinent's Protected Areas.

CRITERIA: (vii) (ix) (x)

(vii): Manas is recognised not only for its rich biodiversity but also for its spectacular scenery and natural landscape.

(ix): The monsoon and river system form dynamic ecosystem processes, which support broadly three types of vegetation: semi-evergreen forests, mixed moist and dry deciduous forests and alluvial grasslands. This leads to the vegetation having tremendous regenerating and self-sustaining capabilities.

(x): Manas provides a habitat for many of India's most threatened species of mammals. Its range of habitats and vegetation also accounts for the high plant diversity that provides vital forage to mega-herbivores.

Gentle giants: A herd of Asian elephants at a crossing in the Manas Wildlife Sanctuary.

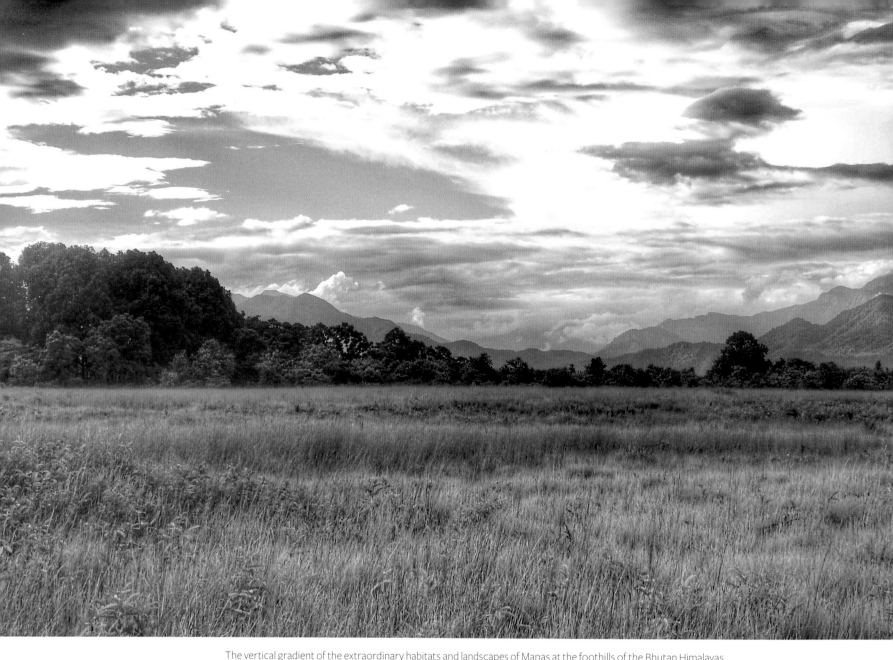

The vertical gradient of the extraordinary habitats and landscapes of Manas at the foothills of the Bhutan Himalayas.

Manas exemplifies nature's resilience against all odds—inscribed in 1985, effaced in 1992 and reinstated in 2011. It witnessed decades of societal turbulence, significant poaching and pressure on its periphery from farming and landless communities. The animals survived, changing their behavioural patterns to avoid daylight and humans. The dense forests, brooks and streams and a very large buffer of pristine forests in the Royal Manas National Park in Bhutan provided a place of solitude and respite.

Manas gets its name from the Himalayan river Mangde Chu that originates in central Bhutan and is joined by her sister Beki, or Dangme Chu, just before the international boundary to flow as one. Such is the spectacular beauty and serenity of the landscape that Mathanguri was a favourite royal retreat in the past. The waters were so turquoise that Everester Edmund Hillary dedicated a Hamilton jet boat from his "Ocean to Sky" expedition to Manas. It would famously traverse the Manas River in record time.

Further southwards along the Mathanguri-Bansbari road, the site's Outstanding Universal Value comes to life! The overhead flight of the great hornbills, the capped *langur* feeding on *semul* silk-cotton tree buds, or a rare glimpse of the very rare *deo-hanh*, the white-winged wood duck, in forest brooks is what one may expect along the eastward road.

In the grassland-woodland edge, a stately *sambhar*; the telltale signs of "Hajmola" pellets of a hispid hare; when in season, the delightful courtship ritual of the *ulu moira*, or Bengal florican; a drove of hog deer; a nonchalant *gaur* in its trademark "white socks"; a stately elephant herd on a salt lick; and to top it all, a very lucky encounter with a melanistic black panther. It is indeed nature's gift at its finest! Pygmy hogs are rare to sight, and so are the golden *langur*s, geographically isolated by the Manas River, but they all thrive and hence add to some

of the natural values of the site, possibly the highest in the entire northeastern region.

Manas was not regained in easy terms as it took more than nineteen years of reconstruction and revival. Local self-government brought in stability, and along with it came the implementation of textbook concepts of wildlife management. Adult rhinos and swamp deer were successfully translocated from Pabitora and Kaziranga to build a founder population.

Tigers were counted, and the good news was that their numbers were increasing and they roamed fearlessly across the Manas landscape, thereby providing the evidence that conservation must extend beyond political borders. Flood-rescued, orphaned rhino and elephant calves from Kaziranga also found a new home and a second chance at freedom in the wild. Protection and surveillance were increased as was the rebuilding of infrastructure, from anti-poaching camps and roads to the provisioning of patrol vehicles and trained manpower. In all this, the community-conservation model of incentivising local youth, including former poachers, to work for the betterment of the sanctuary set a benchmark, replicated along the forests in the Manas buffer. With peace restored, loyal tourists returned, as did the new and adventurous for whom Manas is truly a wilderness experience. •

Sonali Ghosh

The Bengal florican is a critically endangered grassland species found in Kaziranga and Manas.

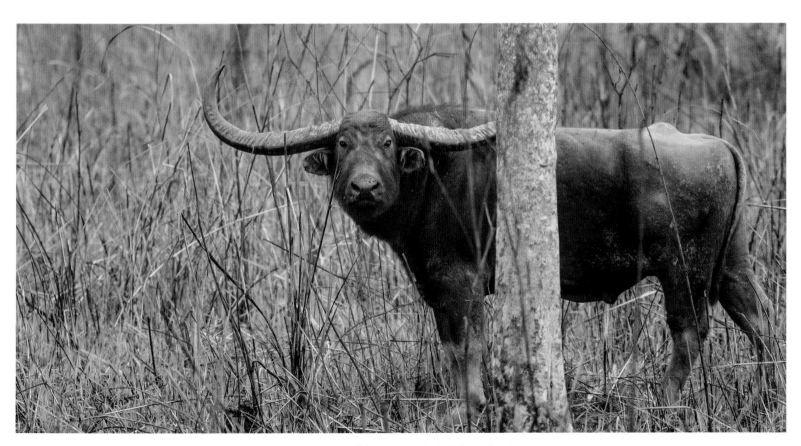

A majestic wild water buffalo grazes on the fresh flush after the burning.

Keoladeo National Park

LOCATION: Rajasthan, India

COORDINATES: N27 9 32 E77 30 31

DATE OF INSCRIPTION: 1985

CATEGORY: Natural

OUTSTANDING UNIVERSAL VALUE

The Keoladeo National Park represents an important wintering ground of Palaearctic migratory water birds and is renowned for its large congregation of non-migratory resident breeding birds. A man-made oasis of a reservoir, surrounded by wooded landscape in an otherwise arid part of India, it has become an important destination for serious birdwatchers and general tourists alike. Its regulated water supply provides pools of varying water depths, making for abundant breeding grounds for fish and other aquatic flora and fauna, thereby becoming an excellent refuelling station for migratory water birds and an important heronry site for resident birds.

CRITERIA: (x)

(x): The site is a wetland of international importance for migratory waterfowl, where birds migrating down the Central Asian flyway congregate before dispersing to other regions. During the breeding season, the most spectacular heronry in the region is formed here.

The first flight of a pair of Sarus cranes against the early morning sunlight at Keoladeo, India's only artificially created natural World Heritage Site.

Patience, thy name is purple heron!

Keoladeo is a visual symphony of colour, flapping feathers, and chattering, excited tourists. To its wetlands flock migratory birds: some to breed, nurse and nurture, and others to simply refuel and rest before resuming their journey to even more distant lands.

On the fringes of the western periphery of the Gangetic basin, this haven for birdlife was once a royal hunting ground. Imperial and commemorative inscriptions record a grim reminder of the past, of thousands of birds killed by officials and royalty in a single day, sometimes in just a few hours. This led to the local extinction of several species. It took decades of systematic research and advocacy by scientist-conservationists such as Dr Salim Ali before the conservation and protection of avifauna sites such as Keoladeo were encouraged in post-Independence India.

In time, Keoladeo evolved from a royal hunting area to a wetland that augmented water supply to settlements in the vicinity. At the same time, it became a sanctuary for avian visitors. Migrating ducks and geese were attracted to the water and the fish, and the site today hosts some 450 species of birds. Pelicans, spoonbills, ibises, darters, sandpipers, mallards, gadwalls, shovellers, teals, spot-billed ducks, tufted ducks, kingfishers, cormorants, egrets, storks and Sarus cranes also populate this now-thriving sanctuary.

In this regard, the conservation stories of two magnificent crane species that took separate trajectories are worth retelling. The Siberian crane, a majestic but critically endangered species that breeds in northeastern Siberia, once flew into Keoladeo for the warmer periods. Hunting across its range in the Hindukush Himalayas led to this route being forgotten altogether. The non-migratory Sarus crane, on the other hand, continues to survive and thrive as traditional values and tolerance for the species get supplicated in India. Keoladeo and the adjoining agricultural landscape now provide an excellent breeding and feeding refuge for these birds throughout the year. Both these birds remind us that natural values transcend political boundaries and are strengthened with greater cultural values.

The woodlands, dominated by thorny *babool*, provide a refuge for spotted deer, blackbuck, reticulated python, *nilgai*, wild pigs, peafowl, long-billed and white-backed vultures, and the occasional leopard. Raptors are therefore found abundantly as eagles, falcons, falconets, kites and owls are the apex predators.

Water is key to the health of Keoladeo. It has benefitted from adjoining irrigation projects. Within the site, water conservation measures, including natural embankments and solar-powered borewells, have helped tide over the critical dry period in summer. Being a small Protected Area that may have reached its carrying capacity in terms of the number of wild animals it can support, specific interventions, such as the removal of invasive trees (*Prosopis juliflora*) and predatory species (African catfish), are part of the measures carried out by park authorities to retain the wetland values of the site. ●

Sonali Ghosh

A black kite (*Milvus migrans govinda*) oversees the day's proceedings.

A majestic spotted deer stag (*Axis axis*) in search of its herd.

The Mountain God
An Icy Summit

Dr Sonali Ghosh and Dr Shikha Jain

"Indian sacredness continues to anchor millions of people in the imagined landscape of their country. Its unity as a nation has been firmly constituted by the sacred geography it has held in common and revered: its mountains, forests, rivers, hilltop shrines."

—Diana L. Eck, *India: A Sacred Geography*, 2012

One of the simplest definitions of a cultural landscape, as stated by UNESCO, is "combined works of man and nature". The category of cultural landscape includes cultural properties that represent a living, dynamic manifestation of the harmonious co-existence of cultural ideologies within a natural environment and setting. India presents a vast spectrum of cultural landscapes set within its diverse terrain, with the Himalayas in the north, the central plains, the Thar Desert in the west, the Deccan Plateau in the south, and a range of coastal settlements across its peninsular edges.

The northeastern part of the country provides excellent examples of associative and living cultural landscapes. Among these, the Khangchendzonga National Park in Sikkim was inscribed as a mixed site in 2016; it exemplifies the attributes of an associative cultural landscape, with reverence for the mountain god Dzonga and other gods residing in associated natural peaks and landscape features of the area, who are worshipped by three local tribes of Sikkim. As a mixed site, the Khangchendzonga National Park was additionally recognised for its outstanding natural features, with an ecosystem mosaic that provides refuge to several large mammals and apex predators, such as the snow leopard.

The primary challenge in India is to classify the typologies of cultural landscapes given the range and diversity of culture-nature adaptations across the country, with a predominance of religious landscapes and sacred geographies with spiritual associations. A range of typologies identified by scholars include associative, archaeological, relict, institutional, industrial, religious and bio-cultural landscapes.

While the natural heritage of India is largely a manifestation of the country's finest Protected Areas, sites that support true wilderness are often surrounded by a human-dominated landscape. In this case, it is not only effective in-situ protection and management practices but also the nature-connect and pride in the sacred and spiritual values of nature that have helped local communities protect these sites. They continue to provide that critical indivisible connection between people, culture and nature manifested through traditions, folklore, songs, dances and rituals that must be nurtured and encouraged for perpetuity. Definitely, India needs to move forward with further inscriptions for qualifying sites in the category of mixed sites; a few potential such properties are already on UNESCO's Tentative List. ◆

PREVIOUS PAGES
Lying along the old Silk Route, the Kalapokhri lake in Sikkim is part of India's only Mixed Site, the Khangchendzonga National Park.

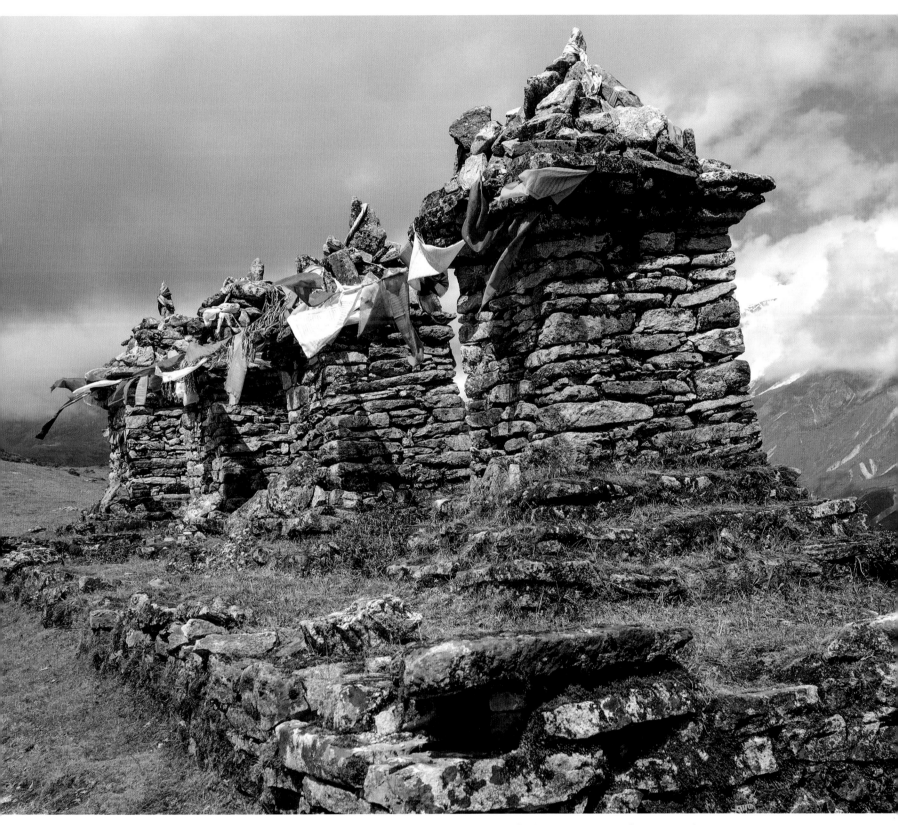

*Chorten*s (Buddhist shrines) made in stone and strung with *dar-cho*s (Buddhist prayer flags) as representations of mountain gods.

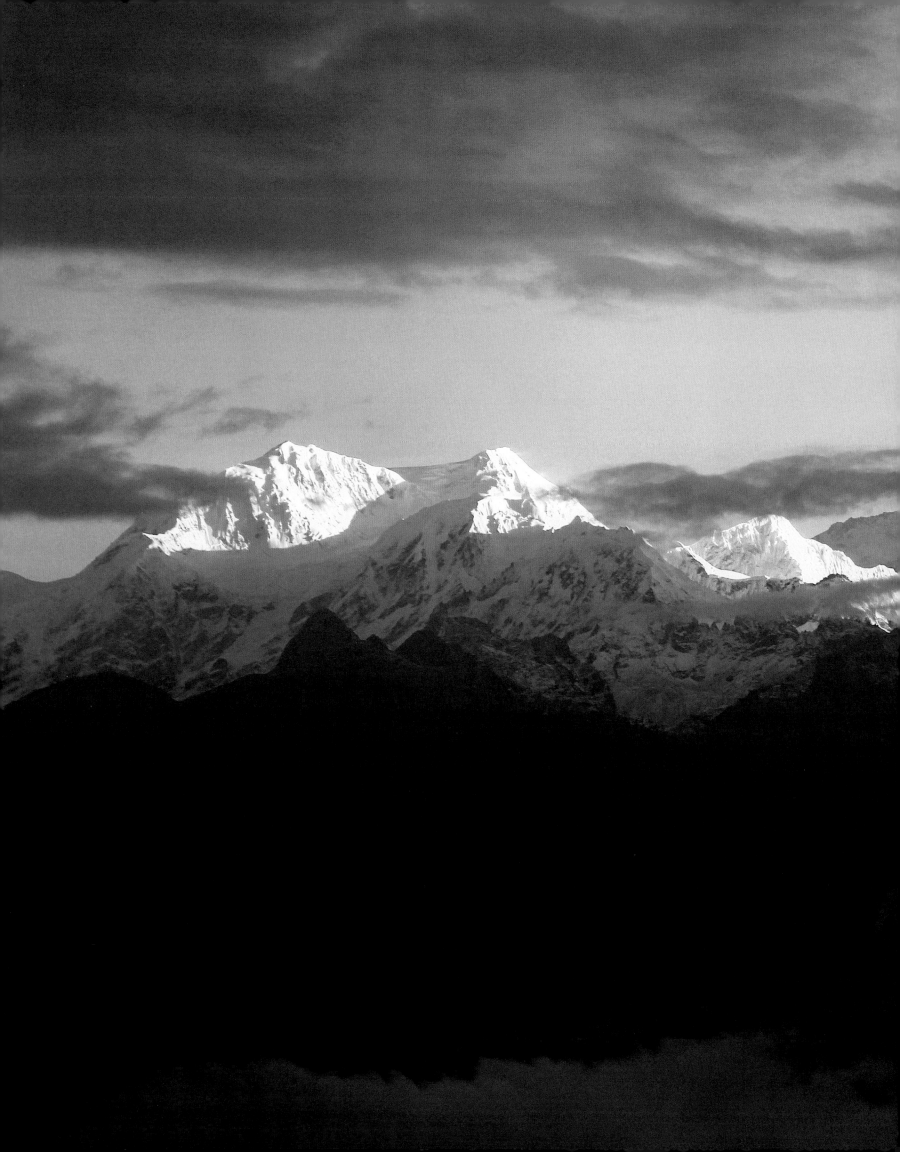

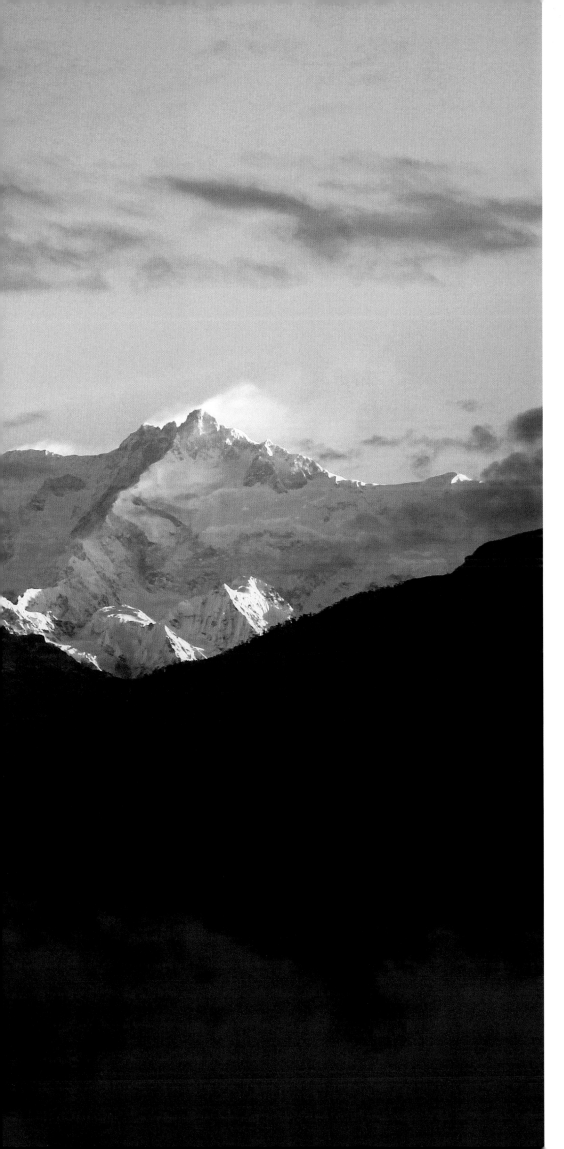

Khangchendzonga
National Park

LOCATION: Sikkim, India

COORDINATES: N27 45 53 E88 22 38

DATE OF INSCRIPTION: 2016

CATEGORY: Mixed

OUTSTANDING UNIVERSAL VALUE

This site exhibits one of the widest altitudinal ranges of any Protected Area worldwide, with an extraordinary vertical sweep of over seven kilometres. It comprises a unique diversity of lowlands, steep-sided valleys and spectacular snow-clad mountains. Mount Khangchendzonga and many natural features within the property are endowed with deep cultural meanings and sacred significance for the many local communities who reside here. The site is also home to a significant number of endemic, rare and threatened plant and animal species.

CRITERIA:: (iii) (vi) (vii) (x)

(iii): The property represents the core sacred region of the Sikkimese, bearing unique witness to the co-existence of Buddhist and pre-Buddhist traditions in the same region.

(vi): It is the heartland of a multi-ethnic culture that has given rise to a syncretic religious tradition, which centres on the natural environment.

(vii): In addition to Mt. Khangchendzonga, the site contains eighteen glaciers and seventy-three glacial lakes, forming an extraordinary landscape.

(x): It is acknowledged as one of the most significant biodiversity concentrations in India, with one of the highest levels of plant and mammal diversity recorded within the Central/High Asian mountains.

The sun rises on Khangchendzonga, the only peak to remain untrodden by mountaineers, owing to its strong spiritual association with the mountain god Dzonga in local Sikkimese culture.

The red panda, a unique animal found in the Khangchendzonga National Park, is also the state animal of Sikkim.

terrain with over twenty peaks above 6,000 metres; eleven between 6,000 and 7,000 metres; and eight between 7,000 and 8,000 metres. Within the Khangchendzonga National Park is Khangchendzonga, the third-highest mountain in the world at 8,586 metres. There are over 4,500 species of flowering plants and a remarkable array of species, many of them endangered or threatened, such as the red panda, the snow leopard, musk deer and blue sheep. The grandeur of the site as a biodiversity cauldron is undeniable, and it is further enhanced by the recognition of several of its sacred mountain ranges, peaks, lakes, caves, rocks, *chorten*s and hot springs that are revered across a range of local cultures and religions in Sikkim. Together with its buffer zone of a biosphere reserve, the Khangchendzonga National Park covers over half of the geographical area of Sikkim.

This site presents one of the most unusual and powerful religious, artistic and cultural associations to its natural elements. To start with, the natural elements are by themselves outstanding, considering the aesthetic and scenic value of the Khangchendzonga mountain range. It is the only Himalayan giant yet to be conquered; British and European mountaineers hesitated to step on the summit in the early twentieth century, respecting the beliefs of the pre-Buddhist and Buddhist communities of Sikkim that even today worship this peak as sacred. Subsequent expeditions are said to follow this tradition of leaving the summit undefiled.

The cultural values associated with the mountain's peak and surrounding landscape are harmoniously rooted in both the indigenous Lepcha culture and the Buddhist traditions of the Sikkimese Bhutias. The site today represents the

As India's first mixed heritage site, the Khangchendzonga National Park is truly an excellent example of a community-driven initiative. In 2003, experts on natural heritage and the Ministry of Environment and Forests were about to nominate the site as a natural property, recognising its exceptional flora, fauna and landscape. At this time, the Sikkimese community approached the Government of India to explain their

strong association with the site and to suggest that its cultural value should also be recognised. This resulted in India nominating the Khangchendzonga National Park as an associative cultural landscape, owing to its strong cultural linkages as well as its remarkable natural heritage. The site was inscribed in 2016.

The Khangchendzonga National Park primarily comprises extensive mountainous

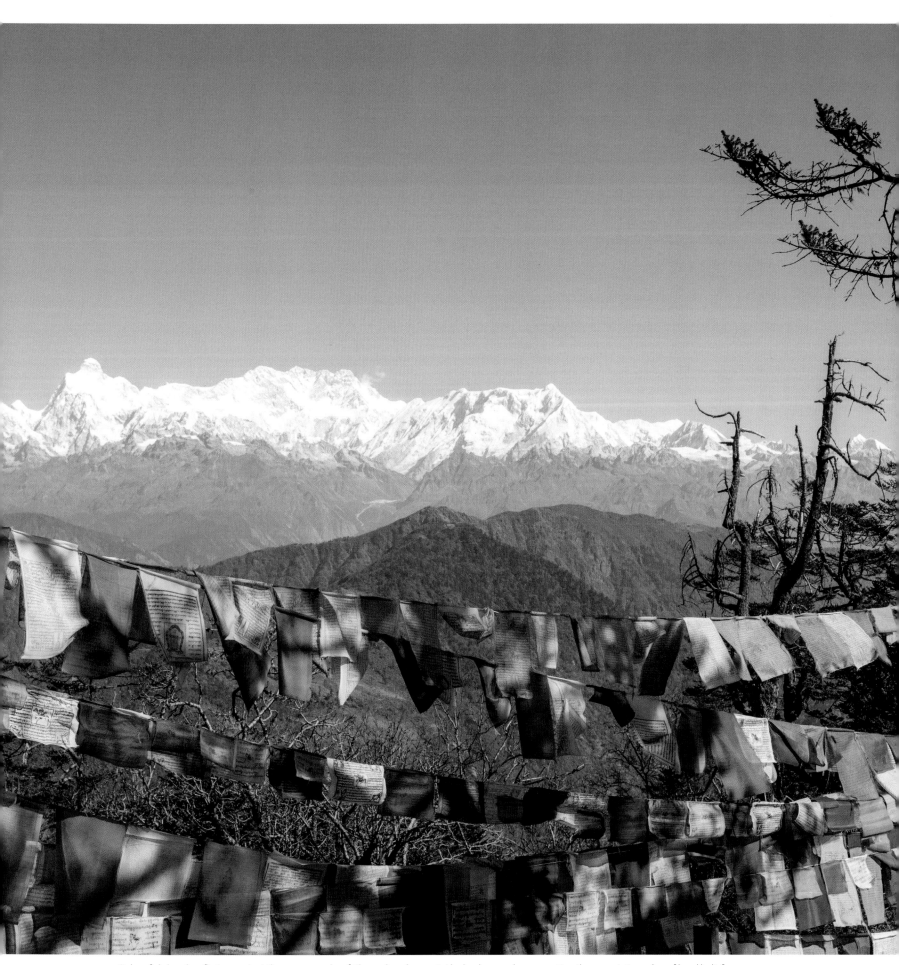

Colourful *dar-cho*s flutter against the snowy peaks of Khangchendzonga in the background, representing the associative value of local beliefs.

pristine and well-preserved highlands of the *beyul* ("the hidden land", according to Buddhist belief) and is the best available living example within the wider pan-Himalayan and Tibetan *beyul* tradition.

The original interlinkage between these natural elements and their cultural values within the Khangchendzonga National Park has been refined over several centuries, integrating two worldviews and celebrating a large and exceptional landscape, while creating an artistic representation of its chief element—the mountain god Dzonga residing on its peak, which also acted as a unifying symbol for all the communities of the area. This interlinkage between the natural and cultural eventually defined what it means to be Sikkimese. It is celebrated annually with the Pang Labhsol festival in Sikkim.

Ecologists believe that the new recognition of World Heritage List will aid in providing an effective measure to bridge the gaps in conservation, livelihood challenges and development. Due to low human population densities, no major developmental projects have been planned, and small-scale eco-tourism initiatives in remote locations have supported local communities with the added incentive of a cash income.

The fusion of culture, religion and environmental protection is tangible proof of the respect towards Khangchendzonga, a guardian deity, shown by people of the indigenous communities. The formal recognition of these biocultural powers signifies the new trend in global heritage conservation in India. ●

Sonali Ghosh and Shikha Jain

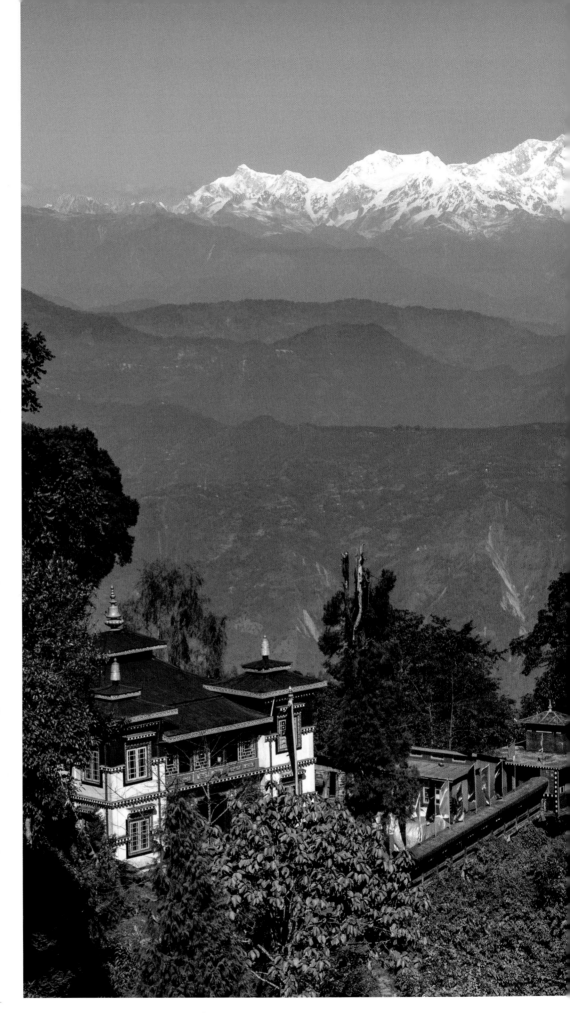

A Buddhist monastery looks out over the Khangchendzonga mountains.

The Nomination Process

1. Tentative List

The first step a country must take is to create an inventory of its important natural and cultural heritage sites located within its boundaries. This inventory is known as the Tentative List, and provides a forecast of the properties that a State Party may decide to submit for inscription in the following five to ten years and which may be updated at any time. This is an important step since the World Heritage Committee cannot consider a property for inscription on the World Heritage List unless it has already been included on the State Party's Tentative List.

2. The Nomination File

By preparing a Tentative List and selecting sites from it, a State Party can plan when to present a nomination file. The World Heritage Centre offers advice and assistance to the State Party in preparing this file, which needs to be as exhaustive as possible, making sure the necessary documentation and maps are included. The nomination is submitted to the World Heritage Centre for review and to check for completeness. Once a nomination file is complete the World Heritage Centre sends it to the appropriate Advisory Bodies for evaluation.

3. The Advisory Bodies

A nominated property is independently evaluated by two Advisory Bodies mandated by the World Heritage Convention: the ICOMOS and the IUCN, which respectively provide the World Heritage Committee with evaluations of the cultural and natural sites nominated. The third Advisory Body is the International Centre for the Study of the Preservation and Restoration of Cultural Property (ICCROM), an intergovernmental organisation that provides the Committee with expert advice on conservation of cultural sites, as well as on training activities.

4. The World Heritage Committee

Once a site has been nominated and evaluated, it is up to the intergovernmental World Heritage Committee to make the final decision on its inscription. Once a year, the Committee meets to decide which sites will be inscribed on the World Heritage List. It can also defer its decision and request further information on sites from the State Parties.

5. The Criteria for Selection

To be included on the World Heritage List, sites must be of outstanding universal value and meet at least one out of ten selection criteria. These criteria are explained in the Operational Guidelines for the Implementation of the World Heritage Convention, which, besides the text of the Convention, is the main working tool on world heritage. The criteria are regularly revised by the Committee to reflect the evolution of the concept of world heritage itself.

Until the end of 2004, World Heritage Sites were selected on the basis of six cultural and four natural criteria. With the adoption of the revised Operational Guidelines, only one set of ten criteria exists.

How is Outstanding Universal Value established for a site to be recognised as a World Heritage Site?

Outstanding Universal Value is identified through the presence of any one or more of the ten criteria listed in Paragraph 77, Chapter II of the Operational Guidelines. A site is considered to possess Outstanding Universal Value if it satisfies one or more of the following criteria:

Criteria (i): To represent a masterpiece of human creative genius;

Criteria (ii): To exhibit an important interchange of human values, over a span of time or within a cultural area of the world, on developments in architecture or technology, monumental arts, town-planning or landscape design;

Criteria (iii): To bear a unique or at least exceptional testimony to a cultural tradition or to a civilisation that is living or has disappeared;

Criteria (iv): To be an outstanding example of a type of building, architectural or technological ensemble or landscape that illustrates (a) significant stage(s) in human history;

Criteria (v): To be an outstanding example of a traditional human settlement, land-use, or sea-use representative of a culture (or cultures), or human interaction with the environment especially when it has become vulnerable under the impact of irreversible change;

Criteria (vi): To be directly or tangibly associated with events or living traditions, with ideas, or with beliefs, with artistic and literary works of outstanding universal significance. (The Committee considers that this criterion should preferably be used in conjunction with other criteria);

Criteria (vii): To contain superlative natural phenomena or areas of exceptional natural beauty and aesthetic importance;

Criteria (viii): To be outstanding examples representing major stages of Earth's history, including the record of life, significant on-going geological processes in the development of landforms, or significant geomorphic or physiographic features;

Criteria (ix): To be outstanding examples representing significant on-going ecological and biological processes in the evolution and development of terrestrial, freshwater, coastal and marine ecosystems and communities of plants and animals;

Criteria (x): To contain the most important and significant natural habitats for *in-situ* conservation of biological diversity, including those containing threatened species of outstanding universal value from the point of view of science or conservation.

It should be noted that criteria (i) to (vi) apply for cultural heritage properties, including cultural landscapes, and criteria (vii) to (x) apply for natural heritage properties. Mixed heritage properties should satisfy both cultural and natural criteria (one or more from each segment).

Sites on the Tentative List

A Tentative List is an inventory of those sites that each State Party intends to consider for nomination. India has thus far submitted the following 42 sites for consideration as World Heritage Sites.

CULTURAL SITES

Temples at Bishnupur, West Bengal

The Ancient Buddhist Site of Sarnath, Uttar Pradesh

Mattanchery Palace, Ernakulam, Kerala

Sri Harmandir Sahib, Amritsar, Punjab

Group of Monuments at Mandu, Madhya Pradesh

The River Island of Majuli, Brahmaputra River, Assam

Silk Road Sites in India (Union Territories of Jammu & Kashmir and Ladakh, Uttar Pradesh, Bihar, Punjab, Puducherry, Tamil Nadu)

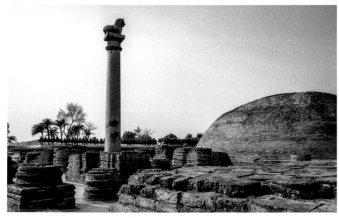

Pillars of Ashoka, Vaishali in Bihar

Mughal Gardens, Union Territory of Jammu & Kashmir

Santiniketan, West Bengal

Delhi—A Heritage City

The Qutb Shahi Monuments of Hyderabad, Telangana

Monuments and Forts of the Deccan Sultanate, Karnataka and Telangana

CULTURAL SITES

Cellular Jail, Port Blair, Andaman & Nicobar Islands

Dholavira—A Harappan City, Gujarat

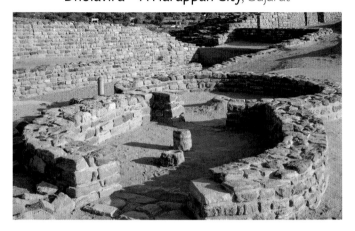

The Glorious Kakatiya Temples and Gateways,
Warangal, Telangana

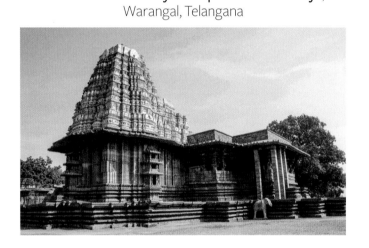

Apatani Cultural Landscape, Arunachal Pradesh

Iconic Saree-Weaving Clusters of India

Saree weaving in progress at Chanderi, Madhya Pradesh

Sri Ranganathaswamy Temple, Srirangam, Tamil Nadu

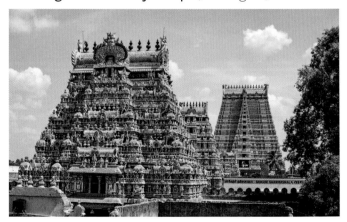

Monuments of Srirangapatna Island Town, Karnataka

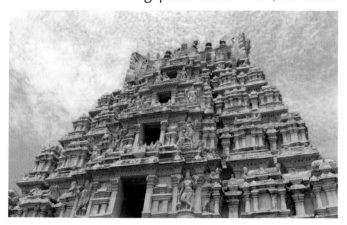

Sites of Satyagraha, India's Non-Violent Freedom Movement

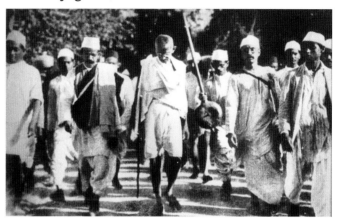

Gandhi leading the famous 1930 Salt March, a notable example of *satyagraha* (non-violent resistance)

Padmanabhapuram Palace, Tamil Nadu

Thembang Fortified Village, Arunachal Pradesh

Sacred Ensembles of the Hoysala, Karnataka

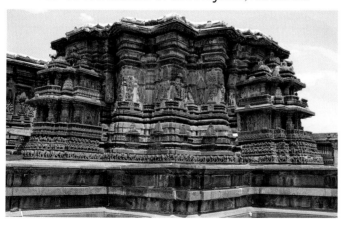

Moidams—The Mound-Burial System of the Ahom Dynasty, Assam

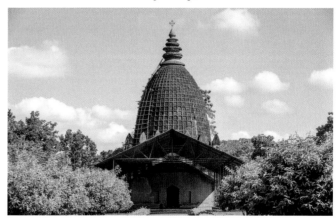

CULTURAL SITES

Ekamra Kshetra—The Temple City, Bhubaneswar, Odisha

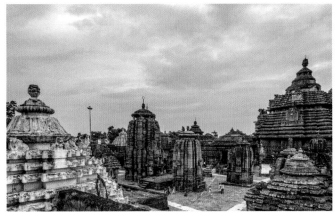

Matheran Hill Railway, Mountain Railways of India (Extension)

The Neolithic Settlement of Burzahom, Union Territories of Jammu & Kashmir and Ladakh

Chettinad, Village Clusters of the Tamil Merchants, Tamil Nadu

Archaeological Remains of a Harappa Port-Town, Lothal, Gujarat

Bahá'í House of Worship, New Delhi

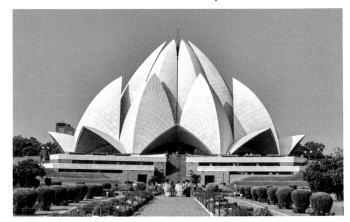

Evolution of Temple Architecture—Aihole-Badami-
Pattadakal, Karnataka

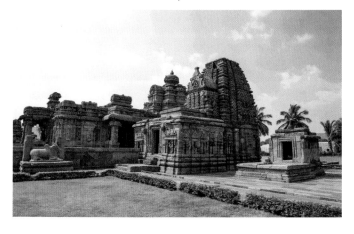

Sites along the Grand Trunk Road, in Punjab, Haryana,
Uttarakhand, Uttar Pradesh, Bihar and West Bengal

Arab Ki Sarai Gateway at the Humayun's Tomb Complex in Delhi

The Historic Ensemble of Orchha, Madhya Pradesh

NATURAL SITES

Namdapha National Park, Arunachal Pradesh

Wild Ass Sanctuary, Little Rann of Kutch, Gujarat

Neora Valley National Park, Darjeeling, West Bengal

Desert National Park, Thar Desert, Rajasthan

Cold Desert Cultural Landscape of India, Union Territory of Ladakh

Chilika Lake, Odisha

Keibul Lamjao Conservation Area, Manipur

Narcondam Island, Andaman & Nicobar Islands

Garo Hills Conservation Area, Manipur

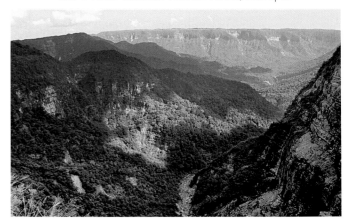

Bibliography

Angel, Oryana. "Goan, Not Forgotten." *Traveller.* Published December 7, 2013. https://www.traveller.com.au/goan-not-forgotten-2ypx4

Asher, Frederick M. *Nalanda: Situating the Great Monastery.* Mumbai: The Marg Foundation, 2015.

Baig, Amita, and Rahul Mehrotra. *Taj Mahal: Multiple Narratives.* Delhi: Om Publishers, 2017.

Basu, D. K. *The Rise and Growth of the Colonial Port Cities in Asia.* Berkeley: University Press of America, 1985.

Batisse, Michel, and Gérard Bolla. "The Invention of 'World Heritage'" in *History Papers 2*, Paris: Association of Former UNESCO Staff Members, AFUS, 2005.

Begley, W. E., and Z. A. Desai (translator). *Taj Mahal: The Illumined Tomb*, Cambridge: Aga Khan Program for Islamic Architecture, 1989.

Behl, Benoy K. *The Ajanta Caves: Ancient Paintings of Buddhist India.* London: Thames & Hudson, 2005.

Berkson, Carmel. *Ellora: Concept and Style.* New Delhi: Abhinav Publications, 1992.

Bindra, Prerna S., Sonali Ghosh, Anuranjan Roy (eds.). *Wild Treasures: Reflections on World Natural Heritage Sites in Asia—An Anthology.* New Delhi: Aryan Books International, 2019.

Boesiger, Willy (ed.). *Le Corbusier: Oeuvre Complète 1952-57.* Zurich: Verlag für Architektur (Artemis), 1958.

Cable, Bob. *Darjeeling Revisited: A Journey on the Darjeeling Himalayan Railway (Narrow Gauge).* West Sussex UK: Middleton Press, 2011.

Cameron, Christina, and Mechtild Rössler. *Many Voices, One Vision: The Early Years of the World Heritage Convention.* London: Routledge, 2016.

Chandra, Bipin, Mridula Mukherjee, Aditya Mukherjee, Sucheta Mahajan, K. N. Panikkar. *India's Struggle for Independence.* New Delhi: Penguin Books, 1989.

Chaudhari, K. K. *Maharashtra State Gazetteers: History of Bombay—Modern Period.* Mumbai: Government of Maharashtra, 1987.

"Chhatrapati Shivaji Terminus." *Know India.* https://knowindia.gov.in/culture-and-heritage/monuments/chhatrapati-shivaji-terminus.php

Chiba, Moe, Shikha Jain, Sonali Ghosh, V. B. Mathur, (eds.). *Cultural Landscapes of Asia: Understanding and Managing Heritage Values.* New Delhi: Aryan Books International, 2018: 204.

Chola Temples, World Heritage Series Guide Book, New Delhi: Archaeological Survey of India, 2007.

Urban Heritage in Indian Cities: Compendium of Good Practices. New Delhi: National Institute of Urban Affairs, 2015.

Corbusier, Le. "1. The Master Plan, 2. The Capitol" in *Marg*, Vol. 15, No. 1 (1961): 5–19.

———. "Chandigarh: The New Assembly Building" in *Design Annual*, Vol. 6 (1962): 109–14.

"Continental/Continental: The Himalayas." *The Geological Society.* https://www.geolsoc.org.uk/Plate-Tectonics/Chap3-Plate-Margins/Convergent/Continental-Collision

Cousens, Henry. *The Chalukyan Architecture of the Kanarese Districts*, New Delhi: Archaeological Survey of India, 1926, 1996 [reprint].

Currim, Mumtaz. *Jannat: Paradise in Islamic Art.* Mumbai: The Marg Foundation, 2012.

Daniélou, Alain, and Kenneth F. Hurry (translator). *A Brief History of India.* Rochester, Vermont: Inner Traditions International, 2003.

Dayalan, D. *Cave-temples in the Regions of the Pandya, Muttaraiya, Atiyaman and Ay Dynasties in Tamil Nadu and Kerala*, Vols. 1, 2 & 3. New Delhi: Archaeological Survey of India, 2014.

Debroy, Bibek, S. Chadha and V. Krishnamurthi. *Indian Railways: The Weaving of a National Tapestry.* Gurugram: Random House India, 2017.

Deva, Krishna. *Khajuraho.* World Heritage Series Guide Book. New Delhi: Archaeological Survey of India, 1965.

———. *Temples of Khajuraho*, Vols. 1 & 2. New Delhi: Archaeological Survey of India, 1990.

Devakunjari, D. *Hampi.* New Delhi: Archaeological Survey of India, 1970, 1998 [reprint].

Dhavalikar, M. K. *Sanchi.* New Delhi: Oxford University Press, 2003.

———. *Ellora.* New Delhi: Oxford University Press, 2003.

Dubey-Pathak, Meenakshi. "The Rock Art of the Bhimbetka Area in India" in *Adoranten*, 2014: 5–22.

Dwivedi, Sharada, and Rahul Mehrotra. *Bombay Deco.* Mumbai: Eminence Designs Pvt. Ltd, 2008.

Dwivedi, Sharada, and Rahul Mehrotra. *Fort Walks.* Mumbai: Eminence Designs Pvt. Ltd, 1999.

Evenson, Norma. *Chandigarh.* Berkeley: California Architectural Press, 1966.

Fergusson, James. *History of Indian and Eastern Architecture*, Vol. 2. New Delhi: Munshiram Manoharlal, 1998 [reprint].

Fry, Edward Maxwell. "Chandigarh—New Capital City" in *Architectural Record*, Vol. 117, 1955: 139–148.

———. "Le Corbusier at Chandigarh" in *The Open Hand: Essays on Le Corbusier.* Cambridge, MA: MIT Press, 1977: 350–363.

Futagawa, Yukio (ed.). "Le Corbusier: Chandigarh, The New Capital of India" in *Global Architecture (G.A.)*, Vol. 30. Tokyo: A.D.A. Edita.

Galla, Amareswar. *World Heritage: Benefits Beyond Borders.* Paris: UNESCO Publishing and Cambridge: Cambridge University Press, 2012.

Geary, David. *The Rebirth of Bodh Gaya: Buddhism and the Making of a World Heritage Site.* New Delhi: Dev Publishers and Distributors, 2018.

"Geology." *Great Himalayan National Park.* Last updated July 07, 2020. https://www.greathimalayannationalpark.org/terrain-2/geology/

Guha Thakurta, Tapati. "The Production and Reproduction of a Monument: The Many Lives of the Sanchi Stupa" in *South Asian Studies*, Vol. 29. London: Routledge, Taylor and Francis Group, 2012: 77–109.

Guha, Sudeshna. *Artefacts of History: Archaeology, Historiography and Indian Pasts.* New Delhi: Sage, 2015.

Hampi. World Heritage Series Guide Book, New Delhi: Archaeological Survey of India, 2007.

Hooja, Rima. *A History of Rajasthan.* New Delhi: Rupa Publications, 2006.

Hoyland, John Somervell (translator) and S. N. Banerjee. *The Commentary of Father Monserrate, Society of Jesus, on His Journey to the Court of Akbar.* London: Oxford University Press, 1922.

"India." *World Heritage Convention, UNESCO.* http://whc.unesco.org/en/statesparties/IN

Jain, Shikha. "Jaipur as a Recurring Renaissance" in *New Architecture and Urbanism: Development of Indian Traditions.* (Eds.) Deependra Prashad, Saswati Chetia. New Delhi: INTBAU (International Network for Traditional Building, Architecture and Urbanism), 2009.

Jain, Shikha. "Chaupara, Bazzars and Havelis" in *Cultural Capital: A Symposium on Life and Living in the Walled City of Jaipur*, Seminar #660, New Delhi, 2017.

Jain, Shikha. "Indian Cultural Landscapes: Recognition, Protection and Management" in *South Asian Cultural Landscapes Initiatives: Experience in Bhutan.* (Eds.) Roland Lin, Junko Makai and Yeshi Samdrup. Bhutan: Royal Government of Bhutan, Department of Culture, and UNESCO, 2019: 44–48.

Jain, Shikha (ed.). *Princely Terrain, Amber, Jaipur and Shekhawati.* Gurgaon: Shubhi Publications, 2005.

———. "Walking into the Microcosm of Jaipur: Λ Concept Paper". 2012, UNESCO New Delhi and Indian Heritage Cities Network. Jaipur: Government of Rajasthan, 2012.

Jain, Shikha, and Ratnasree Nandivada. "Teaching Laboratories for Positional Astronomy: The Jantar Mantar Observatories in India". *World Heritage Review*, Issue 54. Paris: UNESCO, 2009.

Jain, Shikha, and Rima Hooja (eds.). *Conserving Fortified Heritage.* Cambridge, UK: Cambridge Scholars Publishing, 2017.

Jain, Shikha, and Rohit Jigyasu. "Urban Heritage Management and Conservation in Jaipur" in *Reshaping Urban Conservation: The Historic Urban Landscape Approach in Action.* New York: Springer Publications, 2019.

Jamkhedkar, Arvind P. *Ajanta.* New Delhi: Oxford University Press, 2009.

Jenkins, Philip. "Goa, the Rome of the East." *Christian Century.* Published August 22, 2017. https://www.christiancentury.org/article/notes-global-church/goa-rome-east

Jiwani, Subuhi. "Know Your Monument: Chhatrapati Shivaji Terminus." *Indian Express.* https://indianexpress.com/article/parenting/events-things-to-do/know-your-monument-chhatrapati-shivaji-terminus-5248596/

———. "Chhatrapati Shivaji Terminus: India's Grandest Railway Station." *Academia.* https://www.academia.edu/25390317/Essay_Chhatrapati_Shivaji_Terminus_India_s_Grandest_Railway_Station

Joshi, Kiran (ed.). *Corbusier's Concrete: Challenges of Conserving Modern Architecture.* Chandigarh: Chandigarh Perspectives, 2005.

———. *Documenting Chandigarh: the Indian Architecture of Pierre Jeanneret, Edwin Maxwell Fry, Jane B Drew.* Ahmedabad: Mapin Publishing, 1999.

———. "Le Corbusier's Chandigarh—The Mentor and His Mission" in *Le Corbusier: From Marseilles to Chandigarh 1945-1965.* Paris: Fondation Le Corbusier, 2007.

Joshi, Nikhil. *The Mahabodhi Temple at Bodhgaya: Constructing Sacred Placeness, Deconstructing the 'Great Case' of 1895.* New Delhi: Manohar Publishers and Distributors, 2019.

Joshi, P. (ed.) *Indian Canvas Re-rendered: Documentation of Indo-Saracenic Architecture.* Mumbai: NASA Information and Documentation Centre (NIDC), 2004.

Kalia, Ravi. *Chandigarh: The Making of an Indian City.* New Delhi: Oxford University Press, 1987.

Kaye, G. R. *Hindu Astronomy*, New Delhi. Archaeological Survey of India, 1924, 1998 [reprint].

Keay, John, *India, A History.* London: Harper Press, 2010.

Kerr, I. J. *Building the Railways of the Raj.* New Delhi: Oxford University Press, 1995.

Khajurao. World Heritage Series Guide Book. New Delhi: Archaeological Survey of India, 2002.

Koch, Ebba. *Le Corbusier's Tapestries for Chandigarh.* Chandigarh: Chandigarh Perspectives, 2005.

———. *Mughal Architecture.* Munich: Prestel, 1991.

———. *The Complete Taj Mahal.* New Delhi: Bookwise (India) Pvt. Ltd, 2006.

Konark. World Heritage Series Guide Book. New Delhi: Archaeological Survey of India, 2003.

Lahiri, Nayanjot. *Ashoka in Ancient India.* Ranikhet: Permanent Black, 2015.

———. *Time Pieces: A Whistle-Stop Tour of Ancient India.* New Delhi: Hachette Book India, 2018.

Lang, John T., Madhavi Desai, Miki Desai. *Architecture & Independence: The Search for Identity—India 1880 to 1980.* New Delhi: Oxford University Press, 1997.

Latif, Syad Muhammad. *Agra, Historical and Descriptive: With an Account of Akbar and His Court and of the Modern City of Agra.* New Delhi: Asian Educational Services, 2003.

London, Christopher W. (ed.). *Architecture in Victorian and Edwardian India.* Mumbai: Marg Publications, 1994.

———. *Bombay Gothic.* Mumbai: PICTOR Publishing, 2012.

Longhurst A. H. *Pallava Architecture: Part I (Early Period).* New Delhi: Archaeological Survey of India, 1924, 1998 [reprint].

———. *Pallava Architecture: Part II (Intermediate or Mamalla Period).* New Delhi: Archaeological Survey of India, 1928, 1998 [reprint].

———. *Pallava Architecture: Part III (The Later Rajasimha Period).* New Delhi: Archaeological Survey of India, 1930, 1998 [reprint].

———. *The Story of the Stupa.* New Delhi: Asian Educational Services, 1979.

Lourenço, José. *The Parish Churches of Goa: A Study of Façade Architecture.* Panjim: Amazing Goa Publications, 2005.

Ludden, David. *India and South Asia: A Short History.* London: Oneworld Publications, 2014.

Mahabalipuram. World Heritage Series Guide Book. New Delhi: Archaeological Survey of India, 2012.

Mankodi, Kirit. *Rani Ki Vav, Patan.* New Delhi: Archaeological Survey of India, 2012.

Martin, Terry, and J. I. C. Boyd. *Halfway to Heaven: The Story of One of the Most Remarkable Railways in the World: The Darjeeling Himalayan Railway: 1879-2000.* Chester, Cheshire, UK: Rail Romances, 2000.

———. *The Iron Sherpa: The History of the Darjeeling Himalayan Railway. Vol. 2.* Chester, Cheshire, UK: Rail Romances, 2010.

Meskell, Lynn. *A Future in Ruins: UNESCO, World Heritage, and the Dream of Peace.* Oxford: Oxford University Press, 2018.

Metcalf, Thomas R. *An Imperial Vision: Indian Architecture and Britain's Raj.* New Delhi: Oxford University Press, 2002.

Michell, George. *Elephanta.* Mumbai: Jaico Publishing House and Deccan Heritage Foundation, 2002.

Michell, George, and Gethin Rees. *Buddhist Rock-Cut Monasteries of the Western Ghats.* Mumbai: Jaico Publishing House and Deccan Heritage Foundation, 2017.

Mitra, Debala. *Konarak.* New Delhi: Archaeological Survey of India, 1972.

Morris, Jan. *Stones of Empire: The Buildings of the Raj.* New York: Oxford University Press, 1983.

Moynihan, Elizabeth B. *The Moonlight Garden: New Discoveries at the Taj Mahal*. Seattle: University of Washington Press, 2000.

Mukherjee, Anisha S. *Jantar Mantar: Maharaja Sawai Jai Singh's Observatory in Delhi*. New Delhi: Ambi Publications, 2010.

Murray, John. *A Handbook for Travellers in India, Burma and Ceylon*. London: J. Murray, 1898.

Nath, R. *Fatehpur Sikri and Its Monuments*. New Delhi: Historical Documentation Research Programme, 2000.

Okada, Amina (text), Jean-Louis Nou (photographs) and Andre Bareau (Introduction). *Ajanta*. New Delhi: Brijbasi Printers, 1996.

Osipova, Elena, L. Wilson, Ralph Blaney, Yichuan Shi, Max Fancourt, Miranda Strubel, Salvaterra T., Claire Brown, and Bas Verschuuren. *The Benefits of Natural World Heritage*. Switzerland: International Union for Conservation of Nature, 2014.

Osipova, Elena, Yichuan Shi, Cyril Kormos, Peter Shadie, Celia Zwahlen, Tim Badman, Matea Osti, Bastian Bertzky, Mizuki Murai, Remco van Merm. *IUCN World Heritage Outlook 2014: A Conservation Assessment of All Natural World Heritage Sites*. Switzerland: International Union for Conservation of Nature, 2014: 64.

Owen, Lisa N. "Beyond Buddhist and Brahmanical Activity: The Place of the Jain Rock-Cut Excavations at Ellora". Unpublished Dissertation for Doctor of Philosophy at University of Texas, Austin, 2006.

Pattadakal. World Heritage Series Guide Book. New Delhi: Archaeological Survey of India, 2008.

Peck, Lucy. *Agra: Architectural Heritage*. New Delhi: Roli Books, 2008.

Pereira José. *Churches of Goa*. New Delhi: Oxford University Press, 2002.

Perur, Srinath. "Chhatrapati Railway Terminus, Mumbai's iconic railway station," for "A history of cities in 50 buildings" series. *The Guardian*. https://www.theguardian.com/cities/2015/apr/21/chhatrapati-shivaji-terminus-cst-mumbai-railway-station

Prajapati, Manibhai K., and Mukundbhai P. Brahmakshatriya. *The Glorious History and Culture of Anhilwad Patan (Gujarat)*. Felicitation Volume. Patan, India: Sanman Samiti, 2009.

Raj, Himanshu. "Old Goa: A Heritage City—Urban Threats and Revival Strategies." *ResearchGate*. Published in October 2015. https://www.researchgate.net/publication/282778757_Old_Goa_A_Heritage_City_-_Urban_threats_and_revival_strategies

Rajagopalan, S., and K.V. Rao. *Old Goa*. Guide Book. New Delhi: Archaeological Survey of India, 1975.

Raleigh, Thomas, Sir. *Lord Curzon in India: Being a Selection from His Speeches as Viceroy and Governor-General of India 1898-1905*. London: Macmillan and Co. Ltd., 1906.

Ramani, Navin. *Bombay Art Deco Architecture: A Visual Journey (1930–1953)*. New Delhi: Lustre Press, Roli Books, 2007.

Rea, Alexander. *Chalukyan Architecture: Including Examples from the Ballari District, Madras Presidency*. New Delhi: Archaeological Survey of India, 1896, 1995 [reprint].

Rezavi, Syed Ali Nadeem. *Fatehpur Sikri Revisited*. New Delhi: Oxford University Press, 2013.

Scriver, Peter and Vikramaditya Prakash. *Colonial Modernities: Building, Dwelling and Architecture in British India and Ceylon*. Routledge, 2007.

Shankar, B., and Shaikh Ali Ahmed. "Significance Assessment of Architectural Heritage Monuments in Old-Goa" in *International Journal of Modern Engineering Research*, Vol. 2, Issue 6, 2012: 4668–4672.

Shivaramamurti, C. *Chola Temples*. New Delhi: Archaeological Survey of India, 1960, 2004 [reprint].

———. *Mahabalipuram*. New Delhi: Archaeological Survey of India, 1952, 2004 [reprint].

The Bridhdeshwar Temple, Thanjavur. World Heritage Series Guide Book. New Delhi: Archaeological Survey of India, 2006.

Trivedi, Vidushi. "The History of Chhatrapati Shivaji Terminus (CST) In 1 Minute." *The Culture Trip*. Published November 17, 2016. https://theculturetrip.com/asia/india/articles/the-history-of-chhatrapati-shivaji-terminus-cst-in-1-minute/

Twining, Thomas. *Travels in India a Hundred Years Ago with a Visit to the United States*. London: James R. Osgood, McIlvaine & Co., 1898.

Vickers, Steve. "In Old Goa, India, a saint's relics raise mysterious questions." *Washington Post*. Published August 14, 2014. https://www.washingtonpost.com/lifestyle/travel/in-old-goa-india-a-saints-relics-raise-mysterious-questions/2014/08/14/c3eaa30c-1e75-11e4-ab7b-696c295ddfd1_story.html?noredirect=on

Wallace, Richard. *The Darjeeling Himalayan Railway: A Guide to the DHR, Darjeeling and its Tea* (2nd ed.). Warwickshire, UK: Friends of the Darjeeling Himalayan Railway, 2009.

Wolmar, Christian. *Railways and the Raj: How the Age of Steam Transformed India*. London: Atlantic Books, 2017.

Woods, Mary N. "The Other and the Modernism: Art Deco Picture Palaces of Bombay," *Art Deco Mumbai*, accessed March 16, 2020. https://www.artdecomumbai.com/research/the-other-and-the-other-modernism-art-deco-picture-palaces-of-bombay/

About the Contributors

Dr Shikha Jain has worked on several nomination dossiers for India and other Asian countries. She was Member Secretary of the Advisory Committee on World Heritage Matters to the Ministry of Culture, India, from 2011–15, during its elected term in the World Heritage Committee. She has worked as a consultant to UNESCO New Delhi on specific missions. She is currently Vice President for ICOFORT, ICOMOS; UNESCO Visiting Faculty at the Category 2 Centre, Wildlife Institute of India, Dehradun; Haryana State Convener of INTACH and Founder Director, DRONAH. She has a post-graduate degree in Community Design and Preservation from Kansas University, USA, and a doctorate in architectural history from De Montfort University, UK.

———

Vinay Sheel Oberoi was an IAS officer of the 1979 batch of the Assam-Meghalaya cadre. He held a post-graduate degree in Economics from the Delhi School of Economics. During his long career of nearly four decades, he served as a consultant with the World Bank, as the Chief (Industry and Technology) of UNDP in India, and the Director of the National Mission on Bamboo Applications (NMBA), among other assignments. From 2010 to 2014, he was the Ambassador and Permanent Delegate of India to UNESCO, in Paris. On his return to India, Oberoi served as Secretary in the Ministry of Women and Child Development, Government of India and Secretary of the Department of Higher Education, Ministry of Human Resource Development. After his retirement, he continued to work in an advisory capacity with various institutions, including several governmental bodies in the fields of education and culture. He passed away in 2020.

Eric Falt has worked in the field of diplomacy and international affairs for three decades, focusing initially on communications and then moving to political affairs and the management of large teams. He has been Assistant Director-General of UNESCO, in charge of external relations and public information, with the rank of Assistant Secretary-General of the UN. Previous assignments have included: attendance of UN Security Council negotiations in New York; participation in the Cambodia peace process; involvement in human rights and peacekeeping activities in Haiti; responsibilities in a humanitarian program in Iraq; and overall promotion of development activities for the UN in Pakistan. He also led the global communications effort of the United Nations Environment Programme (UNEP) and then the global outreach activities of the UN Secretariat in New York. He is currently Director, UNESCO India Cluster Office.

———

Rohit Chawla is one of India's leading contemporary photographers. As the erstwhile Group Creative Director for the India Today Group and *Open* magazine, he has conceptualised and photographed over 300 magazine covers. He has had several solo exhibitions across the world and has also done three coffee-table books.

———

Dr Amareswar Galla is currently Director of the International Centre for Inclusive Cultural Leadership at Anant National University in Ahmedabad, where he also holds a teaching position. He is the founding Executive Director of the International Institute for the Inclusive Museum. He has previously held the

posts of Professor of Museum Studies, the University of Queensland and Professor of Sustainable Heritage Development at the Australian National University. He is co-founder of the global movement for the inclusive museum and intangible heritage studies and was the producer and editor of *World Heritage: Benefits Beyond Borders*, published by Cambridge University Press and UNESCO in 2012.

———

Janhwij Sharma is the Additional Director-General (Conservation and World Heritage) with the Archaeological Survey of India (ASI), overseeing the conservation and management of all protected monuments, including world heritage properties. He is a conservation architect, graduating from the Department of Architecture, Guru Nanak Dev University, and holds a post-graduate degree from the University of York, UK.

———

Amita Baig is a heritage management consultant with nearly three decades of experience in heritage preservation as well as sustainable tourism in India and the Asian region. She worked for many years in Agra with the Taj Mahal Conservation Collaborative. Baig represents the World Monuments Fund in India and has been a member of the Government of India's Advisory Committee on World Heritage Matters and served as a member of the Council of the National Culture Fund.

———

Dr Jyoti Pandey Sharma is a Professor in Architecture at Deenbandhu Chhotu Ram University of Science and Technology, India. She engages with issues pertaining to built heritage and cultural landscapes,

particularly those concerning the Indian subcontinent's legacy of Islamic and colonial urbanism. Her work has been published in peer-reviewed journals and in edited volumes. She has been an invited speaker at a number of international symposia and conferences. Her research has received awards and fellowships including a Summer Fellowship at Dumbarton Oaks Research Library and Collection, Harvard University and a UGC Associate at the Indian Institute of Advanced Study in Shimla.

————

Kiran Joshi has been researching lesser-known nineteenth- and twentieth-century Indian heritage for over twenty-five years, and exploring the diverse meanings and manifestations of Indian modernity and shared heritage. Her seminal work on Chandigarh helped to introduce the notion of "Modern Heritage" in India. She has been associated with ICOMOS International Scientific Committee on Twentieth-Century Heritage (ISC20C) since 2004 and she founded ICOMOS India's National Committee on the subject in 2013. She is a founder member of DOCOMOMO India and served as President of ICOMOS India during 2019–20.

————

Dr Rohit Jigyasu is a distinguished conservation architect and risk-management professional, and the project manager on urban heritage, climate change and disaster risk management at ICCROM, Italy. He served as Vice President of ICOMOS International for the period 2017–20. From 2010–18, he was UNESCO Chair at the Institute for Disaster Mitigation of Urban Cultural Heritage at Ritsumeikan University, Japan. He was the President of ICOMOS

India from 2014–18 and of ICOMOS International Scientific Committee on Risk Preparedness (ICORP) from 2010–19. He has also been a member of ICOMOS International's Executive Board since 2011.

————

Dr Sonali Ghosh is an Indian Forest Service Officer. She has served as a site manager in the Kaziranga and Manas World Heritage Sites, and as a founding faculty at the UNESCO Category 2 Centre at the Wildlife Institute of India. She is a certified IUCN World Heritage Site evaluation expert and has co-edited books on cultural landscapes in Asia as well as an anthology on natural heritage writing. Her current interests lie in exploring nature-culture linkages in heritage and Protected Area management.

————

Dr V. B. Mathur is Chairman of the National Biodiversity Authority and former Director of UNESCO Category 2 Centre on World Natural Heritage Management and Training for Asia and the Pacific Region at the Wildlife Institute of India. A former Indian Forest Service Officer, he has made over thirty-five years of outstanding contribution towards a better understanding of Protected Areas and natural heritage management in India. He also serves as an expert member on various inter-governmental forums.

Image Credits

Index

Captions.

Page 1
The Hawa Mahal (Palace of Winds) in Jaipur. The
coloured glasswork on the windows fills the inner
chambers with a multi-hued spectrum of light.

Page 2
Yakshi Siddhayika, a Jain goddess, is seen here
accompanied by attendants. This panel is in Cave 32 in
the Ellora Caves.

Pages 4–5
An ornate, hand-carved entryway arch on the
porch of the Jami Masjid, in Champaner-Pavagadh
Archaeological Park.

Pages 8–9
A watchful tiger prowls along the lake at the
Ranthambore National Park in Rajasthan. The walls
of the Ranthambore Fort rise above the fog, in the
background.

Pages 10–11
The giant elephants and many smaller carvings of the
famous monolith at Mahabalipuram, variously called
Arjuna's Penance or the Descent of the Ganges.

Pages 12–13
The intricate and dazzling glasswork at the Sheesh
Mahal, or Glass Palace, at the Amber Fort in Rajasthan.

Pages 14–15
A sunny winter morning along the Khangchendzonga in
Singalila National Park.

Pages 16–17
The towering spire of the Virupaksha Temple rises
above the ruins of Hampi in Karnataka.

Page 20
Profuse carvings line the walls of the eleventh-century
stepwell Rani-ki-Vav at Patan.